VEILING IN AFRICA

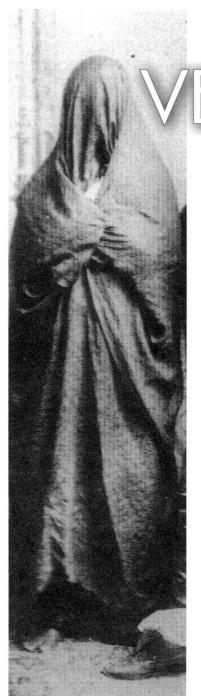

VEILING
in Africa

EDITED BY
ELISHA P. RENNE

Indiana University Press
Bloomington and Indianapolis

This book is a publication of

Indiana University Press
Office of Scholarly Publishing
Herman B Wells Library 350
1320 East 10th Street
Bloomington, Indiana 47405 USA

iupress.indiana.edu

Telephone orders 800-842-6796
Fax orders 812-855-7931

∞ The paper used in this publication meets the minimum requirements of the American National Standard for Information Sciences-Permanence of Paper for Printed Library Materials, ANSI Z39.48-1992.

Manufactured in the United States of America

Library of Congress Cataloging-in-Publication Data

Veiling in Africa / edited by Elisha P. Renne.
 p. cm. — (African expressive cultures)
 Includes bibliographical references and index.
 ISBN 978-0-253-00814-5 (cloth : alk. paper) — ISBN 978-0-253-00820-6 (pbk. : alk. paper) — ISBN 978-0-253-00828-2 (e-book) 1. Hijab (Islamic clothing)—Africa, Sub-Saharan. 2. Veils—Social aspects—Africa, Sub-Saharan. 3. Muslim women—Clothing—Africa, Sub-Saharan. 4. Muslim women—Africa, Sub-Saharan—Social conditions—21st century. I. Renne, Elisha P. II. Series: African expressive cultures.
 BP190.5.H44V45 2013
 391.20882970967—dc23

 2012049581

1 2 3 4 5 18 17 16 15 14 13

CONTENTS

Acknowledgments vii

Introduction: Veiling/Counter-Veiling
in Sub-Saharan Africa • ELISHA P. RENNE 1

PART 1 Veiling Histories and Modernities

ONE Veiling, Fashion, and Social Mobility:
A Century of Change in Zanzibar • LAURA FAIR 15

TWO Veiling without Veils: Modesty and Reserve
in Tuareg Cultural Encounters • SUSAN J. RASMUSSEN 34

THREE Intertwined Veiling Histories in Nigeria •
ELISHA P. RENNE 58

PART 2 Veiling and Fashion

FOUR Religious Modesty, Fashionable Glamour, and
Cultural Text: Veiling in Senegal • LESLIE W. RABINE 85

FIVE Modest Bodies, Stylish Selves:
Fashioning Virtue in Niger • ADELINE MASQUELIER 110

SIX "Should a Good Muslim Cover Her Face?"
Pilgrimage, Veiling, and Fundamentalisms
in Cameroon • JOSÉ C. M. VAN SANTEN 137

PART 3 Veiling/Counter-Veiling

SEVEN Invoking *Hijab:* The Power Politics of Spaces
and Employment in Nigeria • HAUWA MAHDI 165

EIGHT "We Grew Up Free but Here We Have to Cover
Our Faces": Veiling among Oromo Refugees in
Eastleigh, Kenya • PERI M. KLEMM 186

NINE Vulnerability Unveiled: Lubna's Pants and
Humanitarian Visibility on the Verge of Sudan's
Secession • AMAL HASSAN FADLALLA 205

List of Contributors 225

Index 229

ACKNOWLEDGMENTS

This volume grew out of a panel on veiling in Africa at the African Studies Association annual meeting in San Francisco in November 2010. The enthusiasm of the panelists and the interest of the audience encouraged me to invite others to contribute to an edited volume on this topic—which has been under-examined, at least, in the African context. I would like to thank all the contributors, whose prompt and thoughtful responses to my numerous queries have been much appreciated. Special thanks go to Nene Ly, who granted permission for the use of her image on the volume cover, and to Leslie Rabine for taking this photograph. I am likewise grateful to the editorial staff of Indiana University Press, especially Sarah Jacobi, June Silay, and our copyeditor Carrie Jadud, as well as design staff members—all of whose kind but firm organization facilitated the publication process. Dee Mortensen, Senior Sponsoring Editor at Indiana University Press, continues to provide outstanding support for African studies. Finally, I thank the University of Michigan Office of the Vice President for Research for a publication subvention grant for the color plates, which give readers a more vivid view of veiling in Africa.

VEILING IN AFRICA

Veiling/Counter-Veiling
in Sub-Saharan Africa

ELISHA P. RENNE

The little white gauze veil clung to the oval of a face full of contours. Samba Diallo had been fascinated by this countenance the first time he had beheld it: it was like a living page from the history of the Diallobé country. All the features were in long lines, on the axis of a slightly aquiline nose. The mouth was large and strong, without exaggeration. An extraordinary luminous gaze bestowed a kind of imperious luster upon this face. All the rest disappeared under the gauze, which, more than a coiffure would have done, took on here a distinct significance. Islam restrained the formidable turbulence of those features, in the same way that the little veil hemmed them in.

—CHEIKH HAMIDOU KANE, *Ambiguous Adventure*

MUCH HAS BEEN made of the practice of veiling in Europe, particularly in France and Great Britain (Asad 2006; Bowen 2007; Dwyer 1999; Scott 2005; Tarlo 2010; Werbner 2007), and to a lesser extent in Canada, Egypt, Turkey, and Indonesia (Atasoy 2006; Brenner 1996; Çınar 2008; MacLeod 1991; Mahmood 2005). There is also a considerable art historical literature on veiling related to Islamic dress and textiles in the Middle East (Lombard 1978; Stillman 2000; Vogelsang-Eastwood and Vogelsang 2008). Yet as the Senegalese author Cheikh Hamidou Kane's description of the framing of the face of the Most Royal Lady, an older sister of a Diallobé chief, by a "little white gauze veil" suggests, veiling has a long and complex history which, nonetheless, has infrequently been examined in sub-Saharan Africa. This lack of discussion of veiling, an ambiguous term which refers to a range of cloth coverings of the head, face, and body—including the *hijab* and *nikab*,

but also headscarves and shawls, all of which may be conflated as veiling (Scott 2007), reflects the more general association of Islam with the Middle East as well as Western preoccupation with Muslims residing in former colonial metropoles. Yet many Muslim women in sub-Saharan Africa wear veils of some sort (LeBlanc 2000; Fair 2001; Masquelier 2009; Rasmussen 1991; Schulz 2007), which reflects not only the particular history of Islam in various parts of sub-Saharan Africa but also the relations of African Muslims with Islam globally and with the West. As such, the veil may be referred to as a key symbol (Ortner 1973; see also Delaney 1991:32), in this case a thing whose meanings are associated with particular ideas, events, and actions which link important aspects of social life and which often have a specific moral cast. These meanings may be invoked by different Muslim groups and by state officials and may change over time. These two qualities of symbols—their ability to represent connections between seemingly disparate aspects of social life as well as their polyvalent quality—underscore the importance of examining processes whereby meanings of things are contested and/or revised. As with face veils such as the *niqāb,* and a range of related head and body coverings—*hijab,* headscarves, *abaya,* and *jilbab* or *jelabiya*—worn by Muslim women around the world, African women who veil may be seen, depending on the viewer's perspective, as devout and modest followers of Islam, as subordinated women forced to hide their bodies and sexuality, or as threatening beings whose presence challenges democratic, secular ideals (Lewis 2003). While covering one's head, body, and sometimes face with cloth may be framed as the antithesis of social action by women, who are viewed as succumbing to social pressures determined by "male advocates of veiling" (Lazreg 2009:13), veiling in Africa, as elsewhere, reflects a response to a range of complex religious and political situations which have social, gender, and historical dimensions (Mahmood 2005).

Indeed, for some Muslim women in sub-Saharan Africa, veiling may be seen as their choice as proper Muslim women, which furthermore offers them protection and a certain freedom, enabling them to negotiate public space without fear of sexual harassment (Alidou 2005). While dismantling the dichotomy of free unveiled women and suppressed veiled ones was an important analytical advance (El Guindi 1999), an examination of veiling in Africa today reveals the many meanings of veiling there, which have been contested—between Muslims and non-Muslims, as well as within the Muslim community itself, by both men and women—and which have changed over time. Furthermore, historical associations between veiling and independence movements may make it an important aspect

ELISHA P. RENNE

of national identity (Akou 2004), unlike in Turkey, where the wearing of headscarves has been viewed as countering secular ideals of the state (Tavernise 2008a,b). Thus veiling (and related types of Muslim-associated dress) may not be the inflammatory issue it is in Turkey (Pamuk 2004) or in Europe (Scott 2007; Shadid and van Koningsveld 2005), but rather may be viewed as beneficial in the context of national concerns about indecency and nudity (Allman 2004).

Veiling may also be seen as a type of fashionable dress (Moors and Tarlo 2007), which suggests the interconnected dynamics of covered modesty and alluring attractiveness associated with new styles of veiling (Meneley 2007). What is particularly interesting about recent writing on veiling and fashion is the way that this work juxtaposes what is ostensibly traditional—veiling and religion—with modernity, secularism, and fashion (Tarlo 2010; Van Santen 2010). This configuration has particular resonance for the study of dress and veiling in Africa, since, as Jean Allman (2004:3) has noted, Africans have, until recently, been represented as "the people without fashion," who dress within the constraints of "timeless and unchanging" religious practice, the antithesis of the idea of fashion as "up to date" and ever-changing (Simmel 1971). Yet with increasing access to television programs aired on Al-Jazeera and the internet as well as their participation in hajj to Mecca, Muslim women in Africa have a wide range of veiling styles and materials from which to choose. The proliferation of Islamic dress fashions available online, as gifts from returning pilgrims, and as television images reproduced by local tailors has led to the rapid replacement of the old-fashioned with the latest veiling styles.

While the association of veiling with fashion may suggest apparently frivolous concerns, but certainly not disinterested ones, veiling and African dress more generally have played an important role in African nationalist movements. In scenes from a famous example of an anti-colonial nationalist movement, *The Battle of Algiers* (Pontecorvo 1965), veiling was used by women to hide bags filled with grenades and by men to mask their weapons and intentions (Fanon 2003 [1959]). Yet the social ideals associated with these nationalist uses of veiling have been criticized by some Western-educated women in Africa (who may or may not be Muslims) for whom pressure to veil is seen as a form of oppressive subordination (Mernissi 1991). This view is expressed in the story "The Tale of the Woman in Purdah," in Karen King-Aribisala's *Kicking Tongues* (1998:62):

> Each day with my co-wives I cook, we cook, I sit, we sit. We do each other's hair in an intricacy of fine braids until my skull is tight and

throbbing. We look after the children. Always in public I have to wear this veil and be so covered up so that I should not tempt the lusts of men. I am a walking mummy. And as dead.

Yet this story also captures the sense of duplicity, masking, and disguise associated with veiling in particular and cloth in general (Schneider and Weiner 1986:179). For when the Woman in Purdah's husband must quickly hide from a menacing group of men seeking repayment—for what service, it is unclear—she dresses him in a kaftan and veil, which serve the purposes of both husband and wife. The men leave and the Woman in Purdah extracts a promise of release from the confines of house and veil.

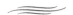

Contributors to this volume consider these complementary, sometimes conflicting, aspects of veiling in Africa from social, cultural, political, and/ or historical perspectives, focusing on three interrelated themes, which frame the book's three parts. In part 1, Veiling Histories and Modernities, veiling is considered in the context of cultural ideologies associated with historical, social, and political events—including reformist religious movements and specific political circumstances of colonial and post-colonial states—and in the ways that these events have contributed to changing styles of veiling. For example, while veiling in late-nineteenth-century Zanzibari society was restricted to an Omani ruling elite, with the abolition of slavery on the island in 1897, women of African and former slave descent began covering their heads with *kanga* cloths to mark their new status. As Laura Fair explains, different fashions in Islamic dress emerged during the twentieth century which were worn by Zanzibari women of all backgrounds. Alternately, these shifts in styles of veiling may reflect generational, educational, and gendered, rather than status, distinctions. Working on the borders to two former French colonies, Niger and Mali, Susan Rasmussen examines veiling in terms of the concept of *takarakit*, shame, which underscores the intersection of gender identities and veiling (Anderson 1982). In Tuareg society, where both women and men wear head coverings (Rasmussen 1991) and where men, but not women, wear face veils (Murphy 1964), *takarakit* has recently come to be more closely associated with women, rather than with men as it was in the past. This shift represents the influence of not only Islamic scholars, but also the political violence and environmental disasters which have led Tuareg women and men to migrate to urban centers and refugee camps, where

different concepts of shame and modesty—and veiling practices—prevail. The dimension of time and social change may be seen in another way through the changes described by Elisha Renne in the styles and materials used in veiling by Muslim women in southwestern and northern Nigeria. In southwestern Nigeria, where there are equal numbers of Muslims and Christians, many Muslim women position themselves in relation to modern time, as being open to new ideas (e.g., Western education), wearing light, stole-like veils over their headties. In northern Nigeria, where the population is largely Muslim, different styles of veiling, such as the *hijab,* may be used to distinguish wearers' ideological interpretations in relation to time—e.g., the time of the Prophet—and may hence be seen as a form of "anti-fashion" (Heath 1992:27). Such narratives look beyond the veil to take into account other factors which have affected African interpretations of Muslim propriety, which may be maintained or altered in present-day society. This shifting and, at times, contested nature of veiling underscores the importance of context and specificity in discussions of veiling in Africa and Muslim women's contribution to religious practice in their communities.

Veiling may also be considered as an aspect of the circulation of Muslim women's fashionable dress—particularly ever-changing veiling styles, which situate these garments within the wider range of dress practices that underscore the inadequacy of the traditional-modern/religious-secular dress dichotomies for explaining the contextualized meanings of veiling in different African societies. In part 2, Veiling and Fashion, contributors consider topics ranging from changes in gender relations and the practice of piety to the multiple meanings associated with veiling. Veiling can reflect religious modesty and fashionable glamour; contributors examine dress styles of Muslim African women and the sources—both material and inspirational—for fast-paced fashions in veiling styles in sub-Saharan Africa. Leslie Rabine focuses on the "supple" variations in veiling fashions in Senegal, which reflect distinctive dispositions and interpretations of Islam as well as the obfuscation of specific social meanings. In Niger, where a reformist Islamic movement has led many Muslim women in the town of Dogondoutchi to wear new styles of veiling which materially express their piety, Adeline Masquelier notes that women are nonetheless concerned with wearing fashionable veils. Veiling fashions thus occupy a seemingly paradoxical intersection of ethos and aesthetics, of piety and beauty, of modesty and attraction, although one might argue that these concepts are dialectically interrelated, with each defining the parameters of the other. Yet as Rabine observes, the religious and aesthetic dimensions of veiling

are fluid and may frequently change, a key aspect of being fashionable and up-to-date. Spatial connection and new veiling fashions are also an important aspect of José van Santen's analysis of Muslim women in Cameroon who have adopted new styles of veiling relating to their performance of hajj. For those who wear *hijab* obtained in Mecca as a way of maintaining connections between Cameroon and Mecca, the *hijab* emphasizes their inclusion within a wider Muslim community. Nonetheless, new forms of fashion may be rejected on moral grounds. At the local level, some Muslim women and men contest this new veiling style, seeing it as an unwarranted distinction which separates those who wear the *hijab* from those who follow more familiar Islamic practice. This diversity of experiences and meanings associated with veiling in Africa and its diaspora underscores the interrelated trajectories of faith and fashion by which particular Islamic identities are expressed.

The implications of veiling in expressing particular Islamic identities within larger Muslim society and, at times, in relation to the nation-state and a global Islam are examined in part 3, Veiling/Counter-Veiling. Veiling itself has been a source of discord as well as a reflection of conflicting interpretations of Islam within Muslim communities (Ahmed 2003 [1992]; Mahdi 2008). Veiling and counter-veiling practices, which include the refusal to veil or to wear particular forms of veils as well as resentment at feeling forced to veil, may also reflect occupational positions, ethnic differences, and religious experiences associated with pilgrimage. These veiling and counter-veiling occupational positions are examined by Hauwa Mahdi, who focuses on the question of why urban and rural Muslim women, who perform different types of work, do or do not wear the *hijab* in northern Nigeria. Focusing on federal legislators' attempts to enforce a national dress code and religious leaders' insistence that Muslim women wear the *hijab,* she argues that wearing the *hijab* may facilitate inclusion for women working in particular sorts of workspaces. Urban women are more likely to do so, while infrequent *hijab* wearing distinguishes rural women doing agricultural work. These local conflicts over veiling and counter-veiling, inclusion and exclusion, take on another valence in refugee settlements in Kenya, where Oromo women from Ethiopia have strategically begun to veil. Their decision to wear a body-encompassing black *abaya* in Kenya, but not elsewhere in the Oromo diaspora, reflects their attempt to mask difference. As Peri Klemm observes, Oromo women have downplayed the visual expression of a distinctive Oromo ethnic identity in favor of an inclusionary form of dress which facilitates their position as Muslim women within the larger Kenyan nation-state. This strategic use of veiling, in particular,

ELISHA P. RENNE

ranging from the casual wearing of head- and body-covering veils to the use of the *burqa,* may be seen in the actions of the Sudanese journalist Lubna Al-Hussein. Amal Fadlalla's analysis of the case of Lubna's pants and associated veiling practices, for which she was twice tried, underscores how, at the state level, veiling practices may resonate with larger national issues about the role of women in politics and with legal ideologies. Lubna's case was consequently taken up as a cause célèbre in France, reflecting contradictory concerns with oppressed Muslim women and African immigrants. Public veiling restrictions as well as veiling requirements, as evidenced in laïcité or in Shari'a law, may be used to support secularism or Islam, respectively. Veils, headscarves, *niqāb,* and *burqa* are thus related to state political regimes that have led to a range of responses to the practice of veiling in Africa and elsewhere.

———

If there has been such a range of interpretations of the veil across the globe, one might then ask: what is so distinctive about veiling in sub-Saharan Africa? Several aspects of historical experience—during pre-colonial, colonial, and independence eras—have contributed to veils being interpreted in particular ways that have influenced veiling/counter-veiling practices there.

To begin, there have been extensive historical ties between sub-Saharan African societies and Muslim areas in North Africa and the Middle East, which include the introduction of Islam to African societies long before Europeans traveled within the continent (Levtzion 2000). For example, Al-Bakri mentioned the Muslim king of Gao in eleventh-century West Africa (Levtzion and Pouwels 2000), while early evidence of a Swahili coast mosque and Muslim burial sites, excavated in the Lamu archipelago, was dated to the late eighth and mid-ninth centuries (Pouwels 2000:252). Additionally, extensive trade networks with Egypt and Tripoli (Johnson 1976; Lydon 2009) contributed to the exchange of materials and ideas which fostered conversion to Islam by the Sahelian political elite, and to a certain extent, by the populace at large.

These religious and trade relationships with North Africa and the Middle East have also lent a particular form to the practice of slavery in Africa, with societies built upon a set of social relations between royal, freeborn, and slave families, seen in the Senegambia, in the empire of Mali, in the Sokoto Caliphate, and in Swahili coastal societies. Ideas about caste, race, and religion contributed to the legitimacy of slavery in societies, as

in an area now part of northeastern Nigeria and western Cameroon where Hamman Yaji's raids of non-Islamic villages and gifts of slaves were commonplace in the early twentieth century (Vaughan and Kirk-Greene 1995). These practices also provided European governments with the anti-slavery justification to pursue the division and subsequent colonial rule of sub-Saharan Africa. Fair (2001) provides a particularly lucid example of the ways that former slaves in Zanzibar took up the dress practices of their former owners as a way, in part, of asserting their new freedom. Roberts (1992) describes similar practices among former slaves in Mali.

The legacies of distinctive European colonial regimes—British, French, German, Portuguese, Belgian—in sub-Saharan Africa have also influenced present-day government responses to veiling. In the former French colony of Cameroon, the concept of *laïcité* (a particular form of secularism represented by the separation of church and state and associated with public school laws in France; Scott 2007:15) has affected Muslim school girls' veiling practices (Van Santen 2010). Alternately, in northern Nigeria, British colonial policy to observe customary (i.e., Shari'a) law has legitimated more recent efforts to incorporate Islamic dress within educational and health institutions there.

Indeed, dress has constituted an important aspect of the relationships between colonial officials and African independence leaders, between converts to Islam and to Christianity, between different ethnic groups, and generationally, between those with Western education and those without it (Renne 1995). These expressions of difference with respect to veiling may clearly be seen in Islamic reformist movements which advocate changes in veiling styles as part of a program of religious reform. Such stylistic changes (and the reformist movements they represent) may also be rejected by other Muslim women in the community, whose counter-veiling styles reflect their adherence to other Muslim sects. Such was the case in Zaria City in the early 1980s, where, with the advent of the reformist movement Movement against Negative Innovations and for Orthodoxy (Jamā'at Izālat al-Bid'a wa Iqāmat al-Sunna, known as Izala; Renne, this volume), women began wearing the *hijab* in public spaces. Those who rejected Izala encouraged their children to taunt these women as they walked by, although this derision has largely ceased as the *hijab* has come to be associated with a global Islam and has gained wider acceptance.

Finally, the particular situation of many African countries vis-à-vis the West during the independence era has played a role in the popularity of veiling in some Muslim communities. For example, the force but also failures of modernity have reinforced fears for the viability of Islamic commu-

ELISHA P. RENNE

nities (Last 2008). Additionally, structural adjustment programs introduced in the 1980s have contributed to economic austerity and inequality, which have fueled anti-Western Islamic movements in which Western dress styles and education are rejected in favor of a range of Islamic forms.

<p style="text-align:center">⸺</p>

These distinctive historical experiences of Islam in different parts of sub-Saharan Africa are reflected in the volume contributors' discussions of veiling practices, contexts, and meanings. Not only has the past framed the varied valences of veiling presently witnessed in the continent; it also suggests some of the ways that African veiling/counter-veiling may proceed in the future.

WORKS CITED

Ahmed, Leila. 2003 [1992]. The discourse of the veil. In *Veil: Veiling, Representation and Contemporary Art,* ed. D. Bailey and G. Tawadros, 42–55. Cambridge: MIT Press.

Akou, Heather. 2004. Nationalism without a nation: Understanding the dress of Somali women in Minnesota. In *Fashioning Africa: Power and the Politics of Dress,* ed. J. Allman, 50–63. Bloomington: Indiana University Press.

Alidou, Ousseina. 2005. *Engaging Modernity: Muslim Women and the Politics of Agency in Postcolonial Niger.* Madison: University of Wisconsin Press.

Allman, Jean, ed. 2004. *Fashioning Africa: Power and the Politics of Dress.* Bloomington: Indiana University Press.

Anderson, Jon. 1982. Social structure and the veil: Comportment and the composition of interaction in Afghanistan. *Anthropos* 77 (3/4): 397–420.

Asad, Talal. 2006. French secularism and the "Islamic Veil Affair." *Hedgehog Review* 8 (1–2): 93–106.

Atasoy, Yildiz. 2006. Governing women's morality: A study of Islamic veiling in Canada. *European Journal of Cultural Studies* 9 (2): 203–221.

Bowen, John. 2007. *Why the French Don't Like Headscarves: Islam, the State, and Public Space.* Princeton: Princeton University Press.

Brenner, Suzanne. 1996. Reconstructing self and society: Javanese Muslim women and "the veil." *American Ethnologist* 23 (4): 673–697.

Çınar, Alev. 2008. Subversion and subjugation in the public sphere: Secularism and the Islamic headscarf. *Signs* 33 (4): 891–913.

Delaney, Carol. 1991. *The Seed and the Soil: Gender and Cosmology in Turkish Village Life.* Berkeley: University of California Press.

Dwyer, Claire. 1999. Veiled meanings: Young British Muslim women and the headscarf. *Journal of Islamic Studies* 16 (1): 35–61.

El Guindi, Fadwa. 1999. *Veil: Modesty, Privacy and Resistance.* Oxford, U.K.: Berg.

Fair, Laura. 2001. *Pastimes and Politics: Culture, Community, and Identity in Post-Abolition Urban Zanzibar, 1890-1945.* Athens: Ohio University Press.

Fanon, Franz. 2003 [1959]. Algeria unveiled. In *Veil: Veiling, Representation and Contemporary Art,* ed. D. Bailey and G. Tawadros, 74–87. Cambridge: MIT Press.

Heath, Deborah. 1992. Fashion, anti-fashion, and heteroglossia in urban Senegal. *American Ethnologist* 19:19–33.

Johnson, Marion. 1976. Calico caravans: The Tripoli-Kano trade after 1880. *Journal of African History* 17:95–117.

Kane, Cheikh Hamidou. 1963. *Ambiguous Adventure.* Trans. Katherine Woods. Oxford: Heinemann.

King-Aribisala, Karen. 1998. *Kicking Tongues.* Oxford: Heinemann.

Last, Murray. 2008. The search for security in northern Nigeria. *Africa* 78 (1): 41–63.

Lazreg, Marnia. 2009. *Questioning the Veil: Open Letters to Muslim Women.* Princeton: Princeton University Press.

LeBlanc, Marie. 2000. Fashion and the politics of identity: Versioning womanhood and Muslimhood in the face of tradition and modernity. *Africa* 70 (3): 443–481.

Levtzion, Nehemia. 2000. Islam in the Bilad al-Sudan to 1800. In *The History of Islam in Africa,* ed. N. Levtzion and R. Pouwels, 62–91. Athens: Ohio University Press.

Levtzion, Nehemia, and Randall Pouwels, eds. 2000. *The History of Islam in Africa.* Athens: Ohio University Press.

Lewis, Reina. 2003. Preface to *Veil: Veiling, Representation and Contemporary Art,* ed. D. Bailey and G. Tawadros, 10–14. Cambridge: MIT Press.

Lombard, Maurice. 1978. *Les textiles dans le Monde Musulman du VIIe au XIIe siècle.* Paris: Mouton.

Lydon, Ghislaine. 2009. *On Trans-Saharan Trails: Islamic Law, Trade Networks, and Cross-Cultural Exchange in Nineteenth-Century West Africa.* Cambridge: Cambridge University Press.

MacLeod, A. 1991. Hegemonic relations and gender resistance: The new veiling as accommodating protest in Cairo. *Signs* 17 (3): 533–557.

Mahdi, Hauwa. 2008. The hijab in Nigeria, the woman's body and the feminist private/public discourse. Paper presented at the African Studies Centre, Leiden.

Mahmood, Saba. 2005. *Politics of Piety: The Islamic Revival and the Feminist Subject.* Princeton: Princeton University Press.

Masquelier, Adeline. 2009. *Women and Islamic Revival in a West African Town.* Bloomington: Indiana University Press.

Meneley, Anne. 2007. Fashions and fundamentalisms in *fin-de-siècle* Yemen: Chador Barbie and Islamic socks. *Cultural Anthropology* 22 (2): 214–243.

Mernissi, F. 1991. *The Veil and the Male Elite: A Feminist Interpretation of Women's Rights in Islam.* Trans. Mary Jo Lakeland. Reading, Mass.: Addison-Wesley.

Moors, Annelise, and Emma Tarlo. 2007. Introduction. Muslim fashions. Special issue, *Fashion Theory* 11 (2/3): 133–142.

Murphy, Robert. 1964. Social distance and the veil. *American Anthropologist* 66 (6): 1257–1274.

Ortner, Sherry. 1973. On key symbols. *American Anthropologist* 75:1338–1346.

Pamuk, Orhan. 2004. *Snow.* Trans. Maureen Freely. New York: Knopf.

Pontecorvo, Gillo, director. 1965. *The Battle of Algiers.*

Pouwels, Randall. 2000. The East African coast, c. 780 to 900 CE. In *The History of Islam in Africa,* ed. N. Levtzion and R. Pouwels, 251–271. Athens: Ohio University Press.

Rasmussen, Susan. 1991. Veiled self, transparent meanings: Tuareg headdress as social expression. *Ethnology* 30 (2): 101–117.

Renne, E. 1995. *Cloth That Does Not Die: The Meaning of Cloth in Bunu Social Life.* Seattle: University of Washington Press.

Roberts, Richard. 1992. Guinee cloth: Linked transformations in production within France's empire. *CEA* 32 (4): 597–627.

Schneider, Jane, and Annette B. Weiner. 1986. Cloth and the organization of human experience. *Current Anthropology* 27 (2): 178–184.

Schulz, Dorothea. 2007. Competing sartorial assertions of femininity and Muslim identity in Mali. *Fashion Theory* 11 (2/3): 253–280.

Scott, Joan W. 2005. Symptomatic politics: The banning of Islamic headscarves in French public schools. *French Politics, Culture and Society* 23 (3): 106–127.

———. 2007. *The Politics of the Veil.* Princeton: Princeton University Press.

Shadid, W., and P. S. van Koningsveld. 2005. Muslim dress in Europe: Debates on negotiation of difference. *Gender, Place and Culture* 6 (1): 5–26.

Simmel, Georg. 1971. *On Individuality and Social Forms.* Ed. D. Levine. Chicago: University of Chicago Press.

Stillman, Yedida. 2000. *Arab Dress: A Short History from the Dawn of Islam to Modern Times.* Ed. N. Stillman. Leiden: Brill.

Tarlo, Emma. 2010. *Visibly Muslim: Fashion, Politics, Faith.* Oxford, U.K.: Berg.

Tavernise, Sabrina. 2008a. For many Turks, head scarf's return aids religion and democracy. *New York Times,* 30 January.

———. 2008b. Under a scarf, a Turkish lawyer fighting to wear it. *New York Times,* 9 February.

Van Santen, José. 2010. "My 'veil' does not go with my jeans": Veiling, fundamentalism, education and women's agency in northern Cameroon. *Africa* 80 (2): 275–300.

Vaughan, James, and Anthony Kirk-Greene, eds. 1995. *The Diary of Hamman Yaji: A Chronicle of a West African Muslim Ruler.* Bloomington: Indiana University Press.

Vogelsang-Eastwood, Gillian, and Willem Vogelsang. 2008. *Covering the Moon: An Introduction to Middle Eastern Face Veils.* Leuven: Peeters.

Werbner, Pnina. 2007. Veiled interventions in pure space: Honour, shame and embodied struggles among Muslims in Britain and France. *Theory, Culture, & Society* 24 (2): 161–186.

ELISHA P. RENNE

PART I

Veiling Histories and Modernities

Veiling, Fashion, and Social Mobility: A Century of Change in Zanzibar

LAURA FAIR

"THE VEIL" HAS never been a static thing, nor have its use and meaning been firm. In this chapter, I explore changes in veiling habits in Zanzibar over the course of more than a century, illustrating both how and why the veil has changed over time. Though "the veil" is often condemned in the West as a sign of women's subordination, here I illustrate that in Zanzibar women have often used the veil to assert both their freedom and their economic might. The bulk of this chapter examines changes in veiling fashions over the course of the twentieth century, but I begin with a brief discussion of a more recent trend to illustrate that the uses and meanings attributed to the veil worn by women in the Isles of Zanzibar—which includes two large islands, Unguja and Pemba, and several smaller ones which came to be known collectively as Zanzibar—are often completely hidden from casual observers in the West.

At the turn of the twenty-first century a new veiling fashion was increasingly seen on the streets and in the markets of Zanzibar. Suddenly, it seemed, growing numbers of women were donning the *niqāb,* choosing to cover their faces entirely when in public rather than wearing the more common *buibui,* which left their faces open, or the more casual *kanga,* thrown over the top of the head and draped over the shoulders and chest. Where did this new style come from, I wondered? And what was the impetus for this change? (Plate 1).

Both the popular Western press and more academic publications were filled with articles discussing the growing presence of "radical" Islam across the globe. In East Africa, many Western observers speculated, in both print and in private, that the *niqāb* was symbolic of a growing Islamic fundamentalism in the Isles. Saudi money was freely flowing into East Africa at the time, and in Zanzibar it was being used to finance the building of large and opulent mosques, as well as institutes of Islamic education.

Since the mid-1980s Iranian scholars, educators, and publications had also been increasingly seen there, and women, in particular, were encouraged to attend classes and discussion groups on Islamic reform. The bombings of the American embassies in Dar es Salaam, Tanzania, and in Nairobi, Kenya, in 1998 added to the refrain commonly heard in the Western press that East Africans were falling into the grip of Al-Qaeda. Increasingly we were told that the donning of the *niqāb* by Zanzibar women was a public testament of their allegiance to the political aims of Al-Qaeda and an endorsement of fundamentalist interpretations of Islam. Western feminists, too, had their fears that the women who adopted this new form of veil were being pressured to do so by men and that the *niqāb* foreshadowed a restriction on women's larger presence in the public domain.

My own research on this topic over the last fifteen years suggests that such fears are largely unfounded. When asked why they were now wearing the *niqāb,* women whom I spoke with in Zanzibar were unanimous in saying it had far more to do with fashion than with fundamentalism. Among those now wearing the *niqāb,* nearly everyone I asked about why she wore it mentioned its being "in fashion" before all else. It was new, it was stylish, and wearing it was fun. As later sections of this chapter show, Zanzibari women have always taken fashion and style quite seriously, and one of the many attractions of the *niqāb* is its range of styles. While most are black, they are frequently adorned with embroidery, sequins, or rhinestones, making their fashion possibilities endless. They are also commonly worn with a matching *jilbab* (overcoat), which can again be fashioned from a range of fabrics, from opaque black to negligee sheer, and adorned with different patterns and material decorations, in myriad colors. Unlike the previously common "veil" worn in Zanzibar, known as the *buibui,* the new style allows for far more personalized expression of style. The variable and constantly changing styles of the *niqāb* and *jilbab* make them the preferred veil worn by younger women, and those with expendable income. Like young women in the West who frequently abandon perfectly good winter coats because their color and style are "so last year," or put aside jeans that have "gone out fashion," many young Zanzibari women abandon perfectly good veils for something new to hit the stores, something more "hip" and fashionable.

None of the women whom I interviewed said that they wore the *niqāb* because they considered themselves "more devout" than those who did not. Furthermore, none of the women I spoke to who regularly attended "reformist" or "fundamentalist" religious training and discussion groups wore the *niqāb*. Most were, in fact, quite critical of this new fashion trend. Many women attending these discussions said that the *niqāb* represented

conspicuous consumption and a "waste" of money that could be put to more pious ends. Changing styles all the time, they asserted, was contrary to what the Prophet had in mind when he encouraged modesty in dress. Others speculated that women donned the *niqāb* as a means of hiding their identity while pursuing nefarious pleasures. I couldn't help but laugh and recall these responses during the early days of Ramadan 2011, when I passed the shop of a Hindu woman selling *bajias* (fried bean snacks) and every female inside was eating while wearing a *niqāb*. While many of the women who identified with "reformist" trends in the Isles also veiled in fashions that differed from the common *buibui,* their preference was for simple styles that left a woman's face, and thus identity, open for all to see.

Feminist fears that the *niqāb* might portend growing restrictions on women's mobility or limits on their presence in the public domain were also not supported by my research. When *niqābs* first appeared in the Isles, they were most commonly sported by young professional women who worked outside of the home. Like their elders who first adopted the *buibui* roughly a century before, they said they wore the veil as one expression of their economic independence and autonomy. Wearing a fashionable *niqāb* and *jilbab* meant that a woman had income to spare, and usually that she earned and controlled her own income, and had a profession that allowed her to support herself independently of a man. Nowadays, it is difficult for young couples to get by on only one income, and while many Zanzibari women have often run small businesses or engaged in trade, in the past twenty years growing numbers have also entered the formal labor market. As they have done so, men's historic obligation of providing for their wives' clothing has increasingly become a thing of the past. Men with whom I spoke whose wives wore the *niqāb* all said they were thrilled that their wives had independent incomes, since few husbands were willing to indulge in buying a veil that could easily run three to ten times the price of their own daily fashions, and yet quickly "go out of style." Meeting the needs of a woman whose veil alone could run US$100–200 was simply beyond the means or desires of most men. Men were unanimous in saying women wore the new *niqāb* and ever-changing *jilbab* for themselves, not for men.

Several working women also equated the *niqāb* with cosmetics. It was an adornment that enhanced their beauty—drawing attention to their eyes—and it protected their complexion from the harmful rays of the tropical sun while walking to and from work, waiting for public transportation, or shopping at the market during the heat of the day. Another fashion trend that appeared in the Isles at roughly the same time as the new veil was the use of skin-lighteners and bleaches, which had previously been banned

under the socialist regime. As neoliberalism took hold new commodities flooded the market, including skin lighteners and the *niqāb* (Thomas 2008). Light, bright complexions became the new fashion rage. For women concerned with maintaining their current beauty without damaging their skin over the long term, the *niqāb* simply made more sense.[1]

Many women, including myself, also experienced unconventional degrees of freedom when wearing the *niqāb*. There is something exceptionally fun about being in public incognito. You can see and observe everyone on the streets, but almost no one can tell who you are. It takes a trained eye, and a degree of intimacy, to be able to identify a woman wearing a mask. Like Batman and Robin, or better yet, Catwoman, you garner unaccustomed respect when you walk down the street: crowds part to let you pass, and you can travel about town both undetected and unmolested. Men who typically made a habit of flirting with me in the market or certain shops didn't say "boo" when I wore the *niqāb*. Other women too said they enjoyed the freedom conveyed by traveling incognito; they could do their errands in record time.

None of the women I interviewed about wearing the *niqāb* expressed any sympathies for Al-Qaeda, Osama bin Laden, or "radical" Islam writ large. This new form of veil had nothing to do with Islamic fundamentalism infiltrating the Isles, in fact it had more to do with neoliberal trade and conspicuous consumption than with religious devotion of any form. This new veiling fashion had nothing to do with women's enhanced subordination or their reluctance to appear in the public sphere. Rather, like their grandmothers before them, these young women donned the veil as one expression of their economic autonomy and larger sense of social freedom overall.

The History of Veiling in Zanzibar

Dress has historically been used as one of the most important and visually immediate markers of class, status, and ethnicity in East African coastal society. As one of many forms of expressive culture, clothing practice shaped and gave form to social bodies (see also Hansen 2000; Hendrickson 1996; MacGaffey and Bazenguissa-Ganga 2000; Martin 1994). In this chapter I examine the social, cultural, and performative processes through which women constructed new individual and collective identities in early-twentieth-century urban Zanzibar. Dress played a critical role in this process. Drawing on cultural elements from their varied, transnational pasts, women in urban Zanzibar crafted newly imagined identities

as Zanzibaris, as they sought to overcome historical divisions between Arab and African, slave and free, and replace them with a new and decidedly modern cosmopolitanism. As with the English usage of the term, this cosmopolitanism carried connotations of being "sophisticated, urbane, worldly," and "free from provincial prejudices" (Brennan 1997:19). It also carried important political implications, as women crafted this cosmopolitanism by weaving together threads from the diverse cultural heritage of their parents, with the aim of creating a larger, more inclusive, fabric of citizenship within the Isles. These processes became particularly pronounced after the abolition of slavery in Zanzibar, in 1897, and continued beyond the period discussed here. And although both male and female slaves participated in efforts to enhance respect for their rights in island society, the ways they publicly expressed their changing definitions of self were often gendered in important ways (Fair 2001:195–264).

Zanzibar in the Nineteenth Century

Prior to the 1830s, Zanzibar was a small and relatively unimportant Swahili town. When the sultan of Oman, Seyyid Said, decided to move his capital to Zanzibar in the 1830s, the fortunes of the Isles changed rather dramatically. Over the course of the next fifty years, what had once been a small fishing village on the western side of Unguja Island grew to become a sprawling urban trading town of more than 80,000 permanent residents. By mid-century, Zanzibar had become the premier trading entrepôt linking traders and goods from Europe, the Americas, and India with those from East and East-central Africa. Among the most important commodities imported from Europe and India during the nineteenth century was cloth, while by far the most lucrative goods exported from East Africa were ivory and slaves. Slaves, and the profits derived from both their sale and their labor, were at the very heart of Zanzibar's economic transformation (Cooper 1977; Cooper 1981:271–301; Sheriff 1987). Slave labor transformed the forest- and shrub-covered coral islands of Unguja and Pemba into the most productive clove plantations in the world, netting vast profits for plantation owners, the majority of whom were immigrants from Oman. Swahili, Yemeni, Omani, and Indian immigrant traders also utilized slave labor to transport goods from ships to godowns, to package materials for trade, and to provide domestic and other services to support crews and fellow merchants from across the globe. As the wealth of Zanzibar grew over the course of the nineteenth century, tens of thousands of free immigrants from neighboring Swahili towns, the Arabian peninsula, and South

Asia decided to settle permanently in the Isles. By far the largest segment of the islands' urban and rural population, however, was made up of slaves captured from the East African mainland. On the eve of the twentieth century, some three-fourths of Zanzibar's estimated population were either enslaved women and men or recently manumitted slaves (Commission on Agriculture 1923:38).[2]

Dress served as a critically important and immediately visible marker of class and status difference in nineteenth-century Zanzibar. The fewer and less ornate clothes one wore, the lower was one's status. Slaves in nineteenth-century Zanzibar typically wore only the slightest of clothes, which were usually made of cheap, coarse white cotton cloth, known as *merikani* because it came from the United States. Male and female slaves during this era often wore only one piece of cloth, which men wrapped around their waists and women tied under their armpits. Slaves employed in the households of the elite sometimes wore additional cloth as well. Because over 95 percent of those who lived in Zanzibar, including slaves, were Muslims, the coverings men and women wore on their heads were also very important markers of class and status. Male slaves were forbidden from wearing caps on their heads, while female slaves were prohibited from wearing headcloths or veils. Perhaps as a further marker of their low social status many slaves of both genders also shaved their heads. Slaves were also required to go barefooted while in the presence of the freeborn (Bakari 1981:173; Burton 1872:428; Figure 1.1).

Members of aristocratic Omani households who were at the other end of the social hierarchy wore the most elaborate costumes and head-dresses. Several yards of extremely expensive cloth, imported from abroad, was wrapped around the heads of Omani men to form a *kilemba*. Similar head-wrappings were sometimes worn by Omani women as well, although typically a woman of the aristocracy would only be seen by those outside of her immediate family while wearing a richly embroidered face mask known as a *barakoa*, a long silk scarf that hung from the head to the back of the knees, known as an *ukaya*, and a long-sleeved, knee-length shirt with frills around the collar accompanied by matching frilled pants, known as *marinda*. The clothing of freeborn Swahili members of society varied by gender and class, but typically included some form of cap or headscarf for both men and women, sewn or wrapped cloth which covered the body from shoulder to at least the knee, if not the ankle, and shoes. Swahili men's clothing typically included a long, white, loose-fitting gown, known as a *kanzu*, and a sewn cap, known as a *kofia*. While the value and quality of the cloth worn by the poorest Swahili woman may have varied little

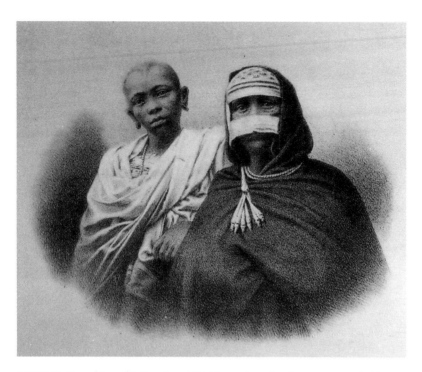

FIGURE I.I. Concubine of Sultan Seyyid Said wearing a *barakoa,* accompanied by a young slave attendant wearing *merikani* (reprinted from Guillain, *Documents sur l'histoire,* vol. 3, 1856).

from that of slaves, whenever possible, when leaving home, a free Swahili woman would mark her status as freeborn by covering her head with a cloth or cap and her shoulders with a longer cloth that reached to the ankles (Fair 2001:65–109). Locally made sandals of leather were also worn by fashion- and status-conscious Swahili (Figure 1.2).

Abolition and the Fashioning of New Identities

Immediately after abolition in 1897, many former slaves began to assert their social and economic autonomy—some by bargaining for reduced labor obligations to their owners, others by leaving their masters and mistresses and moving either to unoccupied land in the countryside or to town (Cooper 1980; Fair 2001). Former slaves also asserted their status as free individuals by adopting previously forbidden forms of dress, by transforming Islamic rituals so that they were more inclusive of women

FIGURE I.2. Common Swahili dress in the early twentieth century: *kanzu* and *kofi* for men, *kanga* for women, often with a second *kanga* draped over the head (courtesy of the Zanzibar National Archives).

and men who were devout and pious but formally uneducated, and by identifying themselves as freeborn Muslim Swahili, rather than as members of the ethnic communities from which their enslaved parents were drawn. Adopting Swahili-style clothing was one means of giving bodily form to these new identities as free "Swahili." By 1900, the Swahili *kanzu* and *kofia* had become the most common form of dress worn by men in the Isles. During the early years of the twentieth century "Swahili" women also transformed their dress, abandoning cloth associated with servility and increasingly adopting a new form of cotton piece-good, known as *kanga*. The first *kanga*s, known as *kanga za mera,* were actually produced locally, in the 1890s, by innovative merchants hoping to capitalize on island women's desires for more variable clothing fashions (Handby 1984; Linnebuhr 1992; Yahya-Othman 1997). *Kanga za mera* were made by block-printing on sheets of white *merikani* cloth, primarily with dyes of black or red. These new fashions were highly popular, although their popularity was nothing compared to that of the brightly colored imported *kanga*s which became the rage after 1897—the year of the abolition decree (Department of Overseas Trade 1897:14). Although the price of a new pair of *kanga*s was five times the cost of the cloth typically worn by slave women, the former were greatly

preferred. British trade reports speak of the vast new market opportunity provided to British manufacturers and traders by island women who were said by many to be busily transforming their identities from those of slaves into "slaves of fashion." The reputation of island women as highly fashion-conscious buyers engaged in endless displays of conspicuous consumption appears to date from this era. "Zanzibar is the Paris of East Africa," wrote one official in 1900, "and the Zanzibar belles are admittedly the glass of fashion. To keep up their reputation for smart dressing involves the frequent purchase of new *kangas,* of which, I understand, a Zanzibar girl will possess as many as two to three dozen sets at one time" (Department of Overseas Trade 1900:15).

Women in turn-of-the-century Zanzibar took great pride in establishing the fashion trends of East Africa. While new, attractive *kanga* designs sold rapidly in the first weeks after arrival in Zanzibar town, "the latest" designs went quickly out of fashion. "It must not be supposed that a woman with any proper respect for herself or for her family will be seen in these patterns in three months' time," warned one British official (Department of Overseas Trade 1897:14). Traders and manufacturers were therefore encouraged to produce small batches of particular designs in order to capitalize on women's preferences for "limited edition" prints; they were also warned of Zanzibari women's very particular tastes, and encouraged to send samples to the Isles first, to determine if a particular color and design combination would be found appealing to island women before embarking on large-scale production of a specific design. In 1900, a newly arrived "smart" *kanga* design would sell for four to five rupees in the first week of arrival, rapidly dropping in price to a low of one rupee within two months. After that the only hope a merchant had for disposing of his remaining stock was to ship it off to an associate in Pemba, who, in turn, would ship his unsold stock off to another shopkeeper on the mainland (Department of Overseas Trade 1897:14, 1899:10, 1900:15; Younghusband 1908:34–35).

Within a period of three years after the abolition of slavery the typical fashions seen in the Isles had been radically transformed. As both men and women began to disassociate themselves from their heritage as slaves and claim new identities as free Swahili they appropriated new forms of clothing to give visible expression to their changing definitions of self (Fair 2001).[3] Whenever economically possible, these new "Swahili" men and women began to wear clothing that covered more of their bodies than previously allowed, including heads, shoulders, legs, and feet. For both men and women, consumption—particularly of imported clothing—was seized

upon as one expression of social and economic autonomy. For women, however, the availability of new and ever-changing *kanga* designs also fostered a desire for conspicuous consumption and display. Wearing the latest style to hit the town, a woman demonstrated to her chosen audience that she had money to spare and could afford to use it to dress up in the newest fashion. Consumption, particularly of imported goods, became an important social marker of cosmopolitanism for members of this generation, demonstrating both their relative wealth, compared to their parents and other East Africans, and their location at the center of the transnational flow of goods and ideas between East Africa and the oceans beyond.

Islam, Veiling, and Respectability

The association of veiling and purdah with status, property, and propriety was widespread in pre-colonial Muslim Africa (Cooper 1994; Mirza and Strobel 1989; Smith 1981:22). Research across the continent indicates that the adoption of the veil and increased seclusion on the part of slave women was common within families that aspired to move up the social hierarchy in the post-abolition period. In coastal East Africa as well, the adoption of various forms of veils by slave women was an indication of their growing empowerment. In a volume first published in 1903, Mtoro bin Mwinyi Bakari, a member of the coastal educated elite, explained the difference between contemporary slaves in a portion of the sultan's dominions along the East African coast and those of the past. He asserted that slaves no longer did the work that they used to do; they were disobedient as well as disrespectful (Bakari 1981:173–174). In Mtoro's opinion this "revolution" in slave behavior, when "slaves began to give themselves airs," could be traced to the adoption of the *ukaya,* veils previously reserved for the free, by certain members of the servile class. Mtoro observed a distinct correlation between the lines of dress that demarcated class and status, and respect for the hierarchies embodied in the dress themselves. Mtoro was not alone. Commenting on the widespread adoption of elite fashions, including the veil, by women of slave heritage in Zanzibar, Adija Bakari told me:

> During the days of slavery one was not allowed to wear certain clothes, these were the clothes of the Arabs [and the freeborn]. But after slavery was done away with . . . the Swahili and others started to wear these clothes. Now you felt like you had become one of the wealthy Arab mistresses, the freeborn ladies. In the earlier days you couldn't wear such clothes, only the wealthy members of the ruling class wore them. You could never dress like a mistress. Once

slavery was abolished, however, you could dress like a lady. . . .
No one could stop you.[4]

The fashions of veiling popular in the Isles changed significantly over time, and continued to vary depending on wealth and residence, yet by the turn of the twentieth century nearly all free women in the Isles were at least covering their heads and shoulders with a *kanga* when in public.[5] This remained the most common form of veiling practiced by women in the countryside through the 1950s. Around the turn of the century another new form of veil also began to appear in the Isles: the *buibui*. It was first worn exclusively by the urban elite, but was quickly adopted by women of all class and ethic backgrounds in the Isles. Explaining the rapid spread of the *buibui* in the years immediately following World War I, several women that I interviewed said that the *buibui* was "the latest fashion to hit the town" or that it became the style that "everyone who was anyone" in the Isles was wearing.[6] European observers made similar assertions, suggesting that by the 1920s all Zanzibari women of "quality" as well as those who "aspired" to move beyond the lower classes were wearing the *buibui* veil (Ingrams 1931:309–311; Pearce 1920:247). As part of a larger shift in social identities, women adopted the *buibui* as one means of expressing their identities as Zanzibaris, free people born in the Isles.

The *buibui* was comprised of a long piece of dark silk or cotton cloth sewn in a circle and then tied around the head with a sewn-in string (Figure 1.3). The *buibui* also had a sheer veil, known as an *ukaya*, that could be draped in front of the face under the eyes, thrown over the face completely, or worn down the back of the head, leaving the face open and exposed. Made of sheer silk or thinly woven cotton, an *ukaya* allowed a woman to see where she was going, even when worn covering her entire face and head. This style, known as *ghubighubi,* from the Kiswahili *ghubika,* to cover from head to foot, was the most common style of wearing the *buibui* from the time of its introduction around World War I until the late 1950s or early 1960s (Figure 1.4). The *ghubighubi* fashion was later replaced by two styles, the one known as *wazi,* or open, and the other as *kizoro,* allegedly after the popular Zorro films of the era. This dialogue between Zanzibari veiling fashions and global film culture reveals the cosmopolitan nature of veiling fashions often considered quite parochial in the West. Throughout most of the 1960s and 1970s the *wazi* fashion was dominant in the Isles. Then in the 1980s what was previously known as *kizoro* made a limited reappearance, now known however as *kininja,* after the Ninja action films popular with the younger generation of island cinema fans. Again, while Westerners might consider the Zorro or ninja style to be more restrictive than the *wazi*

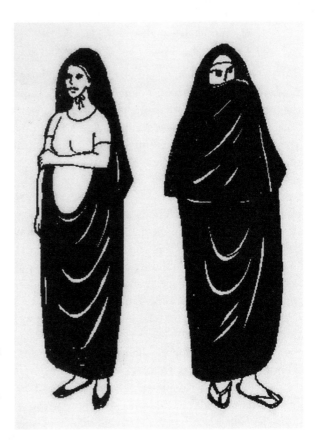

FIGURE 1.3. Women showing two ways of wearing *buibui* (drawing by Helen Liu, courtesy of Helen Liu).

fashion, in the Isles it was associated with the most lithe and agile actors of the time. Women who today wear the *niqāb* are also commonly described as dressing like ninjas.

For the women who came of age following the First World War, covering themselves from head to foot with a *buibui* was a public demonstration of their respectability as well as their growing understanding of Islamic prescriptions for modesty in dress and behavior. The responses most frequently given to the question, "Why did women begin to wear the *buibui* instead of a *kanga* or *ukaya?*" included, "A *buibui* covered you completely, rather than simply covering your head, and was therefore a sign of respect for yourself, your parents, and Islam." Others suggested, "For religious reasons it was best if you covered your body, especially in front of men"; "Covering yourself in public demonstrated your modesty"; or "The *buibui* symbolized you were a woman of dignity and rank, and worthy of respect."[7] Although few of the mothers of women born in the 1910s wore the *buibui*,

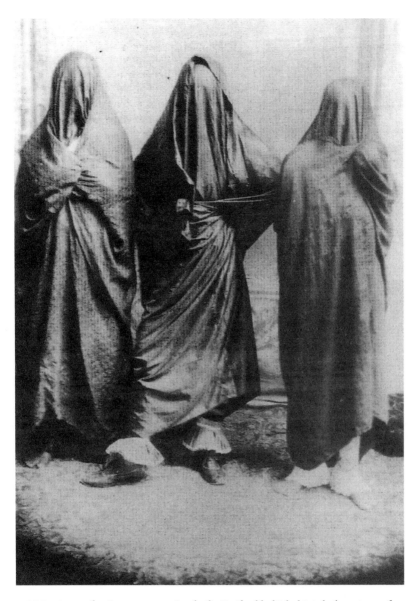

FIGURE I.4. Zanzibari women wearing *buibui* in the *bhubighubi* style (courtesy of the Zanzibar National Archives).

they gave *buibui*s to their daughters as evidence that their children were "becoming more educated about Islam" and that "owners could no longer stop them from asserting their respectability."[8] The young women of this generation, who were amongst the first to wear the *buibui,* were not only the first generation to reach maturity after the abolition of slavery; they were also the first to truly cultivate identities as Zanzibaris (Fair 1998).

During these first decades of the twentieth century the number of adherents to Sufism, particularly the Qadiriyya brotherhood, expanded dramatically in Zanzibar. New forms of Islamic ritual and practice centered around Tariqa spread widely as former slaves made new claims concerning the importance of religious practice and piety as the basis for spiritual standing and equality. Unlike in the Ibadhi and Shafi'i schools, which dominated Zanzibar during the nineteenth century, status within the Sufi brotherhoods was based on religious devotion and daily practice rather than heritage or having studied with the most prestigious scholars. The egalitarian nature of Tariqa doctrine and practice in East Africa was reflected in the relatively large number of individuals from marginal backgrounds who rose to leadership positions within the brotherhoods as well as the open participation of women in many Sufi religious rituals (Iliffe 1979:208–216; Issa 2006; Lienhardt 1959; Nimtz 1980). Sufis not only welcomed women, the poor, and former slaves into their midst; they empowered them to critically evaluate Islamic practices in the Isles by teaching them the *Qur'ān* and the Sunna through oral recitation. In the nineteenth century most Islamic study was confined to those who were literate, and again, mostly to men. Very few slaves had the time or tenacity to learn how to read and write. Nineteenth-century Islamic scholarship, based on literacy, thereby excluded all but the most elite or determined individuals. When asked to explain why so many young women of her generation adopted the *buibui* while those of her mother's generation did not, one woman explained, "Because we had the opportunity to study and learn we understood the meaning of the *Qur'ān.* God will forgive them, our elders did not have such opportunities."[9] The *buibui* also symbolized women's growing identities as Muslim Zanzibaris; it was worn by all young women regardless of class or ethnic background. While slave-owners in the nineteenth century frequently used their superior knowledge of Islam as an additional means of distancing themselves from their slaves, now the children of former slaves adopted the veil as a public proclamation of their equality before God, their freedom from the bonds of the elite, and their new status as free citizens of the Isles.

While the *buibui* reflected a growing ideology of spiritual equality among East African Muslims, it nonetheless allowed Zanzibari women the freedom to express and debate hierarchies rooted in more material concerns. The range of imported fabrics that were fashioned into *buibuis* during this period was extensive, and each had a name, often reflecting the particular qualities of the cloth. Women of property displayed their wealth by purchasing fine black silks from which their *buibuis* were made. The majority of the islands' women, however, typically wore *buibuis* crafted from imported cottons, though here again the quality of the cotton, its rarity on the local market, and the fineness of the gauze used for the *ukaya* worn in front of the face were viewed as important displays of class. Women often saved over considerable periods of time in order to purchase higher-grade fabric for their *buibuis*, as one's public presentation of self-worth was literally wrapped in the choice of *buibui* cloth. While *buibui* fabrics were widely read as public statements of economic ability, a number of women suggested that *buibuis* could also be used to conceal poverty. A *buibui* crafted from a fine grade of cloth could allow a relatively poor woman to present a public persona of middle-class wealth and respectability. As Salma Halfa told me, "If you put on your *buibui* no one will know what kind of clothes you have on underneath. Maybe your clothes are ripped or badly worn, but once you put on your *buibui* you appear clean and beautiful."[10]

A number of women also said that the relative anonymity of a *buibui* worn in the *ghubighubi* style allowed women the freedom to engage in activities that ran counter to the very images of respectability and piety they and their families were seeking to advance. Like the women discussed at the beginning of this chapter, who were wearing the *niqāb* and eating in public during Ramadan, elderly women also said that the *buibui* easily disguised their identity, making it easier to do things they didn't want others to see them do. Several women shared their experiences of wearing a *buibui* in the *ghubighubi* fashion and then sneaking out to meet a lover, entering into an establishment known for selling alcohol, or going to a party uninvited. All said that covering their faces allowed them to feel relatively secure that word of their activities would not be widely spread. Additional precautions were sometimes taken by women who regularly engaged in such activities, such as purchasing a second pair of cheap shoes that could be discretely switched mid-journey for one's regular shoes.

Like the adoption of the *kanga* by the previous generation, the wearing of the *buibui* during these years was associated with social and economic ability. Yet it appears that nearly every young woman who came of age

in the 1920s and 1930s in urban Zanzibar had such aspirations. Although few of the mothers or grandmothers of survey respondents adopted the *buibui*—"each generation has its fashions," explained Fatma Abdalla—96 percent of the women interviewed who were born in Zanzibar after World War I wore the *ghubighubi* style in their youth.[11] As Swahili mothers gave birth to the first post-abolition generation they identified their children as indigenous islanders on their birth certificates, and they gave their daughters *buibuis* when they matured—as visible, public expressions of their children's identities as free, good Muslim Zanzibaris (Kuczynski 1949:660–668).

The age at which women began wearing the *buibui* varied by class as well as residence. Young women from elite urban families were often given their first *buibui* by their mothers when they were between the ages of seven and ten. Women whose parents were of the laboring classes generally received their first *buibui* at puberty, or roughly age fourteen. Women born in the countryside typically did not begin to wear a *buibui* until after they were married, if they wore one at all. Only after World War II did women in the countryside begin to wear the *buibui* in large numbers, and most women said that they were given their first *buibui* by their husbands as part of the wedding trousseau. Although large numbers of women from the mainland migrated to the Isles over the years, it was not until the 1960s that most began to wear the *buibui*. Although they too were Muslim, they considered covering their bodies and heads with a kanga to be sufficiently modest dress. *Kangas* were also easier to move in when working on a farm or preparing food, and in fact most women in town also simply wore *kangas* around the home or the streets of their neighborhoods, reserving their *buibuis* for "dressing up" or "going out."

Women's memories of how they felt about wearing the *buibui* varied considerably, although most considered the *buibui* a sign of their growing maturity. Several women who began wearing a *buibui* at the age of seven or ten said they felt confined and found their previous freedom to run and jump replaced with continuous tripping when they first began to veil. More typically, however, women said that they felt "fashionable," "respectable," or "like a woman" once they began to wear the *buibui*. Many respondents said that wearing a *buibui* made them feel as though they were becoming adults, and that donning a *buibui* encouraged others to treat them like adults as well. Many women recalled how something as simple as wearing a veil transformed adults' perceptions and treatment of them when they were teens. One day they were dismissed as children; the next, they were received as adults.

Throughout history men and women have consciously manipulated their material world in order to physically fabricate their identities as well as to differentiate themselves from others. In nineteenth- and early-twentieth-century Zanzibar as well, consumption served to display subjectivity. Customary practices combined with material inequalities to visually distinguish members of the islands' nineteenth-century aristocracy from the majority slave population. Veils, *barakoas,* and *kofias* immediately identified a wearer as a member of the elite while simultaneously "naturalizing" this position. In a region where most residents were Muslims, the relative nakedness of many slaves served as "proof" of their barbarity. Covering their heads and bodies was one of the first public demonstrations that formerly servile men and women made of their freedom in the post-abolition era. In adopting clothing styles formerly reserved for members of the freeborn or elite, newly emancipated slaves asserted their right to be seen and treated as cultured adults worthy of respect. One hundred years later, wearing the *niqāb* provides women with another sort of freedom.

All too often, Western observers characterize Muslim women who wear the veil as downtrodden victims, dominated by ancient and unchanging religious habits and gender-based social subordination. This brief introduction to the history of veiling in Zanzibar should help to dispel such quick characterizations. Clearly, "the veil" is neither ancient nor unchanging. It is a form of clothing which has gone through numerous transformations over the past century and which women have willingly appropriated as a means of giving material expression to both their power and autonomy. Listening to Zanzibari women, it becomes clear that wearing the veil is intended to elicit not pity, but rather esteem and admiration.

NOTES

1. For more on African women's concerns over their complexions see Lynn Thomas, "The Modern Girl and Racial Respectability in 1930s South Africa," in *The Modern Girl around the World: Consumption, Modernity, and Globalization,* ed. A. Weinbaum et al. (Durham, N.C.: Duke University Press, 2008), 96–119.

2. This estimate was made in 1895 by Sir Lloyd Mathews, first minister of the sultan of Zanzibar. Report of Sir Lloyd Mathews, cited in Commission on Agriculture (1923:38).

3. Although colonial administrators estimated that, in 1895, three-fourths of Zanzibar island's total African population were either slaves or recently manumitted slaves, by the time of the first complete census in 1924, only twelve percent of the protectorate's African population were defining themselves as members of the Nyasa, Yao, and Manyema ethnic communities, the three principal communities

from which Zanzibar's slave populations were drawn (*Report of the Zanzibar Native Census* [Zanzibar: Zanzibar Government Printer, 1924]).

4. Interview by the author in Kiswahili with Adija Saloum Bakari, 3 July 1995.

5. The data for this article come largely from a seventy-five-part clothing questionnaire administered in Zanzibar in 1995 by myself and three research assistants: Ally Hassan, Zuhura Shamte, and Maryam Omar. Respondents ranged in age from fifty to one hundred six.

6. Interviews with Mwanamvita Mrisho, 16 July 1995, and Mauwa binti Khamis, 24 July 1995.

7. From the 1995 clothing questionnaire.

8. Interviews with Fatuma Abdalla, 16 July 1995, and Adija Saloum Bakari, 3 July 1995.

9. Interview with BiMkubwa Stadi Fundi, 8 August 1995.

10. Interview with Salma Halfa 29 June 1995.

11. Interview with Fatma Abdalla, 16 July 1995.

WORKS CITED

Bakari, Mtoro bin Mwinyi. 1981. *The Customs of the Swahili People: The Desturi Za Waswahili of Mtoro Bin Mwinyi Bakari and Other Swahili Persons,* trans. and ed. James Allen. Los Angeles: University of California Press.

Brennan, Timothy. 1997. *At Home in the World: Cosmopolitanism Now.* Cambridge: Harvard University Press.

Burton, Richard. 1872. *Zanzibar: City, Island and Coast.* Vol. 1. London: Tinsley Brothers.

Commission on Agriculture. 1923. *Report of the Commission on Agriculture. .* Zanzibar: Zanzibar Government Printing Office.

Cooper, B. 1994. Reflections on slavery, seclusion, and female labor in the Maradi region of Niger in the nineteenth and twentieth centuries. *Journal of African History* 35 (1): 61–78.

Cooper, Frederick. 1977. *Plantation Slavery on the East Coast of Africa.* New Haven: Yale University Press.

———. 1980. *From Slaves to Squatters: Plantation Labor and Agriculture in Zanzibar and Coastal Kenya, 1890–1925.* New Haven: Yale University Press.

———. 1981. Islam and cultural hegemony: The ideology of slaveowners on the East African coast. In *The Ideology of Slavery,* ed. Paul Lovejoy, 271–301. Beverly Hills: Sage.

Department of Overseas Trade. 1897. *Zanzibar, Report on Trade.*

———. 1899. *Zanzibar, Report on Trade.*

———. 1900. *Pemba, Report for the Year.*

Fair, Laura. 1998. Dressing up: Clothing, class and gender in post-abolition Zanzibar. *Journal of African History* 39 (1): 63–94.

———. 2001. *Pastimes and Politics: Culture, Community and Identity in Post-Abolition Urban Zanzibar, 1890–1945.* Athens: Ohio University Press.

Handby, Jeannette. 1984. *Kangas, 101 Uses.* Nairobi: Lino Typesetters.

Hansen, Karen Tranberg. 2000. *Salaula: The World of Secondhand Clothing and Zambia.* Chicago: University of Chicago Press.

Hendrickson, Hildi. 1996. *Clothing and Difference: Embodied Identities in Colonial and Post-Colonial Africa.* Durham, N.C.: Duke University Press.

Iliffe, John. 1979. *A Modern History of Tanganyika.* Cambridge: Cambridge University Press.

Ingrams, W. H. 1931. *Zanzibar: Its History and Its People.* London: H. F. and G. Witherby.

Issa, Amina Ameir. 2006. The legacy of Qadiri scholars in Zanzibar. In *The Global Worlds of the Swahili: Interfaces of Islam, Identity and Space in Nineteenth- and Twentieth-Century East Africa,* ed. Roman Loimeier and Rudiger Seesemann, 343–362. Berlin: Lit Verlag.

Kuczynski, Robert. 1949. *Demographic Survey of the British Colonial Empire.* London: Oxford University Press.

Lienhardt, Peter. 1959. The mosque college of Lamu and its social background. *Tanganyikan Notes and Records* 52:228–242.

Linnebuhr, Elisabeth. 1992. Kanga: Popular cloths with messages. In *Sokomoko: Popular Culture in East Africa,* ed. Werner Graebner, 81–90. Atlanta: Rodopi.

MacGaffey, Janet, and Remy Bazenguissa-Ganga. 2000. *Congo-Paris: Transnational Traders on the Margins of the Law.* London: International African Institute in association with James Currey.

Martin, Phyllis. 1994. Contesting clothes in colonial Brazzaville. *Journal of African History* 35 (3): 401–426.

Mirza, Sarah, and Margaret Strobel. 1989. *Three Swahili Women: Life Histories from Mombasa, Kenya.* Bloomington: Indiana University Press.

Nimtz, August. 1980. *Islam and Politics in East Africa: The Sufi Order in Tanzania.* Minneapolis: University of Minnesota Press.

Pearce, F. B. 1920. *Zanzibar: The Island Metropolis of Eastern Africa.* London: Unwin.

Sheriff, Abdul. 1987. *Slaves, Spices and Ivory in Zanzibar.* London: James Currey.

Smith, Mary. 1981. *Baba of Karo: A Woman of the Muslim Hausa.* New Haven: Yale University Press.

Thomas, Lynn. 2008. The modern girl and racial respectability in 1930s South Africa. In *The Modern Girl around the World: Consumption, Modernity, and Globalization,* ed. A. Weinbaum, L. Thomas, P. Ramamurthy, U. Poiger, and M. Dong, 96–119. Durham, N.C.: Duke University Press.

Yahya-Othman, Saida. 1997. If the cap fits: Kanga names and women's voice in Swahili society. *Swahili Forum* 4:135–149.

Younghusband, Ethel. 1908. *Glimpses of East Africa and Zanzibar.* London: John Long.

Zanzibar, Government of. 1924. *Report of the Zanzibar Native Census.* Zanzibar: Zanzibar Government Printer.

TWO

Veiling without Veils: Modesty and Reserve in Tuareg Cultural Encounters

SUSAN J. RASMUSSEN

IN THIS CHAPTER, I analyze the power and vulnerability of a gendered cultural value that not only involves the literal wearing of veils, but also incorporates a more general respect, shame, and modesty, called *takarakit* in Tamajaq, the local Berber (Amazigh) language of the Tuareg residing in oases and towns of Niger, Mali, Algeria, Libya, and Burkina Faso. This concept conveys several related yet distinct sentiments or attitudes. Most Tuareg are Muslim, semi-sedentarized, socially stratified, and until recently, predominantly rural and nomadic, but now semi-nomadic.[1] Local mores permit much free social interaction between the sexes, and most women enjoy high social prestige, can independently own property, and are not secluded or veiled; rather, it is men who are veiled. During evening festivals, social occasions, and courtship between the sexes, *takarakit* and "veiled" sentiments with indirect expression are traditionally encouraged, albeit with some social license. In the pre-colonial stratified, endogamous social system, persons who were forbidden to marry were allowed to flirt at the evening festivals. Despite some degree of relaxation permitted under cover of darkness, *takarakit* has long been particularly important there, with highly stylized etiquette, stricter for men than for women. More generally, men are supposed to always respect women, whether during informal sociability, in courtship conversation, or at the evening musical festivals, and are not supposed to boast of or discuss openly their relations with women. Men ideally should be modest, even self-effacing, in women's presence. They should not be aggressive or coercive toward women. Thus there is some coincidence between *takarakit* and respectful conduct more generally. There is also an overlap between *takarakit* and some other values, such as *imojagh* (dignity or honor) and *eshshek* (decency). As anywhere, not

everyone follows this ideal conduct. *Takarakit* is both asserted and violated, a "flashpoint" for debate.

In order to better explain *takarakit,* I first introduce a vignette depicting courtship at a "new" or "contemporary" evening gathering. I critically discuss some hermeneutic challenges to translating the term *takarakit.* Finally, I compare the atmospheres at "traditional" (i.e., older, longstanding, and still-prevalent) and new festivals, both of which feature informal sociability, courtship, and distinctive forms of veiling (or non-veiling), in Tuareg communities, focusing on the urban setting of Kidal, in northern Mali.

Although there are connections and overlaps between *takarakit* and visual markers of modesty such as the veil, this value is not at all limited to physical or visual dress. Men's veiling has been studied extensively, in terms of its longstanding and changing social and religious meanings (Claudot-Hawad 1993; Murphy 1967; Nicolaisen and Nicolaisen 1997; Rasmussen 1991, 2010).[2] Nor is *takarakit* exclusively expressed in the material forms of Tuareg women's draped robes, headscarves, and shawls (Rasmussen 2005, 2009b). In fact, although I show that *takarakit* is partly expressed in the dress of both sexes and that its meanings pertain, in part, to local interpretations of Islamic modesty and piety, this value has additional distinctive meanings which are specific to local contexts. Thus the expression of *takarakit* extends far beyond modest dress or veils.

In this chapter, I focus primarily upon the non-visual markers of *takarakit* in social practice, referring to the visual markers such as veils insofar as the latter shed light on the former. In other words, I explore how visual markers such as veils shed light on what they are not. In some contexts, *takarakit* is a way of veiling without veils. For example, "veiled sentiments" and subtle, indirect communication in courtship are ideals. *Takarakit,* in some respects, is similar to some other peoples' concepts of honor, shame, and modesty, but it differs from them in other respects. I also emphasize social practice and begin with a case study: a puzzling incident of violation of *takarakit,* when a man abandoned a woman at a "modern" evening musical concert in Kidal. Local residents strongly disapproved of this action, and in their comments, they invoked *takarakit.* This "negative case" and its outcome clarify both the meaning of *takarakit* and changing relations between the sexes. My goal is to move beyond strictly normative frames, to bridge the gap between psychological sentiments and their social manifestations, and to minimize slippage in translation of this term.

The Case Study: From Courtship to "Dating"

AN UNPLEASANT INCIDENT:
THE SATURDAY NIGHT "DATE" AND ITS SETTINGS

One Saturday night in the cold, dry season in the northern Malian town of Kidal, I accompanied a group to two venues, the first a newly opened bar and dancing club called Le Grotte. We sat down in comfortable armchairs, ordered soft drinks, and chatted. A young man asked a woman to dance. She did this somewhat reluctantly, allowing him to pull her onto the floor, and they danced only once, briefly.

Le Grotte consists of a disco and bar, partly indoors and partly outdoors, with its terrace open to the evening sky and stars. Music there, unlike at older Tuareg festivals, does not feature the traditional *tende* mortar drum with women's still-popular poetic songs. Instead, the new local "popular rock"—a globally influenced genre called *ichumar* or guitar, sung in Tamajaq and accompanied by guitar, bass, and drums—is played.[3] At the bar, both alcoholic and non-alcoholic drinks are served. Sometimes, musicians from the famous Tuareg guitar band Tinariwen come by to relax. Although there is no cover charge, drinks are expensive by local standards, so mostly middle-class or affluent men in their twenties and upward come there. Few women, and even fewer Tuareg (i.e., Tamajaq-speaking, who self-identify as Tuareg) women frequent this place. The latter tend to arrive in all-female groups and dance together in a circle. Some non-Tuareg women (Songhai, Bambara, and other West Africans) dress in Western or disco-style clothing (i.e., jeans, miniskirts, camisoles), but overwhelmingly, most of the Tuareg women, even at Le Grotte, dress in voluminous, shimmering, pale-colored robes wrapped in a style recalling saris and togas, in Tamajaq called variously *tesoghelnets* (from the verb meaning "to go around" or circulate) or *legers* (French denoting lightweight) (Rasmussen 1991, 2005, 2009b), but not featuring any facial or head veiling.

Kidal is a town of about 20,000, but most residents are semi-nomadic, migrating in and out of town seasonally to assist their rural relatives with herding. In the past, they traveled freely, herding livestock and conducting caravan trade. Early in the twentieth century, French colonial forces built a prison there, brought troops from what is now Senegal to fight Tuareg resistance across this region, and eventually absorbed the region into French West Sudan. On independence in 1960, Malian armed forces established military bases in Kidal. There have been several Tuareg armed rebellions against the state governments of Mali and Niger, from tensions over uneven "development" of the different regions, taxes, food relief

SUSAN J. RASMUSSEN

distribution, artificial nation-state boundaries, and pressures to permanently settle. Around 2006, there was an influx of new residents from Niger fleeing droughts and unemployment. In 2012, some residents returned to the region from Libya, while others have left the northern region of Mali in the wake of armed conflicts there.[4] Although traditional Tuareg leaders' powers have been modified and there is some ethnic diversity in Kidal, the Tamajaq language and Tuareg culture, arts, and symbolism predominate.

Le Grotte, opened in 2004, is one of several new venues in Kidal that are popular with youth for evening entertainment. These places have become arenas for both the assertion and violation of *takarakit,* illustrating its nuanced, situated, and contested meanings. The policeman who opened Le Grotte faced some resistance from local Islamic scholars and the *amenokal,* the traditional leader of the regional Tuareg Ifoghas descent group. After some debate, they gave their permission, on the condition it be constructed on the edge of town, well away from other neighborhoods.

After visiting La Grotte, we proceeded to a local hotel with music. There the "suitor" attempted to pair off with the woman with whom he had briefly danced by sitting close beside her.

To be continued . . .

INTERLUDE

In some ways, this couple's "date" was not a radical departure from "tradition," but was a "modern" variant of more longstanding Tuareg mixed-sex evening festivals featuring music, poetry, song, dancing, flirtation, and courtship conversation, which are much beloved and still take place in most towns and rural villages. These gatherings, which include a drummer, a female chorus, and male dancers, have always featured some license, but also, ideally, *takarakit*-related restraint. Even with some relaxed joking and flirting, there are rules for "correct" behavior and pressure for men to be "gallant" toward women. Courtship conversation featuring wordplay, jokes, and indirect allusion follows mixed-sex evening musical festivals. One can chat in groups and/or meet one's sweetheart alone, away from onlooking elders. At these older festivals, called variously *tende,* after the drum featured, or *ahal,* one is supposed to keep one's eyes lowered and to dress with great care in one's best festival clothing, with men wearing their turbans with their veil high over their mouths and noses and women wearing their dressy indigo-dyed robes, shawls, and headscarves (Figure 2.1). Social critiques and personal desires are only indirectly expressed in poems and songs, there are special festival personal names, and only subtle hand signals communicate sexual innuendo, such as requests from

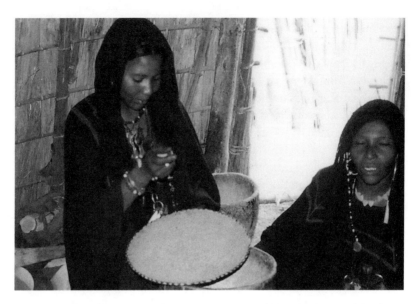

FIGURE 2.1. Bejeweled Tuareg women, wearing headscarves and shawls (photograph by S. Rasmussen).

a suitor to meet later, and acceptance or rejection of a suitor by the woman (Gast 1992; Rasmussen 1995, 2000). A man should not challenge a woman's rejection.

Men, in particular, are supposed to exercise restraint, but both sexes should behave with dignity, respect, and modesty. For example, a man should be gracious, and should not pressure, show anger toward, or argue with a woman. Fights are frowned upon at these mixed-sex gatherings. Social, sometimes sexual, contacts between young unmarried people are therefore common and not objected to, but they should be discreet. Such behavior is required by the honor and moral code of the pre-colonial aristocracy *(imajeghen)*, who often still promote this ideal, and commoners may follow this, except smith/artisans *(inaden* or *inhaden)* and descendants of slaves *(iklan* or Buzu in Niger, Bella in Mali). However, these groups' freedom from *takarakit* is regarded not as its violation but rather as part of their social roles as mediators.

One might surmise that the new guitar concerts and dancing clubs are relaxing this code, but additional forces are at play. Indeed, even the older gatherings are changing. Gast (1992:168–170) and Rasmussen (2000) describe the effects of social upheavals in post-independence Algeria,

Niger, and Mali on Tuareg nomads there.[5] More sedentarization and houses, labor migration, and armed conflict have devalorized the moral socialization role of the older evening festivals. Yet despite some continuities and parallel transformations, the commercial concerts at urban youth centers, hotels, and dancing clubs differ from the older gatherings in significant ways. Monetization in a precarious economy, with widespread unemployment and fewer livestock as wealth, produces behaviors that many adults and elders lament as lacking *takarakit* or being "shameless." At a popular youth center's musical concerts, for example, many adolescents at the door may try to view the show without paying the steep (by local standards) 1000 CFA (about US$3) entrance fee. Some use the clever technique of standing in line after a paying customer, and, if the customer paid with a large bill, expecting change, the "hangers-on" behind him/her try to enter by "tailgating" the paying customer, telling the ticket collector that he/she is "treating" the next person in line.

Thus, ideals and violations of *takarakit* occur at both the traditional mixed-sex evening festivals and the more modern, often also urban, gatherings and concerts. How powerful, in the sense of creating inward shame, are sanctions relating to violation of *takarakit* as modest and respectful conduct?

THE SATURDAY NIGHT "DATE," CONTINUED: REACTIONS AND OUTCOME

To return to this case study: Following our brief stay at Le Grotte, we walked across town to the Hotel des Dattiers, which has an outdoor cabana for live talent shows called *des soirées culturelles* (evening parties) featuring contemporary pop music—that night, rap performed by local Tamajaq-speaking adolescents. Most Tuareg men there wore an eclectic mix of turban-veils and Western jeans or pants and t-shirts, although in town many youths tend to drop the veil except on these special occasions and before elders, marabouts, and leaders (Rasmussen 2010). A few young women wore low-riders and tight camisoles, but as at Le Grotte, these were mostly non-Tuareg women. Significantly, there were no married Tuareg women at either the Hotel des Dattiers or at Le Grotte, whereas at "traditional" *tende* festivals, recently married, still-childless women may attend and even flirt casually with men (Rasmussen 1995, 1997).

At the Hotel des Dattiers, we sat down on folding chairs to watch the talent show. Several times, the aspiring "suitor" moved his chair close beside the woman he desired, and placed his arm around her shoulders. Each time, the woman subtly but firmly slipped out of his arms and moved

her chair a distance away, discouraging his advances. After the third rebuff, the rejected suitor, furious, abruptly rose to his feet, tossed his chair petulantly, and stomped out. By abandoning his "date" there, well after 11 PM, he flouted local etiquette, as a Tuareg man who approaches or "pairs off" with a woman should accompany her home.

Of course, this couple's inner motives here are difficult to ascertain. But the man's anger was apparent, strongly suggesting his interpretation of the woman's actions as rejection, rather than "proper" behavior or modesty. Also, she displayed obvious discomfort with his advances; while witty and subtle conversation between women and men is acceptable, overt, physical advances in public are not. Rather, they are considered "shameful," lacking *takarakit.*

Several days later, I discussed this incident with friends and colleagues. They all expressed shock and one man commented, "Normally, we [men] call in such a man [who treats a woman that way] and we impose a fine on him!" But the suitor had already fled into the countryside. I wondered, did he merely wish to avoid paying a fine? Or did he genuinely feel shame (*takarakit*)? The man who commented was not sure, but insisted that the suitor "had no *takarakit*" (here, most likely denoting respect as well as shame), since he had so abruptly gotten up and left his companion there to fend for herself late at night without taking her home. Then, in order to illustrate the hazards of abandoning a woman during an evening festival, one man recounted another incident, when he, his wife, and her woman friend earlier went to the same hotel for another *soirée musicale.* He related: "We had to leave, and we offered to accompany my wife's friend home, but she wanted to stay there longer, so we left, despite our misgivings. Later that evening, when she left the festival alone, she was accosted ('struck') on the street [either bothered, or actually targeted for a rape attempt—he was vague on this, perhaps from a sense of *takarakit*]. She felt a slap or a blow. She was possessed by spirits [he used the term *des diables* in French, saying she was 'struck by a spirit' (perhaps a euphemism for male attacker in this incident]. For three months afterward, she needed powerful marabout (Islamic scholar) treatments (of amulets and Qur'ānic verses) in order to be cured!"

The raconteur used this story to warn us all that a woman should never walk alone at night; "for then, spirits may strike a woman." He used the idiom of spirits to interpret the urban social problem of what many view as youths' "abandonment of *takarakit*," of increased violence, and of the new dangers and uncertainty, particularly at night, revealing change but also continuity with spirit beliefs; for spirits and the devil (called Iblis)

SUSAN J. RASMUSSEN

can also be associated with love, music, and evening festivals—the positive side of courtship (Rasmussen 1995).

Meanwhile, the errant young man remained in the countryside for nearly a month, hiding among his relatives, until the "storm" blew over and he quietly returned to Kidal—subsequently wearing his veil tightly enveloping his head and face, in the highest (and most modest) style over his nose—and the matter was not brought up again. This most modest veil style's meaning was ambiguous: it can convey either extreme shame, respect, reserve, or occasionally, defiance through exaggeration (Claudot-Hawad 1993).

This "negative case," while representative of neither all *takarakit* ideals nor all its violations, provides a useful point of departure for discussion of *takarakit,* revealing both its active and passive senses of being respectful (or not) and being respected (or not) by others. In Tuareg communities, *takarakit* is still supposed to play a central role in relations between the sexes. It is not asymmetrical: both women and men should observe this value, but as noted, men are slightly more pressured to observe it. Reserve, modesty, "shame," and respect are expressed in a "proper" man's conduct, but not solely by the turban–face veil about which it is said, "the veil and the trousers are brothers" (Murphy 1964, 1967; Rasmussen 1991, 2010). *Takarakit* is also embodied by men's actions: not coercing women into sexual relations; not speaking publicly about personal relationships; not secluding or beating wives or other female relatives; respecting women, as expressed in the proverb "women are for the eyes and ears, not solely the bed"; and, before certain elders, parents-in-law, and respected leaders, refraining from exposing the mouth and nose, from eating, and from pronouncing their names. Many women still tend to own the tent and livestock, educate children, visit and receive unrelated males before and after marriage, travel and herd, and represent themselves in legal cases (Plate 2). Thus far, the vast majority of Tuareg married women cover the head, hair, and the nape of the neck, but do not veil the face; only those very few women who are married to Arab men and are secluded inside their Arab husbands' compounds do so. Occasionally, older Tuareg women draw the edges of their headscarves closely about their mouths, but this style is not permanently fixed, and it never covers the face entirely (Rasmussen 1991, 1997). Instead, it is Tuareg men who customarily wear a turban/veil that ranges in style, according to degree of social distance and reserve desired to be conveyed, from covering the mouth to covering the nose as well (Figure 2.2). In the towns, some youths are beginning to drop this headdress, but they still tend to wear it in the presence of elders, parents-in-law, Islamic

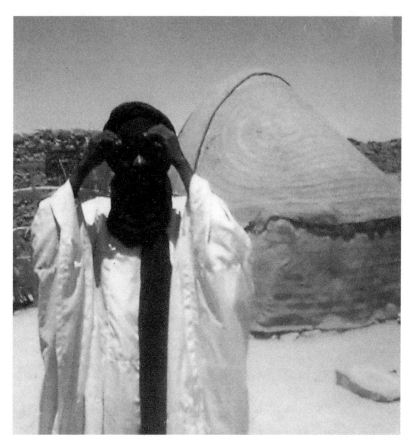

FIGURE 2.2. Veiled and turbaned Tuareg man (photograph by S. Rasmussen).

scholars, and other respected persons, and the men's veil is still prevalent in the countryside (Rasmussen 1991, 2010).

Yet sedentarization, political violence, travel, labor migration, interethnic marriage, and the breakdown of seniority and hierarchical inherited client-patron relationships affect this powerful yet fragile value in relations between the sexes. *Takarakit*—once ideally emphasized more by men than by women, and more by nobles than by subordinates—now emerges in different contexts, and increasingly, also pressures women. Additionally, some youths increasingly violate this value, though its power still persists.

Key to understanding the concept of *takarakit* are intersubjective meanings negotiated during encounters. Next, therefore, it is instruc-

tive to consider problems of translation—specifically, of prevalent use of a gloss or cover-term in anthropology and in Tuareg communities to convey nuanced local meanings of concepts relating to the English terms "reserve"/"respect," "shame," "modesty," and "honor."

Recasting "Reserve/Respect/Shame/Honor"

In much Tuareg sociability, *takarakit* is the centerpiece of moral critique. For example, a friend commented to me as we observed young men, many unveiled, dancing with women in couples accompanied by guitar bands in Agadez, Niger, "We have abandoned *la honte* (French for "shame," often used for the Tamajaq *takarakit*)!" At *tende* festivals in the countryside, only men dance, waving lances and swords, and approaching a standing chorus of women who, through their song verses, mock and judge them and convey critical social commentary. Like many other Tuareg, this man translated *takarakit* from Tamajaq into French, the official language of Mali and Niger, as *la honte*. What do Tamajaq-speaking local residents of multiethnic, multilingual, semi-sedentarized communities who translate *takarakit* as *la honte* mean? Does *la honte* have the same meaning as when they use the Tamajaq term, *takarakit*? Behaviors that are considered shameful or shameless, respected or respectful, disrespected or disrespectful, or modest or immodest, or that elicit embarrassment, vary across cultural settings and over time. One challenge is that *takarakit* is felt (or not felt) as a personal sentiment, taught didactically as a moral value, and followed (or violated) in a social context. In the central case of the young man who abandoned his "date" in Kidal, did he feel *takarakit* later, or was he merely perfunctorily "saving face," but not contrite? Also, why were there so few social consequences—primarily gossip—despite others' strong disapproval of his conduct?

This relationship between shame, modesty, respect, and reserve is elusive. Some collapse these concepts into a single local term. French ethnographers of the Tuareg (Bernus 1981; Casajus 1987, 2000; Claudot-Hawad 1993; Lhote 1953), including local Tuareg ethnographers writing in French (Ag Erless 1999; Ag Solimane 1999), translate *takarakit* as *la honte* or occasionally as *la pudeur*. In the ethnographic literature in English on the Tuareg, *takarakit* appears translated variously as denoting reserve/respect, shame, modesty, and embarrassment (Kohl 2009; Murphy 1964, 1967; Nicolaisen and Nicolaisen 1997). Yet the concept of takarakit, like that of veiling, is difficult to interpret across cultures and languages. One must not only elicit local residents' own definitions, both in general exegeses and

specific contexts, but also note their indexical uses in social predicaments involving transgressions. Although many multilingual, formally educated Tuareg translate *takarakit* verbally into French as *la honte,* there are hints of additional meanings. Here I concentrate on connections and similarities, as well as discontinuities and contrasts, between these concepts in collisions of values in new social predicaments. Are restrictions breaking down, or simply being enforced differently? Do people still feel ashamed, but transgress and disobey some respect-related conduct nonetheless, or does *takarakit* still deter?

Unpacking *Takarakit*

Among the Tuareg, whose honor and dignity *(imojagh)* does this value of *takarakit* protect? *Takarakit* is indexical—its significance changes depending on the context. Often, it is referred to as a positive ideal to uphold, or a positive character trait, somewhat approaching the sense in English of respect or respectfulness or worthiness of respect. But it can also signify embarrassment: for example, in an admonishment when one's conduct is undignified, immodest, or simply shameless or shameful.

Particularly illuminating here are references to modesty and honor in Muslim communities neighboring Tuareg society. Mahmoud discusses the Arabic concept of ʿaura in the context of a key doctrinal position that accords female sexuality a significant weight in provocation of illicit sexual desire, as expressed in a *hadīth:* "The woman, all of her, is unseemly/unprotected (ʿaura); if she goes out from the house, the devil will oversee her (actions)" (Mahmoud 2005:106). This provides the basis for regulating women's appearance in public in the view of Islamist reformists in Egypt and some other Muslim societies. The Arabic term, ʿaura, is complex and has a variety of meanings, including weakness, faultiness, unseemliness, imperfection, disfigurement, and (female) genitalia (Mahmoud 2005). The English term "pudendum" (pl. "pudenda") best captures this meaning of ʿaura since it refers not only to genital organs, but also to that "of which one ought to be ashamed" (Mahmoud 2005:107). Yet there is flexibility and variation in this; for example, many women of lower socioeconomic classes work in mixed-sex offices, and exercise greater vigilance in their dealings with men (Mahmoud 2005:107).

Despite the common adherence to Islam, gender relations in Egypt are very different from those in Tuareg communities in and around the Sahara (Rasmussen 2009a). Local Tuareg cultural interpretations of Islam complicate the concept of modesty in relation to religion on several fronts. As

noted, there is considerably greater freedom of social interaction between the sexes. There is male as well as female modesty in dress, which refers to but also departs from Islam in its rationalizations. Finally, as already observed, these mores extend to wider practices than to dress and veiling alone. There are also additional meanings to Tuareg men's veiling and women's head and body coverings besides Islam—for example, pollution beliefs pre-dating conversion to Islam between the eighth and eleventh centuries CE, such as beliefs that evil spirits enter through bodily orifices (Nicolaisen 1961; Rasmussen 1991). Indeed, among the Tuareg, the whole array of religious injunctions is ambiguous and contested. Islamic scholars/marabouts tend to require more modest dress and less mobility from their female relatives, and are ambivalent about secular music and mixed-sex gatherings. Yet when issues of modesty and respect arise, most Tuareg women and men tend to phrase them in terms of class- and age-based dignity and reserve, rather than gender or Qur'ānic religious injunctions. For example, many admonish someone of aristocratic descent for "not behaving like a noble" or for "behaving like a smith/artisan" or "a slave," and punish a child for disrespecting an older woman by staring at her fixedly.

Takarakit remains closely associated with status and prestige—formerly, pre-colonial inherited social strata. In contrast to gendered contexts, this value was not symmetrical here, but varied according to one's background/origin in the older hierarchy determined by descent and endogamy. In its longstanding sense, still often appealed to in principle if not always followed in practice, *takarakit* is above all a noble value: *imajeghen* are supposed to show the strongest sense of *takarakit;* others also are subject to this value, albeit to lesser degrees. Nobles' subordinates in the old system—smith/artisans, tributaries, freed clients, and slaves and their descendants—were supposed to have the weakest sense of *takarakit,* and their descendants today still do in local stereotype (Rasmussen 2007, 2010). Smith/artisans recite noble genealogies, sing praise songs, help arrange noble marriages, and act as oral historians, ambassadors, and go-betweens. Their lack of reserve (*takarakit*) enables them to pronounce what other persons of higher status cannot, to joke more freely, and to act as confidants, but also powerful social commentators. *Takarakit* in these contexts is observed in relationships anthropologists designate as respect/avoidance/shame relationships, and is traditionally absent in joking relationships.

Takarakit is also related to intergenerational relationships: all persons, regardless of gender or social origins, are supposed to become more dignified, modest, and reserved upon aging—i.e., when one's children marry—and all youths are supposed to treat most elders (exceptions being

one's maternal grandparents and maternal uncles, with whom one practices joking relationships) with reserved, respectful, and modest conduct and attitudes. Elderly women often wear their headscarves higher over the mouth, closely resembling the men's face veil, and wear less jewelry, simpler embroidery, and more voluminous robes, and elderly men often wear their veil hood-like over the sides of the face (Rasmussen 1997:14). Respectful youths are not supposed to ask questions of elders—in particular, the mother-in-law (Rasmussen 1997:xix; 2001:44). In sum, *takarakit* implies a moral dichotomy not between the sexes in Tuareg society, but rather, between different ages and social strata.

Thus these meanings and practices of *takarakit* among Tuareg contrast markedly with similar concepts among Egyptian Arabs and Iraqi Kurds. Among many Iraqi Kurds, honor, modesty, and shame are associated not with women's assertiveness, but with men's domination and biopower, as in the still-frequent honor killings (King 2008:317–342). There is, in other words, fear of an invader/raider into woman's womb/field. But why is the invaded female punished and not the invader male? By contrast, among Tuareg, the threatening invader into the female-owned tent is the bridegroom—who (his legitimacy notwithstanding) represents a potential danger to women's matrilineal-based properties and inheritance. Tuareg rural wedding imagery (of circling on camels around the nuptial tent by the groom's relatives) symbolizes this process (Casajus 1987), in its parallels to war raiding in the past. Virginity is traditionally not important in the bride, although a few men returned from labor migration, political exile, and military campaigns now say they prefer virginal brides. But the woman—wife, sister, or daughter—is not punished in rape, rare in Tuareg society thus far—and also, women are subject to social ostracism, rather than corporeal punishment or honor killings, only in cases of giving birth to illegitimate children. Indeed, it is the new husband who becomes the focus of anxiety: he must show his benign intentions and become integrated into the bride's household by bridewealth payment, initial uxorilocal residence, and groomservice (Rasmussen 1997). Traditionally, it is not the patriliny that most Tuareg men ideally should seek to protect, but rather, their women's safety from violence.

Significantly, it was the "shameless" suitor who violated *takarakit* in the case presented earlier, and who was of noble and marabout background, who was criticized for ungallantly abandoning the woman, leaving her at the mercy of possible aggression from spirits and humans; the woman was not blamed for remaining at the hotel concert. Yet many men today, suffering from low morale, defeats in battle, and sporadic unemploy-

SUSAN J. RASMUSSEN

ment, now seek to protect their dignity or compensate for its perceived loss by greater aggression. Some turn to Islamist-reformist affiliations, and others to weapons, or to distant migration. Alongside the still-powerful ideals of modesty and even humility of the male self and respect toward women, there is some erosion of longstanding matrilineal protections, as men resent the threats to their own male dignity and honor. In the errant suitor's case, he acted with exaggerated dignity, but in so doing sacrificed his honor, in aggressively emphasizing empowering male assertion in reaction against perceived rejection by the woman with whom he flirted.

Thus one major difference between the Tuareg notion of *takarakit* and some other peoples' notions relating to shame, modesty, and honor is the traditional gender symmetry in the Tuareg case, perhaps with somewhat greater pressure on men, although there is evidence this has been changing somewhat recently. Nor does *takarakit* necessarily always convey embarrassment, but there are hints, shown presently, that it is associated with a sense of shame in some contexts.

Modest and Respectful/Respected vs. Immodest and Disrespectful Attitudes and Conduct in Tuareg Society and Cultural Encounters

These varied meanings of *takarakit* raise questions about the borders of Tuareg identity—how they are protected, and how they relate to gender and sexuality. The flows of people and goods into the region are two-directional: in migrant labor, political exile, and refugee status in order to escape droughts and armed conflicts. More recently, refugees, including some Tuareg former rebels, have returned to the regions of northern Mali and Niger in order to escape the war in Libya. Also, in Kidal, some residents have had longstanding tensions with both the Malian army and the Islamist reformists. How are local Tuareg men protecting their female kin from these outside threats, including sexual vulnerability? What relation does this bear to *takarakit* and how might this lead to changes in *takarakit* and sexual prohibitions?

The state can indeed become an exogenous threat and enter into honor discourse (King 2008:333), which, I contend, has had distinctive cultural consequences. Many Tuareg parents have always been wary of sending girls to secular schools. They say, "women prefer to stay inside the tent." Yet women are the focus of protection, not oppression. There is not compulsory seclusion, except for Tuareg women married to Arab

men. For most local residents, this appeal to women's place inside the tent evokes the tent as female-owned nuptial dowry, central to marriage and household property in nomadic camps, and, in many more sedentarized and urban settings, still often found alongside men's houses inside the same compound. Even in Kidal, on divorce, the man always leaves his wife's tent, and it is considered shameful for a husband to request the return of bridewealth. In the ambivalence toward girls' education, this appeal to the tent is motivated by fear that male teachers will harass female students, and that girls will abandon their culture. In other words, in these contexts, women must be "hidden" from the political violence of the region.

There are challenges to *takarakit* conventions. Many families also fear to allow their daughters to enter the new Kidal restaurants, from fear they will be harassed by outside men there, particularly soldiers, who often frequent them. Many rural, older, and more conservative Tuareg men feel ashamed to eat in public in restaurants, but timidly venture there when in town, turning their backs to the room and lifting their veils only slightly to eat hurriedly. Mostly urban adolescent men frequent these places, often unveiled and unashamed. Traditionally, it is shameful for both sexes, but even more so for men, to eat in mixed-sex company outside the household, and shameful for men to uncover the mouth. The male *takarakit* concerning eating is rooted in the nomadic communities, where, recall, there is initially stricter uxorilocal residence, groomservice, and intense *takarakit* toward parents-in-law, than there is in the towns. The point here is that *takarakit* as an obligation is subtly shifting, in some contexts, from men to women. This is not as salient visually in most Tuareg women's head covering thus far, except in cases where Tuareg women marry conservative Arab men and/or where they marry very devout Kunta Arab Islamic scholars.

Gender and class-related *takarakit* issues also emerge in public performances. Although women act in urban plays, men outnumber them (and the latter sometimes play female roles). Female actors are more comfortable performing poetry, singing, and playing the traditional musical instruments. Women are not discriminated against in acting; rather, the cultural emphasis for women of noble background on *takarakit* inhibits them from elaborate gestures and making people laugh, the latter associated with lower-status persons. In their commentaries on these strictures, local residents also mentioned additional Tamajaq terms related to *takarakit,* such as *(e)shshek,* decency (often overlapping with the more positive sense of "reserve" in *takarakit* in usage), and *imojagh,* denoting dignity or honor (etymologically related to regional terms for the pre-colonial aristocracy).

Similarly, many Kidal residents felt that women should not display themselves at the new "Miss Kidal" beauty contests because of reserve (*takarakit*) and modesty, since they associate freedom from reserve (*takarakit*) with social subordinates. Some also fear that allowing women to display themselves before so many people across different media might provoke jealousy associated with the evil eye. Many in Kidal changed their attitudes, however, when it was announced that prizes were offered, which were seen as benefiting the women winners. Indeed, some residents associated these beauty contests with women's liberation because of the economic opportunity offered, the opposite view from much Euro-American feminist ideology. But in contestants' dress, local modesty norms persisted: competing girls wore traditional robes and headscarves/veils in one phase of the contest, and European dress (but not bathing suits) in the other phase. Traditionally, rural Tuareg also have an approximation of women's beauty contests, called *taghamanant* in Tamajaq, which are judged by men. There are also men's beauty contests which are judged by women.[6]

The implications of these patterns for modesty and gender are interesting. In this Kidal beauty contest, in contrast to women's thus far "low profile" in schools and restaurants, women are, on the one hand, becoming less hesitant to exhibit themselves in public. Yet on the other hand, they are becoming more the visual objects of male gaze and judgment; whereas in the older contests, this process was, like *takarakit,* symmetrical and reciprocal: both sexes judged each other.

As noted, *takarakit* denotes respect and reserve—i.e., the opposite of what anthropology has long called "familiar joking relationships." For example, *takarakit* is absent in relations between Tuareg age-mates and cousins, and between nobles and smith/artisans, the latter considered "like cousins" (Casajus 1987; Fischer and Kohl 2010; Kohl 2009; Murphy 1964, 1967; Rasmussen 1997), where disrespect is expected. But in this joking relationship context, lack of *takarakit* carries ludic and mediating, not anti-social, intentions. According to Ewangaye (2005:61) and Kohl (2009:63), the youthful *ichumaren* age cohort has taken over the role formerly monopolized by the *inaden* artisans, who lack *takarakit* as a necessity for their traditionally mediating roles. The *ichumaren* youths, according to these authors, have become "new censors, speakers, and guides of society."

Although I agree with these authors about the absence of *takarakit* among artisans and youths to some degree, I argue that this lack of *takarakit* on the part of many *ichumaren* youths has very different meanings and consequences from artisans' traditional lack of *takarakit.* Thus these parallels should not be overdrawn. In contrast to smith/artisans, *ichumaren*

youth are not formally mediators between chiefs or other "official" sectors of Tuareg society. Rather, these youths act much more informally on an ad hoc basis, and often for individual rather than collective goals.

In the earlier-cited example, the would-be suitor clearly acted without *takarakit,* but not in a familiar, joking relationship, nor for the mediating purposes of social harmony or bringing people together. Instead he acted from individualistic and even (in the view of other youths) selfish motives: of stung vanity upon being rejected. Thus he violated the still-important values of modesty, restraint, and respect toward women in an anti-social way. Indeed, as also shown, rather than mediating or bringing people together, the man fled, isolating himself from social responsibility. The suitor also accompanied a woman who was not the choice of his parents for marriage. Moreover, he was in a family of aristocratic background with many prominent marabouts/Islamic scholars, but he did not avoid the popular, modern, and secular *ichumar*/guitar music that they disdained as "cursed," as opposed to liturgical music. He defied his elders and parents on several fronts.

Thus for those who disobey and insult from selfish motives, their lack of *takarakit* is neither playful nor mediating, but is anti-social. According to a clinic nurse in Kidal, "youths have a different mentality now, lack of motivation except money. . . . Youths interpret democracy as lack of discipline." An actor/comic asserted that "elders' authority has been breaking down since the early 1990s rebellion." Some adults had mixed feelings about young rebel fighters who painted their faction's initials on a tomb in a rural area, judging them to have no *takarakit* (*iban takarakit*) despite the fighters' protection of the villagers; desecrating ancestral graves and tombs is viewed as highly disrespectful.

In towns, many work away from home and for longer hours. There is less time for tea-drinking and elaborate rituals, which have served as not solely occasions of sociability, but also gender and class socialization for youths. Cell phones are now often used to photograph people without their permission. In some respects, this practice is a departure from previous restraints, but it also represents a continuation of a custom pervasive at the older evening festivals, where young men often shine their flashlights on women's faces, hoping to attract their attention (Rasmussen 1995). But the cell phone's photo is potentially multiply reproduced in the electronic media, even beyond Walter Benjamin's concept of mechanical reproduction in modernity, and poses even greater danger of invasion of privacy.

Another arena for debates over *takarakit* is the lyrics in English-language rap music, currently very popular with young people. Upon being

asked by friends to translate some very explicit verses we heard while listening to a CD, I, too, experienced my own form of *takarakit!* I explained that many women do not like what is called "gangsta rap" because they feel that these sexually explicit and sometimes misogynistic verses disrespect women. My friends (both male and female) quickly nodded in comprehension, and ceased asking me to translate, thereby implying that they still felt somewhat constrained by *takarakit.* Most modern Tamajaq *ichumar* guitar lyrics still observe rules of *takarakit,* in their indirect allusion to love matters, but a few verses are becoming more explicit.

Other foci of *takarakit* are losing their hold. In Kidal, in contrast to many rural areas, there is no shame attached to a mother and her oldest daughter both giving birth a month apart. Families hold namedays there for each child without shame. Whereas in the countryside, there is *takarakit* felt by the mother- and son-in-law in encountering each other while the former is pregnant at the latter's child's nameday.

In sum, there are gendered, class-derived, and age-related ideals of *takarakit* and related values, which all intersect, coincide, and overlap, and their respective terms are sometimes used interchangeably by local residents, although these qualities are not precisely equivalent, and I heard the term *takarakit* used most often in different regions and dialects. In social upheavals, some youthful men are rebelling against some strictures of *takarakit* (Keenan 2004; Rasmussen 2001:182) with ill manners and suspect morality. Yet in everyday life, this value remains powerful, but not because it is always adhered to; rather, because many lament its presumed demise so vehemently.

Thus the issue is not so much whether *takarakit* remains powerful overall, but rather, for whom and how (or not), and why (or why not). Of interest to the present analysis is whether *takarakit* remains gender-neutral (that is, symmetrical, demanded of and powerful for both sexes). Data suggest that increasingly, men more than women violate or resist *takarakit* in its connotation of respect, but women are increasingly the focus of *takarakit* in its connotation of modesty and reserve. How and why are these processes occurring?

Takarakit in Crisis

SEDENTARIZATION, MIGRATION, URBANIZATION, AND ARMED VIOLENCE

Relevant to these ongoing transformations, debates, and tensions are wider social changes in Tuareg society, particularly in marriage practices

and the general "position" of women and the matriliny (Keenan 2004; Rasmussen 2000, 2009a, 2010). Changes in marriage practices and women's position generally in Tuareg regions of southern Algeria, northern Mali, and Niger are as follows: first, girls tend to marry at a much earlier age, often when nubile. In former times, girls tended to marry in their early twenties. This trend has to do with economics: many families of aristocratic background have lost their traditional source of livelihood, herds, and even those who take up oasis gardening suffer from intermittent droughts. Many try to marry off their daughters earlier, to men who are well-to-do, older men, and men from outside ethnic groups and/or different social origins, who often are more prosperous and offer higher bridewealth, but have different views of women's roles.

There is also some decline, though not a complete demise, in the importance of the matriline and respect for women in many sedentary communities (Gast 1992; Keenan 2004:143; Oxby 1990; Rasmussen 2006, 2010). In Kidal, it is true that many residents—male and female—eagerly related to me matrilineal origin mythico-histories; this was in contrast to residents of some other regions—for example, in the Air Mountains near Mt. Bagzan in Niger—who were more reticent about these and gave public "lip-service" to men's emphasis upon patrilineal and Qur'ānic mythico-histories. Yet as a social organizational principal beyond mythico-history and ritual symbolism, the matriline has become less relevant due to influences of the nation-state, Qur'ānic legal interpretations and policies, and loss of livestock—women's principal wealth. Women's traditional "living milk" property, going to daughters, sisters, and nieces in the form of livestock, date palms, and other personal effects, is now less accessible. This trend has undermined the preeminent position that women once held. Access to the matriline is no longer of the political importance it once was, since traditional regional Tuareg leaders such as the *amenokal* face modified powers and competition from prefects and other central state authorities. Also, in sedentary gardening and urban communities, many women have an increased domestic workload and are pressured to bear more children for gardening work (Rasmussen 2010). These processes, combined with fear of political violence and threatening outsiders in the region, tend to set women physically more apart and in greater interior seclusion than in the nomadic milieu.

Thus women tend to be more isolated in the sedentary and urban domestic domains, and for many elders, parents, and Islamic scholars, the boundaries of society are becoming situated around women's bodies. This increasing focus on women's bodies does not involve honor killings, full

SUSAN J. RASMUSSEN

face-veiling, seclusion, or other mandatory restrictions thus far; ideally, at least, it centers on their protection. But many younger men are less likely to express respect through modesty or to feel protective of women, since they have skipped various forms of men's socialization, no longer departing on salt and date caravans with older male relatives. Although they have not ceased, these caravans are on the decline because of diminishing livestock, armed conflicts, and competition from trucks. Many (though not all) youths now go on labor migration or to military camps abroad, where they acquire alien gender ideas. In addition, many with few economic means tend to feel frustrated by the difficulty of marriage. In Kidal, for example, many men cannot afford the bridewealth, negotiated as about 300.00 CFA. Also, the wedding celebration in the town features guitar, rather than *tende* drum music, and the *ichumar* guitar music tends to feature verses mostly composed by men, expressing male perspectives; whereas the *tende* drum music, as noted previously, is mostly composed by women, expressing female perspectives, and often critiques male transgressions (Rasmussen 1995).

Some men manipulate Islamic marriage and divorce procedures to their own advantage. For example, polygynous marriages to a second co-wife are based on the man's love choice and are referred to as "a man's marriage," following a first marriage arranged by parents, referred to as a "family marriage." A Tuareg woman in Niamey, Niger, who had divorced her husband because he had taken a second wife, lamented to me that "Here, men no longer respect women." Yet a man there who had divorced his wife complained to me, "she spent all her time over at her sister's home." Kohl (2009:88) notes that, although men often discard their code of honor after migrating abroad—for example, relaxing sexual restrictions with foreign women—many prefer to marry women back home in the rural Sahara since the latter adhere more to codes of courtship—for example, not becoming pregnant out of wedlock. They thereby apply this *takarakit* standard more to women than to men. Thus there are hints of an emerging double standard in some contexts that reverses the old egalitarian, symmetrical, and gender-neutral sense of *takarakit,* particularly among youths, i.e., those who are biologically mature but still unmarried, semi-employed, and not property owners, whom many stereotype as lacking *takarakit.*

Takarakit is still used as a standard to measure conduct, even by the same people, such as youths and artisans, who are stereotyped as lacking this trait. But youths' conduct, in contrast to that of artisans, is not

condoned, but criticized. Furthermore, the hold *takarakit* has over each sex is loosening in some contexts, but persisting, even tightening, in others. In some areas, these changes occur symmetrically in gendered domains, while in others, asymmetrical changes affecting women and men differently are emerging. The diverse situations in which *takarakit* is recognized to be observed or resisted reveal that for many Tuareg, *takarakit* has both positive and negative poles of meaning, which are invoked depending on intention and consequence.

What do these local responses to perceived violations of this value imply about modesty, reserve/respect, and culture and emotions more generally? More broadly, how are emotions generally, and reserve or modesty in particular, to be understood in relation to more literal visual covering and "veiling"? Inward and mutual, intersubjective perceptions and expressions of reserve/respect/shame/modesty are related, but they are not direct reflections of each other. With the exception of men's veiling, there is no precise correspondence between psycho-social *takarakit* and visual covering of the person in Tuareg society. Yet overall, these attitudes and practices are mutually illuminating. To conclude, I advocate enriching the now-proliferating dialogues on women's veiling and modesty by opening up perspectives to include more extended meanings of "covering" the person, in order to escape some circular arguments concerning the connections between material veiling and gender. In addressing gendered modesty, the focus should extend beyond women's veiling; otherwise we risk reducing the veil to an "icon," or simply a synecdoche for complex social practices.

NOTES

The data for this essay are based on my long-term field research in Niger and more recently Mali on topics of spirit possession, the life course and aging, smith/artisans, gender constructs, verbal art performance, and youth cultures, and also, briefer research in France among Tuareg and other Berber (Amazigh)–speaking expatriates and immigrants. In these projects, I am grateful for support from Fulbright-Hays, Social Science Research Council, Wenner-Gren Foundation, the Committee for Research and Exploration at National Geographic, Indiana University, and the University of Houston.

1. The Tuareg, also called Kel Tamajaq after their language, are believed to have originated in the Fezzan region of Libya, in the central Sahara. Many have moved to more southern parts of the Sahara and its Sahel fringe during droughts and wars, and have also been transhumant, with seasonal herding and trading between the desert and the savannah areas and more recent labor migration, political exile, and immigration farther afield. Relations with settled farming popula-

tions have been generally peaceful: in pre-colonial times, aristocratic Tuareg collected tribute from some sedentary groups in exchange for protection, and, like other ethnic groups neighboring the Tuareg, sometimes raided for slaves, who were gradually integrated into Tuareg society in fictive kinship relationships (Nicolaisen and Nicolaisen 1997). Colonial and post-colonial state borders have interfered with local ecological balance and subsistence practices of herding, oasis gardening, and caravanning, and introduced tensions into these relationships, particularly in zones where nomads and farmers collide (see Claudot-Hawad 1993; Dayak 1992; Rasmussen 2001).

2. The Tuareg men's turban/face veil, called *tagelmust* in some dialects, has complex and changing meanings. These include male gender role modesty, especially identified with the pre-colonial *imajeghen* aristocracy, respectful etiquette and social distance, aesthetic beauty, and protection from evil spirits traditionally, but also, more recently, pride in ethnic and cultural identity (see Murphy 1967; Rasmussen 2010). By contrast, the Tuareg women's scarf/shawl does not usually cover the face, but rather the hair and nape of the neck, and is primarily a sign of married social status (see Rasmussen 1991, 2005, 2009b). Like the men's veil, however, the women's scarf/shawl may be adjusted in different styles to convey varying degrees of modesty according to context, though most Tuareg women never cover the entire face, in contrast to many Arab and Pakhtun Afghan women.

3. The type of music is composed and performed by predominantly young men in an age cohort called *ichumaren.*

4. In 2012, Tuareg nationalists declared the Republic of Azawad in the town of Kidal, while Islamists called Ansar Eddin seized control of Timbuktoo and Gao, and Malian post–coup d'etat military forces sought to suppress the former political regime.

5. There have been occasional rapes of women and break-ins at some tourism-oriented "festivals in the desert" and at the older festivals. Some outsiders mistakenly assume that free social interaction and courtship imply that Tuareg women are "free" (Gast 1992:169). Recently, there was a murder at one wedding festival near Gao, Mali, and there are reports of some rapes occurring in the Gao and Timbuktoo regions during the 2012 armed conflicts there between Islamist reformists, the Malian army, and Tuareg nationalists.

6. In rural communities, I observed that men are judged somewhat differently: they race their camels and make them dance, and are judged mostly for their skill, although men's dress and appearance also count. An actor in Kidal confirmed these points.

WORKS CITED

Ag Erless, Mohammed. 1999. *Il n'y a qu'un soleil sur terre: contes, proverbes, et devinettes des Touaregs Kel Adagh.* Aix-en-Provence, France: Edisud.

Ag Solimane, Alhassane. 1999. *Bons et mauvais présages: Croyances, Coutumes, et Superstitions dans la société Touarègue.* Paris: L'Harmattan.

Bernus, Edmond. 1981. *Touaregs Nigeriens: Unité culturelle et diversité régionale d'un peuple Pasteur.* Paris: ORSTOM.

Casajus, Dominique. 1987. *La tente dans l'essuf.* Cambridge: Cambridge University Press.

———. 2000. *Gens de parole: Langue, poésie, et politique en pays tourage.* Paris: Editions la decouverte.

Claudot-Hawad, Helene. 1993. *Les Touaregs: Portrait en fragments.* Aix-en-Provence: Edisud.

Dayak, Mano. 1992. *Touareg: La tragédie.* Paris: Editions Jean Lattes.

Ewangaye, Mohammed. 2005. Tuareg artisans. In *The Art of Being Tuareg,* ed. K. Loughran-Bini and T. Seligman, 57–70. Palo Alto: Iris and B. Gerald Cantor Arts Center; Los Angeles: UCLA Fowler Museum of Cultural History.

Fischer, Anja, and Ines Kohl, eds. 2010. *Tuareg Society within a Globalized World: Saharan Life in Transition.* London: Tauris Academic Studies.

Gast, Marceau. 1992. Relations amoureuses chez les Kel Ahaggar. In *Amour, Phantasmes, et Sociétés en Afrique du Nord et au Sahara,* ed. T. Yacine, 151–173. Paris: l'Harmattan-Awal.

Keenan, Jeremy. 2004. *The Lesser Gods of the Sahara: Social Change and Contested Terrain amongst the Tuareg of Algeria.* London: Frank Cass.

King, Diane. 2008. The personal is patrilineal: Namus as sovereignty. *Identities: Global Studies in Culture and Power* 15:317–342.

Kohl, Ines. 2009. *Beautiful Modern Nomads.* Berlin: Reimer.

Lhote, Henri. 1955. *Les Touaregs du Hoggar.* Paris: Payot.

Mahmoud, Saba. 2005. *The Politics of Piety.* Princeton: Princeton University Press.

Murphy, Robert. 1964. Tuareg kinship. *American Anthropologist* 66:1257–1274.

———. 1967. Social distance and the veil. *American Anthropologist* 69:163–170.

Nicolaisen, Johannes. 1961. La magie et la religion touaregues. *Folk* 13:113–160.

Nicolaisen, Ida, and Johannes Nicolaisen. 1997. *The Pastoral Tuareg.* Copenhagen: Rhodos.

Oxby, Clare. 1990. The living milk runs dry: The decline of a form of joint property ownership and matrilineal inheritance among the Twareg (Niger). In *Property, Poverty, and People: Changing Rights in Property and Problems of Pastoral Development,* ed. P. T. W. Baxter and Richard Hogg, 222–228. Manchester: Manchester University Press.

Rasmussen, Susan. 1991. Veiled self, transparent meanings. *Ethnology* 30 (2): 101–117.

———. 1995. *Spirit Possession and Personhood among the Kel Ewey Tuareg.* Cambridge: Cambridge University Press.

———. 1997. *The Poetics and Politics of Tuareg Aging.* DeKalb: Northern Illinois University Press.

———. 2000. Between several worlds: Images of youth and age in Tuareg popular performances. *Anthropological Quarterly* 73 (3): 133–145.

———. 2001. *Healing in Community.* Westport, Conn.: Bergin and Garvey.

———. 2005. Dress, identity, and gender in Tuareg culture and society. In *The Art of Being Tuareg: Saharan Nomads in the Modern World,* ed. Kristyne Loughran and Thomas Seligman, 139–158. Palo Alto: Iris and B. Gerald Cantor Arts Center; Los Angeles: UCLA Fowler Museum of Cultural History.

———. 2006. *Those Who Touch: Tuareg Medicine Women in Anthropological Perspective.* DeKalb: Northern Illinois University Press.

———. 2007. Revisiting shame: Continuing commentary on Mirdal's article. *Culture and Psychology* 13 (2): 231–242.

———. 2009a. Do tents and herds still matter? In *Gender in Cross-Cultural Perspective,* ed. C. Sargent and C. Brettell, 162–174. Upper Saddle River, N.J.: Prentice Hall.

———. 2009b. Critically re-thinking "Islamic dress": Deconstructing disputed meanings in Tuareg (Kel Tamajaq) women's clothing and covering. *American Journal of Semiotics* 25 (1–2): 1–23.

———. 2010. The slippery sign: Cultural constructions of youth and youthful constructions of culture in Tuareg men's face-veiling. *Journal of Anthropological Research* 55 (4): 471–493.

Intertwined Veiling Histories in Nigeria

ELISHA P. RENNE

"Hijab *is my pride*"

—Packaged hijab, sold at Oja'ba Market, Ibadan, 31 May 2011

"God instructs us to wear hijab, *is it not the Prophet who said we should wear it?"*

—Woman interviewed in Zaria City, 25 April 2001

VEILING IN NIGERIA—a practice which consists of wearing a cloth which may cover the head, body, and at times, the face, feet, and hands—reflects a complex set of social relationships that have religious, political, and historical dimensions. In Nigeria, Muslim women with different ethnic backgrounds wear a range of veiling styles. In the southwest, some Yoruba Muslim women wear the all-encompassing black *burqa*-like garment worn by women known as *ẹlẹẹha* (Plate 3) while the majority wears the more common stole-like *iborun* over *gele* headties. More recently, some have worn different styles of *hijab.* In the north, Hausa Muslim women are more likely to wear the *hijab* worn in a range of styles, including the recent "fashion *hijab*," although some still prefer the style of headtie and *gyale* style similar to those worn in the southwest. In both the north and south, women's thinking about veiling and their decisions about what types of veils they wear reflect the specific histories of Islam and of Islamic organizations in Yorubaland and Hausaland respectively.

In this chapter, I consider the social and political contexts of particular types of veils and veiling practices which have historically been associated with two religious reform movements in Nigeria—the Ansar-Ud-Deen Society of Nigeria (Jam'iyyat Ansar ad-Din Naijiriya), originating in the

south, and Jamāʿat Izālat al-Bidʿa wa Iqāmat al-Sunna (the Society for the Removal of Innovation and the Reinstatement of Tradition), colloquially known as Izala, originating in the north. This comparative approach, however fraught, underscores the complex meanings of veiling associated with religious belief, ethnicity, and place in Nigeria as well as the myriad styles of veils worn and the frequent changes in veiling regimes. While these movements emerged at different times in the twentieth century—Ansar-Ud-Deen was founded in Lagos in 1923; Izala was founded in Jos in 1978—and had distinctive but not unrelated emphases, both groups included reforms which focused on the education of married women. The doctrinal importance of women's education for these movements had differing consequences for the practice of seclusion and veiling for Yoruba and Hausa Muslim women in Nigeria. Yet despite reformist intersections, veiling has also been used to distinguish Muslim women's ethnic identity. On the one hand, Yoruba Muslims have tended to stress forms of veiling which are compatible with cultural ideals of progress-in-time and social integration in southwestern Nigeria, where there are approximately equal numbers of Yoruba Muslims and Christians. On the other, ideals of Islamic authenticity prevail among Hausa Muslims in northern Nigeria, where the population is largely Muslim and where veiling practices may be used to distinguish wearers' ideological interpretations in relation to time—e.g., the time of the Prophet. Thus in both northern and southwestern Nigeria, Muslim women may wear various types of veils, which include a headtie (*gele,* Yoruba) and stole (*iborun,* Yoruba; *gyale,* Hausa) combination, or more recently the *hijab,* although for different reasons. In the north, where seclusion is considered part of the modest behavior prescribed by the *Qur'ān,* veiling, and more specifically wearing a *hijab,* enables married Muslim women in Hausa society to extend their mobility by delineating a moral space outside of their homes (Renne, forthcoming). In the southwest, women may veil in order to visually express a pious Islamic identity—as with *ẹlẹẹha* women—or to maintain their acceptance of aspects of Western modernity while asserting their presence as equal members of multi-religious Yoruba society. These distinctive dynamics, the expression of a proper, Islamic identity in a Christian context, may be seen in the recent demands of young Muslim women—in both Oyo State in southwestern Nigeria and in Kaduna State in the north—to incorporate veils into school uniforms, initially introduced by British colonial officials and missionaries. In this chapter, I consider how veiling in southwestern Nigeria—mainly in Ibadan, in Oyo State—and in northern Nigeria—mainly in Zaria City (the old walled section of the northern Nigerian town of Zaria), in Kaduna State—has had distinct but

not unrelated historical trajectories, reflecting particular religious beliefs and relations, concepts of ethnic identity, and ideas about time and the past, which may be seen in the intersections and divergences in the types of veils worn by Yoruba and Hausa Muslim women.

Islamic Reform, Women's Education, and Veiling in Northern Nigeria

Veiling in northern Nigeria has a long history, associated with influences from Islamic empires to the west (Mali and Songhay) and east (Bornu), from the nineteenth-century Sokoto Caliphate, and from trans-Saharan trade, as well as from more recent textiles brought by southern traders and brought back from Saudi Arabia by those performing hajj (*kayan Mekka*). Nana Asma'u, the daughter of Sheikh 'Uthman dan Fodio, the religious reformer and leader of the nineteenth-century jihad that led to the establishment of the Sokoto Caliphate,[1] wrote of the importance of women's modest comportment and dress, including the use of veils (Mack and Boyd 2000:83). Furthermore, Nana Asma'u established a system of Islamic education for women which has continued into the twenty-first century. The *jaji* women teachers whom she trained covered themselves with cloths as they went about the city of Sokoto and its environs instructing other women in knowledge of the *Qur'ān* (Boyd 1989).

In the beginning of the twentieth century, Muslim Hausa women in northern Nigeria veiled mainly using handwoven cotton textiles, referred to as *zane, mayafi,* or *kallabi,* which could be loosely draped over a coiled headscarf (*gwaggwaro*). At that time, women did not wear the overall body covering known as the *hijab,* nor did they wear the *gyale,* a type of imported, diaphanous, stole-like veil probably introduced to northern markets by Yoruba traders in the 1940s. As one such trader explained: "Yoruba traders called the cloth that Hausa women in Zaria were calling *mayafi* (stole) by the Yoruba word, *gele* (headtie)," so that eventually, the diaphanous stole-like head covering that they brought from Ibadan to sell came to be known as *gyale* (Interview, Zaria City, 3 June 2011). This man's observation corresponds to the remarks of an older woman living in Zaria City, who noted:

> We weren't brought up with *hijab* and it is not in our culture. Even before, women were covering their bodies with big wrappers (*zane*), not *gyale* (*kallabi*). *Gyale* is in modern times. (Interview, Zaria City, 22 July 2001)

ELISHA P. RENNE

Although numerous terms for women's head covering may be found in the 1934 Hausa dictionary compiled in late 1920s and early 1930s, neither the *gyale* head covering nor the *hijab* are mentioned in this volume (Bargery 1993 [1954]). Within their compounds, married women wore head kerchiefs (*kallabi*) or wrapped headscarves (*gwaggwaro;* see Smith 1954). Photographs from the early twentieth century show Hausa women in public wearing *zane* handwoven cloth wrappers, at times with cloths draped over their heads (Figure 3.1).

Interviews of Zaria City women suggest that while women were conscious of the importance for Muslim women to cover themselves in public, most women could not correctly recite verses from the *Qur'ān* or *hadīth* or read Arabic or Ajami script.[2] Nor was there any special dress or veil associated with women's Islamic education. However, this situation changed with the advent of the Islamic reform movement Izala during the late 1970s.

RELIGIOUS REFORM IN ZARIA

For many women in Zaria, the introduction of the *hijab*—a specific style of veil that covers the head, shoulders, and at times, the entire body, but not the face—as proper Islamic dress is associated with the beginnings of the Movement against Negative Innovations and for Orthodoxy (Jamā'at Izālat al-Bid'a wa Iqāmat al-Sunna, known as Izala; Umar 1993) and its support for Islamic education for married women in northern Nigeria (Kane 2002; Loimeier 1997). This movement, formally organized in 1978, was instrumental in establishing classes for adult married women (Islamiyya Matan Aure) and in encouraging women to attend them, particularly in Zaria and Kaduna beginning in late 1970s and early 1980s (Renne 2012). Married women living within the old walled section of Zaria, Zaria City, began to wear the *hijab* when attending the newly established Islamiyya classes for married women there.

When they were introduced in Zaria City, Izala classes for married women were considered revolutionary by some who felt that breaking the prevailing rules of seclusion (Callaway 1984; Renne 2004; Schildkrout 1983) would lead to immorality and dissension in the home. This situation was complicated by the implicit (and at times, explicit) criticism of the two prevailing Islamic groups in northern Nigeria, the Qadiriyya and Tijaniyya orders, by the Izala leader, Sheikh Abdullahi Gumi, and his followers. While heeding Gumi's advice to seek Islamic knowledge in order to improve themselves as proper Muslim wives and in order to better train their children, married women attending Islamiyya Matan Aure classes,

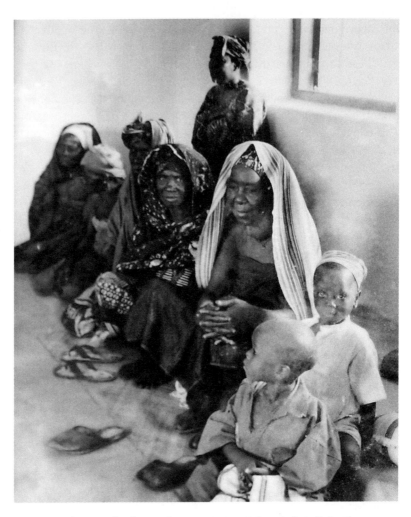

FIGURE 3.1. Photograph taken in the 1930s in a Zaria hospital or clinic. The women seated on mats on the floor are wearing a range of different veil-cloths (*mayafi* or *zane*) over headscarves (*kallabi*) or headties (*gwarggwaro*). The woman standing in the background is wearing a *gele*-type headtie and may be Yoruba. Not only is she wearing a *buba* and wrapper outfit, a style of Yoruba dress, she may also be working as a hospital attendant, as Yoruba women were more likely to be educated at this time (photograph from the Duckworth Collection, reproduced with the permission of Northwestern University, Evanston, Illinois).

which were generally held at night, faced considerable criticism. While women had been covering themselves with *gyale* cloths up to that time, by wearing the more body-encompassing *hijab,* women sought to protect themselves and their respectability when entering public space in order to attend Islamiyya classes:

> I started wearing *hijab* at the time Shagari became head of state [1979].[3] It is at that time that I entered Islamiyya and started wearing *hijab.* When people saw me with *hijab,* they were saying it is not good. There was a time we wore black *hijab* and children were chasing us. There was even a time we went to one village and they stoned us. But there is not this problem now, because *hijab* is now popular. . . . I do wear *hijab* if I am praying and if I am going out, everywhere I am going I wear *hijab.* I don't even have *gyale.* (Interview, Zaria City, 18 March 2001)

As was the case with other aspects of Izala reforms which have been internalized as proper Islamic belief and practice by the Movement's followers, Zaria City women began to reevaluate what was considered proper Muslim comportment in their community. Indeed, it was the Izala scholars (*malamai*) who encouraged married women coming to their classes to wear the *hijab,* based on their teaching of Qur'ānic *sura* (e.g., Sura 24:30 on modesty; *Al-Qur'ān* 1994) that instructed women to cover themselves. As one *malam* noted, "At the beginning, [we at] the school didn't care [what they were wearing] if women were [just] going out—they could wear any cloth they wanted. But if she's coming to school, she must be wearing a uniform— the *hijab*" (Renne, forthcoming). They also supported the *hijab* for their students' protection from the antagonistic behavior of the movement's detractors, particularly when the schools first began.

This shift from the *gyale* to the *hijab* reflects the tendency of religious reformers to represent themselves as purifying past practices (El Guindi 1999)—in this case, by ridding Islam of innovations (*bid'a*) that were not clearly outlined in the *Qur'ān* and *hadīth* (Kane 2002). While the initial wearing of *hijab* allowed married Muslim women to extend their mobility by delineating what constituted a moral space outside of their homes in order to acquire Islamic education taught by their Izala teachers, it antagonized others for whom the wearing of the *hijab* had other meanings. For some, it was seen not as a material symbol of Izala's reforms, but as a representation of Izala's critique of Qadiriyya and Tijaniyya as having incorporated un-Islamic innovative practices. For others, it was seen as contrary to Hausa culture, as women had been using the shawl-like *zane* and *gyale*

prior to the introduction of the *hijab* (Figure 3.2) These different readings of and reactions to women's wearing the *hijab* contributed to conflict over the *hijab* in Zaria City.

Several women who wore the *hijab* in the early 1980s mentioned the hostility with which they were received in parts of Zaria City, and elsewhere, where Qadiriyya and Tijaniyya prevailed and where Izala reforms were reviled. Despite these initial confrontations, however, women persisted in wearing the *hijab* in public, when attending Islamiyya classes, and when praying in their houses. Indeed, as women became accustomed to wearing the *hijab,* they became less and less comfortable wearing the *gyale* head cover/shawl, with some women rejecting the *gyale* altogether.

This way of thinking about proper public dress—the *hijab* rather than *gyale*—is also expressed in terms of dress aesthetics, conflating moral comportment with the aesthetics of beautiful dress (Tarlo 2010):

> Yes, I do wear *hijab*. Really, I started wearing *hijab* five years now. At the time *hijab* came out, any person who is seen with *hijab,* they called her 'yar Izala and other things.
>
> Every time if you see me you see me in *hijab*. In the respect of a woman, *hijab* has an effect, any woman who is seen with *hijab,* they will be looking at her with importance, because she is not seen in ugly dressing. Like a woman who is seen with *gyale,* you see she didn't dress beautifully. (Interview, Zaria City, 7 May 2001)

Another woman's comments also point to the particular gendered dynamics of public space and marriage which are defused by the wearing of a *hijab*. Without proper covering of their bodies, women "invite" men to make sexual advances which devalue them. For while the association with Islamiyya classes for married women made women's presence in public controversial, it was not simply going to class that caused problems for some women. A married women could be subject to harassment if a man saw her wearing a small headscarf or head shawl with her neck or arms showing, uncovered, in public. The idea that even the slightest glance at an ankle could compromise a woman's respectability by inciting a man's inquiring glance led many women to prefer the security of wearing a *hijab,* at times with socks:

> I wear *hijab* because if I put *gyale* on, I feel as if I've lost my respect because I feel I don't cover all my body and I will not be comfortable. But if I wear *hijab* I will pass a gathering of men and I will not feel anything because I know nothing shows of my body. The

ELISHA P. RENNE

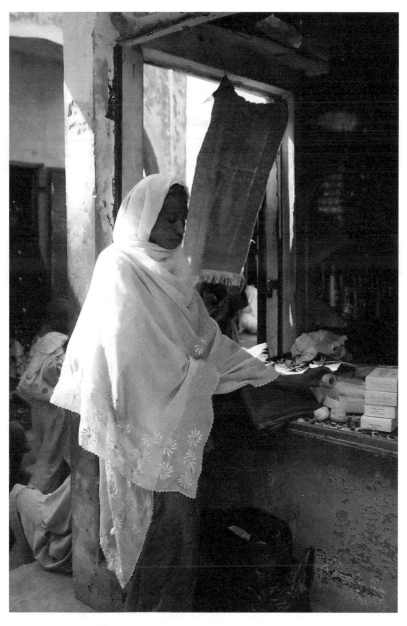

FIGURE 3.2. Hassana Yusuf wearing *gyale* veil at Zaria City market, with prayer rug hanging in background (photograph by E. Renne, 23 February 2006, Zaria City).

effects of *hijab* in the respect of women are many. (Interview, Zaria City, 15 June 2001)

These experiences suggest the tensions felt between women and men in public, which have been played out in attempts, associated with Shari'a law, to sexually segregate public transportation and other public venues. However, actual physical assault is not common, although it does occur. Rather, women's sense of insecurity stems from a sense of being outside the prescribed physical space of their husbands' or parents' compounds. By wearing the *hijab,* they extend this secure space—through its moral connotations of Islamic propriety associated with dress in the past, during the time of Sheikh 'Uthman dan Fodio and the Sokoto Caliphate or even of the Prophet.

Islamic Reform, Women's Education, and Veiling in Southwestern Nigeria

Different social practices and historical circumstances led to distinctive Islamic communities in different Yoruba sub-ethnic areas of southwestern Nigeria. In the eighteenth century, Islam was practiced in Lagos in the court of King Adele I (Gbadamosi 1978b:5) and in the northern Yoruba Kingdom of Oyo, where Islam was said to have been introduced by an Arab scholar-traveler, while Igboho was also influenced by Muslims from the Nupe Kingdom to the north (Gbadamosi 1978b:6). Indeed, during the nineteenth century, the metropolis of Ilorin—the center of the Emirate of Ilorin in the northern part of Yorubaland—was part of the northern Nigerian Sokoto Caliphate (Gbadamosi 1978b:10). In the nineteenth century in southern coastal areas, formerly enslaved men returning from Sierra Leone (known as Saro) and Brazil (known as Aguda) brought Islam and trading networks that fostered a thriving Muslim community, particularly in Lagos (Gbadamosi 1978b:28). This coastal area was also the site of the early British colony of Lagos (annexed in 1861; Mann 2007:5) and Christian missionary activity, which included the founding of churches and schools that influenced subsequent Muslim educational practices in Lagos. Specifically, the large Christian population and the likelihood of there being both practicing Muslims and Christians within large extended families meant that toleration for others' beliefs was necessary, if peace was to be maintained within communities. Furthermore, the political advantages of Western education were not lost on some Muslim leaders, who sought to establish schools where Western as well as Islamic educa-

ELISHA P. RENNE

tional practices were followed. Indeed, their interest in what they saw as beneficial foreign practices or things coincides with more general Yoruba ideas about progress (*ilosiwaju*, literally "going forward") and development (*olaju*, literally "opening the eyes" to new things; Peel 1978). Thus in 1923, a group of young men founded the group known as Ansar-ud-Deen as a way of "modernizing Islam" and distinguishing their aims from earlier Yoruba Muslim practices (Gbadamosi 1978a; Reichmuth 1998).

One aspect of this group's reformist agenda was the education of women, so that "by 1943, an average woman in the Society could read and write fairly well in Yoruba and 'could do her bit in Arabic lesson'" (Gbadamosi 1987b:5). Yet unlike the Izala movement, which supported women's attending classes outside their homes but did not question the institution of seclusion (in Hausa, *kulle*, literally "lock"), Ansar-ud-Deen board members "ruled in 1931 against the seclusion of women after proving 'substantively and without any vestige for doubt that seclusion is not of Islamic birth'" (Gbadamosi 1978a:5). This different assessment of seclusion (in Yoruba, *eha*—literally "to confine," colloquially referred to as "purdah"; Abraham 1962:180) had significance consequences for Ansar-ud-Deen women's veiling practices. For while they might wear *gele* headties and carry an *iborun* shawl on their shoulder when going about in public, they did not necessarily cover their heads with *iborun*, although many women did so. For example, one Muslim Yoruba woman described her mother's and aunts' veiling practices in the 1960s:

> If they were in the house, they wouldn't cover their heads, but the minute someone came in, they would cover. Or if they were going out, they would use something to cover their heads. But one aunt, even if she didn't cover her head when going out, she would take along an *iborun* just in case. (Interview, 31 May 2011, Ibadan)

However, this form of casually modest veiling was quite distinct from that worn by Yoruba Muslim women who continued earlier practices, which included seclusion. Their style of veiling consisted of a long *jelabiya* gown (also known as *jilbab, jalbaab,* or *jalibaab;* Banire 2006) which hid the hands and feet, along with a head covering and complete face veil that provided a form of mobile seclusion, much as the *hijab* does in the north. Women who wore—and some continue to wear—this type of veil are known as *eleeha* (literally, "owner of confinement") and are married, often to imams or Muslim teachers (see Plate 3).[4] Yet while this style of veiling—complete body, face, hands, and head covering—serves a similar function to *hijab,* it differs as this complete covering of the body and face

is only worn by married women; presently in northern Nigeria, the *hijab* may be worn by infant Hausa Muslim girls.

These two types of veiling styles may still be seen in southwestern Nigeria, with Ansar-ud-Deen women wearing *iborun* over *gele* and sometimes a cap with an *iborun* tied around it (Fashola 2010).[5] Ẹlẹẹha women continue to wear the all-encompassing *jelabiya* with head and face veil as well as socks, although some women now wear face veils with sequined patterns, which distinguish more fashionable wearers from those using the older *burqa*-like forms of veiling. However, more recently some Muslim Yoruba women have incorporated various new styles of veiling into their repertoires, particularly the use of *hijab*. Depending on size, they are described as the "cape *hijab*" (a short *hijab* that covers the head and shoulders), the slightly longer "triangle *hijab*," *khimur* (capes), and the "long *hijab*" (that reaches to the ground), usually worn with a headtie (Olagoke n.d.). While these new styles of veiling are less common than the use of *iborun,* several of the more recently formed Yoruba Muslim groups such as NASFAT (Nasrul-Lahi-il Fathi), inaugurated in March 1995, encourage the wearing of *hijab* (Nasrul-Lahi-il Fathi 2011). This shift to more covered forms of veiling reflects several trends in southwestern Nigeria, including the importance of strengthening and expressing one's Muslim identity. As one Yoruba Muslim woman explained:

> When I was going to school, we didn't wear *hijab* as part of our uniforms, we went to school for Western education so you expected to wear Western dress. Even when I was at the university, I took an *iborun* with me and wore it at mosque but would take it off after going out. . . .
>
> [But now] being educated in one's religion is seen as being an important part of learning, not just Western education alone. By doing this, people have become more informed about their religion and have a better sense of what is required, what one ought to do. I personally became more aware of the importance of covering one's head in public as I learned more about Islam, part through reading the *Qur'ān*. (Interview, Ibadan, 31 May 2011)

Thus women students at the NASFAT-founded Fountain University, located in Oshogbo, in Oyo State, frequently wear *hijab* and *jelabiya* as everyday dress and at graduation ceremonies.

This increased awareness of Muslim identity in the late 1990s was paralleled by the increasing presence of born-again Pentecostal churches in southwestern Nigeria.[6] Despite their very different religious creeds, both

born-agains and Muslim women are concerned with dress as an expression of moral decency as well as religious identity.[7]

Student Demands for Islamic Uniforms

In southwestern Nigeria, the growth of NASFAT Islam and Pentecostal Christianity in the late twentieth century, expressed in increasing assertions of religious distinction and in particular styles of dress, contributed to Muslim secondary school students demanding to be allowed to wear Islamic dress as part of their school uniforms in Ibadan in 2003:

> From one secondary school to the other Muslim youths went around to distribute some pieces of cloth sewn into *Hijab* to female students to wear on their school uniform . . . Some principals of schools felt insulted, most especially such places of learning with Christian background. (Olagoke n.d.:20)

Women students were reported subsequently protesting at the Oyo State Secretariat [government building], singing, "We want *Hijab* in secondary schools. Don't Christianise Muslim girls" (Olagoke n.d.:21).[8] The next day there were protests "about the continued disruption of studies by Muslim youth out to enforce the use of the veil (*hijab*) in public schools in the state" (Babasola 2003b). These demands—for Islamic school uniforms—and counter-demands against them in Ibadan took place during the time of the second election of President Olusegun Obasanjo, a born-again Christian who had been active in Christian Association of Nigeria (CAN) activities since its inception in 1976 (Christian Association of Nigeria 2011) and had more recently participated in RCCG mega-revivals in Lagos in 2002 and 2003 (Marshall 2009:240).

In Kaduna, in northern Nigeria, Muslim women students made a similar demand for Muslim school uniforms six years earlier, in June 1987. Once again, these demands occurred within a larger political context. In March 1987, violence between Christian and Muslim students at the Advanced Teachers College at Kafanchan (in southern Kaduna State) subsequently spread to other towns in Kaduna State (Ibrahim 1991:122). Queen Amina College, the elite secondary school for women in Kaduna, had a school population which was equally divided into Christians and Muslims (Ibrahim 1988:102). As it had initially been a Catholic school, students wore Western-style uniforms (skirts and blouses) when attending classes, a situation that Muslim students sought to change with support from Izala leaders in Kaduna. Some members of the Muslim Students Society began to attend

classes wearing trousers, *abaya* (similar to the *jelabiya*), and *hijab,* while Christian students continued to wear the old uniforms. In an attempt to defuse the situation, state officials decided that the two uniforms would be acceptable; however, there was continued friction until a transfer of teachers and students was instituted (Ibrahim 1988:103). Yet ten years later, in both Ibadan and Kaduna, a dual uniform system had become normalized, and it is commonplace to see Muslim secondary school students wearing *hijab* and trousers as part of their school uniforms.

Northern and Southwestern Islamic Intersections/Divergences

Despite the increasingly quotidian appearance of Muslim schoolgirls wearing *hijab* in both northern and southwestern Nigeria, significant differences in the meanings of these visual expressions of religious identity exist, as interpreted by those in Christian and Muslim communities and within Muslim communities themselves. Thus, *iborun* and *gele* styles of veiling continue to be popular among many older Yoruba Muslim women, as suggested by what is worn in the streets of Ibadan and what is sold at Oja'ba Market, one of the main markets for Islamic dress, books, and prayer rugs in that city (Figure 3.3). As was the case in Zaria when Izala members introduced the wearing of *hijab* within their community, other southwestern Islamic groups initially disliked Yoruba reformist groups for what they represented, an implicit and sometimes explicit criticism of earlier Islamic organizations. In Ibadan, one Yoruba Muslim woman, who regularly wore an *iborun* and *gele* veil, remarked that her husband would not like her to wear a *hijab* because of its association with NASFAT. Similarly, some Muslim Yoruba women continue to dress in the *ẹlẹẹha* style.

However, there is another aspect of the *hijab* which may disincline Yoruba Muslims toward wearing this style of veil, namely its association with Hausa Muslims and with what some see as northern Nigerian Islamic practices, such as seclusion and women's relative lack of Western education, which counter Yoruba ideals of *olaju* (enlightened development). In Ibadan, this ethnic-related distinction may be seen by comparing Yoruba Muslim women, who commonly wear *iborun* and *gele,* to the many presumably Hausa Muslim women wearing *hijab* in the Sabo area of the city (Cohen 1969). Alternatively, some of these Hausa Muslim women living in Ibadan may view Yoruba Muslim women's preference for *iborun* and *gele* as insufficiently Islamic and as Yoruba Muslims' accommodation to social pressures to conform to ethnic and social, rather than religious, demands.

ELISHA P. RENNE

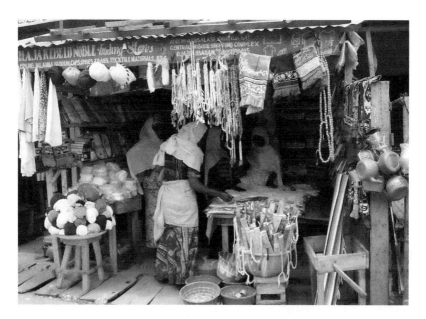

FIGURE 3.3. Women wearing *gele* and *iborun* veils shopping at Oja'ba Market, Ibadan. Along with a range of *iborun, hijab,* prayer beads and rugs, incense, water kettles, and men's caps, a range of *jelabiya* are on display in a back room (photograph by E. Renne, 31 May 2011, Ibadan).

In the north, among Yoruba Muslim women who are members of large trading families residing among a Hausa Muslim majority in Zaria City, older women may accommodate local preferences for the *hijab* by wearing them as prayer veils when going to mosque, although they commonly wear *gele* and *iborun* (Interview, Zaria City, 3 June 2011). The public presence of these women as traders, veiled in this fashion, in Zaria City market also contrasts with many otherwise-secluded Hausa Zaria City women who wear *hijab* in public when attending social events, going for health care, or working as teachers and health personnel. While they may work as education and health professionals, these women do not sell in or go to the market, reinforcing Hausa Muslim women's sense of themselves as morally superior Muslims.[9]

These divergences of veiling preferences among Nigerian Muslim women on the basis of ethnicity nonetheless also point to the long-standing settlements and relations of Hausa Muslims in southwestern Nigeria and Yoruba Muslims in the north (Olaniyi 2006). Both groups were involved in long-distance trade in cloth and in agricultural commodities, such as

kola and onions, which was facilitated by religious connections (Johnson 1973; Kriger 2006). During the colonial period, some Yoruba Muslim traders from southwestern Nigerian towns such as Oshogbo and Ede eventually settled in northern Nigerian communities such as Zaria, where they later brought and raised their families. Although British officials during the colonial period attempted to restrict the residence of southern migrants to the new area of Zaria, known Sabon Gari (literally, "new town"; Olaniyi 2006:236), they failed in this effort, as some Yoruba Muslims moved into an area of the old walled Hausa Muslim Zaria City known as Anguwar Bayan Kasuwa, where they maintained stalls in the main market. One man, Alhaji Mohammed Bashir, born in Oshogbo, first came to Zaria City around 1950, having followed his father as a trader, first in provisions and then in cloth. He would buy cloth in Gbagi Market, Ibadan, and take it north to sell in Zaria. It was this long-distance trade that probably led to the Hausa word *gyale,* referring to a stole-like cloth used to cover the head. Similarly, some of the *hijab* and *jelabiya* available for sale in markets in Ibadan, particularly in shops in the Sabo (Hausa) area of the city, were brought south by Hausa traders. One particular style of *hijab* which became popular in the north around 2007, known as the "fashion *hijab*," began to be seen on the streets of Ibadan in subsequent years.

Converging Veiling Fashions and Concepts of Time

While the style of *hijab* made with a variety of patterned, plain, and textured cloths, known as "fashion *hijab*" in Zaria and Kaduna in the north, is not nearly as common in the southwest, concern about appearing both fashionable and modest is another aspect of veiling in Nigeria which links Hausa and Yoruba Muslim women. In Lagos, particular shops and boutiques cater to affluent Muslim women looking for stylishly exclusive *jelabiya,* capes (*khimur*), stoles (*iborun*), and *hijab*. In 2005, one shop owner, Mrs. Saidat Otiti, sponsored a fashion show on Victoria Island in order to advertise her shop, Baytuzeenah, described as "a one stop shop for Islamic materials and clothing." In a speech given at the event by the former Deputy Governor of Lagos State, Alhaja Sinatu Ojikutu, she stated that

> the Islamic way of dressing is neither traditional nor cultural, but an injunction from the Almighty that women should dress simply and decently. . . . The idea of featuring outfits in these different categories is to show that you can dress the Islamic way as a career woman, school girl or housewife and still look trendy and fashionable. (Anonymous 2005)

Similar shops and boutiques specializing in Islamic fashions for women may be found in Kaduna and Kano, along with stalls in local markets where imported *abaya, gyale,* and *hijab* are sold. In both the north and south, some of these garments may also be brought back to Nigeria by women who have traveled to Mecca on hajj (Liman 1996).

However, in the north and south, many women purchase cloth which they give to tailors, who sew them in specified styles. Initially Hausa Muslim women in Kaduna and Zaria had been wearing a variety of long and short *hijab*s made with plain cotton/polyester fabric. These early *hijab* were then replaced, by some women, with fashion *hijab* made with fabric in floral or geometric patterns. These early, more showy patterns were replaced in the following years with new styles in textured weaves and small printed patterns. When asked about the fashion *hijab,* why and how young women came to wear it, several cited Kannywood (Kano film industry) movie stars as influencing them, while others mentioned their desire to dress fashionably. "I'm wearing fashion *hijab* because it's the fashion of the time!" (*ana yayinshi*), one woman explained (Interview, Zaria City, June 2009).

The fashion *hijab* continues to be popular in the north, and it is seen, although infrequently, in the southwest, where new styles of *jelibiya* perform a similar fashionable function. Yet this concern with wearing *hijab, jelibiya,* and other forms of veiled dress that reflect "the fashion of the time," as one young woman put it, reflect specific concepts of time that convey particular moral valences. This "fashion of the time" accentuates the present, as Simmel (1971:303) has noted: "Fashion always occupies the dividing-line between the past and the future, and consequently conveys a stronger feeling of the present." Yet the fashion of the moment soon becomes old-fashioned and out-of-date; hence fashion also suggests the ever-changing forward movement. Dressing well and fashionably, then, corresponds with the valorized Yoruba notion of *ilosiwaju,* progress, as movement forward, for the better, in time. Similarly, Hausa Muslim women wearing the fashion *hijab* make reference to the *hijab*'s initial association with married women's Islamic education, to their improvement as a group. These ways of thinking about improvements over past Islamic practices are associated with a modernity "marked by the arrow of time" (Latour 1993:67), as evidenced by women's education in the cases of both the Ansar-Ud-Deen and the Izala movements, but they may be challenged by other ways of thinking about time. In the case of more recent reformist Islamic movements, NASFAT in southwestern Nigeria and Salafiyya in northern Nigeria, the time privileged is not forward-looking time but rather a time—perceived as a better, more moral time—which refers to the

past, e.g., to the time of the Prophet. This way of thinking is represented in veil styles which are related to beliefs about past fashions, which, in the case of Salafiyya women, may be seen in the wearing of long *hijab* with socks. In pursuing a fashionable appearance, women accentuate the relationship between ethics and aesthetics, religion and beauty, underscoring the ways that "being in fashion" demonstrates one's knowledgeable participation in a group identity. Yet these changing fashions in veiling styles raise the question of why, since fashions come and go, women continue to veil in Nigeria today.

Why Veil in Nigeria?

It appears that Muslim women in twenty-first century Nigeria are veiling in increasingly various ways. Explanations for this efflorescence in veiling are similarly many and diverse. Some women who attend Islamic education classes seek to express their expanded knowledge and pious commitment to Islam through dress.[10] In a related way for others, wearing a veil provides a sense of security derived from following Qur'ānic tenets that support protection from unwanted male attention, as the Yoruba Imam of Ikọle-Ekiti explained:

> Evil thoughts are so powerful that they would intoxicate a man to the extent that he would finish his evil action before coming back to his normal self, only then to regret his actions; it is the same with women. Because of this situation, God felt so bad and found a way out, by asking that women should be kept in purdah (ẹha). When we do this we will have peace and enjoy our lives, on earth and in heaven. (Interview, Ikọle-Ekiti, 2002)

This point, that the covering of women's bodies with cloth serves as a source of divine protection, is more forcefully made in an anecdote from a booklet purchased in Zaria in 2005:

> In Bayero University, Kano, there was some womanizers (among whom) one day one saw a sister fully Hijabed [sic]. He then intended to try her to see whether her piety was a faked one. On going closer to her, he began to shiver when she turned and looked at him. And he stammered " . . . just come to greet you and ask how your study is moving." This man then walked away unable to add anything to what he had said. So brothers, just look at how Allah protected this sister, because she was obedient to Allah. That

　　　　ELISHA P. RENNE

is how Allah will protect any woman from any bad man provided she fears Allah and wears Islamic dresses. (Ibrahim n.d.:17)[11]

These comments are couched in terms of gender, and certainly, veiling and seclusion support a particular system of gender mores. Yet there are other sources of insecurity in twenty-first-century Nigerian society which have contributed to Muslim women's veiling. A failing infrastructure, government's inability to provide basic services such as water and electricity, armed robberies, and bombings have contributed to people's sense of vulnerability "on both a physical and spiritual plane" (Last 2008:41). For many, Islamic reforms provide a means for addressing societal problems, for as Ibrahim (1991) has noted, politics and religion have long been interconnected in Nigeria. In southwestern Nigeria, Muslim leaders in nineteenth-century Lagos had close relations with Yoruba kings, and in the twentieth century those extended to British colonial officials (Obadamusi 1978b).[12] In the north, the Muslim leader 'Uthman dan Fodio instituted Shari'a law throughout the Sokoto Caliphate, while the *sarkin* (kings) of the seven Hausa emirates worked with the British and later with Nigerian government officials. Such relationships between Islamic groups and the Nigerian state continued through the twentieth century. Ansar-ud-Deen and NASFAT in southwestern Nigeria, and the Izala and Salafiyya movements in northern Nigeria, are just four examples of the many reformist groups that have arisen since the early 1900s. Their doctrines, which include prescriptions for women's education and dress, have not only served to distinguish these different groups, but have also been put forward to address their sense of political malaise and societal immorality (Last 2008). Through veiling, women may challenge or support prevailing political ideologies.[13]

Regardless of why women veil in southwestern and northern Nigeria, and in what ways they do so, a comparison of their explanations and practices points to several overall themes which may contribute to the social analysis of veiling in Africa more generally. First, how the concept of seclusion (and related ideas about gender) are interpreted and practiced is a critical element in explaining why women veil, both in northern and southwestern Nigeria. If seclusion is strictly interpreted and married women are expected to remain within their households unless they have their husbands' permission to leave, wearing the veil (particularly *jelabiya* and *hijab*) may be seen as providing an extension of this secluded space. Others, who interpret the *Qur'ān* (specifically Sura 24:30 and Sura 33:57) differently, see coverings when in public as satisfying prescriptions for modest dress, rather than practicing some form of house seclusion. Thus

what these coverings consist of depends on local interpretations of what "covering" means, to the extent of exposure to different styles of veils, and of what sorts of materials are available.

Second, the social context of individuals and groups, whether they are majority or minority populations—in terms of religion or ethnicity—in any given area, influences veiling practices. For example, in southwestern Nigeria, where Islam and Christianity are equally dominant monotheisms practiced by Yoruba women and men—at times within a single extended family—there is considerable pressure to accommodate other religious perspectives. Indeed, conflict in this multi-religious setting is as likely to occur between different Islamic groups, as when reformist groups criticize predecessors (as was the case with initial resistance to the Ansar-Ud-Deen Society), as it is between Muslims and Christians. Distinctive forms of veiling may be used to play down these differences or to accentuate them. Although this inter–Islamic group conflict may also occur in northern Nigeria, as it did in Zaria in the 1980s and '90s between the reformist Izala movement and followers of Qadiriyya Islam, visually represented by *hijab* and different forms of prayer practice, recurring violent conflict has also occurred between Muslim and Christian populations in Kaduna and Plateau states, where there are a range of religious configurations within Muslim-dominated political rule (Ibrahim 2000).[14]

Third, the history of particular areas in relation to the Middle East and North Africa, other West African empires, the West, and the African diaspora have contributed to distinctive veiling practices in northern and southwestern Nigeria. The north's proximity to early African Islamic empires (Songhay, Mali, and Bornu) and the subsequent establishment of the Sokoto Caliphate contributed to the more widespread practice of Islam there as compared with the southwest, where Islam was introduced somewhat later through West African, Middle Eastern, and Indian Islamic scholars.[15] In nineteenth-century Lagos, the return of Saro and Aguda Yoruba Muslims from Sierra Leone and Brazil, respectively, and its annexation by the British contributed to the development of schools that provided both Islamic and Western education, resulting in the emergence of educated Muslim elites who positioned themselves as modern, English-speaking progressives. The Ansar-Ud-Deen Society, which originated in Lagos and spread to other cities in the southeast and the north, sought to reform earlier Muslim practice through such innovations as introducing women's education and ending seclusion. In Jos, Kaduna, and Zaria, members of the reformist group Izala, many of whom were Islamic scholars, educated professionals, and business people, positioned themselves as supporters

both of the modern state of Nigeria and of a return to traditional Islamic practice based on readings of the *Qur'ān* and *hadīth* alone, echoing the earlier reforms associated with the establishment of the Sokoto Caliphate in the nineteenth century. Women's veiling practices not only reflect these historical changes but also suggest the ways that Muslim women in Nigeria have actively participated in them.[16]

NOTES

I would like to thank the women of Zaria City for their cooperation and helpful interviews. Special thanks go to Hassana Yusuf for research assistance in Zaria and to Sherifat Oladokun and Taibat Olaitan for their research assistance in Ibadan. I am also grateful to Alhaji (Dr.) Shehu Idris CFR, Emir of Zazzau, for permission to conduct research in Zaria City and Professor S. U. Abdullahi, former Vice Chancellor of Ahmadu Bello University, for research affiliation. Finally, the author gratefully acknowledges funding from the National Science Foundation (2002) for research on women's Islamic education in Zaria City and from the Pasold Foundation (2009) for research on the history of head coverings in Zaria.

1. In 'Uthman dan Fodio's writings, he strongly supported both the education of married women and veiling (Ogunbiyi 1969:55–56).

2. Nonetheless, many did attend *allo* schools as young girls, where *allo* boards were used for memorizing verses from the *Qur'ān.*

3. She is referring to the former head of state, President Shehu Shagari, who took office in 1979.

4. The history of *ẹlẹẹha* and their particular form of veiling in relation to Yoruba migration and the early-twentieth-century performance of hajj remains to be written.

5. In a website photograph of the 2010 Ramadan Tafsir, 6th Justice Muri Okunola Memorial Ramadan Lecture, held by the Ansar-Ud-Deen Society of Nigeria at Ikeja, Lagos, some women in the audience wore white *hijab,* although the older women seated in the front row all wore variations of the *iborun* (stole) and *gele* styles of veils (Fashola 2010).

6. For example, "more than 70 percent" of born-again churches in the Agbowo area of Ibadan were established after 1990 (Marshall 2009:85).

7. A bill legislating modest dress for women was presented in the Nigerian Senate by a southeastern Nigerian legislator and also had strong support from northern Nigerian Muslim groups (Adaramola 2008).

8. Protests were also held at secondary schools in Ibadan. Thirty-nine Muslim students who protested at the Olubi Memorial Grammar School, at the Kejide Girls Grammar School, and at Orogun Grammar School appeared in magistrate courts in Ibadan over the 17 March 2003 demonstrations (Babasola 2003a).

9. Nonetheless, Olaniyi (2006:239) notes that Yoruba Muslim women in the north "played an intermediary role between the hosts and immigrants," since they were actively engaged in trade and the sale of prepared food. Yoruba Muslim women also work in Zaria City in health clinics and schools.

10. Mahmood (2005) provides examples and analysis of this dynamic in Egypt.

11. This excerpt comes from the booklet *Hijab: The Shield of the Umma,* which was purchased in Zaria and probably published locally. Several other locally published booklets on Islamic dress for women include works by Abdullah (n.d.), Banire (2006), Ismail (n.d.), Muhammed (n.d.), and Olagoke (n.d.). All but one of these booklets, Ramatu Muhammed's *Moral Virtous for Women,* were written by men.

12. The Yoruba Muslim Ilorin Emirate provides an interesting example of the intersection of northern Nigerian political organization with southwestern Nigerian cultural practices regarding Muslim women's veiled autonomy, and with respect to trade and education (Reichmuth 1993:186).

13. The familiar example of the relationship between veiling and political ideology may be seen in the extensive literature on the French government's rulings on veiling in public schools and on wearing *burqa* in public (see Scott 2007). By way of contrast and indirect disapproval, a report on the French prohibition of *burqa* was published in the same issue of the northern Nigerian paper *Daily Trust* as a story on the Ilorin State Court of Appeal's ruling that Muslim women students could wear *niqāb* when attending classes at the Kwara State College of Education (Abubakar 2009; Anonymous 2009).

14. I have been told that this violence has led some Christian women to wear the *hijab* as a form of camouflage.

15. The Emirate of Ilorin, which was part of the Sokoto Caliphate, is an exception as Islam was introduced earlier to this Yoruba-speaking area in southwestern Nigeria.

16. Boyd and Last (1985) discuss earlier examples of women's agency and dress in religious practice during the Sokoto Caliphate, while Ahmed (2011) considers contemporary examples of this dynamic.

WORKS CITED

Abdullah, Abdul R. n.d. *Islamic Dress Code for Women.* Darussalam Research Division.

Abraham, R. C. 1962. *Dictionary of Modern Yoruba.* London: Hodder and Stockton.

Abubakar, Mustafa. 2009. Court upholds use of veil in college. *Daily Trust,* 23 June.

Adaramola, Zakariyya. 2008. Muslim group wants indecent dressing bill. *Daily Trust,* 18 July. www.dailytrust.com (accessed 18 July 2008).

Ahmed, Leila. 2011. *The Quiet Revolution.* New Haven: Yale University Press.

Al-Qur'ān. 1994. Trans. Ahmed Ali. Princeton: Princeton University Press.

Anonymous. 2005. True Muslim women unveiled. *Saturday Punch,* 5 March.

Anonymous. 2009. Sarkozy says burqas are "not welcome" in France. *Daily Trust,* 23 June.

Babasola, Sina. 2003a. AAGM: Ibadan students protest plans to enforce wearing of veils by Muslim youths. *Vanguard* (Nigeria), 18 March. www.newsbank.com (accessed 26 Sept 2011).

———. 2003b. Thirty-nine Muslim youths arraigned over Ibadan protest. *Vanguard* (Nigeria), 19 March. www.newsbank.com (accessed 26 Sept 2011).

Banire, Buniyamin A. 2006. *"Hijaabah Sister": Alalu Barika Obinrin.* Lagos: Al-Bayaan Islamic Publications Limited.

Bargery, G. P., 1993 [1954]. *A Hausa-English Dictionary.* 2nd ed. Kaduna: Ahmadu Bello University Press.

Boyd, Jean. 1989. *The Caliph's Sister: Nana Asma'u, 1793-1865, Teacher, Poet, and Islamic Leader.* London: F. Cass.

Boyd, Jean, and Murray Last. 1985. The role of women as Agents religieux in Sokoto. *Canadian Journal of African Studies* 19 (2): 283-300.

Callaway, B. 1984. Ambiguous consequences of the socialisation and seclusion of Hausa women. *Journal of Modern African Studies* 22:429-450.

Christian Association of Nigeria (CAN). 2011. "About Us." http://www.canonline .org.ng/aboutus.html (accessed 2 September 2011).

Cohen, Abner. 1969. *Custom and Politics in Urban Africa.* Berkeley: University of California Press.

El Guindi, Fadwa. 1999. *Veil: Modesty, Privacy and Resistance.* Oxford, U.K.: Berg.

Fashola, Tunde. 2010. 2010 Ramadan Tafsir, 6th Justice Muri Okunola Memorial Ramadan Lecture, Ansar Ud-Deen Society of Nigeria at Ikeja, Lagos. Governor of Lagos State website. http://www.tundefashola.com/archives /photos/2010/08/22/20100822P01.html (accessed 2 September 2011).

Gbadamosi, Tajudeen G. O. 1978a. *The Ansar Ud Deen of Nigeria: Case Study in Islamic Modern Reformist Movement in West Africa.* London: Muslim Institute for Research and Planning.

———. 1978b. *The Growth of Islam among the Yoruba, 1841-1908.* Atlantic Highlands, N.J.: Humanities Press.

Ibrahim, Abubakar Saddiq. n.d. *Hijab: The Shield of the Umma.* Trans. Zakariya Garba Umar.

Ibrahim, Jibrin. 1988. Les uniformes des lycéennes nigérianes. *Politique africaine* 29 (May): 101-104.

———. 1991. Religion and political turbulence in Nigeria. *Journal of Modern African Studies* 29 (1): 115-136.

———. 2000. The transformation of ethno-regional identities in Nigeria. In *Identity Transformations and Identity Politics under Structural Adjustment in Nigeria,* ed. A. Jega. Uppsala: Nordic Africa Institute; Kano: Centre for Research and Documentation.

Ismail, Muhammad. n.d. *The Hijaab . . . Why?* Trans. Saleh As-Saleh. Kano: Merciful Press.

Johnson, Marion. 1973. Cloth on the banks of the Niger. *Journal of the Historical Society of Nigeria* 6:353-363.

Kane, Ousmane. 2002. *Muslim Modernity in Post-Colonial Nigeria.* Leiden: Brill.

Kriger, Colleen. 2006. *Cloth in West African History.* Lanham, Md.: AltaMira.

Last, Murray. 2008. The search for security in northern Nigeria. *Africa* 78 (1): 41-63.

Latour, Bruno. 1993. *We Have Never Been Modern.* Trans. Catherine Porter. Cambridge: Harvard University Press.

Liman, Usman Shehu. 1996. *Hajj 91: Travel Notes of a Nigerian Pilgrim.* Zaria: Ashel Enterprises.

Loimeier, Roman. 1997. *Islamic Reform and Political Change in Northern Nigeria.* Chicago: Northwestern University Press.

Mack, Beverly, and Jean Boyd. 2000. *One Woman's Jihad: Nana Asma'u, Scholar and Scribe.* Bloomington: Indiana University Press.

Mahmood, Saba. 2005. *Politics of Piety: The Islamic Revival and the Feminist Subject.* Princeton: Princeton University Press.

Mann, Kristin. 2007. *Slavery and the Birth of an African City: Lagos, 1760–1900.* Bloomington: Indiana University Press.

Marshall, Ruth. 2009. *Political Spiritualities: The Pentecostal Revolution in Nigeria.* Chicago: University of Chicago Press.

Muhammed, Ramatu. n.d. *Moral Virtous for Women.* Kano: Flash Printers.

Nasrul-Lahi-il Fathi (NASFAT). 2011. NASFAT website. http://www.nasfat.org/ (accessed 26 August 2011).

Ogunbiyi, I. A. 1969. The position of Muslim women as stated by 'Uthman b. Fudi. *Odu,* n.s., 2: 43–60.

Olagoke, S. A. n.d. *Islam and Concept of Hijab.* Ibadan: SAO Multi Ventures.

Olaniyi, Rasheed. 2006. Approaching the study of the Yoruba diaspora in northern Nigeria. In *Yoruba Identity and Power Politics,* ed. T. Falola and A. Genova, 231–250. Rochester, N.Y.: University of Rochester Press.

Peel, J. D. Y. 1978. *Olaju:* A Yoruba concept of development. *Journal of Development Studies* 14:139–145.

Reichmuth, Stefan. 1993. Islamic learning and its interaction with "Western" education in Ilorin, Nigeria. In *Muslim Identity and Social Change in Sub-Saharan Africa,* ed. L. Brenner, 179–197. London: Hurst.

———. 1998. Education and the growth of religious associations among Yoruba Muslims: The Ansar-Ud-Deen Society of Nigeria. *Journal of Religion in Africa* 26 (4): 365–405.

Renne, E. 2004. Gender roles and women's status: What they mean to Hausa Muslim women in northern Nigeria. In *Qualitative Demography: Categories and Contexts in Population Studies,* ed. S. Szreter, A. Dharmalingam, and H. Sholkamy, 276–294. Oxford: Oxford University Press.

———. 2012. Educating Muslim women and the Izala movement in Zaria City, Nigeria. *Islamic Africa* 3 (1): 55–86. www.islamicafricajournal.org.

———. Forthcoming. The hijab as moral space in northern Nigeria. In *African Dress: Fashion, Agency, Performance,* ed. K. T. Hansen and D. S. Madison, 135–157. Oxford, U.K.: Berg.

Schildkrout, E. 1983. Dependence and autonomy: The economic activities of secluded Hausa women in Kano. In *Female and Male in West Africa,* ed. C. Oppong, 107–126. London: Allen and Unwin.

Scott, Joan W. 2007. *The Politics of the Veil.* Princeton: Princeton University Press.

Simmel, Georg. 1971. *On Individuality and Social Forms.* Ed. D. Levine. Chicago: University of Chicago Press.

Smith, Mary F. 1954. *Baba of Karo.* New Haven: Yale University Press.

Tarlo, Emma. 2010. *Visibly Muslim: Fashion, Politics, Faith.* Oxford: Berg.

Umar, Muhammad Sani. 1993. Changing Islamic identity in Nigeria from the 1960s to the 1980s: From Sufism to anti-Sufism. In *Muslim Identity and Social Change in Sub-Saharan Africa,* ed. L. Brenner, 154–178. London: Hurst.

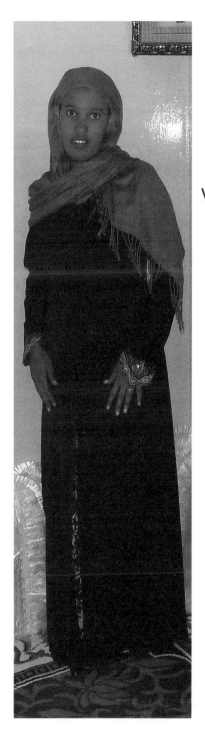

Veiling and Fashion

Religious Modesty, Fashionable Glamour, and Cultural Text: Veiling in Senegal

LESLIE W. RABINE

BY ITS METAMORPHOSIS from austere religious symbol into fashionable adornment, the veil in Senegal illustrates the power of fashion to transform social polarization into dialogical process. This process began in the 1990s, when Islamic sects from Iran and Saudi Arabia, quite foreign to the Sufi brotherhoods that compose most of Senegalese Islam, gained a foothold among young people. Although the population of Senegal is 95 percent Muslim, Senegalese women have historically not worn Middle-Eastern-style veils. But for young women in the orthodox movements, *hijab*-style veils symbolized a "purer" form of Islam, in part as protest against a complex conjunction of historic forces. These included economic crisis, immense unemployment, out-of-control political corruption, and the post-colonial dominance of Western powers, as well as disillusionment with Sufi leaders. Through orthodox Islam, young people rebelled against the local "traditions" of their elders, and identified with a powerful anti-Western global movement (Augis 2009:217–219).

Contributing historic issues included the growing polarization between the West and Islam, evidenced in part by restrictions against Muslim veiling in many European countries (Morin and Horowitz 2006; Scott 2007:2). Senegalese people reacted against "les affaires des foulards" in France, heated debates from the late 1980s to 2004 about a law to ban girls wearing Islamic *hijab* from public schools (Bowen 2007; Scott 2007). Senegalese people with whom I spoke during my research, whether they were for or against veiling, dismissed the French law of 2004 as a symptom of anti-Islamic prejudice by their former colonizer.

The French legislation serves as my point of departure for exploring the veil in Francophone Senegal, and not only because the new Senegalese veiling practices included in some measure a gesture of solidarity with

fellow post-colonial Muslims in France. The polarizing debates in France also contrast tellingly with the ways that the Senegalese dealt with the Islamic veil, transforming social and religious polarization into dialogical exchange. This different treatment of the veil is all the more significant in that the majority of Senegalese in the 1990s had rejected the garment, as had the French, as an alien accouterment of an alien religious order.

The debates that culminated in the 2004 anti-veiling law created hardened polarized positions in France. In the campaign against the veil, it became a univocal symbol of anti-secular political Islam and women's submission to men's coercion (Bowen 2007:106, 229; Scott 2007:18). The veil assumed "a true meaning" against which the law would presumably send "a clear message" (Bowen 2007:182).

But in Senegal veiling instead became part of a dialectic by which the new orthodox Islamic movements softened their original sharp opposition to both the secular state and the indigenous Sufi orders. As orthodox Islam became integrated into Senegalese culture, veiling conversely broadened from the exclusive practice of orthodox women and flowed into the larger world of ambiguous, unstable fashion signs. As non-orthodox women have taken it up, the veil floats almost indecipherably in a web of changing religious, cultural, and fashionable meanings.

Fashion here is defined as a particular form of dress system (Eicher and Roach-Higgins 1992) characterized by capitalist production for the consumer market, rapid change, ephemerality, and the agonistic game of being "in fashion" (Breward 2003; Simmel 1904; Wilson 1985:13, 67). Like any fashion system, the Senegalese system inevitably follows the process of co-opting garments from the religious, military, or legal realms, eroding their former meanings, and transforming them into playful adornments, disguises, and costumes (Craik 2009:59–61; Hollander 1994:17). Rather than transparently communicating strict social classes or categories, fashions instead invoke fantasies and enact imaginary identities (Berry 2000:32–46). Veiling in Senegal offers one case in which fashion, by its very power to confuse the clear religious meaning of a garment, can create possibilities for social dialogue instead of polarized, deadlocked conflict, as in France. By its seeming frivolity, its process of transforming serious dress into a playful game, fashion can sometimes do serious social work. As a text of unstable religious symbols and fashionable signs, the veil emphasizes heterogeneity among Muslim women. During my research, I continually ran into the impossibility of forming generalizations about which women wear the veil, as well as when, why, how, and where they wear it.

Scarves and Veils in the History of Senegalese Fashion

The veil travels through the realms of religious austerity, cultural respectability, and fashionable play in the larger historical context of Senegalese dress and fashion. As a historically specific dress system, fashion became the basis of French economic and political development in the seventeenth century (Breward 2003:24). Through trade and more importantly, colonialism, fashion spread worldwide, with the result that cultures around the world developed original local fashion systems based on both local and transnational dress (Craik 2009:20, 26; Schulz 2007:256–260).

As France set out to make itself the world fashion leader, it also laid claim to its first French cities in sub-Saharan Africa: Saint-Louis in 1659, and Gorée in 1677, both islands on the coast of Senegal (Aïdara 2004:9; Biondi 1987; Camara and Benoist 2003:6). In these cities, African women developed their own fashion system as early as the eighteenth century. Wolof women who entered into local marriages (*mariages du pays*) with French officials and merchants established communities where they and their *métisse* descendants, called *Signares,* became powerful and wealthy through the transcontinental textile trade (Aïdara 2004:76–78; Boilat 1984:7, 212; Camara and Benoist 2003:59–75). (There is still some debate on whether or not the *métisse* community of Saint Louis and Gorée engaged in the transatlantic slave trade.) For their original costumes, their charm and allure, the Signares have attained mythic status in Senegal. They remain the model of the cosmopolitan elegance for which Senegalese women are famous in Africa.

In the early twentieth century, citizens of the coastal cities developed the sartorial art that would make Senegal the fashion capital of French West Africa (Keller 2008:474; Mustafa 2006). Central to this art is the flowing *grand boubou.* Endowing the body with volume and majesty, the *grand boubou* at its most elegant is made of heavily starched European cotton damask. The *boubou* lends itself to a wealth of dyeing and embroidery techniques, which go in and out of fashion about every six months (Heath 1992:22; Mustafa 1997:171; Mustafa 1998; Rabine 2002:27–33). Men wear the *grand boubou* with matching loose trousers, and women with *pagnes* (wrappers). An alternative to the *grand boubou* for men is the caftan, and for women a loose dress called the *ndoket.* Women complete the look with high-heeled shoes, theatrical makeup, artfully applied scent, heavy gold jewelry, and a voluminous headscarf. One major sign of being "in fashion" concerns the ever-changing and difficult-to-master styles of tying the headscarf.

This headscarf, contrary to the rules of orthodox Islam, leaves the ears, neck, and some of the hair uncovered. Although an essential part of the Senegalese Muslim fashion ensemble, and a visible marker of Muslim identity, the headscarf has no specific religious significance. Codes of respectability dictate that a married woman wear it in public, but when tied with haughty allure, it is also a keystone of *Sénégalaise* glamour (Figure 4.1).

Yet the headscarf is just one of many scarves and veils in the Senegalese Muslim wardrobe. Muslim women, whether Sufi or orthodox, wear a prayer scarf when they pray. This is usually in a sheer fabric, adorned with embroidery, beading, or appliqué. Women drape it loosely over their head, leaving the ends hanging down or throwing one end over a shoulder. In the course of the twentieth century, this same style of scarf came more broadly into use for middle-aged women. They wear it in addition to a headscarf for more or less formal occasions (including having their photos taken), but usually not when they are working, either inside or outside the home. This scarf also has no religious significance. It signifies an added layer of respectability that comes with age. By contrast, it is women in their mid-thirties and younger who wear the Arabic style.

To make matters more confusing, all four of these head coverings are called a *foulard* (scarf). The prayer scarf and the Arabic-style *foulard* are sometimes called *le voile* (veil). Senegalese do not use the word *hijab,* but rather call this an *ibadou,* after the Jamāʿatou Ibadou Rahman, the most influential orthodox Islam organization. Since this term can be somewhat disparaging, I will use "veil" to designate the Middle Eastern style for the sake of clarity.

However, the heavy textiles of handwoven strip-cloth that swathe West African women's head, shoulders, and upper body on their wedding night are also called "veils." Muslim women do not consider this veil Islamic, but rather a garment imbued with the rituals of their ethnic traditions. Senegalese fashion has absorbed all four types of "scarves" as well as the handwoven textile used in the wedding veil.

As the above review of scarves and veils suggests, the Senegalese Muslim fashion system combines demands of elegance and beauty with complex demands of social respectability. As a code of respectability, Muslim fashion relates to the practice of *sañse,* the art of "dressing well" (Heath 1992:21). *Sañse* implies sartorial elegance as the public display of means, honor, and reputation, especially at wedding and baby-naming ceremonies, where women engage in gift exchanges that historically served to solidify networks of reciprocal obligation.

But in the 1990s, the same socioeconomic crises that attracted many young Senegalese to austere Middle Eastern Muslim dress brought about

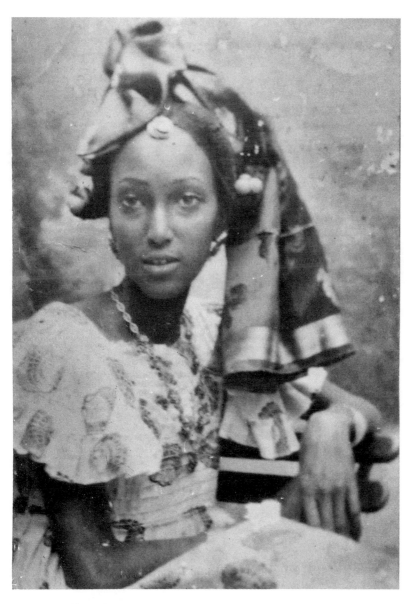

FIGURE 4.1. Tola Wade in a silk headscarf. Saint Louis du Sénégal, 1940s (photograph by E. Sursock, courtesy of Abdourahmane Niang).

an inflation of ostentatious *sañse* display for women in the their thirties, forties, and fifties (Buggenhagen 2009:194–196; Mustafa 1997, 1998). Although middle-class professional women and men decried the waste of such expenditures, women of popular neighborhoods clung to their traditional networks of reciprocal obligation as the source of security when the whole fabric of society seemed to be unraveling.

These same global historical forces brought yet another movement to Senegal. Daring Western youth fashions expanded, even while some young people were abandoning fashion for the plain garb of Middle Eastern Islam and an older generation was engaging in more lavish display of Senegalese Muslim fashion. Since at least the beginning of the twentieth century a Senegalese Western fashion system, called *tenue européenne,* had existed alongside the Muslim fashion system, called *tenue traditionnelle* or *tenue africaine.* But by the end of the 1990s, global mass media attracted many young women to tight jeans with skimpy t-shirts and young men to *les baggy.* Hip-hop became a much larger movement than orthodox Islam, as thousands of young people identified with African Americans and their struggles against racism, while they integrated rap with their Sufi practices. Like their counterparts in reformist Islam, the Senegalese hip-hoppers identified with a global movement, sought to raise people's consciousness, defied family traditions, and opposed local power structures (Drygun 2011; Herson and McIlvane 2009; Matador 2011; Niang 2006). While young orthodox Muslims chose to veil themselves, young Muslim hip-hoppers enthusiastically embraced *les streetwear.*

By 2010 these three dress systems of orthodox Islam, *tenue africaine,* and Western streetwear had gone through a process of integrating with one another. This process began with newly orthodox young women rejecting any concession to Western or Senegalese fashion. A 1999 news article describes the women's dress at the mosque of the *Association des Etudiants de L'Université de Dakar* (AEMUD): "At the entrance, a curtain protects thirty or so young women from prying eyes. . . . Their scarves [*foulard*] tightly tied, they await the teaching of the imam, demurely seated. . . . No concession to coquetry here. No make-up, no nail polish, no jewelry. . . . In short, none of the seductive devices of which *les Sénégalaises* are so fond and which give them their reputation for elegance" (Syfia 1999; my translation).

The author assumes an inherent conflict between modest religious dress and the celebrated Senegalese fashion expertise. But as Elisha Renne points out in this volume's introduction, in general "these concepts are dialectically interrelated." Moors and Tarlo likewise criticize the "unspoken assumption" that fashion and religious modesty "operate in inverse

proportion to one another" (2007:133; see also Osella and Osella 2007). They cite examples from several countries where new reformist Islamic movements initially adopted austere dress: "However, it did not take long for such styles to be elaborated and reworked into . . . 'Islamic Fashion'" (2007:137; see also Abaza 2007:287; Augis 2009:216).

Such is the case as we move from 1999 to another description of the AEMUD mosque in 2007: "[Students] dressed in 'Ibadou' style pray next to students wearing t-shirts with Akon, [or] 50 Cent" (Thurston 2009:9). Here we see, in the case of men, the integration of reformist Islam and hip-hop styles, so opposed to each other in the 1990s.

In addition, by 2011, "traditional" Senegalese fashion had brought the straying orthodox daughters back into its sumptuous folds. The veiled women walking through the university campus on a Friday afternoon of 2011 were wearing *tenue africaine* with veils color-coordinated to their outfits. By acquiescing not only to the inexorable force of fashion, but specifically to Senegalese fashion, the veil could no longer symbolize an Islamic youth movement dedicated to "complete and deliberate rupture with the [Senegalese] past of ancestors, traditions and the state" (Diouf 2003:7).

Yet a further sartorial irony was operating here. In 2010 and 2011 no Dakaroise "in fashion" would be wearing a *grand boubou*. The current mode was a slightly fitted tunic over a *pagne* (Plate 4). This tunic came from the caftan, a long-standing men's alternative to the *grand boubou,* directly adopted from the Arabic *jellaba.* A photograph from the 1950s shows the grandfather of my Dakar hostess Gnilane in an actual Arabic *jellaba* and fez. In 1999, the *jellaba* style had briefly come into fashion for women, its exaggerated playful references to menswear making it all the more flirtatiously feminine. In other words, despite the 1990s adoption of Arab Muslim dress to symbolize rupture with local Islam, the local fashions which assimilated the veil in 2010–2011 remind one that Arab influence already had a long history in Senegalese fashion.

On other days of the week, many orthodox university students, like many young orthodox professional women, wear an ensemble of pencil trousers and a short tunic. No longer the nondescript trouser outfit of the 1990s, these ensembles, often in simple, well-tailored black and white, look chic and elegant. Even shy and demure Oumou, a strict Ibadou, wears her white veil with jeans and the beautifully worked, heavy gold bracelets so highly prized in traditional *sañse* (Figure 4.2).

Orthodox women consumers can also choose from an enormous range of veil and scarf styles, showing the influence of new and growing Muslim fashion industries in Saudi Arabia, Iran, Turkey, Egypt, Great Britain, and

FIGURE 4.2. Young orthodox Muslim in white "Ibadou" veil, jeans, and heavy gold bracelets, Dakar, 2011 (photograph by L. Rabine).

the U.S. (Abaza 2007; Akou 2010; Balasescu 2007; Sandikci and Ger 2007; Tarlo 2010:189–217). So in yet another ironic twist, the global historical forces that combined to give Middle Eastern Islam a foothold in Senegal also gave rise to new and expanding global industries that target the Muslim consumer market. The young women of the 1990s who renounced corporeal adornment in the name of identifying with global Islam found themselves in a global movement where fashion was booming.

The overdetermined web of historic changes that brought the first ascetic veils to Senegal also brought them under the dispersive power of fashion. Any fashion industry, whether in Paris, Dakar, or Dubai, mines looks from a wide variety of dress systems, so that no national, ethnic, or religious style can remain pure. Television and the internet bring new fashions to Senegalese audiences via CNN, French Canal Plus, Al Jazeera, You Tube rap videos, Muslim women's web sites, and Bollywood. And Senegalese young people have joined this sartorial "global village" (Givhan 1999:162) on their own terms and through the lens of their own cultural history.

Student Didaa Badji, at the Dakar graphic arts school Sup'Info, offers one interpretation of the reciprocal integration of new Islamic veiling practices, hip-hop streetwear, and Senegalese fashion. She was among a group of students presenting their new e-magazine with the hip-hop-inspired name *Wassup?* in February 2011. For the presentation, she dressed like the other students in tight jeans and the black "Wassup?" t-shirt, differing only by her brown veil and white long-sleeved undershirt. Didaa's spirited leadership defied stereotype even more than her outfit. After the presentation, the students went outside for a photo shoot. Didaa took the lead in arranging their pose. Placing herself as the central focal point, she lay on the street and playfully lifted one long leg straight upward in a crotch-revealing pose. A woman student held her bare ankle, while a male student leaned over her with his hand grasping her shoulder (Figure 4.3). Not at all demure and retiring, Didaa nonetheless came to school on Friday in a heavily embroidered brown damask *tenue traditionnelle* and her brown veil, while the other students still wore jeans and their "Wassup?" t-shirts or tank tops. "Religion," Didaa said, "requires [*oblige* in French] veiling."

Religious Obligation or Personal Choice: The Veil and Senegalese Islam

Orthodox imams in Senegal preach veiling as a religious requirement (*une obligation*), citing the two relevant but hardly explicit passages from the *Qur'ān*, i.e., Sura 24:30 and Sura 33:59. Yet people differ sharply on this

FIGURE 4.3. Didaa Badji in veil and hip-hop t-shirt with fellow students and staff of the *Wassup?* e-magazine. Sup'Info graphic arts school, Dakar, 2011 (photograph by L. Rabine).

issue. Didaa and other young women affirmed the obligation, but the members of two Haal Pulaar families, whom I've known for many years, denied its validity. My focus on these two families, connected to each other by ties of marriage and friendship, best suited this project because I have had close relations with their members for many years. And although I interviewed other people, I found that veiling and religious beliefs in Senegal were delicate subjects and required the kind of long-standing intimacy that fostered free discussion. I will call one family Tall and the other Sy.

Almost all members of these families are devout Muslims affiliated with one branch or another of the Tijaniyya, the largest Sufi brotherhood in Senegal (Mbacke 2005:ix). In the Tall family, three of the four sisters started wearing the veil, as directed by their father, when they were seventeen years old. During their adolescent years they were affiliated with the orthodox Jamāʿatou Ibadou Rahman, but have returned to the Tijaniyya. Aissatou, the eldest, continues to practice strict veiling. Coumba, now thirty, removed the veil while a university student in France. The third sister, Mariama, wears the veil for work but not at home, even when guests and strangers are present. The youngest sister, Aminta, who told me, "I am

the rebel," refused to wear the veil. In the Sy family, matriarch Mame Waye and her numerous female descendents engage in a large variety of veiling and non-veiling practices, but none wear the orthodox, hijab-like style.

All people from both families who spoke with me emphatically insisted that the veil is a matter of personal choice. Other women have, like Didaa, told me with equal insistence that veiling is a religious requirement. Among all these women, however, some who affirmed the obligatory status of the veil did not consistently wear it, while others who contested the idea of a requirement consistently veiled themselves. The major determinant for calling the veil a requirement was a woman's age. In my research, it was very young women, of lycée or university age, who said that religion requires veiling.

Mame Waye's daughter Dieynaba is a social worker in her thirties and a devout Muslim. "It's a *very* personal choice," repeated Dieynaba. This notion of "personal choice" does not at all correspond to the liberal American concept of "individual choice." It suggests rather the conviction that a truly religious commitment must come from within, that external imposition is meaningless. This signification of personal choice comes out in Aissatou Tall's analysis of her own strict veiling: "It is really a personal choice. No one can impose it on anyone unless that person is oneself." For Aissatou, serious veiling comes out of a conscious process of self-reflection. When I asked for her analysis of veiling, she said: "My analysis began with myself. It's a personal conviction. *My* conviction."

Like Aissatou, Dieynaba's eldest brother Bocar insisted that "religion does not impose the veil." A retired banker who studies the *Qur'ān* and its scholarly interpretations with lively interest, he maintains that Islam does not *require* anything. Impatient with my questions that tried to pin down and simplify Islam, he too insisted that serious religious practice resulted from difficult self-reflection rather than external requirements.

This conviction defies Western stereotypes as much as does Didaa's hip-hop/Muslim outfit and exuberant leadership. My longtime friend Nafissatou challenged stereotypes in a different way when she analyzed veiling from outside the oppositional framework of personal choice versus religious obligation. A Wolof and a devout adherent of the Murid brotherhood, Nafissatou explained the vagaries of Senegalese veiling in the context of Senegal's unorthodox version of Islam. She said that Islam requires veiling, but in an objective manner, as if it had nothing to do with her: "Islamic law requires one to wear the veil, but we don't wear the veil in Senegal as in countries that are 100 percent Muslim. We weren't brought up for that." As if to illustrate the difficulties of generalizing about veil

practices in Senegal, Nafissatou, a beautiful and fashionable woman in her thirties, was actually wearing a *foulard* over her head and shoulders when she made this statement. When I asked her about the apparent contradiction, she insisted that she had just been praying when I came over.

Given that Senegal is 95 percent Muslim, her statement that Senegal differs from countries which are 100 percent Muslim might seem surprising. Nafissatou's analysis refers rather to the unique diffusion of Islam in Senegal, through Sufi brotherhoods during French colonialism. Although Islam came from North Africa and the Middle East to Senegal as early as the eighth century, it did not become a mass religion until the mid-nineteenth century. At that time, furthermore, Islam did not spread as a singular spiritual force that transcended differences of tribe, ethnicity, and distance, as its founders intended. Rather, it took the form of four Sufi orders, three of them taking root in specific regions and ethnic groups: the northern Haal Pulaar region for the Tijaniyya; the central Wolof region for the Muridiyya; and the Cap Vert peninsula of Lébou fishing villages for the Layèenne (Diouf and Leichtman 2009:5; Mbacke 2005:19, 31, 56–57, 67–68).

The basic doctrine of Sufi Islam, established in the eleventh century, reinforced the localized character of Senegalese Islam (Mbacke 2005:9–11). According to this doctrine, each Muslim must be in a relation as submissive disciple (*talibé*) to a spiritual master, a cheikh, or in Senegal a marabout. Three of these Sufi orders have an even more local quality. Although the Tijaniyya originated in Arabic North Africa, its founder in Senegal was the Haal Pulaar Cheikh Oumar Tall (1796–1864). The Muridiyya and Layèene are wholly indigenous to Senegal. Khadim Mbacke argues: "[The] popularity [of the Sufi brotherhoods] on the African continent has much to do with their assimilation of spiritual African customs and elements, such as . . . the equation of spiritual guides with traditional chiefs" (2005:14). These are precisely the "impurities" and "traditions" that the young orthodox Muslims of the 1990s were rebelling against.

The Sufi brotherhoods, and especially the influential Muridiyya, emphasize service, in the form of labor and gifts to powerful spiritual guides, over strict religious practice. Since colonial times, these cheikhs and khalifs have built powerful, wealthy dynasties (Diop 1981:321–336; Thioub et al. 1998). Instead of condemning Western-style democracy and demanding an Islamic state, they profited greatly by providing voter blocs for the party of Catholic anti-colonial leader and first President Léopold Sédar Senghor in the decades before and after Independence (Loimeier 2009:240–241; Njami 2006).

All of these policies have worked together to make the brotherhoods exploitative in some ways, but freeing in others. They allow for followers to harmonize devout Islamic faith with full engagement in secular global cultures. Young Murid and Tijani find no conflict between their devotion to Islam and their devotion to transnational hip-hop, or for that matter, *les streetwear* and lavish *tenue traditionnelle*. The brotherhoods end up fostering an Islam which prides itself on its tolerance and openness.

But in the 1990s, the same complex of historical forces that brought about all the other religious and sartorial changes discussed above contributed to internal fragmentation and a loss of authority among the brotherhoods (Buggenhagen 2009:194; Loimeier 2009:243). Rival heirs and claimants to leadership set up competing movements or branches within the Muridiyya and Tijaniyya. Increasingly in the 1990s, the Murid and Tijani cheikhs could no longer wield authority to deliver voting blocs (Thurston 2009:5–6). Their very disciples treat any marabou who supports a corrupt politician with derision and protest (Leral.net 2011).

While this deterioration of the disciple-master relation has allowed Islamic groups like JIR and AEMUD to gain a firm foothold in Senegal, it has not allowed them to become a major force or to counter the "overwhelming power" of the brotherhoods (Loimeier 2009:242; see also Augis 2009:229). A principal quality of Senegalese culture since the time of the Signares is its ability to incorporate differences from outside and go on being itself. This power of expansive assimilation has had its effect on the orthodox orders. At first strident in their condemnation of the secular state and Sufism, JIR and AEMUD have ceased to demand Shari'a, have made concessions to the brotherhoods, and have drawn closer to indigenous Senegalese Islam (see, for example, Dacosta 2009).

At the same time some movements within the brotherhoods have adopted certain elements of orthodoxy, which include veiling. Didaa pronounces herself "100 percent Murid," and Aissatou is active in the big Tijani Mosque of Dakar.

The sartorial dialogic, like the rapprochement between orthodox orders and the Sufi brotherhoods, goes both ways. The veil has, in its turn, effected a loosening of the rules that govern the venerable, honored headscarf. For the past three decades, fashion codes dictated that the headscarf be made in the same fabric as the *boubou* and *pagne*. But in 2010–2011, some women were using the filmy veil material for headscarves. And as some women have turned to veiling, other Muslim women have moved in the opposite direction and have started wearing Muslim *tenue traditionnelle*

with no head covering at all, even on Ramadan Fridays, something almost unheard of in the past.

But all these different styles, uses, and non-uses of veils and scarves do not merely reflect the dialogical reciprocity between Sufi and orthodox Islam. The dissemination of the veil into Senegalese fashion, I would argue, also acts to produce this dialogic process.

Fashionable Veiling as a Dialogic Force

A striking visual example of this dialogical process appeared at a neighborhood religious conference during Ramadan 2010. Such conferences are popular ways to mark Ramadan, and this one was held on a Dakar boulevard. One principle of *sañse* is that all the women at such occasions dress identically, or at least in identical fabric (Heath 1992:26). For this occasion the women all wore outfits and head gear in the same white fabric, but the whole first row of seats contained young women in veils, while behind them sat the older women wearing headscarves. In the 1990s, parents had vigorously opposed their daughters wearing veils (Augis 2009:220), while the veiled daughters had sternly rejected their mothers' and grandmothers' sartorial traditions. Dressing in the same fabric signifies shared identity, and on this occasion that had special meaning. It was a sign that women across the generations had dissolved their opposition into a shared act of co-opting the veil into Senegalese religious and sartorial "traditions."

These white outfits also illustrate the transformation of veiling from a serious religious commitment into a fashion, since most of the young women at this conference did not habitually wear veils. It is in becoming a fashion that veils can perform this dialogical process.

Another neighborhood religious conference, also during Ramadan 2010, but in Saint-Louis du Sénégal, expands this significance of fashion as a dialogic force. At midday a group of about twenty adolescent women spilled out of the conference hall. Their fashionable tunics in the current style of *tenue traditionnelle* were all made from the same white fabric embroidered with gold or silver. Their identical veils were adorned with a little sequined embroidery and a silk flower. Happy and animated, they trotted down the street in high-heeled slides, some in metallic gold leather. A young man standing next to me told me they were "Ibadou," which they were not.

The conference organizers were Niassène, a new, extremely popular, and quite unorthodox movement in the Tijaniyya that does not require veiling. The young women were eager to talk to me. Laughing and chatting, they told me they wore veils "because religion requires it." They asked me

to take their photo. Then they spent so much time arguing about whose email account would receive the photos that women monitors came by and put a stop to the whole activity. The monitors were in their late twenties and early thirties, their more prestigious status signified by veils made of a material entirely covered with large hot-pink sequins (for this style, see book cover). Here fashion and religious modesty are indeed not "in inverse proportion to each other."

The extravagance of these Ramadan ensembles acts as a reminder that world religions have historically had a double attitude toward fashion. Priests, ministers, and imams decry the vanity and distracting sexual allure of fashionable finery. But religious holy days and festivals in Christianity, Judaism, and Islam are principal times when one steps out for the first time in the season's newest fashions and dons special dress clothes. For the young women at these and other Ramadan religious conferences, veils had entered that realm of special dress up fashions for religious holidays.

My hosts Bocar and Gnilane, who are devout and intellectual Muslims, greeted my account of the Saint-Louis religious conference with impatience. Bocar disapproved of Ramadan religious conferences as "beauty contests." Gnilane told me, "you won't see those young women wearing veils on other days," and added that many women wore them "to follow fashion."

Her comment points to the fact that the veil in Senegal has become fashion in two senses. First, the act of wearing the veil has become, as Coumba Tall said, "a phenomenon of fashion." Second, the veil follows fashion trends, to which the hot pink or turquoise sequin veils bear witness. Coumba and her eldest sister Aissatou are ambivalent about the veil as fashion in the first sense, but enthusiastic about the second sense.

Of the first sense of fashion, Aissatou comments: "Recently, women wear it in all structures, in all milieus. In fact it's become an effect of fashion more than anything else. Women wear veils any which way." But balancing her disapproval is the idea that the more women wear veils as an effect of fashion, the easier it is for women like her to gain acceptance for serious religious veiling. The conviction that veiling is a personal choice does not mean that it is always easy. For example, Aissatou has found that religious veiling can create difficulties in finding a job (Augis 2009:221). When Aissatou did get a job in personnel management, the difficulties did not end.

> I saw that people were afraid, and finally I told myself to take it as a challenge. So I always tried to create a certain conviviality. Finally I realized that I was like anyone else, that the veil didn't prevent me from being convivial and having normal relations with people. So

they shouldn't see me as if I came from another planet, or as if I had another state of mind, like an extremist or something.

The dissemination of the veil as fashion eases the perception of veiled women as alien and extremists.

Indeed, as the young man's mistaken comment about the fashionably veiled young women in Saint-Louis suggests, one can no longer identify an Ibadou or a Sufi by her dress. If fashion can serve to express people's identity, it can also work to disguise or confuse identity. Many people in Senegal label any woman who wears a veil an Ibadou. But Nafissatou criticizes this labeling, saying, "They are simply Muslims. We call them Ibadou, but they don't call themselves Ibadou."

At this historic moment in the dissemination of the veil as fashion, it works both to create a dialogic process and to instigate conflict about mistaken identities. Soukeyna Niang provoked one such conflict around labeling and identity when she posted a photo of herself in a veil on Facebook. To a comment from a male friend, she responded indignantly: "Me, I am not Ibadou, not at all. It was an occasional moment when I did that, and I took a few photos of it. But I'm NOT Ibadou. Take a good look." Soukeyna found herself caught between the thrill of photographing herself costumed as an exotic imaginary other and the alienating feeling of being boxed in, labeled, and stereotyped.

As the costume or the passing fancy of Soukeyna and the young women at the Saint-Louis Ramadan conference, the veil performs as fashion in contrast to the prescribed uses of ritual dress or uniforms. While the latter clearly communicate the wearer's identity, fashion can either communicate or hide an identity. A woman on a Dakar street wearing a veil could be an Ibadou, a Murid, a simple Muslim, or someone making a fashion statement. This movement of the veil into the ambiguities of fashion has the potential to relieve orthodox women from being stereotyped. At the same time, it allows other women to wear the veil as a means of protection, though not always effective, from sexual harassment—or, as in the case of Soukeyna, as a way to play with imaginary identities.

Ambivalence of the Veil

Despite the veil's dissemination into the polysemy of fashion, it stubbornly remains a severe non-fashion in various ways. For some woman the veil still acts as a "barrier" in their relation to others. In this incarnation, the veil is not even an "anti-fashion" like the counter-cultural street

styles—hippie, punk, hip-hop—that designers have appropriated as high fashion (Polhemus 1994:8–13). Even while Muslim high fashion has so appropriated the veil, it leads a double life—a single garment existing in parallel, incompatible sartorial realms.

Some women welcome the quality of the veil as barrier in social relations. For Dieynaba Sy, even the headscarf provides that kind of protection: "It's more respectable, it's a barrier. No one will dare hit on you (*draguer*)." But other women are dubious about the power of the veil to protect a woman. The youngest Tall sister, Aminta, who steadfastly refused to veil, told me that she briefly wore the veil at the age of sixteen in order to "escape masculine attentions." But, she joked, it didn't work: "In spite of the veil, they still made their declarations of love."

In contrast to Dieynaba and Aminta, the two eldest Tall sisters experienced emotional ambivalence about their religious veiling. And while Aissatou, as we saw above, told me she took the barrier as a challenge, six months later she said that she was going through "a project of reflection" about modifying her veiling. "Even the *Qur'ān* asks us to reflect," she said. Aissatou was finding the veil "a brake" in her professional life, but added, "the transition is difficult."

Coumba finally found the veil too much of a brake against her development into womanhood. She left Senegal to attend a French university in 1999 at the age of nineteen, received her undergraduate degree in 2002, and took her doctorate in aeronautical engineering in 2009. She now lives in Montreal. "Just before my graduation, I removed the veil. This was a hard decision; it took me two years to do it." Two influences motivated her decision. First, "all the people I knew in France, my aunt and uncle and my host family, knew I had good marks in school, and they advised me to abandon the veil because it would harm my career, close doors to me."

But the second motive went much deeper:

> And then I also realized that the veil no longer reflected the person I had become. The act of veiling was a brake. It restricts your relations with other people. People are reserved with you, and you can't converse on a lot of subjects. You can't go out, go to the movies, go dancing. I wanted to go out with friends. I had changed a lot. The first year I was totally focused on studying. And the other students were saying: that girl is crazy. She is always studying in her tiny room. I had come from my little city in Senegal, and felt that I had not come to enjoy myself but to study, get degrees, and go back to my country. I began to realize that I was wrong. I had good grades, but something was missing, and that something had

to do with the veil. You find that it's a pity not to have the benefit of being twenty-two, and I hadn't really had my youth, because I'd worn the veil since the age of seventeen. Now I had a need for my youth.

So for Coumba, the veil had become multiply encumbering. It had become a negative barrier against professional opportunity, friendship with other young people, and a whole wealth of conversational topics and enriching activities. But it also became a barrier within herself, between the young African girl she had been, and the cosmopolitan young woman waiting to come to life: "It was as if I was lying to myself by wearing the veil, not only the exterior veil but the deeply profound internal veil."

During her years in France, Coumba did not lose Muslim devotion, but she did integrate French culture and French values: "I asked myself: couldn't I still do good by wearing my veil just at home?" Here she voices the central French value of republican *laïcité* (secularism) at the heart of the conflicts around the "Scarf Affairs" (Bowen 2007:11–33; Scott 2007:90–123). Coumba notes, "In France they push you to leave your religious beliefs at home, and when you are in public, to be like any other person, which is not possible, but they push you to 'integrate yourself' to their country and culture."

It might seem at first glance that Coumba's process of integrating African and French identities affirms the French conviction of the necessity for a law to ban girls wearing veils from lycées. But a deeper consideration of Coumba's process shows it countering the rationale behind the law. The Scasi Commission report to the French government, and the resulting law of 2004, rest on the assumption that external compulsion is the best way to integrate young Muslims into French *laïcité*. Coumba's two-year struggle to give up the veil rather lends support to the minority position. In this view, the law provokes a hardening of Islamic opposition and institutionalizes "the flagrant contradiction inherent in exclusion" (Balibar 2004:354; see also Gaspard and Khosrokhavar 1995).

Indeed, Coumba's experience with the one professor who did compel her to remove the veil had that contradictory effect of excluding her and alienating her from French *laïcité*: "French people can be narrow-minded; maybe it is a fear of losing their tradition and cultural heritage. Actually, I had a very sad experience with one professor who literally used to oblige me to remove my *foulard* during his class." She remembers no other hostile reaction to her veil, but when I remind her of this experience, she just says: "a nightmare."

If Coumba had started veiling a few years later in Senegal, she might not have found it such a restriction from youthful experimentation or inti-

mate gab fests about "taboo subjects." The spirited student Didaa certainly does not let the veil restrict her. Neither does Coumba's younger sister, Mariama, who expresses herself as easy-going about veiling. A systems administrator, Mariama says: "My wearing the veil has lasted thirteen years, but since I've been married it's become more supple. That's because I only wear it when I go out. When I'm at home, I don't do it."

Mariama has arrived at a modus vivendi and a style of veiling that, in contrast to the experience of her elder sisters, does not place so many barriers between herself and others. Moreover, her analysis combines this sense of ease with the themes already explored of personal choice and the impossibility of knowing a woman's identity by her veil:

> I also have a personal approach to the concept. Modes of veiling differ from one individual to another: there are Islamicist, fundamentalist, and brotherhood practitioners. But for me personally, it was my father who proposed it to us at a young age, and I learned to adapt it to myself as time went by, because I get something out of it. (Certain parts of my body aren't visible when I go out, because Islamically speaking, they should be reserved for the touch and view of my husband.) The only difference is that I don't hesitate to make my head beautiful.

Indeed, Mariama has her hair done in whatever elaborate braiding and extensions form the current fashion.

These five examples—Dieynaba, Aissatou, Aminta, Coumba, and Mariama—suggest the range of different attitudes toward the veil. Their distinctive analyses, even among sisters, also suggest the impossibility of generalizing about the veil.

Challenging Stereotypes

The veil in Senegal defies still other generalizations and stereotypes, for instance the misconception that it symbolizes the wearer's submission to male authority. Here too the contrasting experiences of Aissatou and Coumba challenge this stereotype. Aissatou, who steadfastly veils, also showed extraordinary strength of will against an authoritarian husband. She separated from her husband when she was pregnant. He did not want her to go out of the home or to work, but she needed to do her internship and her field interviews for her master's thesis:

> It's something I can't accept because if I accept this today, then tomorrow I won't be able to pursue rigorous studies without being

thwarted. When there are things to be done, you have to be consistent. You can't marry a woman who has won her [undergraduate] degree and then demand that she be a housewife. Even women who don't have a degree have the need to work, to be productive instead of just staying at home.

Aissatou stood up for her strong conviction, even though it countered the Islamic doctrine that women should not work outside the home except when necessary (Augis 2009:224–225). By contrast, Coumba's unhappy memory of submitting to authority concerns the professor who forced her to *remove* the veil: "I had no choice, and I realize I was too young to stand and say NO." Also in contrast to Aissatou, she regrets that she could not defy coerced submission. Even as the poised, confident, highly accomplished scientist, Coumba still holds within her the old image of herself as the powerless, forlorn young girl: "I felt so bad. I had to sit at the back of the class—ALONE—untying my *foulard,* and wondering when it would stop."

Coumba's inner strength allowed her to prevail over this coercion. But another contrast between her and Aissatou challenges yet a further stereotype. The fact of veiling or not veiling does not predict a woman's attitude toward being fashionable (Moors and Tarlo 2007:211). Coumba, who removed the veil for the sake of youthful joys, professes indifference to fashion. Aissatou may take veiling very seriously but loves fashion and even considered being a fashion designer "because it's an interest of mine." About her textile choices for veils, Aissatou laughingly says: "A concern for fashion is also involved. . . . For example there are some *foulards* that I don't wear and that I leave for the *mamans.*" She enthusiastically favors her own original style: a sumptuous headscarf *over* a filmy ornate veil: "*C'est jolie,*" she says. And when Aissatou triumphantly defended her master's thesis, she wore a black mortar board over a filmy white veil.

But even Coumba agrees that prayer veils should be beautiful, as does her ninety-something-year-old mother-in-law Mame Waye, matriarch of the Sy family. Mame Waye spends many hours of her day in prayer and has always shied away from being photographed. But she astonished me one Friday of Ramadan when she insisted I photograph her. She had just put on a new white veil, embroidered in bright lovely colors.

Coumba explains Mame Waye's enthusiasm for this veil: "For Friday prayer, the women will carefully choose their clothes, because it is the best day of the week. On Fridays, Mame Waye wears all white, clean and neat, beautiful. And she puts on perfume. Only on Fridays" (Figure 4.4). For Coumba the perfume, like the beautiful white clothing, and the act of covering one's head, hands, and feet, "is part of a whole set of marks" that

FIGURE 4.4. Mame Waye in white veil for Friday prayer, Dakar, 2008 (photograph by L. Rabine).

mark a special time away from daily life, "a moment between me and God." She follows a similar regime for Friday prayer: "Perfume can be compared to makeup—a little class to look good for yourself and others, and as a religious act. To appear in the best way—clean, perfumed, neatly and well dressed, with one of your most beautiful veils—is welcome."

This concern for beauty in religious dress goes along with the importance that Senegalese have historically accorded to fashion as a primary form of aesthetic creativity. When I tell Senegalese colleagues that I research fashion, they say that I am studying "the aesthetic." But for Senegalese Muslims, fashion as an art goes beyond a look or a garment. It is an expert practice that requires training and initiation into its secrets. Both men and women express pride in their ability to carry off any style from any culture—European, Arabic, Asian—and to wear it with elegance, panache, and comfort (Rabine 1997:97).

So it is not surprising that when a new Arabic style comes on the scene, whether inspired by orthodox religion or not, women pick it up and take pride in showing that they can master the art of wearing it. People have told me that little girls practice early the mastery of sartorial arts, for instance walking with the elegant gait required by the *grand boubou*. Thus Mame Waye's eleven- and twelve-year-old granddaughters, having heard about my research, popped into my room one day to show me proudly that they knew how to tie the veil in the orthodox Arabic way, even though no adults in their family practice this kind of veiling. For the two young girls, tying the veil had a sense of playing dress-up, of trying on imaginary identities.

From the construction of new religious identities to the play of fantasy identities, the veil in Senegal becomes a metaphoric textile weaving together a host of differences: religious, stylistic, visual, generational, cultural, and aesthetic. In order to emphasize the enormous spectrum of differences in this textile, I use as concluding example a veiled self-portrait by a man. Mouhamedou "Papis" Ndiaye is a computer engineer, photographer, and graphic artist. He posted on Facebook a striking, beautiful photograph of himself with head and face tightly veiled in an indigo scarf. Only the eyes showed. The caption quotes Aimé Césaire: "The mouth of those who have no mouth" (Ndiaye 2011). Papis had immigrated to Morocco for work, and having confronted racism against Black Africans there, he became sensitive to racism against other people.

For him, the veil image alludes to the "problem between the Moroccans and the Berbers. In Morocco, the Arabic language outranks the language of origin, of the Berbers who were initially the first inhabitants of these lands. . . . So you see . . . the Berbers don't have their say." Having begun as a

way for Muslim women to construct a new self-identity, the veil in Senegal can also be a vehicle for empathetic identification with other people. We have seen the veil as a protest against corporeal aesthetics, as the epitome of corporeal aesthetics for Friday prayer, and even as an art piece that uses aesthetics as a "weapon" of protest (Ndiaye 2011). But as regards his image as weapon, Papis responded to Facebook commenters that his art was fighting "through fashion [*en mode*]." As art and as "fashion," even a veil as extraordinary as Papis's can take its place in the ever-unfurling text of Senegal's expansive culture.

NOTE

Heartfelt thanks to the Tall sisters and the Sy clan. Special thanks to Coumba and Ali for discussing this project with me every step of the way; to Bocar and Gnilane for hosting me in Dakar; to Nene for taking it upon herself to recruit photographic subjects; and to Mame Waye, her children, and grandchildren for sustaining my body, spirit, and research. Thanks to Mame Waye's children: Awa, Ousmane, and Khadidiatou, Dieynaba and Nouhoum, Dede and Fatim, Oumar and Ndeye Khady. And thanks to the grandchildren: Abdoulaye, Oumar, and Bocar; Salif and Aminta; Oumar and Haby; Bineta; Bundaaw; and all the Hourayes.

WORKS CITED

Abaza, Mona. 2007. Shifting landscapes of fashion in contemporary Egypt. *Fashion Theory* 11 (2/3): 281–297.

Aïdara, Abdoul. 2004. *Saint-Louis du Sénégal d'hier à aujourd'hui.* Brinon-sur-Sauldre: Grandvaux.

Akou, Heather Marie. 2010. Dressing Somali (some assembly required). In *Contemporary African Fashion,* ed. S. Gott and K. Loughran, 191–204. Bloomington: Indiana University Press.

Augis, Erin. 2009. Jambaar or Jumbax-out? How Sunnite women negotiate power and belief in Orthodox Islamic femininity. In *New Perspectives on Islam in Senegal: Conversion, Migration, Wealth, Power, and Femininity,* ed. M. Diouf and M. Leichtman, 211–236. New York: Palgrave.

Balasescu, Alexandru. 2007. *Haute couture* in Tehran: Two faces of an emerging fashion scene. *Fashion Theory* 11 (2/3): 299–317.

Balibar, Etienne. 2004. Dissonances within laïcité. *Constellations* 11 (3): 353–367.

Berry, Sarah. 2000. *Screen Style: Fashion and Femininity in 1930s Hollywood.* Minneapolis: University of Minnesota Press.

Biondi, Jean-Pierre. 1987. *Saint-Louis du Sénégal: mémoires d'un métissage.* Paris: Denoël.

Boilat, David. 1984 [1853]. *Esquisses sénégalaises.* Paris: Karthala.

Bowen, John Richard. 2007. *Why the French Don't Like Headscarves: Islam, the State, and Public Space.* Princeton: Princeton University Press.

Breward, Christopher. 2003. *Fashion.* Oxford History of Art. Oxford: Oxford University Press.

Buggenhagen, Beth. 2009. Beyond brotherhood: Gender, religious authority, and the global circuits of Senegalese Muridiyya. In *New Perspectives on Islam in Senegal: Conversion, Migration, Wealth, Power, and Femininity,* ed. M. Diouf and M. Leichtman, 189–210. New York: Palgrave.

Camara, Abdoulaye, and Joseph Roger de Benoist. 2003. *Histoire de Gorée.* Paris: Maisonneuve et Larose.

Craik, Jennifer. 2009. *Fashion: The Key Concepts.* Oxford: Berg.

Dacosta, Ibrahima. 2009. Touba: la 'Jamatou Ibadou Rahmane' adhère à l'Observatoire pour la paix. *Agence France Presse,* 13 December. http://www.aps.sn (accessed 14 September 2011).

Diop, Abdoulaye-Bara. 1981. *La Société wolof: Tradition et changement: Les Systèmes d'inégalité et de domination.* Paris: Karthala.

Diouf, Mamadou. 2003. Engaging postcolonial cultures: African youth and public space. *African Studies Review* 46 (2): 1–12.

Diouf, Mamadou, and Mara Leichtman. 2009. Introduction to *New Perspectives on Islam in Senegal: Conversion, Migration, Wealth, Power, and Femininity,* ed. M. Diouf and M. Leichtman, 1–20. New York: Palgrave.

Drygun. 2011. Interview. Dakar, 9 February.

Eicher, Joanne, and Mary Roach-Higgins. 1992. Definition and classification of dress: Implications for analysis of gender roles. In *Dress and Gender: Making and Meaning,* ed. R. Barnes and J. Eicher, 8–28. Oxford: Berg.

Gaspard, Françoise, and Fahrad Khosrokhavar. 1995. *Le Foulard et la République.* Paris: La Découverte.

Givhan, Robin. 1999. Global village. In *Icons of Fashion: The 20th Century,* ed. G. Buxbaum, 162–163. Munich: Prestel.

Heath, Deborah. 1992. Fashion, anti-fashion, and heteroglossia in urban Senegal. *American Ethnologist* 2: 19–33.

Herson, Ben, and Magee McIlvane. 2009. *African Underground: Democracy in Dakar.* Documentary film. Nomadic Wax and Sol Productions Foundation.

Hollander, Anne. 1994. *Sex and Suits.* New York: Knopf.

Keller, Candace M. 2008. Visual Griots: Social, Political, and Cultural Histories in Mali through the Photographer's Lens. Ph.D. diss., Indiana University.

Leral.net. 2011. La Section Benno de Mbacke met en garde contre tout "ndigeul" en faveur de Wade. 12 June. http://www.leral.net (accessed 14 September 2011).

Loimeier, Roman. 2009. Dialectics of religion and politics in Senegal. In *New Perspectives on Islam in Senegal: Conversion, Migration, Wealth, Power, and Femininity,* ed. M. Diouf and M. Leichtman, 237–256. New York: Palgrave.

Matador. 2011. Interviews. Dakar, 25 and 28 January.

Mbacke, Khadim. 2005. *Sufism and Religious Brotherhoods in Senegal.* Princeton: Marcus Wiener.

Moors, Annelies, and Emma Tarlo. 2007. Introduction to Muslim Fashions. Special issue, *Fashion Theory* 11 (2/3): 133–142.

Morin, Richard, and Juliana Menasce Horowitz. 2006. Europeans Debate the Scarf and the Veil. Pew Global Attitudes Project. Pew Research Center Publications, 20 November. http://pewresearch.org (accessed November 2010).

Mustafa, Huda Nura. 1997. Practicing Beauty: Crisis, Value, and the Challenge of Self-Mastery in Dakar: 1970–1994. Ph.D. diss., Harvard University.

———. 1998. Sartorial ecumenes: African styles in a social and economic context. In *The Art of African Fashion.* Eritrea: Africa World Press.

———. 2006. La mode Dakaroise: Elegance, transnationalism and an African fashion capital. In *Fashion's World Cities,* ed. C. Breward and D. Gilbert, 177–220. Oxford: Berg.

Ndiaye, Mouhamedou. 2011. Personal Facebook page, 4 and 15 August. https://www.facebook.com (accessed 15 September 2011).

Niang, Abdoulaye. 2006. Bboys: Hip-hop culture in Dakar, Sénégal. In *Global Youth? Hybrid Identities, Plural Worlds,* ed. P. Nilan and C. Feixa, 167–185. London: Routledge. Kindle ebook edition.

Njami, Simon. 2006. *C'eĩtait Senghor.* Paris: Fayard.

Osella, Caroline, and Filippo Osella. 2007. Muslim style in South India. *Fashion Theory* 11 (2/3): 233–252.

Polhemus, Ted. 1994. *Street Style.* New York: Thames and Hudson.

Rabine, Leslie W. 1997. Dressing up in Dakar. *L'Esprit créateur* 37 (1): 84–107.

———. 2002. *The Global Circulation of African Fashion.* Oxford: Berg.

Sandikci, Özlem, and Güliz Ger. 2007. Constructing and representing the Islamic consumer in Turkey. *Fashion Theory* 11 (2/3): 189–210.

Schulz, Dorothea E. 2007. Competing sartorial assertions of femininity and Muslim identity in Mali. *Fashion Theory* 11 (2/3): 253–279.

Scott, Joan Wallach. 2007. *The Politics of the Veil.* Princeton: Princeton University Press.

Simmel, Georg. 1904. Fashion. *International Quarterly* 10: 130–155. Reprinted in *American Journal of Sociology* 62 (May 1957): 541–558.

Syfia. 1999. Sénégal: Le foulard islamique, rempart de la vertu. 1 February. http://www.syfia.info (accessed 15 September 2011).

Tarlo, Emma. 2010. *Visibly Muslim: Fashion, Politics, Faith.* Oxford: Berg.

Thioub, Ibrahima, Momar-Coumba Diop, and Catherine Boone. 1998. Economic liberalization in Senegal: Shifting politics of indigenous business interests. *African Studies Review* 41 (2): 63–90.

Thurston, Alexander. 2009. Why is militant Islam a weak phenomenon in Senegal? http://www.cics.northwestern.edu (accessed 15 September 2011).

Wilson, Elizabeth. 1985. *Adorned in Dreams: Fashion and Modernity.* London: Virago.

Modest Bodies, Stylish Selves: Fashioning Virtue in Niger

ADELINE MASQUELIER

You must cover your body because it is God's command. God will send angels to light up the graves of women who cover their heads with veils.

—Izala preacher, Dogondoutchi, 1994

According to a hadīth, *the woman who does not veil will never smell the smell of paradise. [. . .] Every time she comes out of her home uncovered, she shares the sins of all the men who look at her.*

—Izala preacher, Dogondoutchi, 2006

IN THE EARLY 1990s a wave of religious fervor swept through Niger, promoting the development of a "heightened self-consciousness" (Eickelman and Piscatori 1996:39) about what it meant to be Muslim. The sharpening of Muslim identity in turn translated into an unprecedented focus on dress codes and the fashioning of modest personae. Members of an emerging anti-Sufi reformist movement known colloquially as Izala[1] insisted that local male and female garb be modified. While they urged men to shed their voluminous *riguna* (robes) in favor of the *jaba*—a tunic worn over short-hemmed pants, they were especially keen to ensure that women concealed their bodies from head to ankles. Women wearing "skimpy" attire were harassed, and occasionally attacked, for exposing their state of undress and by implication, their lack of religious engagement. The modesty of a "true" Muslim's attire was a measure of her virtue, Izala preachers declared, as they grew beards and put on turbans.

These attempts to define morality through the creation of virtuous women in contradistinction to (presumably morally corrupt) Western

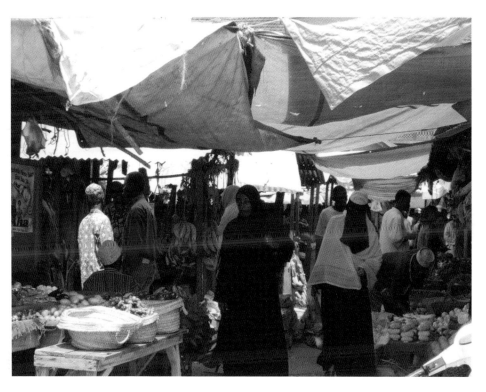

PLATE 1. Market in Zanzibar, with women wearing *abaya* and Ninja veiling style with *niqāb* (photograph by Laura Fair).

PLATE 2. Tuareg woman, wearing headscarf and shawl, collecting leaves (photograph by Susan Rasmussen).

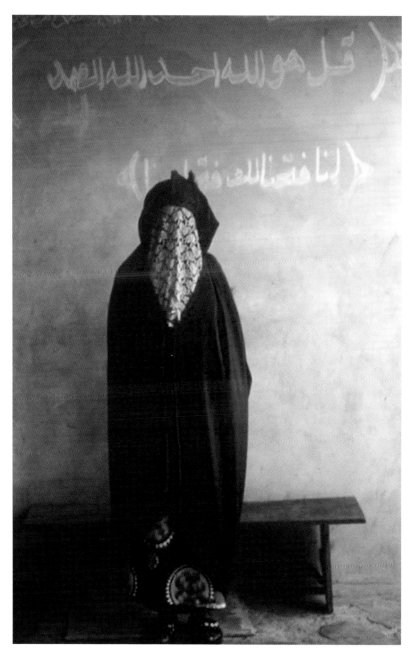

PLATE 3. Ekiti Yoruba ẹlẹẹha, Ikọle-Ekiti. Two passages from the Qur'ān are written on the wall behind her, Sura 112:1–4 and Sura 48:1–3. February 2003, Ikọle-Ekiti (photograph by Elisha Renne).

PLATE 4. Coumba Tall in a fashionable *tenue traditionnelle* tunic with *pagne* and headscarf, 2010 (photograph by Leslie Rabine).

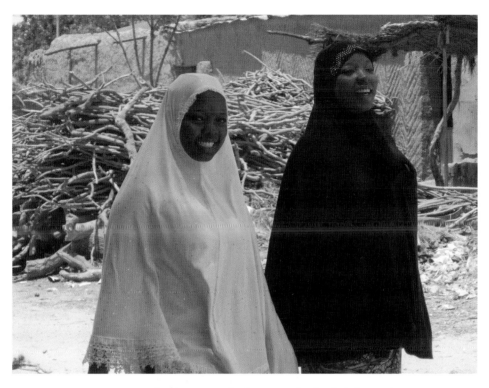

PLATE 5. Two unmarried girls wearing the latest trend in *hijabi* fashion. The girl on the left wears a *hijabi* whose fabric is adorned with tiny rhinestones and fringed with lace. The girl on the right wears a *hijabi* with rhinestones around her forehead, Dogondoutchi (photograph by Salifou Hamidou).

PLATE 6. Woman wearing new fashions from Mecca (photograph by José C. M. van Santen).

PLATE 7. Co-wives farming wearing *dan kwali* headscarves (photograph by Hauwa Mahdi).

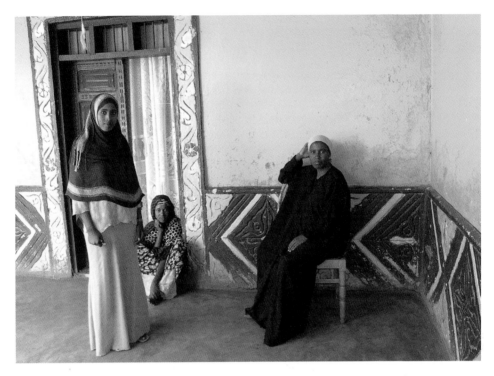

PLATE 8. Three young women from Awwaday, a small town in eastern Ethiopia outside Harar. Awwaday is world-renowned for its production and distribution of *khat,* a leafy plant that is chewed as a past-time throughout the Muslim world, and its inhabitants are well-to-do by Ethiopian standards. This affluence allows the woman at the right to own *abaya,* which is rarely seen today in Ethiopia. The other two women wear the more typical *foota,* a long scarf used to cover the head, hair, and torso in public (photograph by Peri Klemm).

womanhood do not mean that reformist Muslims are unconditionally and uniformly against fashion, however. Arguably, at a time when women's bodies are ever more critical sites of ideological struggles about Islamic morality, the Izala movement has been remarkably successful in enforcing forms of female encompassment and sartorial control deemed essential for the preservation of moral boundaries and chaste selves. In many Nigérien households, tight-fitting, form-enhancing garments have been abandoned in favor of more modest attires. Yet attention to the specific contexts in which modest attire is worn, the various expressions this modesty takes, and the diverse meanings attached to it reveals a complex picture of Muslim sartorial trends in which piety is not necessarily antithetical to fashion and modest clothes can have decidedly "chic" implications, especially when notions of purity and cosmopolitanism are the object of ongoing, at times personalized, redefinitions.

If women's dress has been impacted by the redefinition of modesty in Muslim reformist discourses, it is nonetheless problematic to assume that the concept itself had no prior currency in the region. Women's understanding of modesty and their experience of veiling antedates current debates over whether to wear *hijabi* (veil; pl. *hijabai*). Partly because they were more embodied than discursive, the practices through which women traditionally displayed Muslimhood have been eclipsed by the more visible presence of the *hijabi*. Although head coverings such as *hijabi* have become important markers of personal faith and communal affirmation of piety, one mustn't overlook women's prior efforts to fashion their bodies as Muslim. Aside from complicating the picture of veiled female bodies as signifiers of the wider moral order, a focus on the diversity of women's sartorial traditions and trends helps trace continuities between past and present practices.

Whether in the colonial imagination, in feminist discourses of various origins, or in the writings of Islamic studies specialists, the veil has born a heavy semantic load as an icon of Muslim identity. To some, it evokes restriction, patriarchal domination, and "backwardness" (El Saadawi 1980; Mernissi 1987). For others eager to recuperate women's agency from its previous invisibility, it is an expression of female resistance and emancipation (El Guindi 1999; Zuhur 1992) or a form of "accommodating protest," whereby women veil as a strategy to protest restrictions of their movement (MacLeod 1991). Whether they vilify or glorify the practice of veiling, these perspectives are based on the assumption that Islam is the main determinant of women's status, operating rigidly to set both limits and opportunities in women's lives. By constructing Islam as a monolithic

entity existing independently of the socio-historical context within which it develops, these approaches constrain our understanding of how women selectively make use of Islamic tenets to reconcile occasionally competing societal and religious requirements. By focusing on the veil strictly in terms of identity politics, these views overlook women's lived experience and the ways that *hijabai* (veils) and other modest garments circulate as objects of consumption and desire, subject to the dynamics of a constantly evolving fashion market.

The salience of the veil in contemporary debates about Muslim women's rights, Ahmed (1992) notes, can be traced to colonial efforts to portray Muslim societies as backward, in need of civilizing reforms. In the British campaign to conquer the hearts and minds of Egyptian subjects, veiling was a key signifier of women's oppression and, by implication, of the backwardness of the religion promoting these oppressive customs. Much was done, therefore, to insure its elimination. Through its capacity to condense a history of struggles over the definition of Muslim womanhood, the veil acquired a broader significance over time, becoming, in the way it both constituted and challenged power, a prime example of dress as "political language" (Allman 2004:1). The problem with this legacy is that regardless of whether it is perceived as empowering or repressive, the veil has ultimately little to do with Muslim women's efforts to define their place in society. As an item of clothing, Ahmed (1992:166) contends, "the veil itself and whether it is worn are about as relevant to substantive matters of women's rights as the social prescription of one or another item of clothing is to Western women's struggles over substantive issues."

Without denying that the historical co-optation of feminism by colonial and patriarchal institutions has clouded debates surrounding the veil, I maintain that focusing on women's articulation of how these issues bear on their everyday realities is crucial to any analysis of Muslim womanhood. This analytical perspective is especially important in the present case given that, unlike Muslim women who cover their bodies to resist Western imperialism, the women I've worked with in the provincial town of Dogondoutchi focus instead on notions of piety, morality, and interiority when explaining why they veil. With the intensification of reformist appeals for a common Muslim identity in the early 1990s, these notions were granted a more universal significance and the *hijabi* itself became iconic of reformist identity. Nonetheless, these ideas remain informed by local social realities, acquiring slippery and contradictory valences in certain contexts, such as when the *hijabi* is used as an instrument of disguise by women wishing to appear virtuous.

Mindful of Lazreg's (1994:14) observation that, "while the veil plays an inordinate role in representations of women . . . , it is seldom studied in terms of the reality that lies behind it," I examine the diverse strategies through which Dogondoutchi women balance the conflicting demands of trendsetting fashions and Islamic norms, and how, in the process, they reformulate both the fashionable and the moral. By centering not on the general significance of head coverings but on the particular meanings they acquire for specific actors in specific circumstances, I address three interrelated issues: (1) women's lived experience of the *hijabi* and other head coverings in light of traditional notions of modesty and emerging conceptions of female bodies as repositories of a newly prescribed Islamic morality; (2) their contextual responses to the heightened moral concerns of Islam; (3) the role that foreign soap operas play in lending "cinematic authority" (Appadurai and Breckenridge 1995:35) to local fashions.

Embodying Virtue, Asserting Interiority

Since the early 1990s Izala women in Dogondoutchi have been wearing the *hijabi,* a tailored veil that often encompasses the body from head to ankles, theoretically allowing women to move in public spaces. The professed intent of the *hijabi* is to hide women from the public eye and protect their virtue. In Izala households, women and girls as young as four don unicolored veils signifying their pious intentions. Over the years, the *hijabi* has undergone alterations. Originally the bright shades of women's generic veils enhanced the wearers' visibility while ensuring their uniformity. Today the veils young women wear are often shorter and duller in color, but they have become substantially ornamented. Non-Izala girls (and occasionally a lone Christian girl) wear these statements of sartorial modesty in their effort to acquire respectability. Some are encouraged to do so by mothers who a decade ago virulently condemned their *hijabi*-clad neighbors for their sartorial excesses. Meanwhile, other styles of head covering have surfaced, informed and inflected by Izala modalities of piety, to create new solidarities and, inevitably, new distinctions as well.

Given the salience of the *hijabi* in religious discourses, one might forget that most adult women, before the emergence of Izala, already wore some type of head covering—referred to as *lullu'bi, mayafi,* or *zane.* A simple rectangle of cloth covering the upper body, the *mayafi* signified respectability. In the 1980s prepubescent girls could appear bare-headed in public, but grown women who did not wear a *mayafi* over the smaller headscarf (*diko*) would be identified as loose women, their lack of virtue matched by

their sartorial laxity. Ordinary yet practical, the *mayafi,* long a marker of Muslimhood, is used for myriad purposes, from tying an infant on one's back to providing insulation from the cold (Figure 5.1). It was eclipsed by the *hijabi* when Izala reformists transformed local female garb. In fashioning a compelling expression of moral womanhood, Izala followers invested the *hijabi* with religious significance—an issue I return to.

Mayafi-wearing women do not understand modesty as a strategic expression of religious identification. They were socialized into a world of Muslim values rooted in social practices experienced not as identity-fashioning so much as embodied praxis. For those who learned to cover their heads and stay home long before Izala preachers enjoined women to do so, wearing a head covering (and living in seclusion) contributes to an ethics of embodiment that bears only tenuous relations to emerging politics of religious identity. Yet, the veil they wear (silently) participates in the constitution of pious subjectivity. One can say that the *mayafai* women put on when stepping outside function not as a symbol of religious sensibility so much as a "social skin" (Turner 1980)—part of their intimate selves and of that which mediates their relationship to the world.

Clothes have materiality and texture, which we often forget as we narrowly set our sights on what the veil stands for. This analytical focus on the way that "cloth is turned into clothing" betrays how interest in the materiality of clothing has given way to a concern for "the sociality of clothing" (Norris 2005:83). The latter reduces clothing to "its ability to signify something that seems more real—society or social relations—as though these things exist above or prior to their own materiality" (Miller 2005:2). Concentrating on the materiality of clothing, I suggest, is central to developing an understanding of women's experience of veiling. It implies paying attention to how head coverings function as a protective cover, affecting bodiliness and altering women's sense of self and space. When asked why they wear a head covering, women in Dogondoutchi rarely elaborate beyond the usual "We veil to cover [*li'ke*] our bodies." *Li'ke* means "to cover" and "to close." By covering much (or all) of their upper bodies behind headcloth, women seal themselves off to the outside world, creating a pious interiority that is integral to their moral selfhood. More than hiding the body, the veil "protects, reassures, isolates" it (Fanon 1965:59). It plays an essential role in the constitution of agency, autonomy, and subjectivity.

In describing the physical trauma unveiled Algerian women experienced during the War of Independence, Fanon (1965:59) hinted at the protective physicality of head coverings:

ADELINE MASQUELIER

FIGURE 5.1. A woman wearing a *mayafi*, Dogondoutchi, 1994 (photograph by
A. Masquelier).

Without the veil she has an impression of her body being cut up into bits, put adrift; the limbs seem to lengthen infinitely. When the Algerian woman has to cross the street, for a long time she commits errors of judgment as to the exact distance to be negotiated. The unveiled body seems to escape, to dissolve. She has an impression of being improperly dressed, even of being naked. . . . The absence of veil distorts the Algerian woman's corporeal pattern. She quickly has to invent new dimensions for her body, new means of muscular control.

By reporting on how the unveiled women relearns her body, its outline, how it moves in space as well as its relation to surrounding space, Fanon showed how the veil, as a "technique of the body" (Mauss 1973), participated in the incorporation of Algerian womanhood, helping to define the contours of women's physical and moral selves. Pious femininity, here, hinged on a corporeal sense of self-defined interiority, that was experiential rather than verbalized, actualized through the layering of cloth around the body and the sense of agentive autonomy this layering produced. This interiority is part of the habitus (Bourdieu 1977), the generative principle through which social rules are inscribed in persons' bodies and dispositions without ever becoming the subject of explicit reflection. Izala preachers understood the extent to which the success of their mission to cover women's bodies depended on the formation of a habitus through which head coverings would be mimetically learned to become a "social skin" and the basis for naturalizing moral rules. Girls, they insisted, should start wearing *hijabai* early. "Little girls who wear *hijabai* are used to them and comfortable," Alhaji Omar explained. The notion of comfort alluded to is key, for as Fanon argued, it suggests that rather than being experienced as restrictive, the practice of covering her body enhances a woman's self-definition. Being "comfortable" with the *hijabi* entails a confident sense of mobile agency and a naturalization of the moral distinctions this garment outlines in the first place. To cite Mahmood (2005:157–158), this is an example of a "mutually constitutive relationship between body learning and body sense" whereby "your body literally comes to feel uncomfortable if you do *not* veil."

That many women's experience of moral interiority is largely embodied was clarified for me one evening as I walked with my friend Bebe through the marketplace. Thirty-five-year-old Bebe had married at fifteen and lived in partial seclusion ever since. Although she could visit kin and neighbors after nightfall, she was restricted to the marital compound during the day. Yet ever since our first encounter I had thought of her as a

ADELINE MASQUELIER

self-assured woman. That resilient confidence, I realized then, was rooted in the secure interiority afforded by seclusion.

Bebe had not been to the marketplace since marrying. Instead of experiencing a thrilling sense of newfound freedom, she seemed ill at ease, continually readjusting her head covering as if to tighten its protective grip around her shoulders. Later, she told me that walking in the marketplace in the presence of men had made her feel ashamed. She had felt the weight of men's stares on her body: "When I was young, I liked going to the marketplace. But now, I feel such *kumya* [shame]. It felt so heavy in there, I could barely walk." Rather than feeling liberated, Bebe was paralyzed; the awareness of her immodesty had produced a crippling feeling of inadequacy. Despite the anonymity afforded by darkness, she could not shake the degradation that had engulfed her in the marketplace.

Praxis, Moore (1994:78) notes, "is not simply about learning cultural rules by rote, it is about coming to an understanding of social distinctions through your body, and recognizing that your orientation in the world, your intellectual rationalizations, will always be based on that incorporated knowledge." In the marketplace, Bebe's incorporated knowledge of her secluded status resurfaced as an intense feeling of vulnerability upon being exposed to the world. She was so accustomed to the comforting presence of her courtyard's mud walls that her *mayafi* was of little use in open space. Similar to Algerian women's account of how they felt without their *haïk* (veil), Bebe's testimony reveals the trauma of being exposed to the glares of men. By walking through the marketplace instead of avoiding it as she previously did, my friend had not so much invaded that space as she herself had been invaded. The paralyzing fear she experienced was symptomatic of her overwhelming *kumya*. Bebe knew she was committing an impropriety, even if she pretended not to know at the time: this knowledge had translated into a somatic experience of shame.

Aside from clarifying how secluded women experience public places as a contraction, rather than an expansion, of subjective space, Bebe's ordeal reminds us that "to take on the *higab* is a very different thing from having always worn some sort of head covering, having always thought of yourself as religious and moral, or having never left the bounds of family control" (Abu-Lughod 1997:511). Although current controversies about Nigérien women's sexuality, space, and status may well be about nationwide struggles over the definition of moral community (Ong 1990), for women like Bebe pious self-determination did not take the form of an articulated statement. It was neither a kind of political action nor a declaration of difference. Rather, it took shape within the naturalizing grounds

of the physical self, a profoundly wordless yet meaningful experience. As both learned and naturalized, bodiliness, Durham (1999:392) notes, is "an important modality for inarticulate mutual recognition between people." Bebe's experience alerts us to the urgency of focusing our analyses of Islamic dress on forms of embodied praxis that have received scant attention since the emergence of the veil as a symbol of Islamic militancy.

Emerging Definitions of Modesty

Although the practice of veiling predates the advent of Islam, Izala members insisted early on that the order to veil came directly from the *Qur'ān:* men whose wives and daughters didn't wear *hijabai* demonstrated their unfamiliarity with the *Qur'ān.* The Prophet told his wives to cover their bodies, Izala preachers proclaimed, citing Sura 33:59. Thus, pious women should emulate these archetypical figures of Islamic virtue and wear a veil, especially when leaving their homes. Though the avowed purpose of *hijabi* was to shroud women in respectability, the bright yellow, green, or turquoise shades ensured that *hijabi* wearers would be noticed wherever they went. Yet if the veil is meant to hide female bodies from undesirable stares, it has not replaced seclusion. Rather than enabling women to move freely in public areas, the *hijabi,* by casting women as devout Muslims, reinforces the image of piety that their status as secluded wives already communicates to the world.[2] Thus, although *hijabi*-clad women are not barred access to the Friday mosque, they (like other women) pray in the privacy of their homes. Although Izala men and women recognize that the *hijabi* permits women to enter public space, more than one have pointed out to me that by staying home a woman demonstrates greater piety.[3] It follows that while *hijabi*-clad women are (technically) allowed to leave the house to visit a sick relative, vote, or seek medical treatment, it is preferable that they remain home when not fulfilling their social or civic duty or facing an emergency. In any case, it is imperative, I was often reminded, that they first seek permission from their husbands before stepping out of their homes.

The *hijabi* covers a woman's hair, ears, and neck and hides the contours of her body, making it difficult to assess her shape or size. Ideally it produces a generic body shape (Figure 5.2). It is sewn so that the opening for the head fits snugly around the wearer's face, making pins or knots unnecessary. As such, it differs from the clingy prayer shawls (*mayafai*) whose designs and ornamentation are subject to evolving trends, often featuring embroideries, sequins, or silky fringes—although in recent years the *hijabi* too has featured ornamentations. *Mayafai* are popular in Muslim circles

ADELINE MASQUELIER

FIGURE 5.2. A woman and her daughter wearing *hijabai*. Note the embroidery on the girl's *hijabi*. Dogondoutchi, 2009 (photograph by S. Hamidou).

where Izala fashion is unpopular: their slippery folds must be continually adjusted by their wearers, an "inconvenience" young women have learned to exploit when they want capitalize on the garments' seductive potential. Although these veils ostensibly hide the figure underneath, allowing for a semblance of propriety, they become a "provocative shape-revealing item of apparel" when maneuvered by expert hands (Rugh 1986:109). Often made of semi-transparent fabrics, they reveal as much as they conceal.

It was precisely to highlight the distinctiveness of Izala's sartorial emblem of female piety that reformist husbands and fathers were instructed on the characteristics that their wives' and daughters' *hijabai* should bear in the early 1990s when women and young girls were learning to inhabit the new sartorial norms established by reformist Muslim leaders.[4] Only the face and hands should emerge from the cloak draped around the woman's body. If a woman carries an infant on her back, the child's body should be covered by the *hijabi*—although infant girls tied on their mother's backs could technically be fitted with their own tiny *hijabai*. Izala women were originally attired in long-sleeved tunics and drawstring pants that ensured coverage without hindering mobility or preventing the performance of household chores. The preservation of modesty should not come at the expense of domestic productivity. Nor should the veil be restricted to members of prosperous households. If it was to serve as proof of women's pious dispositions, it had to be not only practical but also affordable. Alhaji Boubacar, a tailor and member of Izala, began making veils for his wives after returning from the hajj in 1990. After seeing Muslim women in Mecca, he copied their head coverings. Wearing the *hijabi*, he believed, was an expression of positive virtue: like other pious acts such as praying or giving alms, it increased a believer's chances of being justly rewarded on Judgment Day. Other Izala men followed suit. Soon every Izala woman in town wore outfits tailored by Alhaji Boubacar or his assistants.

Meanwhile followers of Malam Awal, a charismatic but controversial Muslim preacher who established a new Sufi order known as Awaliyya, wore white clothes. In the Sahel, where wind, dirt, and dust conspire to cover every surface with grime, wearing white clothes takes dedication and signals the depth of one's religious commitment—especially if one belongs to an impoverished household where soap and water allocations are minimal. To fashion a new identity for his female adepts, Awal devised the *hirami,* a white headcloth that knotted under the chin and was secured with a scarf tied around the head (Figure 5.3). Aside from creating a distinct look, wearing *hirami* supposedly increased one's chances of entering paradise.[5] Thus Dogondoutchi women could be identified at a glance depending on whether

FIGURE 5.3. A member of Awaliyya wearing the *hirami*, Dogondoutchi, 2007 (photograph by A. Masquelier).

they wore a *hijabi*, a *hirami*, or a *mayafi*. Note that *mayafai*-wearing women insisted that, although they were meant to cover a women's head, these head coverings were about fashion, not religion.

Faith and fashion need not be mutually exclusive, however. Indeed, the emergence of various forms of Islamic consumption suggests that the relationship between fashion, morality, and modernity is more complicated than is conventionally recognized. The proliferation of head coverings of both Izala and non-Izala inspiration are evidence of wider efforts to recast women's image in a society increasingly concerned with correct Islamic conduct yet reluctant to sacrifice women's desire be fashionable. Over the last decade, as the *hijabi* became redesigned to suit emerging fashion sensibilities, it lost its exclusive association with Izala militancy and began to signify piety in a more encompassing sense. Muslim leaders who once objected to Izala's fervent bid to cover women's bodies, arguing that the *hijabi* was un-Islamic, have stopped denouncing women adopting this type of head covering. They now share the reformists' vision of the veil as a divinely ordained means of promoting moral order in Muslim communities. With the partial unmooring of the *hijabi* from its radical associations, growing numbers of non-Izala women

have incorporated the item in their wardrobes. Significantly, during the month of Ramadan women who do not ordinarily wear *hijabai* adopt one as proof of their religious commitment. Tailors and clothing merchants report that sales of *hijabai* soar during that period of the Muslim calendar.

Given that the *hijabi* does not conceal a woman so much as it marks her as a moral person, the distinctive Izala dress was initially an effective way for Izala men looking for wives to narrow the field of eligible candidates at a glance. In recent years not only have *hijabai* been adopted by non-reformist young women, but Izala men's choice of wives has also reflected increasing flexibility. It is not unheard of for reformists to marry young women from non-Izala households. Thus Binta, whose parents originally disparaged Izala, was contemplating marrying a prosperous Izala merchant. The recently divorced twenty-two-year-old felt that wearing *hijabi* was a small price to pay for the material comforts she would enjoy in her new marital home. Moreover, several of her non-Izala friends owned *hijabai*. More than simply a strategy to optimize her life options—what Kandiyoti (1988) defined as "bargaining with patriarchy"—Binta's decision to wear the *hijabi* was also conditioned by the fact that her friends occasionally wore *hijabai* as well as the discussions she had with them about marriage, fashion, and respectability.

The Commodification of the Pious Look

When *hijabai* first appeared on female bodies, they fell below the knee and matched the rest of the monochromatic outfit—marking their wearers as pious, enlightened Muslims. A few years later they were shorter, and the drawstring pants (too masculine) were jettisoned altogether. The long-sleeved and plain tunics remained as a sign of devotion to Prophetic ideals. Eventually the tunic was abandoned in favor of more flattering garments. By 2004 most Izala women wore wrappers of multicolored, factory-printed fabric and matching blouses. On market day or at naming ceremonies, they wore expensive outfits made of shiny *bazin* (damask weave) or wax-print textile under their *hijabai*. In less than a decade, the strict and sober Izala dress gave way to the sartorial excesses that reformists had rejected as expressions of impiety. In the process, the role of the *hijabi* was reconfigured. Originally fashioned as a class-leveling device signaling loyalty to a radical concept of piety, the *hijabi* now conveys difference (Bourdieu 1984). *Hijabi* styles enable women to distinguish themselves as they negotiate the interface between fashion and morality. Some *hijabai* connote trendiness, others less so. Prices vary, depending on the fabric, the

cut, and the ornamentation—proof that the frugality initially so central to Izala identity has had to compete with other practices of identity-making indexed through conspicuous consumption. Increasingly young girls wear the *hijabi* not to blend with their devout counterparts but to demonstrate sartorial savoir-faire. For others, the *hijabi* is a convenient way to satisfy both aesthetic and religious requirements. Although it remains a central element of pious identities, the *hijabi* has also become a fashion statement.

Among young girls especially, *hijabai* now fall just below the shoulder. They are often mass-produced in Nigeria. Somber tones have replaced the bright colors of earlier days: dark green, blue, black, or brown, with an occasional light orange or white. Today *hijabai* are rarely color-coordinated with the rest of the wearer's outfit, though young women often take great pains to ensure that the various items match. They are often prettified with decorative touches. A popular *hijabi* ornamentation is a lace trim of contrasting shade sewn around the hem. In another pattern, the lace fringe adorns the face opening and the veil falls asymmetrically or is adorned with machine-made embroidery or rhinestones—or both (Plate 5; Figure 5.4). In 2004, a popular *hijabi* featured an upper section made of lacy material and a color-coordinated lower section of plainer fabric, both fringed with several inches of lace. Originally meant to conceal a woman's attractiveness, the *hijabi* is now part of the attraction.

Some girls told me they purchased a *hijabi* because it was fashionable. If their fathers objected to the idea a decade ago, they no longer do. As demonstrated by a group of unmarried girls who wore *hijabai* to go to market and later donned more revealing head coverings to attend a party, the *hijabi* is not necessarily worn all the time—or everywhere—but only when the occasion demands. One would not wear a *hijabi* to attend a wedding celebration, but the *hijabi* constitutes appropriate attire for running errands or attending a public event.[6] A young girl told me she wore the *hijabi* to look modern and gather approval. Aside from symbolizing piety, the *hijabi* provides a way to distance oneself from the "'ignorance' of tradition" as well as from the "'evils' of modernity" (LeBlanc 2000:445).[7] Thus it is popular among non-Izala girls, because instead of erasing a young woman's singularity, it helps her achieve a pious look suitable to the public space of the market, where a woman's presence is read as a sign that she has too much freedom for her own good.

Rather than encouraging uniformity in dress, as originally intended, the spreading popularity of *hijabai* has opened up new possibilities for fashion-conscious girls wanting respectability but not invisibility. Paradoxically, the *hijabi*'s popularity has contributed to the erasure of

FIGURE 5.4. A girl wearing a prettified *hijabi* made of light, patterned fabric. Note how the *hijabi* is knotted at the bottom for added effect. Dogondoutchi, 2009 (photograph by S. Hamidou).

Izala women. Now that anyone can wear a *hijabi,* the veil has ceased to be the defining element of female Izala identity. In other words, a woman's religious affiliation can no longer be determined by whether she wears a *hijabi.* Note that the redefinition of modest garments as fashionable is not an exclusively Nigérien phenomenon. In Egypt, Armbrust (1999:128) notes, the "ascetic, class-leveling, and radically pious" head covering of the reformist movement's early days has become tangled up in complex webs of commercialism. Today Egyptian women wear the *hijab* with bright accessories and blue jeans. In Yemen the late 1990s witnessed a prolific production of modest yet ornate dress intended for wealthy elites eager to differentiate themselves from the pious masses (Meneley 2007). In Turkey the adoption of *tesettür* (religiously appropriate dressing) by middle-class urban Muslim women has spawned a growing industry of Islamic dress sensitive to the demands of taste and fashion (Sandickci and Ger 2005). Women everywhere are experimenting with what it means to be modern and Muslim through the endless reconfiguration of Islamic chic.

Staging Piety:
The Dynamics of Concealment and Revelation

Although the presence of *hijabi*-clad young women in the streets of Dogondoutchi is as much a sign of fashion consciousness as an index of religious devotion, it would be a mistake to minimize the impact that moralizing discourses have had on local understandings of piety and propriety. At a time of heightened Muslim anxiety about the capacity of the clothed female body to signify purity, young women have become aware of the importance of appropriate body coverage in certain contexts. Consider Rabi, a nineteen-year-old for whom dressing up to attend a party meant wearing revealing outfits of Western inspiration such as bell bottom jeans and clingy tops. As I was sitting in her mother's compound admiring the goods a neighbor was hawking door to door, Rabi asked to see the girl's merchandise. After inspecting the purses, she turned her attention to the Nigerian-made *hijabai.* "I want a black one," she said before adding that most of her friends owned a *hijabi.* The peddler had no black *hijabai* left. Rabi told her to come back when she had a new assortment of merchandise for sale. "I want people to show me respect," she blurted when her mother expressed skepticism about her intentions.

Rabi's gesture exemplifies young women's need to create themselves as respectable Muslims as they start thinking about marriage. Recall that Muslim clerics who, a decade ago, criticized Izala women's headdress now

recognize that the *hijabi* should be part of women's attire. Rabi did not pray or fast, a situation her mother lamented: how would she find a husband? The young woman had no intention of giving up her body-clinging outfits, at least for the time being, yet she understood how to capitalize on the *hijabi*'s moral value to project an image of piety when circumstances required it.

The cloak of piety Rabi wished to purchase would not only cover her body but also conceal her impious self. Similarly, a friend told me about his student Samira, who wore a *hijabi* and a face veil to sell fried bean cakes early in the morning and then changed into Western-type clothes to attend school. She was ashamed and hoped to engage in her income-earning activity incognito. He had admonished her severely: the *hijab* was an expression of piety not to be used as part of a cover-up. During the 1979 revolution, Iranian women used the veil to disguise themselves and deflect attention from their actual intentions. Their tactics of concealment succeeded, Bauer (2005) argues, because they operated in a context of expectations about the performance of purity. By appearing to follow rules of propriety, women deceived those who associated modest dress with pure intentions. In Dogondoutchi young women like Rabi and Samira have similarly learned that purity lies in the eye of the beholder, that it is not about following rules but about strategically projecting a virtuous public image. By wearing *hijabai,* they deploy an image of modesty that matches local expectations of what proper women look like while hiding their impiety behind a virtuous facade.

Mass-produced *hijabai* are available through young girls who peddle goods from women's purses to hair extensions, illustrating how piety can be commercialized to appeal to youthful sensibilities. In her pursuit of the latest, a young woman may decide that instead of fancy shoes she needs a lace-trimmed *hijabi,* an unthinkable gesture a decade earlier, when *hijabai* were an undisputable expression of Muslim reformists' frugal piety. Significantly, well-to-do women allegedly distribute prettified *hijabai* as gifts to friends during Ramadan. They have been told that for every prayer their friends accomplish, they will receive their own share of divine rewards. The Nigerian origins of these *hijabai* enhance their appeal. Because they bear the stamp of the foreign while also meeting current modesty requirements, *hijabai* made in Nigeria are popular among young, unmarried women who, like Rabi, are mindful of the need to appear pious but unwilling to sacrifice elegance for the sake of virtue.

That the *hijabi* can be used as a means of disguising the self has prompted some to question the motives of Izala reformists. I was often

told that the *hijabi* was no guarantee of the purity of a woman's character. In 2000 the three wives of an Izala man were suspected of leaving their compound to engage in activities no "reputable" women engaged in. The *hijabi*, a friend argued, was for hypocrites who had something to hide. Another friend recounted the misadventures of a secluded Izala wife who sold cooked food at the market while her husband was away. The young woman hoped to avoid detection, but acquaintances reported seeing her in public—her purple *hijabi* stood out. She was severely punished. The cloak of respectability provided by the *hijabi*, my friend implied, was no protection against the power of gossip. The story further suggests it is problematic to assume that women who "veil" are afforded additional autonomy simply because the layers of cloth they wrap themselves in shroud them in respectability. Although the *hijabi* technically enables its wearer to enter otherwise prohibited spaces in this highly gender-segregated society, Izala husbands are often reluctant to expand their wives' freedom outside the home. Thus Izala wives remain mostly in the marital compound while their husbands spend a great deal of time away.

That Izala wives occasionally get caught when they circumvent the rules of proper conduct suggests that the *hijabi* does not invariably function as a form of "portable seclusion" (Papanek 1973:295) enabling women to move in and out of enclosed spaces, as has been assumed. Although public places such as the mosque are theoretically accessible to *hijabi*-clad women in Dogondoutchi, most remain off-limits, at least to married women of child-bearing age. On the other hand, that the *hijabi* is worn by non-Izala girls aiming for a modest look indicates that veiling does give some women space in which to maneuver without breaching the boundaries of proper behavior. Regardless of a woman's degree of piety, the veil she wears marks her as inherently virtuous—and therefore desirable to potential husbands. Indeed, it is precisely because it signifies that a woman is unavailable that the *hijabi* heightens her appeal. By designating her as chaste and virtuous, it neutralizes her sexuality while enhancing her moral qualities—something Rabi evidently understood.

The notion that women use the anonymity afforded by the *hijabi* to conceal disreputable activities has generated lively debates about the relations between fashion and morality.[8] In August 2003 reports that a veiled she-devil was haunting the eastern town of Zinder looking for seductive encounters provoked a moral panic. In this case the veil enabled a dangerous "pagan" creature to look like a pious Muslim woman by hiding not only her bodily charms but also her harmful intentions (Masquelier 2008). Accounts of the veiled spirit propositioning men echo reports of

gabdi (high-class prostitutes) using the *hijabi* to create the respectability Izala businessmen look for in potential wives (Alidou 2005). While the *hijabi* highlights a woman's moral character by downplaying her sexual attributes, it can just as easily become a screen cloaking a woman's impious nature. The debate on female morality and modesty set in motion by rumors of a veiled she-devil underscores wider concerns about the place of women in Muslim society. Yet, despite a growing consensus that Muslims should wear modest attire, women do not all cover their heads in the same manner. Nor do they agree on what modesty means. How the *hijabi* figures in Muslim women's understanding of female virtue varies. The diverse uses of the *hijabi* compel us to turn our attention away from reified models of veiling and attend to the ways that women variously negotiate their moral identities through the adoption of modest clothing.

Mass-Mediated Models of Islamic Fashion

Whether Dogondoutchi women cover their heads as an expression of naturalized pious dispositions, to align themselves with emerging norms of sartorial propriety, or to express commitment to a particular vision of Islam, the intended meanings of Islamic dress are reconfigured in the process. Neither pure expressions of local sartorial sensibilities nor straightforward imitations of Middle Eastern fashions (after which local styles are supposedly modeled), the varied, changing, and often contested forms that modest dress has taken in Dogondoutchi in recent years point to the lack of consensus over the definition of "Islamic attire." They also highlight the difficulty of predicting what will become fashionable, for whom, and in what context. At the dawn of the millennium some girls had taken to wearing Nike caps under their *hijabai,* and others accessorized their head coverings with winter caps or headbands bearing the names of Colorado ski resorts or the inscription "2000." Although they allowed only a sliver of the headband to be visible under the *hijabi* cloth, they made sure that the foreign logo could be seen. These logo-centric fashion trends exemplify how local lives are "shaped by any number of imaginative links to 'elsewheres' near and far" (Weiss 2002:101).

If these accessories of Western provenance are meant to enhance the cosmopolitan nature of the wearers' outfits—ski caps are considered sufficiently fashionable to be worn at naming ceremonies—they also highlight their modest appearance by containing hair and scalp in a tight restraint. "I started wearing a *hijabi*," eighteen-year-old Aminatou told me, "so my father would let me go out. Before, my father did not let me go anywhere."

ADELINE MASQUELIER

By sporting a black Nike headband under her *hijabi,* the young woman made her body impermeable to intrusive gazes—the headband fit snugly around her forehead, keeping both hair and ears out of sight. Paradoxically, the famous logo, a symbol of the foreign and the fashionable, was eye-catching, ensuring that Aminatou be perceived as a sophisticated dresser. Friends and neighbors likely knew neither the provenance of the logo nor the name of the company it publicized, but they recognized it as foreign.

Not all forms of cosmopolitan identity have their source in the West, however. Increasingly Nigériens have begun to "imagine the 'possible lives'" (Weiss 2002:102) that exist elsewhere. For young girls seeking a modest look that also spells worldliness, South American television serials and Bollywood films have become valuable sources of inspiration. That the characters portrayed in these productions are not Muslims makes little difference. As Larkin (1997:406) notes in the Nigerian context, "Indian films have entered into the dialogic construction of Hausa popular culture by offering Hausa men and women an alternative world, similar to their own, from which they may imagine other forms of fashion, beauty, love, and romance, coloniality and postcoloniality." In Dogondoutchi, fashion-conscious *budurwoyi* (unmarried girls) draw their eyebrows with black pencil in imitation of the pretty heroines of Hindi films currently flooding the local DVD market. Under their *hijabai,* a few don the single wrap dress known as sari—a fashion some preachers encourage on the basis that women in Mecca allegedly wear these. Some women apply a spot of red nail polish between their eyebrows to achieve the so-called Hindu look. They have learned to imitate to perfection the graceful arm motions of dancing Indian heroines, and although they speak no Hindi, they routinely intone the melodies and mimic the sounds of Hindi songs featured in popular Indian films.

Through their indigenization of Hindi fashions and aesthetics, young Dogondoutchi women routinely demonstrate the extent to which the models of consumption provided by Indian cinema have become central to Nigérien public culture. "Modern fashion," Hollander (1993:304–305) notes in the context of Euro-American sartorial practices:

> is confirmed and enhanced by the glamour of screen and television stars, under the guise of being ordinary clothes. For modern clothing, certain commonly accepted coiffures, ways of opening the collar, choices and combinations of common garments, when worn by the superstars confirm the acutely contemporary "rightness" of the particular mode and the sense of glamour. The audience achieves a sense of glamour by association, even in wearing the very common mode.

Just as the baggy pants, oversized T-shirts, ankle-high athletic shoes, and baseball caps of rap performers are now part of the outfit de rigueur for young Nigérien men wishing to appear fashionable, so the Hindi look, inspired by Indian cinema, has become popular among their female counterparts. In this regard, I suspect that sheer scarves imported from South Asia and adorned with subtle blue, yellow, or green impressions were the rage in the mid-1990s—when Indian cinema became available for local consumption—partly because they resembled the flowing head veils sometimes worn by female characters in Indian films.

South American telenovelas, widely described by conservative Muslim leaders as a threat to the moral order because of their explicit depictions of romantic love and sexuality, provide another precious source of inspiration for fashion-conscious young women. Many of the style tips—skin-tight pants, curve-enhancing tops, and straightened hair—that can be gleaned from these television programs are worn by secular, French-schooled Muslims for whom clothing is a means of signaling their cosmopolitanism rather than a mark of religious identity. In fact, clothing designs occasionally derive their names from television, especially Latin American telenovelas (see Grabski 2010).[9] Contradicting Izala preachers' claims, even *hijabi*-clad young women occasionally find confirmation in their favorite television series that their (or someone else's) looks can be modest and glamorous at the same time. In a conversation with Fatima on how women should demonstrate piety in their personal appearance, the young woman instructed me on how to wear the *hijabi*. It is important that both hair and ears are hidden, she pointed out. As she was tying my headscarf—a simple square of cloth—around my head to demonstrate precisely how it was done, her younger sister pointed out excitedly that my newly configured head covering looked just like the headscarf worn by Laura—a protagonist of *La Rue des Mariés*, a Brazilian soap opera airing in Niger in 2004. "It is very pretty," she had exclaimed, referring to my headscarf, "as pretty as Laura's." What intrigued me, aside from the young girl's assumption that "Laura" was so famous as to need no introduction, was how Brazilian urban fashions could serve as a model of Islamic propriety for West African girls (as well as Western visitors seeking a modest look).

That a foreign television star wore a headscarf not only enhanced the glamour of the item but also confirmed its contemporary "rightness" in the eyes of a young Muslim woman looking for validation. Now that it was associated with the sophisticated fashions of *La Rue des Mariés*, the headscarf her sister had tied around my head was no longer an ordinary item. It had acquired an aura, which, rather than clashing with Muslim rules of pious

deportment, affirmed their appropriateness. Besides confirming Nigérien youth's participation in a global order of cultural practices, the recent infatuation with certain Hindi or South American styles demonstrates how local emblems of sartorial modesty are caught up in various "webs of signification, some contradictory, some complimentary—providing both ambiguity and flexibility" (Durham 1999:395). It also shows that the Middle East is but one of many places of sartorial inspiration, "one node of a complex transnational construction of imaginary landscapes" (Appadurai 1996:30). Whereas Meccan fashions authorize the creation of various sartorial expressions of purity and piety, the local images of modesty these fashions inspire occasionally resonate with, but just as often are contradicted or even undermined by, other images from other places that young Muslim women and girls selectively appropriate in their efforts to claim membership in a worldwide community of seemingly empowered consumers.

The *hijabi* that was originally emblematic of the austere and uncompromising values of Izala—as well as a concrete expression of divisiveness—is now part of a wider moral aesthetics through which young girls, even when they are constrained by fatherly expectations, can engage in more masterful and fashion-conscious acts of self-definition. Not unlike the Egyptian veil that is now worn with fashionable clothes, the *hijabi* has migrated across different bodies, markets, and moral arenas as local expressions of "Islamic" style shifted, pushed along by the transnational tides of fashion and religiosity. Along the way it has acquired diverse meanings, has been caught up in different frames of moral references, and has been used to formulate new modes of religiosity. Recently a handful of Dogondoutchi women have thus been seen wearing a *niqāb* (face veil) in addition to the *hijabi* (Figure 5.5).

Partly because the *hijabi,* in addition to undergoing stylistic changes, has moved along the local spectrum of "being in fashion" and expanded the range of religious affiliations it represents in Dogondoutchi, it is problematic to describe it exclusively as an undifferentiated sign of piety, an expression of subordination, a vehicle of emancipation, or, conversely, a symbol of resistance. To do so would imply a consensual intentionality among *hijabi* wearers that is lacking in the current context. If anything, the flexible signifying capacity of the *hijabi* (and other head coverings) sheds light on the slipperiness of religious identities and the "shifting positionality of persons caught in the web of group-affiliations" (Durham 1999:390–391). Put differently, the meaning of the veil is not "exhausted by its significance as a sign" (Mahmood 2005:56). Occasionally, what the veil does, how it feels, and how it speaks to wearers and observers emerges

in the context of particular practices—such as watching Brazilian telenovelas—that are neither religious nor approved by the Muslim leadership.

That young women seeking to fashion Muslim identities look to Brazil or India for inspiration complicates conventional equations of globalization with cultural homogenization. It suggests that the West is hardly the only source of cultural capital for those seeking access to things modern. At the same time women's tendency to wear *hijabai* suggests a concern for appearing to order life according to Islamic standards of piety and propriety. In contrast to Egyptian members of the mosque movement who produce elaborate exegeses of the meaning of the veil (Mahmood 2005), women in Dogondoutchi rarely feel the need to explain why they veil beyond the customary "I veil because God demands it."

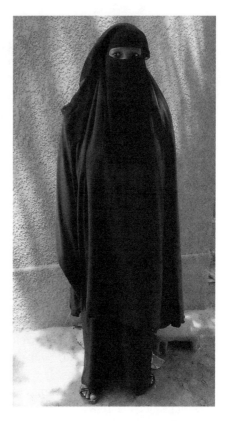

FIGURE 5.5. A young woman wearing a *hijabi complet* made of a *hijabi* and a face veil (*niqāb*), Dogondoutchi, 2010 (photograph by S. Hamidou).

Some invoke *kumya,* others mention the benefits of receiving respect, but most simply say that it is a means of "covering the body." Women's lack of satisfying explanations for veiling suggests how head coverings, regardless of the religious identities they emblematize, participate in the constitution of virtuous subjectivities. Because the meaning of veils, for women like Bebe, encompasses a mode of being-in-the-world acquired mimetically, the modesty created and cultivated through veiling obeys a logic that is vested more in embodied experience than in conceptual categories. Following Butler, we might say that the divinely ordained injunction to veil is not simply a social imposition on Muslim women like Bebe but "constitute[s] the very substance of [their] intimate, valorized interiority" (Mahmood 2005:23).

Although the debates surrounding veiling in Dogondoutchi are mostly controlled by men and driven by husbandly desires, we cannot assume that women there have relinquished all control over matters of modesty. By this I mean that although it is generally (though by no means always) men who decide that their wives and daughters should wear *hijabi,* women and young girls enjoy some control over the color and style of their head coverings. Indeed, women find multiple ways to contribute to the definition of proper Muslim attire. The selective appropriation of foreignness that televised drama authorizes among youthful audiences is but one instance of how women caught in polemics about religious authenticity redefine their identities as moral persons. Even when not particularly loquacious about the subject of veiling, women nevertheless participate in struggles over the terms though which virtuous modesty is inscribed onto their bodies, struggles that are simultaneously aesthetic, moral, and political. While Malam Awal, the Awaliyya's founder, is now *persona non grata* in Dogondoutchi, having lost credibility for not living up to the moral standards he advocated, a few dozen women—many of them senior widows—steadfastly carry the Awaliyya torch. Wherever they go, they don a white headcloth secured by a small bandana tied around the forehead. Even if Awal's booming voice no longer resonates throughout town to urge residents to follow God's command, the *hirami* his adepts continue to wear alerts us to the need for a "politics of presence" (Moors 2006:120) that allows women's nonverbal forms of engagement in the public sphere to be acknowledged.

NOTES

The current essay has been adapted from a chapter of my book *Women and Islamic Revival in a West African Town* with permission from Indiana University Press.

1. The Jamā'at Izālat al-Bid'a wa Iqāmat al-Sunna (Society for the Removal of Innovation and the Restoration of Tradition) advocates a return to a supposedly pure Islam and promotes conservative moral standards. It rejects Sufi practices as innovations and is critical of Niger's secular government. Note that in Nigeria, where the movement originated, Izala is not pressing for Shari'a law. It has been overtaken in this regard by more radical Islamic movements such as Boko Haram (Anonymous 2012).

2. "Seclusion is better than marriage in which a woman can leave her home," an Izala wife explained, because the secluded wife accumulates divine rewards.

3. In contrast, Renne (2012) notes that in Zaria, northern Nigeria, the veil carries a strong enough implication of piety that it frees women from the need to be secluded.

4. In Dogondoutchi young unmarried girls and women may choose to wear the *hijabi* to project an image of piety, but Izala wives (and daughters) put on a *hijabi* at their husbands' (or fathers') insistence. It is not uncommon for preachers to address men when discussing the subject of the *hijabi* in their sermons. The assumption is that husbands ultimately decide whether their wives should wear *hijabi* in public places.

5. In northern Nigeria (and increasingly in Niger's capital), *hirami* refers to the cloth a new generation of Muslim preachers and their followers wrap around their caps. The practice has not reached Dogondoutchi yet. The use of the term to describe a woman's head covering (in which a cloth is wrapped around the head) may be explained by the fact that Malam Awal, who designed the head covering in the late 1990s, grew up and was educated in Nigeria (see Masquelier 2009).

6. In Niger's capital city women attending Arabic or Qur'ānic classes wear the *hijabi* (Alidou 2005). See also Renne (2012). In Dogondoutchi young girls cannot attend some Qur'ānic schools unless they wear an appropriate head covering.

7. The practicality of the *hijabi* has made adepts. A young woman told me it was for convenience's sake that she wore a *hijabi* while praying.

8. Some young women are suspected of wearing *hijabi* to hide their pregnancies. Others, who have earned a reputation for being "easy" girls, are called *malam ta bar banza*, implying that contrary to appearances, they are "damaged goods." The *hijabi* they wear is only a front: they welcome men's advances.

9. Conversely *The Clone*, a Brazilian telenovela starring a Muslim woman of Moroccan origin, launched a fashion trend, with Brazilian women enthusiastically adopting Moroccan and "oriental" clothing and jewelry.

WORKS CITED

Abu-Lughod, Lila. 1997. Movie stars and Islamic moralism in Egypt. In *The Gender/Sexuality Reader: Culture, History, Political Economy,* ed. R. Lancaster and M. di Leonardo, 502–512. New York: Routledge.

Ahmed, Leila. 1992. *Women and Gender in Islam: Historical Roots of a Modern Debate.* New Haven: Yale University Press.

Alidou, Ousseina. 2005. *Engaging Modernity: Muslim Women and the Politics of Agency in Postcolonial Niger.* Madison: University of Wisconsin Press.

Allman, Jean. 2004. Fashioning Africa: Power and the politics of dress. In *Fashioning Africa: Power and the Politics of Dress,* ed. J. Allman, 1–10. Bloomington: Indiana University Press.

Anonymous. 2012. The popular discourses of Salafi radicalism and Salafi counter-radicalism in Nigeria: A case study of Boko Haram. *Journal of Religion in Africa* 42 (2): 118–144.

Appadurai, Arjun. 1996. *Modernity at Large: Cultural Dimensions of Globalization.* Minneapolis: University of Minnesota Press.

Appadurai, Arjun, and Carol A. Breckenridge. 1995. Public Modernity in India. In *Consuming Modernity: Public Culture in a South Asian World,* ed. C. Breckenridge, 1–22. Minneapolis: University of Minnesota Press.

Armbrust, Walter. 1999. Bourgeois leisure and Egyptian media fantasies. In *New Media in the Muslim World: The Emerging Public Sphere,* ed. D. Eickelman and J. Anderson, 106–132. Bloomington: Indiana University Press.

Bauer, Janet. 2005. Corrupted alterities: Body politics in the time of the Iranian diaspora. In *Transgressive Surfaces: Dirt, Undress, and Difference in Comparative Perspective,* ed. A. Masquelier, 122–148. Bloomington: Indiana University Press.

Bourdieu, Pierre. 1977. *Outline of a Theory of Practice.* Trans. Richard Nice. Cambridge: Cambridge University Press.

———. 1984. *Distinction: A Social Critique of the Judgement of Taste,* trans. Richard Nice. London: Routledge.

Durham, Deborah. 1999. The predicament of dress: Polyvalency and the ironies of cultural identity *American Ethnologist* 26 (2): 389–412.

Eickelman, Dale, and James Piscatori. 1996. *Muslim Politics.* Princeton: Princeton University Press.

El Guindi, Fadwa. 1999. Veiling resistance. *Fashion Theory* 3 (1): 51–80.

El Saadawi, Nawa. 1980. *The Hidden Face of Eve: Women in the Arab World.* Boston: Beacon Press.

Fanon, Frantz. 1965. *A Dying Colonialism.* New York: Grove.

Grabski, Joanna. 2010. The visual city: Tailors, creativity, and urban life in Dakar, Senegal. In *Contemporary African Fashion,* ed. S. Gott and K. Loughran, 29–37. Bloomington: Indiana University Press.

Hollander, Anne. 1993. *Seeing through Clothes.* Berkeley: University of California Press.

Kandiyoti, Deniz. 1988. Bargaining with patriarchy. *Gender and Society* 2 (3): 274–290.

Larkin, Brian. 1997. Indian films and Nigerian lovers: Media and the creation of parallel modernities. *Africa* 67 (3): 406–439.

Lazreg, Marnia. 1994. *The Eloquence of Silence: Algerian Women in Question.* New York: Routledge.

LeBlanc, Marie Nathalie. 2000. Fashion and the politics of identity: Versioning womanhood and Muslimhood in the face of tradition and modernity. *Africa* 70 (3): 442–481.

MacLeod, Arlene E. 1991. *Accommodating Protest: Working Women, the New Veiling, and Change in Cairo.* New York: Columbia University Press.

Mahmood, Saba. 2005. *Politics of Piety: The Islamic Revival and the Feminist Subject.* Princeton: Princeton University Press.

Masquelier, Adeline. 2008. When female spirits start veiling: The case of Aldjana Mai Hidjab in a Muslim town of Niger. *Africa Today* 54 (3): 39–64.

———. 2009. *Women and Islamic Revival in a West African Town.* Bloomington: Indiana University Press.

Mauss, Marcel. 1973. Techniques of the body, trans. B. Brewster. *Economy and Society* 2 (1): 70–88.

Meneley, Anne. 2007. Fashions and fundamentalisms in fin-de-siècle Yemen: Chador Barbie and Islamic socks. *Cultural Anthropology* 22 (2): 214–243.

Mernissi, Fatima. 1987. *Beyond the Veil: Male-Female Dynamics in Modern Muslim Society.* Bloomington: Indiana University Press.

Miller, Daniel. 2005. Introduction to *Clothing as Material Culture,* ed. S. Küchler and D. Miller, 1–20. New York: Berg.

Moore, Henrietta L. 1994. *A Passion for Difference.* Bloomington: Indiana University Press.

Moors, Annelies. 2006. Representing family law debates in Palestine: Gender and the politics of presence. In *Religion, Media, and the Public Sphere,* ed. B. Meyer and A. Moors, 115–131. Bloomington: Indiana University Press.

Norris, Lucy. 2005. Cloth that lies: The secrets of recycling in India. In *Clothing as Material Culture,* ed. S. Küchler and D. Miller, 83–105. New York: Berg.

Ong, Aihwa. 1990. State versus Islam: Malay families, women's bodies, and the body politics in Malaysia. *American Ethnologist* 17 (2): 258–276.

Papanek, Hanna. 1973. Purdah: Separate worlds and symbolic shelter. *Comparative Studies in Society and History* 15: 289–325.

Renne, Elisha. 2012. Educating Muslim women and the Izala movement in Zaria City, Nigeria. *Islamic Africa* 3 (1): 55–86.

Rugh, Andrea B. 1986. *Reveal and Conceal: Dress in Contemporary Egypt.* Syracuse, N.Y.: Syracuse University Press.

Sandickci, Özlem, and Güliz Ger. 2005. Aesthetics, ethics, and politics of the Turkish headscarf. In *Clothing as Material Culture,* ed. S. Kuechler and D. Miller, 61–82. London: Berg.

Turner, Terence. 1980. The social skin. In *Not Work Alone: A Cross-Cultural View of Activities Superfluous to Survival,* ed. J. Cherfas and R. Lewin, 112–140. London: Temple Smith.

Weiss, Brad. 2002. Thug realism: Inhabiting fantasy in urban Tanzania. *Cultural Anthropology* 17 (1): 93–124.

Zuhur, Sherifa. 1992. *Revealing Reveiling: Islamist Gender Ideology in Contemporary Egypt.* Albany: State University of New York Press.

"Should a Good Muslim Cover Her Face?" Pilgrimage, Veiling, and Fundamentalisms in Cameroon

JOSÉ C. M. VAN SANTEN

THE ISSUE OF veiling in sub-Saharan Africa has received little attention. Perhaps that is because most women as well as men, Christians as well as Muslims, have used various types of head coverings as indicative of social distinctions as well as protection against the sun. However, in recent decades in Cameroon and elsewhere in Africa, veiling as a form of religious expression has emerged in juxtaposition with modernity, politics, and laïcité (Van Santen 2010b). Veiling is now associated with particular ideas, events, and actions that link important aspects of social life and can alter during the course of a woman's life (Van Santen 2010a). In this chapter, I explore one such change in women's veiling practices, namely the pilgrimage to Mecca, the حج (hajj), one of the five pillars of Islam. What influence does going on hajj have on women's veiling practices in Cameroon?

Globalization and increased cash flow have meant that more Muslim women are able to go on the hajj. On their return, these women are allowed to carry the prestigious title of alhadzja. Although Saudi Arabia does not allow Cameroonian women to make a pilgrimage to Mecca on their own (meaning without a husband), organizers of the hajj have found ways to bypass this rule. Thus women from various ethnic backgrounds and social classes arrive in Mecca and are confronted with new notions of what a "good" Muslim should look like. Some female pilgrims return home with a black face-covering veil (niqāb), intending to begin wearing it on their return. Others consider their usual way of veiling sufficient. In the past non-Muslim women wore a simple headtie, and Muslim women would add an extra piece of cloth in the same color as their gowns. However, after women go on hajj, the choice of veiling can become a significant issue and a topic for discussion.

According to Eickelman and Piscatori (1990:20), external religious truths are perceived, understood, and transmitted by persons historically situated in "imagined" communities, who knowingly or inadvertently contribute to the reconfiguration or reinterpretation of these verities. The key symbol under discussion in this volume, wearing the veil, is one example of such a transmission. While veiling existed among people of countless cultures and religions long before Islam, the veil was never just a fabric but was always also a concept (Heath 2008:1–3). Now, however, in Europe, the practice of veiling is often seen as emblematic of the Islamic world, symbolizing the oppression of Muslim women, segregation, and the backwardness of Muslim societies in general. As an icon of perceived intolerable differences between Muslims and non-Muslims, the veil often becomes a focus for addressing broad issues of ethnicity and integration (Scott 2007:5). However, as Valenta (2006) compellingly argues, discourses about the Muslim veil are hardly ever about the veil itself, because at the heart of the debate is the West's own current crisis of identity and historical destiny. And this debate not only takes place in the West; it also takes place in Africa.

In Cameroon, the prohibition on wearing headscarves at public, state-subsidized schools is an inheritance from its former colonizer, France. During my first stay in the region—I began fieldwork there in 1986—this matter did not form part of the political discourse, as it did in France (Scott 2007). Over the past twenty years, however, fundamentalist Islamic influences from the Middle East have affected the region in various ways: through itinerant preachers, new media, and new Islamic schools subsidized by Saudi non-governmental organizations (NGOs). The issue of "the veil" is cited as a reason for the establishment of private Islamic primary and secondary schools: there, girls need not take off their headscarves. Such changes may jeopardize the authority of local religious leaders (Van Santen 2012).

While Islam itself can be considered a globalizing force *avant la lettre*, globalization has led to new possibilities for travel, resulting in an increase in the number of pilgrims, who then contribute to the reconfiguration of veiling in their own local societies. As discourses and practices must be considered in their historical formation, I will begin by briefly introducing the Islamic communities in Cameroon, in which the Fulbe people (also known as Fulani or Peul) have been politically most influential, to thereafter discuss women's participation in the hajj. Understanding the contemporary reception of different types of veiling in Cameroon requires an analysis that takes account of the political, social, and religious meanings of this garment. As Eickelman and Piscatori (1990:15) point out in

their examination of pilgrimage, such analysis involves dealing simultaneously with different aspects of meaning and the linkages between them, as these levels are not necessarily arranged in a nesting order. To investigate these levels, I present the experiences of two women I have known for over twenty-five years who have recently been on hajj.

Jihad and Colonialism: The Historical Context of Islam

Northern Cameroon has been part of the Islamic world since the West African jihads at the beginning of the nineteenth century. The Fulbe, originally nomadic people from throughout West Africa, had become more strictly Islamized[1] as a consequence of the eighteenth-century jihad associated with the founder of the vast Sokoto Caliphate, 'Uthman dan Fodio (a Pullo, singular of *Fulbe*). He believed that it was his duty to spread Islam, and he simultaneously expanded his empire in what is now northern Nigeria (Van Santen 1993).

When the Fulbe invaded the northern regions of present Cameroon (in the first decades of the nineteenth century), they subjugated acephalous ethnic groups and instigated wars with the existing hierarchically organized kingdoms (Schilder 1994; Van Santen 1993). The Sultan of Sokoto, leader of the Sokoto Caliphate, gave them the right (*tutawal*) to install Fulbe chiefs (*laamibe*) in the defeated areas after a victory. Competence in matters concerning the *Qur'ān* was the main qualification for becoming a chief (Iyébi-Mandjek and Tourneux 1994), with an imam playing his role in these matters or even appointing a chief. After the installation of the *laamibe*, Shari'a law was applied, even to non-Muslims, in many areas of daily life.

German colonizers, the first Europeans to settle in the southern parts of Cameroon, occupied all of these Fulbe-ruled provinces when they marched northwards in 1900–1901 to conquer the area. Following the German defeat in World War I, the French took over as colonial rulers, using the hierarchically organized provinces of northern Cameroon to reign over local populations (Burnham 1996; Van Santen 1993).[2] Thus for the majority of the population, authority resided in a single person, the chief, who exercised all aspects of power—judicial, legislative, executive, administrative, and also religious. Many members of other ethnic groups Islamized. Only in the 1950s did conversion to Christianity become an option, when missionaries settled in the area and converted local non-Islamic populations (Van Santen 1993:28). After independence in 1960, local rulers were able to hold on to their power, and current relations between religious and political leaders in North Cameroon are still close.

As in many other parts of Africa, the line between indigenous custom and Islam is often ambiguous (Rosander 1997). For a long period, Islamized people from other ethnic backgrounds considered the Fulbe way of life tantamount to being a good Muslim. Fulfulde, their language, also became the lingua franca of North Cameroon.[3] As had been the case among the carriers of Islam for the Fulbe, being a Muslim and deepening one's knowledge of the faith, particularly becoming literate by studying the *Qur'ān,* was and continues to be very much a part of identity construction. In North Cameroon until the 1980s, education meant Qur'ānic education, as secular education was associated with the colonial invaders.[4]

Islamic revivalist movements have always been part of the West African Islamic world (Choueiri 1990:20–21; Loimeier 1997; Van Santen 1993:69–101)—the jihad of 'Uthman dan Fodio serves as an example. However, from the 1990s onwards, Islam in North Cameroon has been influenced by new movements calling for a purification of Islam. Itinerant Islamic "white" preachers, *Nasaara,*[5]—also referred to as "Pakistani" regardless of whether they really come from Pakistan—travel around the country, a phenomenon indicated by the Arabic term *daa'wa.* In addition Islamic primary as well as secondary private schools have been established, funded with money from Saudi Arabian NGOs, not only in larger cities such as Maroua and Garoua, but also in small villages.[6] Localized use of media, such as cassette and video tapes and CDs, has had a further influence on communities. Recordings enable Islamic community members to give voice to a variety of interpretations of Islam (Schulz 2007). This situation is also related to the increasing numbers of educated Muslim youth who have received scholarships to study in core areas of the Muslim world, and to access to internet (see also LeBlanc 2000). Another influence is the new phenomenon of some women dressing differently than before—in black *hijab* and colored body-covering garments brought back from Mecca to Cameroon by hajj pilgrims. This phenomenon and its reception is discussed in the following sections of this chapter.

"They Never Took Our Culture into Account": Veiling, Fundamentalism, and Gender

While the veil was once a symbol of value in many religions and cultures (Heath 2008), in recent decades in Western Europe there has often been an automatic "pairing" of Islam with fundamentalism and the debate on veiling. The veiled woman has been taken as a symbol of a religiously

inspired group identity. Studies in the last decades, particularly from a feminist perspective, have revealed the often diverse reasons for the renewed emphasis on veiling in Islamic communities.[7] In many contexts, new positions for women in public life, in the labor market, and in the education system are important factors which explain the sudden popularity of the veil. Yet these socioeconomic changes contribute to ambiguities concerning female identity, both for women themselves and among those in their environment who have to deal with this new situation in public life (Mahdi, this volume; McLeod 1991). Young educated women may use the veil to establish a positive identity as they leave traditional domains within the family. However, recent research among the women themselves discloses a myriad of other reasons beside social ones.[8] These may be religious reasons, political reasons, or a combination of all three, but they are always strategically connected to the structural and personal positions of the women involved. Having been on hajj may be such a position.

A different way of veiling may, but need not necessarily, be related to fundamentalist discourses. As Shaheed (2008:299) explains, political objectives require a degree of social control to maintain their legitimacy. So when women's behavior gains new social meaning, this could lead to the enforcement of required ways of veiling. Within fundamentalist discourses, women are often depicted on the one hand as the symbol of a better society, and on the other hand as the cause of decay of that same society (Hawley and Proudfoot 1994:25–30). Though such an argument may be used to explain why the "properly" veiled woman can be regarded as symbolic of "proper" moral conduct, it exaggerates and confuses symbolic constructions and everyday practices and does not help us to understand the personal perspectives and experiences of real women and men or the dynamics that occur within processes of identification (Van Santen and Willemse 1999). For this reason, in my enquiries, I attach much value not only to women's own reasoning regarding their conduct, but also to the relationship of that reasoning to the contexts of their own lives.

Barkindo (1993:92) uses the hierarchy of veiling as a metaphor to describe the structure of the Muslim city of Kano: women living in seclusion (purdah) are the inner veil; the courtyard wall veils the different apartments of the house and the outer wall veils and protects the family and its property. Although this metaphor is consistent with the courtyard and outer wall of northern Cameroonian towns, here purdah is not a common phenomenon. Generally speaking, gender relations in this area depend on the ethnic, economic, and religious background of the people, and what

this society strikingly demonstrates is that gender is a performance (Butler 1990; Connell 2007; Willemse 2007). Because people frequently change religion and/or occupation, they tend to accept dissimilar contents of gender identities, thus underscoring that these identities are continuously renegotiated and never fixed, one-dimensional, or homogeneous.

In Fulbe nomadic societies, the living spaces of women and men are highly segregated, but women are much respected, not least for their economic occupations: women churn and sell milk. The Fulbe have a range of terms that refer to femininity in which this respect is expressed (Van Santen, forthcoming). Settled Fulbe and town-dwelling women are respected for their economic accomplishments and also for their religious as well as secular education. Urban living spaces are inclined to be less segregated, especially for spouses. Fulbe women from aristocratic backgrounds long ago adopted a lifestyle in which they receive help from servants from other classes or ethnic backgrounds—formerly slaves—to assist their economic activities, thus mediating gender identities.

Concerning veiling in northern Cameroon, a distinction is drawn between various forms of headgear: the ordinary wrap around the head that nearly all women of various ethnic and religious origins wear is known in Fulfulde as *hadiko*. Islamic women add a cloth of the same color as the rest of their outfits, called a *kudel,* around their heads and shoulders. An illustration of Maroua in 1937 (in a French magazine[9]) shows men of the period dressed similarly until today, and women dressed with a *kudel* head covering. Many young women today replace the *kudel* with a shawl, called *lafaay,* of fine material or a colored body-covering veil. The full face-covering black *niqāb* is still uncommon in Cameroon.[10]

The wearing of headscarves in public has in general not been an issue in Cameroon. In the North, most women working in the administration of various public institutions such as the town hall, prefecture, banks, etc., are Muslim; they wear a headscarf and also a *kudel* and/or *lafaay.* Men performing public functions also wear Islamic outfits. Until the 1990s nobody discussed it. The issue of veiling only came to be mentioned with the establishment of private Islamic schools, which are rapidly increasing in number.[11] An official division between state and religion is prescribed by the Cameroonian constitution. As is the case for its former colonizer, France (Scott 2007), no overt symbols of religion are permitted in schools, which are public, secular spaces.[12] Thus wearing headgear in the classroom in state public schools is against official policy, both in the southern Christian parts of the country and in the North, where over 70 percent of the population is Muslim. In Islamic private schools, however, girls can keep on their

JOSÉ C. M. VAN SANTEN

headgear or wear their veils. As the director of an Islamic school argued in an interview in 1996 about the constitutional ruling:

> That fact makes it harder for them to go to school. Not only because their fathers may fear improper behavior but also because they feel ashamed themselves. Those who founded the Cameroonian state and made the rules were all Christians from the South, and they never took our (Islamic) culture into account.[13]

A director of the Islamic secondary school repeated that argument in 2006.[14] Indeed, until the 1990s, all children marched bareheaded for the procession (*defilé*) during the state-organized national festival. It was therefore remarkable that in 1999 in Mokolo (a town in North Cameroon), the children from the subsidized Franco-Arab school (a school system that has existed since colonial times), were seen for the first time wearing a black veil over their shoulders, leaving their faces uncovered. By 2005, at the *defilé* in Maroua, I observed hundreds of primary and secondary students from Islamic schools wearing a school uniform: trousers underneath the skirts that cover the legs, and a white veil covering the head and shoulders (Figure 6.1). I questioned them about their dress and they answered that it was a natural consequence of their Islamic faith, and that they want to be good Muslims.[15] On the other hand, many girls who do not cover their heads during school hours at public schools also believe they are good Muslims. The diverse interpretations of wearing the veil suggest that different discourses are at stake on this issue. Although the veil was not a topic of debate in the 1980s, in retrospect, it seems it must have been an issue after all. People now say that Islamic girls were often kept away from school to avoid the problem of removing their headscarves in the classroom. This is despite the fact that knowledge and education for girls and women is well established in the Islamic culture of the region; 'Uthman dan Fodio (the founder of the Sokoto Caliphate), for example, emphasized women's right to education. Before I discuss the impact on veiling related to women travelling to Mecca as pilgrims, I first discuss the hajj in relation to women in general.

"Indifference of Race, Sex, or Social Status": Women's Hajj

The practice of hajj is founded on the *Qur'ān*, Sura 22:27, which states:

> "And proclaim unto mankind the hajj, they will come unto thee on foot and on every lean camel. They will come from every deep ravine . . ."[16]

FIGURE 6.1. School girls in Mokolo, Cameroon, wearing uniforms with white *hijabs* (photograph by J. van Santen).

The fifth pillar of Islam is *fardh,* an essential duty for all Muslims who are physically and financially able to accomplish it. Ideally, hajj is the event that brings Muslims of all races and creeds together, demonstrating Islam's disregard of race, social position, and nationality.[17]

Since "unbelievers" are not permitted to visit Mecca, there is little Western research available on the hajj.[18] But authors who have written on the subject emphasize the social, political, and commercial aspects of hajj, which has for centuries set in motion a flood of travelers from across the world (Peters 1994).

Until recently in Cameroon, going on hajj was an elite and mainly male affair, and those entitled to the prestigious title of *alhadzai* in Mokolo (the mid-size town where I started my research in 1986) could be counted on one hand. Accumulated wealth and air travel has since increased the numbers able to undertake this religious adventure. Grégoire, referring to the Hausa people in northern Nigeria, describes how the title has also come to signify success in business, enabling merchants to identify themselves as

JOSÉ C. M. VAN SANTEN

members of the local business class (Grégoire 1993:108). Masquelier also notes that in Dogondoutchi (in Niger) the term can be used to refer to a successful merchant (Masquelier 2009:xvi; see also Umar 1993:162).

Some of these merchants sent one or more of their wives on hajj, but large numbers of women going on pilgrimage is a more recent phenomenon. In Malaysia in the 1990s, as McDonnell (1990) records, equivalent numbers of women and men departed on hajj, but this was not the case in Cameroon. I knew only one woman from Mokolo who carried the title *alhadzja* in the 1990s. Her parents had been captured and enslaved as children, and thereafter they Islamized. Having been a fairly respected trader for a lifetime, without a stable husband, she had saved to go on hajj on her own initiative. On her return she added a black translucent *lafaay* (which often slipped off her head) to her usual way of dressing, and she became an even more respected person.

There is little literature on women and hajj, though there are many discussion groups on the web. When reading them, one cannot help forming the impression that women's relationship to the hajj is more complicated than men's. This distinction is not made by scholars such as Shariati:[19]

> Regardless of whether you are a man or a woman, young or old, black or white, you are the main feature of the performance. . . . Annually, Muslims from all over the world are encouraged to participate in this great "show" [hajj]. Everyone is considered equal. No discrimination on the basis of race, sex, or social status is made. In accordance to the teachings of Islam, ALL ARE ONE AND ONE IS ALL. (Shariati n.d.)

Tapper claims that gender equality is the dominant message for Turkish women who participate in the hajj (Tapper 1990:249).

All male pilgrims are required to dress in the same way, using two pieces of unseamed white cloth. Women may wear sewn garments, which are often white but which may be colored (Ahmad 2000; Delaney 2000). During the hajj women are not allowed to cover their faces, but they should wear head veils, and men should not cover their faces or heads. However, discussions on the internet point to many gender differences (noted below), and especially to the fact that women of all ages should attend under the guidance of a male supervisor, *mahram*. Some state that if a woman cannot provide a *mahram*'s expenses, she cannot go on hajj at all, and cite the following sura: "'And hajj . . . to the House (*Ka'bah*) is a duty that mankind owes to Allaah, those who can afford the expenses . . .' [Aal 'Imraan 3:97]."[20]

Relying on various *hadīth* (a saying, act, or tacit approval, validly or invalidly, ascribed to the Prophet Muhammad),[21] others state that the mixing of women and men during the hajj is forbidden (*haram*) while others demand that women discipline themselves to avoid contact. Concerning the practice of circumambulation of the *ka'bah, tawaaf*, some say that while it is a recommended duty (*mustahabb*) it is not essential for women, and they are advised to keep well away from the *ka'bah* while circumambulating to avoid contact with men, even if that means that they cannot touch the Black Stone.[22]

It is further argued that women, unlike the men, should not, as is prescribed, jog the first three rounds during *sa'y* (that is, between al-Safa and al-Marwah, the mountains located in the Masjid al-Haram in Mecca, between which Muslims travel seven times during the hajj). And the issue of haircutting at the last point of *sa'y* at al-Marwah is also a topic of discussion. The supposed equality that some scholars emphasize has apparently not been influential on such discussions, which seem to actively discourage women's ability to fully carry out their religious duties.

In Cameroon, however, a *mahram* does not feature in discussions, and other single women have followed the example of the woman mentioned above. In 2003, the Saudi Arabian government introduced a regulation prohibiting lone women from going on hajj. According to popular discourse, the Saudis feared that women who went on hajj alone would prostitute themselves or that they would earn the money for their journey with prostitution. In the pre-Islamic nomadic tradition, men in Fulbe society never accompanied their wives outside of their houses, and in any case few would be able to afford two such costly journeys in a single year. Were they to follow the rules, women would not be able to go on hajj at all. But the ruling did not provoke an indignant reaction. On the contrary, it led more to laughter: as if they, Cameroonians, would not know how to evade these rules!

The National Hajj Commission (presided over by the Minister of Territorial Administration and Decentralization—MINATD) organizes the annual pilgrimage to Mecca under a secular law entitlement. A similar situation exists in other countries (Constantin 1993:50). With increasing numbers of pilgrims, specialized travel agencies mediate arrangements, organizing transport, accommodation, and the procurement of passports.[23] One of the imams who accompanies the pilgrims, Abdullah, organizes group discussions before the pilgrimage to ensure people are motivated "in a proper way." He prepares women and men traveling in the same group on the "dos and don'ts" of the journey: where to stay, how to behave, eat, pray, and act during *tawaaf*. He ensures that no single woman (officially) joins the hajj.

But he has no scruples about coupling each single woman temporarily with a single male pilgrim for the duration of the hajj, to fool the Saudi Arabian officials. As most Cameroonian citizens have only a religious and not a civil marriage, this is comparatively easy to arrange. As Abdullah says,

> These Saudis, they keep their own women indoors and veiled. They are so frustrated that they are ready to jump on any woman. And then they accuse our women who carry out their religious duty of being prostitutes!? Ooo well, they are big racists anyhow.[24]

Female pilgrims are no longer exclusively the wives of merchants or functionaries. Often sons or daughters send their elderly mothers or sisters. As one man expressed to me, "I think women are entitled to go first, I send my sister. If thereafter I have saved money, I will send my father and one day, *Inch 'Allah,'* I may go myself."[25]

A significant investment is required, and not only for the journey. At least an equivalent amount will be spent on visitors who come to welcome the *alhadzja* when she returns (Figure 6.2). According to scripture, a lamb should be sacrificed at the end of the holy trip (Figure 6.3) and shared freely: "Eat ye thereof, and feed Such as (beg not but) Live in contentment" (Sura 22:36); and "Eat ye thereof and feed the distressed Ones in want" (Sura 22:28) (Ali 1997:831, 828).

Thus, upon one's return food is distributed to every passerby in the street. However, before a new *alhadzja's* return, relatives from afar may stay for several days in order to await her arrival. But the returning travelers are often delayed. The rumor of the pilgrims' return may precede their actual arrival by a week, and the waiting guests must be fed. I once witnessed a household hosting eighty-six persons awaiting a woman's return. It took days of meetings to discuss the actual organization of these events: the buying, cooking, and distribution of food. In another case a sheep was slaughtered every morning just to feed people for breakfast. The exhausted daughter thought that all this was sheer madness: "It is selfishness from the visitors, and it distracts people from the real purpose of the hajj."

Returning pilgrims bring with them garments to cover themselves, but also to give as gifts for close relatives—sisters, daughters, in-laws, or even the local anthropologist: I now have two of these garments! Apart from the value of the material object, what also counts is the spiritual substance of the cloth that has sojourned in Mecca while the recipient of the gift has not yet been to this holy place. New ways of veiling in Cameroon also relate to a growing affluence that enables rich merchants to afford the journey to Mecca more often. Veils in fashion elsewhere are merchandise

FIGURE 6.2. *Alhadzja* exchanging gifts on returning from Mecca on hajj (photograph by J. van Santen).

FIGURE 6.3. Meals prepared for distribution on returning from Mecca on hajj (photograph by J. van Santen).

to bring back, among them the black face-covering veil that can be pur-
chased in Mecca and sold to shops in Cameroon (Figure 6.4).

How do women experience the hajj personally, and how does it influ-
ence their ways of veiling? Two cases that can be considered as typical of
many other cases I witnessed are the accounts of Mouna and Laila.

"The Most Beautiful Experience in My Life": How to Veil after Hajj

MOUNA

Mouna is a Pullo (singular of Fulbe) aged about fifty-five, who was
born in a village twenty miles from Maroua. At an early age she left her
family to marry a man with whom she had a son, but who treated her badly.
She left him and is now with her second husband, who is slightly older
and has always respected her economic and other skills. Of the couple's
six children, only one girl has survived. At Mouna's insistence this very
bright daughter married at age seventeen; the daughter still mourns her
departure from school. To Mouna's great joy, her daughter has produced
four grandchildren. Mouna's brother saved money to send her on hajj. He
discussed the idea with her husband, who, of course, agreed even though
he had not been himself.

Mouna travelled to Mecca in 2008. Upon her return she was welcomed
by many relatives, friends, and neighbors. The bus from the airport with
the returning pilgrims was due to arrive late at night, but was delayed until
4 AM. The mother-in-law of Mouna's daughter, who had already been on
hajj, accompanied me to fetch Mouna by car, and we discussed her experi-
ence at length as we waited in the dark chilly night.

Mouna has travelled for several days without much sleep, but there is
a crowd waiting for her. Seated among many women in the warmth of her
room, she narrates her experiences for hours in a row. She is quite negative
and expresses the hardship she faced:

> Arabs are racists. We had to sleep with many in a hotel room and
> always got up early to pray. It was so hard to walk in all these
> crowds; the full streets were scary and frightening. One day I got
> detached from the group and did not know how to get back to my
> hotel. I liked the chicken we ate but there was not much other lik-
> able food around. The imam was great in guiding us when we went
> shopping, but people treated us badly. When Maama [a woman
> with whom she went] wanted to pray in the streets, the police

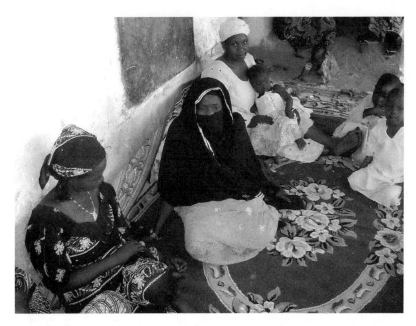

FIGURE 6.4. New black veil worn by an *alhadzja* on returning from Mecca on hajj (photograph by J. van Santen).

told her to get moving. She bravely continued her prayer while pointing at the sky, saying: "for Allah I am just as good as you are!" The Arabs disinfect the hotels in which black Africans stay when they depart.

Mouna had always dressed modestly, wrapping a *kudel* around her when leaving the house. Now she wears a long green extra cloth. She does not cover her face, but while her garments are mostly made of cotton, a material that "breathes," the new cloth is nylon. In the heat and with people around her, it regularly gets too hot. However, she does not remove it in the week that she receives all the visitors.[26]

After the hajj she wears an extra veil (*lafaay*), often white, around her *kudel,* even on visits to her native village. She spends much time in contemplation, thinking about the hajj, and it is striking that one year later she seems to have forgotten the hardship of the journey. She tells me over and over again that it was a wonderful experience that she remembers every night. She recalls that since the hajj her evenings are set aside for prayers, and says: "I have grandchildren, I have been on hajj, I am ready to die now."

JOSÉ C. M. VAN SANTEN

She also reflects on the way women, people, dress in her own surroundings. According to Mouna they do not dress properly; she prefers the Arab way of hiding the body and—after knowing me for many years—even criticizes me for outfits she considers to be exposing too much of my body. Her daughter continues to dress as she always did, and does not agree with her mother on this subject.

Mouna cannot support a face-covering veil. Moreover her brother is absolutely against it, as is her husband, the chief of a quarter in the town. With her face covered, Mouna would be unrecognizable, which could provoke anger. "Moreover," she states, "there are so many discussions about terrorism, and the imams preach that in a black face-covering dress, terrorists may easily hide their weapons."

LAILA

Laila is a Pullo woman of about sixty, from a village forty miles from Maroua. She has a great sense of humor and can make a whole crowd laugh. I have known her for twenty-five years. As a young woman, she was married to the notable (*wakkili*), an advisor to the chief of the town of X. Her husband had been born to a pagan family in the mountains but was captured by a Fulbe chief as a child, together with his sister, and given to the household of another chief in village Y. They were Islamized and have considered themselves Fulbe ever since. Laila and her husband had thirteen children. During their life together he married a second wife.

Laila had always dressed with a *hadikko* over which she loosely threw a *kudel* when leaving the house. Her unmarried daughters dress in a more southern fashion: close-fitting (though ankle-length) dresses, and only a *hadikko*. Their parents do not criticize their way of dressing.

Her eldest son is doing reasonably well financially in the harbor town 1500 kilometers to the south. He was able to send his father on hajj, and he saved again, while supporting his own family and paying most expenses in his father's household. In 2009 it was his mother's turn to go. We discuss the enormous expense, which he thinks has been worthwhile. Now that his parents have fulfilled their religious duty, he plans to spend his money on his own wife and children.

I come to welcome and congratulate Laila on the fulfillment of the hajj, to discover that she wears a black face-covering veil.[27] I look at her in amazement:

> "You must be kidding," I exclaim. "How do you want me to recognize you if you dress up in this funny way?"

She laughs wholeheartedly behind her cover while explaining to me: "You see, Daada Reinout (mother of Reinout), that is how women cover over there, and this is how I am going to cover myself from now on!"

Laila's old mother, who is not really keen on seeing her daughter like this, wears her headcloth in a totally different way. Her daughters also wear their headgear differently, while her granddaughter just drapes a piece of cloth on her head in any way she likes.

During the return celebrations people tend to accept this way of veiling, though most consider it exaggerated. Laila keeps her face cover on for four days, then throws it in a corner of her room, crying, "Allah . . . this is not bearable anymore." When her husband returned from Mecca, he too understood that Arab headgear was the correct way of dressing for men. But a year later, he only wears it for special occasions.

The highest-ranking imam in town lives around the corner from Laila, and he went on hajj too. He has not adopted another outfit, believing that people in his surroundings always dress properly. Preaching his Friday sermons, the imam has an influential position, and when I congratulate him on his new title of *alhadzai,* he jokes that keeping women indoors, as he discovered in Saudi Arabia, is a good thing. In his sermons, however, he underlines people's individual choices.

The imam's first wife is a very open and intelligent woman. For many years she has worn a black *niqāb* when she goes out. She chooses to do so, accepting the criticism she gets: "It often leads to aggressive reaction of the passersby in the street. They get annoyed when they cannot recognize the passerby, but that is their problem, not mine."

Laila continues to cover herself with a *kudel,* occasionally adding a long translucent *lafaay.*

Why a New Way of Veiling?

One may conclude that many women—and men for that matter—dress differently after the hajj. Understanding why requires taking several points of view into account, which include the changing political and social circumstances we have described in the earlier discussion of the new Islamic influences and their impact on this society.

If we consider the hajj to be a rite of passage with three phases, as described by Van Gennep, the departure to Mecca can be regarded as a rite of separation (Van Gennep 1960:147). The sojourn in Mecca and Medina, when women and men dress in white garments, is the liminal phase, the

phase of transition, in which one passes from one social and magic-religious position to another, while wavering between two worlds (Van Gennep 1960:18). The returning ceremony is the phase of reintegration, hence the festivities and food sharing. To mark this phase, and to demonstrate that she has been to Mecca, a woman veils herself differently, asserting that as an *alhadzja* she is no longer the same person. She has fulfilled an important religious duty, and her different way of veiling means that this can be observed by all. An *alhadzja* deserves respect; those around her must be made aware of this, and the veil is a symbol, an obvious sign. The different way of veiling is based on inconsistent arguments: Mouna expressed the view that Arabs are not good Muslims because they discriminate, whereas before God all should be treated as equals. Nevertheless since her hajj, she refers to "their" ways of dressing as being more "appropriate" (Figure 6.5).

Grégoire (1993) notes that for a long period, the performance of the pilgrimage and the acquisition of the title *alhadzai* was reserved for the elite (wealthy merchants) and served a similar purpose. Today this title is borne by so many people that it no longer functions as a sign of distinction. How unfortunate: just as more women take the opportunity to make the journey, the social value of the title seems to diminish. One way to partly compensate this loss is by distinguishing oneself with a different way of veiling.

The resistance against new ways of veiling is also understandable. Launay (1990) stresses that in the realm of religious learning, locally anchored and often hereditary networks of scholarship were long regarded as superior in authority to those associated with and found at the wellsprings of religious knowledge such as Mecca. Launay's historical and anthropological research on the Ivory Coast shows that study in the Arabic-speaking Middle East was not necessarily more prestigious than studying locally. A similar argument applies to Fulbe-influenced communities, where local knowledge and education, *defterinkeewu*, has maintained priority over foreign practices such as the Western education system. In spite of the new Islamic schooling, local Islamic knowledge is not regarded as inferior to the values of the core areas of Islam, and many well-respected religious scholars have undertaken lifelong study without leaving the area.[28] Consequently, these scholars reject the introduction of the black *hijab*. They have less regard for the itinerant "white" preachers and consider that they bring in Wahhabite influences.[29] The views of religious leaders of high standing, interviewed in 2007, 2008, and 2009, support the expressive statement a local imam of a small village made many years ago (Van Santen 2010a:290): "We do not need those black crows. We do not need them in our streets. Fulbe women have always dressed correctly with

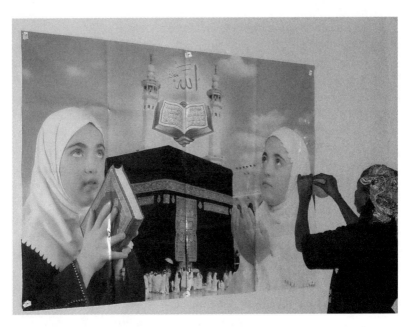

FIGURE 6.5. Poster acquired in Mecca depicting the Ka'aba and "proper" Islamic dress for women (photograph by J. van Santen).

a *kudel* around their head. Now where in the Qur'ān should I read that this cloth ought to be black?"[30]

Many Imams emphasize similar sentiments in their sermons.[31] Ibrahim is imam of the largest mosque in Maroua. Although he studied in Saudi Arabia, he does not support their restrictions on women's room to maneuver. He says that he and the other religious leaders keep a watchful eye on all "new" Islamic influences and developments, including different ways of veiling.[32]

Thirty years ago for Muslim women in Cameroon, modes of covering and veiling were unambiguous. Since then, women have begun making the pilgrimage to Mecca and new styles of dress and veiling have become available (Plate 6). This change has been a topic of much discussion. Some women who wear a black face-cover after returning from hajj do feel uneasy about their new garment, but consider it the correct way to dress. Others who would like to wear it either find the synthetic material uncomfortable or are discouraged from wearing the new garments by family members (male and female), imams, and others.

JOSÉ C. M. VAN SANTEN

The availability of distinctively different veils is not only a religious issue but also an economic one. As I explained, merchants who can afford to go on hajj more often also do so in order to do business, and they can bring back various types of veils. Differences in garments are also political: Islamic schools financed by Saudi NGOs require a different way of veiling, which places the discussion in the context of a struggle for international influence and sovereignty.

The negative reaction of many religious leaders in Cameroon to the face veil or black *hijab* leads me to conclude that the appearance of a new way of veiling is not associated with the political objectives of supporters of resurgence movements in which a degree of social control is required to maintain legitimacy, and through which women's behavior gains new social meaning, as Hawley and Proudfoot (1994) have suggested. I have explained that religious leaders and founders of new Islamic schools believe walking "bare-headed" in public—and this includes taking off the headscarf in classroom—to be an influence from white colonials and Western agencies. This is the reason why many Muslims (parents, religious leaders, pupils) are in favor of Islamic private schools. The face-covering veil (*niqāb*) is regarded as yet another imposition by "white" people (in this case, Arabs) who presume to instruct Africans, this time on correct Muslim conduct. In opposing these ways of veiling, Cameroonian religious leaders repeatedly argue that they have always had learned scholars, and that their women as well as men practice "good" Muslim behavior.

Whatever the reasons, new ways of veiling will be adopted. They may bring women into conflict with their families and communities, while others will steer a middle course between various options and their own convictions. Some women are conscious of the veil being embedded in the complex juxtaposition of religion, politics, and individual wishes and are aware of the contradictory issues outlined above (Van Santen 2010b). However, for others, wearing the veil serves as a marker of their new status as *alhadzja,* or a new fashion which one can choose to wear or not.

We should not efface religious conviction as a reason: Mouna, who adopted another way of veiling, was being completely truthful when she uttered that all her desires had been fulfilled: she had grandchildren and had been to Mecca; she was preparing by many prayers in the evening for the afterlife and prepared to meet death.

The wider choices available to women may even be considered to offer new freedom. If, as an anthropologist, I choose to puzzle over the possible fundamentalist influences on a woman's veiling, is that not my problem—as the wife of the imam above stated—and not hers?

NOTES

Research in Cameroon has been carried out since 1986–1988. The author returned yearly, and was joint director of the research Institute CEDC (University of Dschang) in Maroua in 2001 and 2002. From 2006 to 2009, research was part of the Netherlands Organization for Scientific Research (NWO) project: Future of the Religious Past (subproject Islam in Africa, Moving Frontiers). Material was gathered by (registered) interviews (mostly carried out in Fulfulde), but more often by participant observation, the qualitative anthropological research method. Writing was undertaken with support by a Grant from The Netherlands Institute for Advanced Study in the Humanities and Social Sciences (NIAS).

1. I use the concept "Islamization" and the verb "Islamize" to indicate that the transition from one religion (the so-called traditional religion) to another (the world religion Islam) has the character of a process. The verb "Islamize" is a direct translation from the Fulfulde word *silmugo*. See Van Santen 1993 and 2002.

2. During the colonial period acephalous ethnic groups were at first ruled by Islamic Fulbe. Eventually they resisted rule by Fulbe chiefs, and ethnic (though also Islamized) chiefs were installed.

3. As a people the Fulbe are far from being homogeneous, both in their lifestyle and in their interpretation of Islam. In North Cameroon, for example, I distinguish an elite group who settled earlier and held economic as well as political power. Nomadic Fulbe groups still wander around with their herds, and there are also impoverished Fulbe farmers who settled during the twentieth century.

4. Refusing secular education is now considered an act of resistance against the colonial government. As a result, non-Islamic ethnic groups had a head start in secular education: they were keen on attending missionary schools and in this way getting rid of their inferior status as "unbelievers" and thus uneducated people.

5. The contradiction is that the term *nasaara* (singular, pl. *nasaara-en*) has been derived from the town of Nazareth and means "those who follow him—Jesus—from Nazareth"—in other words, Christians.

6. In 2007 the province Extrême Nord counted twenty-eight private Islamic primary schools; seven were in the process of being set up. There were six secondary schools with a total of 1,318 pupils. In all provinces of Cameroon there are sixteen secondary Islamic private schools. The report with these numbers was given to me by the secretaire à l'éducation Islamique de l'Extrême Nord. Unlike when they were first founded, the schools are now coordinated by the Ministry of Education. For a Nigerian example see Reichmuth (1993).

7. To mention but a few: Ahmed (2011); Bullock (2002); El Guindi (1999); Karam (1998); Masquelier (2009); McLeod (1991); Watson (1994). Research by Dutch authors in which women's reasoning and actions are central includes Jansen (1994); Moors (1995); Van Santen (1993); Willemse (2007).

8. See note 7.

9. In *L'Illustration* 95 (4947), 25 Décembre 1937, front page.

10. The black face-covering *niqāb* is almost exclusively worn by Mousgoum women, a group that lives on the east border near the Logone River. The reasons why they wear these black garments are worthy of further research.

11. See note 6.

12. While such overt religious expression was forbidden in French public schools, secret signs such as small crosses, hands of Fatima, or stars of David are not forbidden in France (Scott 2007:134, 151). However, in Cameroon, crosses are not that common. Simply a lack of money to buy them may be the reason. Catholic priests used to hand out medallions when people converted, but these were very small.

13. Interview with Hammadou Nassourou, August 1996.

14. Interview, 20 November 2006, in Maroua. This interview figures in the film *The Tasbirwol under Attack,* which accompanies the article with the same title (Van Santen 2012).

15. Interviews with schoolgirls were carried out in November 2006 and November 2007 and registered on film. Evidence is also given in the film *Without My Veil I Feel Naked,* which accompanies the article with the same title (Van Santen 2010b).

16. This citation from the *Qur'ān* is from the chapter "Reaching toward Allah" in Shariati (n.d.). Ali (1997) translates "mankind" as "men": "And proclaim the Pilgrimage among men" (1996: section 4, 828), as does A. J. Arberry (1999. part 2, 30).

17. See Shariati (n.d.), *Hajj (The Pilgrimage),* as well as http://www.shariati.com /english/woman/woman1.html (accessed 20 August 2011).

18. For a thoroughly personal insight, see the account by social scientist Abdellah Hammoudi (2005). For a literary history of the hajj, from pre-Islamic origins to the end of the Hashimite Kingdom of the Hijaz in 1926, see Peters (1994, 1995).

19. Ali Shariati (1933–1977) was a respected Iranian Shi'ite sociologist. He studied at Paris University with the French scholar Louis Massignon. Though influenced by the Marxism of Jean-Paul Sartre, Albert Camus, and Franz Fanon, he criticized these thinkers for their rejection of traditional religion. In his opinion the only way deprived nations could counterbalance Western imperialism was through the cultural identity preserved by religious traditions. Shariati was imprisoned in Iran in 1964. After his release he became a popular teacher (Bakhtiar 1996).

20. http://www.islamqa.com/en/ref/96670 (accessed 3 July 2011).

21. Islahi (2009 [1989]:1.1). PDF file (retrieved 12 September 2011).

22. According to the website Islam Q and A, "It was narrated that Ibn 'Abbaas (may Allaah be pleased with him) said: The Prophet (peace and blessings of Allaah be upon him) said: 'No woman should travel except with a mahram, and no man should enter upon her unless she has a mahram with her.' A man said: 'O Messenger of Allaah, I want to go out with the army of such and such and my wife wants to go for Hajj.' He said: 'Go for Hajj with her.' Narrated by al-Bukhaari, 1763; Muslim, 1341." http://www.islamqa.com/en/ref/66800 (accessed 4 July 2011).

23. Only recently the Ministry (MINATD) tried, against the will of the Muslim communities, to centralize this organization: the hajj has become much more expensive and the angry community assumes that part of this money disappears into the personal pockets of functionaries. Mouichi Ibrahim, personal communication, 19 September 2011.

24. Interview, 15 November 2008; interview was filmed.

25. Interview, 8 January 2007.

26. Mouna's return and gatherings thereafter were filmed.

27. Gatherings before and after Laila's return were filmed.

28. I have in mind religious intellectuals such as Ustas Mahmoud, a religious scholar (*ustas*). He lives in Maroua and has an extensive library. I interviewed him several times from 1993 onwards and listened to his sermons. I interviewed him last in October 2007.

29. Wahhabism is the movement developed by the Saudi Arabian Muslim theologian Muhammad ibn Abd al-Wahhab (1703–1792), who promoted the movement to purge Islam of what he considered impurities and innovations.

30. This observation was made during my stay in North Cameroon in August 1992.

31. During researches in 1997 and 1998 I gathered many sermons from local marabouts on tape.

32. Filmed interview with him and his students was carried out in Maroua, November 2007.

WORKS CITED

Ahmad, Sa'īd. 2000. *Teacher of the Hajj Pilgrims.* Trans. Rafiq A. Rehman. Karachi: Darul-Ishaat.

Ahmed, Leila. 2011. *A Quiet Revolution. The Veil's Resurgence, from the Middle East to America.* New Haven: Yale University Press.

Ali, Abdullah Yusuf. 1997. *The Meaning of the Holy Qur'ān.* New York: Touchstone.

Arberry, A. J. 1999. *The Koran interpreted.* Beltsville, Md.: Amana.

Bakhtiar, Laleh. 1996. *Shariati on Shariati and the Muslim Woman.* Chicago: Kazi Publications Inc.

Barkindo, Bawuro M. 1993. Growing Islamism in Kano City since 1970: Causes, form, and implications. In *Muslim Identity and Social Change in Sub-Saharan Africa,* ed. L. Brenner, 91–105. Bloomington: Indiana University Press.

Bullock, Katherine. 2002. *Rethinking Muslim Women and the Veil: Challenging Historical and Modern Stereotypes.* London: The International Institute of Islamic Thought.

Burnham. Philip. 1996. *The Politics of Cultural Difference in Northern Cameroon.* Edinburgh: Edinburgh University Press.

Butler, Judith. 1990. Performative acts and gender constitution: An essay in phenomenology and feminist theory. In *Performing Feminisms,* ed. S. Case, 270–282. Baltimore: John Hopkins University Press.

Choueiri. Youssef M. 1990. *Islamic Fundamentalism.* London: Pinter.

Connell, Raewyn. 2007. *Gender in World Perspective.* Cambridge: Polity.

Constantin, François. 1993. Leadership, muslim identities and East African politics: Tradition, bureaucratization and communication. In *Muslim Identity and Social Change in Sub-Saharan Africa,* ed. Louis Brenner, 36–58. Bloomington: Indiana University Press.

Delaney, Carol. 1990. The "hajj": Sacred and secular. *American Ethnologist* 17(3): 513–530.

Eickelman, Dale F., and James Piscatori. 1990. *Muslim Travelers: Pilgrimage, Migration, and the Religious Imagination.* London: Routledge.

El Guindi, Fadwa. 1999. *Veil: Modesty, Privacy, and Resistance.* Oxford: Berg.

Grégoire, Emmanuel. 1993. Islam and the identity of merchants in Maradi (Niger). In *Muslim Identity and Social Change in Sub-Saharan Africa,* ed. L. Brenner, 106–116. Bloomington: Indiana University Press.

Hammoudi, Abdellah. 2005. *Une saison à la Mecque.* Paris: Editions du Seuil.

Hawley, John S., and Wayne L. Proudfoot. 1994. Introduction to *Fundamentalism and Gender,* ed. John Stratton Hawley, 1–44. New York: Oxford University Press.

Heath, Jennifer, ed. 2008. *The Veil: Women Writers on Its History, Lore, and Politics.* Berkeley: University of California Press.

Islahi, Amin Ahsan. 2009 [1989]. *Fundamentals of Hadith Interpretation.* Trans. Tariq Mahmood Haslmil. Lahore: Al-Mawrid.

Iyébi-Mandjek, Olivier, and Henry Tourneux. 1994. *L'école dans une petite ville africaine Maroua, Cameroun.* Paris: Karthala.

Jansen, Willy. 1994. Mythen van het fundament. *Tijdschrift voor Vrouwenstudies* 15 (5): 79–97.

Karam, Azza M. 1998. *Women, Islamisms and the State: Contemporary Feminisms in Egypt.* New York: Macmillan.

Launay, Robert. 1990. Pedigrees and paradigms: Scholarly credentials among the Dyula of the northern Ivory Coast. In *Muslim Travelers: Pilgrimage, Migration, and the Religious Imagination,* ed. D. Eickelman and J. Piscatori, 175–200. London: Routledge.

LeBlanc, Marie Nathalie. 2000. From *sya* to Islam: Social change and identity among Muslim youth in Bouaké, Côte d'Ivoire. *Paideuma* (46): 85–109.

Loimeier, Roman. 1997. *Islamic Reform and Political Change in Northern Nigeria.* Evanston, Ill.: Northwestern University Press.

Masquelier, Adeline. 2009. *Women and Islamic Revival in a West African Town.* Bloomington: Indiana University Press.

McDonnell, Mary Byrne. 1990. Patterns of Muslim pilgrimage from Malaysia, 1885–1985. In *Muslim Travelers: Pilgrimage, Migration, and the Religious Imagination,* ed. D. Eickelman and J. Piscatori, 111–131. London: Routledge.

McLeod, Arlene Elowe. 1991. *Accommodating Protest: Working Women, the New Veiling, and Change in Cairo.* New York: Columbia University Press.

Moors, Annelies. 1995. *Women, Property and Islam: Palestinian Experiences, 1920–1990.* Cambridge: Cambridge University Press.

Peters, Frank E. 1994. *Mecca: A Literate History of the Muslim Holy Land.* Princeton: Princeton University Press.

——. 1995. *The Hajj: The Muslim Pilgrimage to Mecca and the Holy Places.* Princeton: Princeton University Press.

Reichmuth, Stefan. 1993. Islamic learning and its interaction with "Western" education in Ilorin, Nigeria. In *Muslim Identity and Social Change in Sub-Saharan Africa,* ed. L. Brenner, 179–197. Bloomington: Indiana University Press.

Rosander, E. Eva. 1997. Introduction: The Islamization of 'tradition' and modernity'. In *African Islam and Islam in Africa: Encounter between Sufis and Islamists,* ed. E. Rosander and D. Westerlund, 1–27. London: Hurst.

Schilder, Kees. 1994. *Quest for Self-Esteem: State Islam and Mundang Ethnicity in Northern Cameroon.* London: Avebury.

Schulz, Dorothea E. 2007. Evoking moral community, fragmenting Muslim discourse: Sermon audio-recordings and the reconfiguration of public debate in Mali. *Journal for Islamic Studies* 27: 37–72.

Scott, Joan W. 2007. *The Politics of the Veil.* Princeton: Princeton University Press.

Shaheed, Aisha L. F. 2008. Dress codes and modes: How Islamic is the veil? In *The Veil: Women Writers on Its History, Lore, and Politics,* ed. Jennifer Heath, 290–306. Berkeley: University of California Press.

Shariati, Ali. n.d. *Hajj (The Pilgrimage).* Trans. Ali A. Behzadnia, M.D., and Najla Denny. Evecina Cultural and Education Foundation (ECEF). Jubilee Press. http://www.al-islam.org/hajj/shariati/ (accessed 2 August 2011).

Tapper, Nancy. 1990. Ziyaret: Gender, movement, and exchange in a Turkish community. In *Muslim Travelers: Pilgrimage, Migration, and the Religious Imagination,* ed. D. Eickelman and J. Piscatori, 236–255. London: Routledge.

Umar, Muhammad Sani, 1993. From Sufism to anti-Sufism in Nigeria. In *Muslim Identity and Social Change in Sub-Saharan Africa,* ed. L. Brenner, 154–178. Bloomington: Indiana University Press.

Valenta, Markha G. 2006. How to recognize a Muslim when you see one: Western secularism and the politics of conversion. In *Political Theologies: Public Religions in a Post-Secular World,* ed. H. de Vries and L. Sullivan, 444–474. New York: Fordham University Press.

Van Gennep, Arnold. 1960. *The Rites of Passage.* London: Routledge and Kegan Paul.

Van Santen, José C. M. 1993. *They Leave Their Jars Behind. The Conversion of Mafa Women to Islam (North Cameroon).* Leiden: Vena Publications.

——. 2002. Islamization in North Cameroon: Political processes and individual choices. *Anthropos* 7: 67–97.

——. 2010a. "My 'veil' does not go with my jeans": Veiling, fundamentalism, education and women's agency in northern Cameroon. *Africa* 80 (2): 275–300.

——. 2010b. "Without my headscarf I feel naked": "Veiling," *laïcité,* politics, and Islamist discourse in North Cameroon. In *Religion as a Social and Spiritual Force,* ed. M. ter Borg and J. W. Henten, 194–208. New York: Fordham University Press.

——. 2012. The *tasbirwol* (prayer beads) under attack: How the common practice of telling one's beads reveals its secrets in the Muslim community of North

Cameroon. In *Things: Religion and the Question of Materiality,* ed. D. Houtman and B. Meyer, 180–197. New York: Fordham University Press.

———. forthcoming. "Educating a girl means educating a whole nation": Gender main-streaming, development and Islamic resurgence in North Cameroon. In *On Track with Gender Trajectory: Mapping Gender and Development Studies in Dutch Academis,* ed. T. Davids and A. van Eerdwijk. London: Ashgate.

Van Santen, José C. M., and Karin Willemse. 1999. Fundamentalismen: Discourses over mannelijkheid en vrouwelijkheid. *Lova Tijdschrift* 20 (1): 4–13.

Watson, Helen. 1994. Women and the veil: Personal responses to global process. In *Islam, Globalization and Postmodernity,* ed. Akbar S. Ahmed and Hastings Donnan, 137–157. London: Routledge.

Willemse, Karin. 2007. *One Foot in Heaven. Narratives on Gender and Islam in Darfur.* Leiden: Brill.

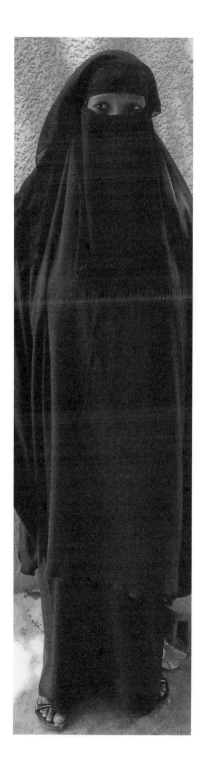

PART 3

Veiling/
Counter-Veiling

Invoking *Hijab:*
The Power Politics of Spaces and Employment in Nigeria

HAUWA MAHDI

THE FACT THAT changes in dress styles are taking place in Nigeria reflects perhaps the normal processes of change which occur in all societies. Yet these transformations, at both the macro-national and micro levels, differ as each reflects a unique experience. In Nigeria, women's dress has increasingly become an object of contention at the macro level, more so in the last three decades than it had in previous years. State actors and some civil society organizations (CSOs) alike have become active in the discourse of and attempts to legislate how women should or should not behave as a moral imperative. In 2007, Senator Ufot Eme Ekaette, one of only nine women in the 109-member Senate chamber of the National Assembly, gained some notoriety for her proposed bill, which in the light of Nigerians' penchant for nicknames soon became known as the Nudity Bill (Adaramola 2008). There are other politicians who share the title of morality police with Ekaette. The senator and former governor of Zamfara State Ahmed Sani introduced the death penalty on sexual offences during his governorship, on 27 January 2000. (He later went on to enhance his moral authority by his marriage to an Egyptian girl in her early teens.) Second, some twenty-six senators (two of whom are women) sponsored the Same-Sex Bill, which prohibits sexual relations and marriage among same-sex partners in Nigeria (Obende et al. 2011). In all these morality bills female and male senators of all backgrounds have come together without a sectarian—religious or ethnic—hitch. In the last thirty years, an era of increasing economic hardship in Nigeria, women have been blamed for anything from droughts to a rise in delinquency among children. Public discourse in the media is filled with debates and arguments that support curtailing women's rights and freedom, often in the name of religion or tradition. The "Nudity Bill" and other morality legislation must be seen in

the context of the general social disorder in Nigeria and attempts by the political elite to grope for answers to unfulfilled yearnings for basic human rights and demands for "progress," particularly in such things as the provision of electricity and running water.

The increased wearing of the *hijab,* I argue, is related to these examples of twenty-first-century morality legislation, as a means of attaining an elusive social order where those who control the state extend their hegemony over both the private and public domains of civil society. The desire to control women's bodies in the public space through legislation, whether by Ekaette's dress code or the *hijab,* constitutes the process of ethnic, religious, and Nigerian identity formation and power negotiation between and among the elite. Controlling dress, especially women's, is also a means by which the elites of these groups hope to control both the biological and social reproduction of society. Thus the attempts to police morality are essentially visions of a future, although their proponents often turn to the past to authenticate their claims. Yet neither Ekaette, who is an Igbo Christian, nor the Islamic reformers can authenticate a historical past with their proposed dressing and sexual behavior codes. The leaders of Islamic reform movements such as Jamāʻat Izālat al-Bidʻa wa Iqāmat al-Sunna, or Izala, as they are popularly called, and the Islamic Movement of Nigeria, also known as ʻYan Shia, as they are called in Hausa, would be hard-pressed to make a case for *hijab* before the 1970s, and that is if one is being generous to them. It is important to make a distinction between *hijab* and the other veiling types that pre-date the 1970s, in the Nigerian popular understandings of this form of dress in this chapter.[1] Even the pre-1970s veils were not widespread across all classes, but were rather class-based behavior. Most importantly, they were not instituted by state laws, nor did they bear the organized social pressure that features in the post-1970s dress code. In this chapter, I argue that the *hijab* represents an underlying power game seen in the workplace and in political decision-making.

In the Arabic language *hijab* simply means "veil," and researchers have analyzed its religious meanings in Islamic religious texts. What constitutes a veil and whether its use is obligatory or not is a highly contested subject, both theoretically and in practice (Mernissi 1991; Mir-Hosseini 2007; Wadud 1999, 2006). My concern here is not with what the two Qur'ānic verses (Sura 24:30 and Sura 33:59) mean, but with the introduction and meanings of *hijab* in the Nigerian context. Furthermore, in this milieu the meanings of the form of veiling known as *hijab* do not apply to all the other various styles of veiling such as *Dankwali* or *kallabi,* both meaning "head-

HAUWA MAHDI

scarf," or *gyale* and *mayafi*, which also mean "veil" in the Hausa language. Implicit in the named Hausa garments are the meanings of how they adorn the body, and in the case of *dan kwali*, broad historical meaning comes into play as well. *Dan kwali* refers specifically to the machine-made scarf, packaged in a *kwali* (box), that became popular in the 1950s, as opposed to the older *kallabi*, which was handwoven, although the two words are used interchangeably sometimes. *Dan* is a prefix often used in the Hausa language to convert basic words into words with more specialized meaning (Kraft and Kirk-Green 1977); thus *dan kwali* could only mean this type of scarf and none other (Plate 7). Rather, the *hijab* in Nigeria refers to the type of veil that came into use from the 1970s and is associated with Islamic revival, specifically, the Izala movement; the actual form of this type of veil originated in the Middle East. Indeed, with changing global *hijab* fashion and varieties, the dominant type in Nigeria does not quite look like any of the familiar Middle Eastern veils, but it is imposed by them." The Nigerian *hijab* is probably closest to *khimar*, as it covers the head tightly, it drapes to the knees or below, and it is worn over other clothing underneath. The decisive difference between the other northern Nigerian (Hausa) veils and the *hijab* is that the previous veils were seldom tightly fitted around the head or anywhere else. The importance of the change from the other veils to the *hijab* is precisely the ideological import of the latter and the role of macro actors in its use.

Here, I seek to explore the hypothesis that the *hijab* is a symbol of the discourse of defining the public space in northern Nigeria, and of who dictates the terms of access to and occupation of that space. It is a qualitative analysis conducted by engaging with one aspect of the body—its use as a work implement—which the *hijab* both veils and hides, in the politics of spaces between clothing and employment. The chapter juxtaposes the *hijab*-wearing behavior of rural women in Nakaye in rural Katsina State on one hand, with that of urban women in Abuja (and Kano) on the other, and focuses on their explanations for why they have taken up wearing the *hijab*. The types of employment and the women's decisions about the *hijab* in the workplace provide the material which connects politics and religion (as ideology) with the discourses of defining the public space. Since most of the wearers opted for *hijab* as adults within the last couple of decades, it is important to hear their views regarding whether they affirm or oppose my hypothesis. Their views are also interesting as means to exploring their motivations, explanations, and the extent to which they have reflected on how their behavior compares with that of previous generations.

Dressing in Identity Politics

By the late 1940s the place of ethnic groups as legitimate political constituencies had already been established in both popular discourse and the several Nigerian national constitutions (Mahdi 2006). Ethnicity became an important part of politics and an important motivation for the formation of political parties (Dudley 1968; Mahdi 2006). For example, as part of their campaign for political votes, politicians of the Northern Peoples Congress began distributing textiles and clothing in areas which would have fallen within the ethnic appeal areas of Northern Nigeria Non-Muslim League, Middle Zone League, the Middle Belt Peoples' Party, and many other ethnic parties. Some politicians went further, distributing cloths as a form of evangelism aimed at converting animists to Islam or Christianity. Early in the colonial period the end of slavery had already instigated an intense struggle for identity between slave and free persons as well as between Muslim and non-Muslim Hausa. Changes in dress and purdah for women were among the main markers of identity formation that came to bloom in the middle of the twentieth century (Last 2000).

As part of their struggle to muster electoral support, the Nigerian political elite have consistently used ethnicity and religion as platforms for launching their political careers; during campaigns, they may dress in local styles as one way of attracting supporters. Yet concurrent to the development of ethnic identity through dressing was the evolution of national identity. Thus, through the twentieth century, the nature of dressing changed and increasingly came to reflect a more nationalist look—i.e., Nigeria-wide, with minimal variations based on linguistic/religious differences. Although this change toward a national dress style was visible for both sexes within the country, it was most prominent on political occasions such as diplomatic and other international forums. *Zane-da-riga,* which means "wrap-around and blouse" in Hausa, largely became national wear, by which anyone with a sense of different national clothing could distinguish Nigerian women from other African women, in the same way that *babban riga* (Maiwada and Renne 2007), the gown for men with the matching cap, has come to represent the Nigerian man.

There has been an escalating campaign in Nigeria to rein in women, as it were, by controlling how they dress, for which women have become objects of violence over the decades. Public discourse carried out in the media is replete with comments, features, and news that reflect that campaign. It has become a systematic trend by state actors and their agents, countered by individuals as well as non-governmental organizations who seek to enhance gender equity. In this struggle, the opposing forces share

a common experience with the rest of world where the law has been an important field of contest. The intervention of the state and its agents in attempting to control women's dress in Nigeria is not a simple issue of Islamist Shari'a versus secular or liberal law. It is rather an issue of a generalized moral-religious perspective of women and their location in the discourses of power (Alliances for Africa 2008).

The escalating attempt by the political class, allied to religious CSOs, to control how women engage with the public space is what has led to Ekaette's Nudity Bill, a part of which prohibits the exposure of the following parts of the body:

> The breast of female above the age of 14 years; the 'laps' of a female above the age of 14 years; the belly and waist of a female above the age of 14; any part of the body from two inches below the shoulders downwards to the knee of the female above the age of 14 years; any part of the body of the male person above the age of 14 years from the waist to the knee, any form of dressing with a transparent cloth which exposes any part of the body as mentioned above. (Ekaette 2008)

According to *Nigeria News,* the bill had two successful outings on the floor of the Senate, and Ekaette felt confident enough to lead a large female delegation to the UN General Assembly to campaign for it. While "Nigeria had the largest turn out which the UN described as the largest ever in its history, the country was also highly criticised and roundly ridiculed both for the number of delegates and triviality of the Nudity Bill at the National Assembly" (Gabriel and Kalu 2008). According to Global Fund for Women (2011), Nigerian women's organizations mobilized to defeat the bill in 2010. The GFW ranked the defeat of the bill one of the ten best global achievements of the women's movement that year. The Nudity Bill is an extension of the attempts at implementing obligatory *hijab* in state institutions in some of the Shari'a states, such as Kano since 2003. Demanding that women wear *hijab* is a byproduct of the alliance of Muslim politicians and Islamist CSOs, as Ekaette's bill is an offshoot of the proliferating churches in the southern parts of the country. Most importantly, none of these religious organizations or politicians could find historical precedent for their attempts to legislate morality through women's dressing.

Gendered Dress Code, Work, and Faith

There was a diversity of Hausa textiles, dressing styles, and fashions during the nineteenth century and up until the 1970s, which I will discuss

shortly. However, the choice of what to wear was not determined by religious or state laws, even if, during the Sokoto Caliphate in the nineteenth century, some Caliphate officials sought to encourage "decent" dressing (Boyd 2000; see also Ogunbiyi 1969). Nonetheless contemporary arguments for the *hijab* which rest on the religious perception of the female body as source of social disorder and sexual immorality are problematic in the Nigerian context. The average Muslim Hausa woman from the working class (*talakawa*) did not dress differently from other groups of women in the Nigerian area until about the middle of the twentieth century. Unlike in the Middle East, where rural women veiled and were generally more clad than men (Hammami 1990), in Hausa society it was rather men of means who dressed more ostentatiously in public (Maiwada and Renne 2007). Yet, from the last decades of the twentieth century, state institutions and religious civil society organizations have been insistent on "decent" dressing, meaning the *hijab.*

My three male interview respondents concur that at the beginning of the twentieth century, Hausa women—other than those of royal, noble, or wealthy classes—had a limited choice of clothing, which consisted mainly of locally handwoven wrappers.[3] As pointed out earlier, by the middle of the twentieth century the availability of textiles had improved to allow more women of all classes to access some type of veil. However, my three respondents agree that throughout their childhood to early adulthood, the majority of Hausa women had only five options—all wrappers—and did not use them as veils: *'Dan-gyada* (literally, son of groundnuts/peanuts), *dunhu, girki, agudu da mai,* or *mai barage. Dan-gyada,* the most common, is about a meter and a half in length [*hannu/hawa uku*][4] and about a meter wide. According to Mallam Musa, who was a weaver in his youth and later a textiles trader, and whom I have interviewed several times about clothing and textiles, these pieces of cotton cloth, all of them in the form of wrappers, were the only clothing women wore. "In those days, they [Hausa women] did not wear *taguwa* [blouse]" (Interview, 29 August 2011)." "In those days, when we were young, at weddings you would hardly find ten men with *riga* [gowns]. They only wore *walki* and *bante.*[5] As for a woman, she could have *Girki,* or *Dunhu,* or *Dan-gyada (Da-gujjiya),* or *Kama-yanke,* or *Mai-barage,* [wrappers made of] handwoven cloth. Women wore woven cloth and men wore leather." "She will wear one of those, bear her *digirgiri* [a big woven basket that could contain five *tiya*[6]] and a *buta kilaki,* sometimes called *allasuwamu* [a kind of kettle], and that is it. In addition a man of some means, he could have a *riga* [men's gown] and cap [*habar kada,* literally crocodile's tongue, referring to the cap's two flaps] made from

sakar fari [white handwoven cloth]. I have worn them myself" (Interview with Mallam Musa, Nakaye, Katsina State, 28 July 2011). For men Mallam Abdulhamidu agrees that *walki* was the main clothing for men, but adds *karabi*[7] as the second item of clothing men wore. In addition, if somebody they knew well enough in their circle of friends or relatives had a cotton gown, one could also borrow it when going to special occasions (Interview, Birnin Kuka, 31 July 2010).

I wanted to have a fuller understanding of the how Hausa women dressed, so I asked Mallam Musa, "Where did women tie *Ɗan-gyaɗa* (*Da-gujjiya*), is it at the chest?" He replied, "It is not possible to tie that cloth at the chest, that would have to be *Dunhu* [which is bigger]. *Ɗan-gyaɗa* (*Da-gujjiya*) could only be worn at the waist. Blouses weren't common then because *atampa* [manufactured printed textiles] had not been introduced yet. All the other types of cloths apart from *Ɗan-gyaɗa* were very expensive —she had to sell a goat to afford them"—or sell farm produce with the equivalent value of a goat to afford them. Mallam Musa took me through the whole process of dressing and comportment of Hausa women. Nowhere did he even mention *gyale, mayafi* or *lullubi,* though their wearing might seem to coincide with the expansion of import trade in textiles and sewing machines (Maiwada and Renne 2007). I pressed both Abdulhamidu and Mallam Musa further on women's dressing to ascertain whether rural Hausa women wore any covering on the head, and both respondents categorically insisted that these women did not use any of the three items of clothing named above. "Did women wear blouses?" I asked. "No, [he answered,] but they could wear a *kallabi* [headscarf] the size of *kyalle* [meaning a small strip of cotton cloth not as big as the modern *Ɗan kwali*]." Furthermore, there was no difference of dressing between married and unmarried women. What differentiated which of these cloths women wore was the means to buy them. Most women from Katsina to Gombe, a route my informant traveled as a trader, were not able to afford them more than *Ɗan-gyaɗa.* Similarly, Mallam Musa gave me a detailed description of *doka,* women's dominant hairstyle at the beginning of the twentieth century, and how beautiful the braids were. In fact as I pressed both men further, they each responded with disbelief that I expected women to wear more. To my question about *mayafi, lullubi,* or *gyale,* Mallam Abdulhamidu answered, "A'a kuma!" a jovial expression to the effect of, "what did you expect?"

When Mallam Musa referred to *atampa,* he was alluding to change in women's dressing during the century, including the increasing use of *mayafi* and blouses among lower-class and rural Hausa women around the third decade of the twentieth century. While the conduct of state actors,

including the increasing use of religion in politics (Bello 1986), might have contributed to the expanding use of *mayafi* or *lullubi*,[8] there is no evidence of direct legislative intervention to support or enhance the practice. Indeed even as the use of these veils expanded, there was opposition among some educated individuals to the change (Danbatta 1958). The adoption of these larger pieces of cloth in the 1940s and 1950s was only possible because of the expansion of trade with the industrialized world that occurred under colonial rule (Figure 7.1). It was also a decision arrived at by individual women based on the resources available to them and the types of employment they had. Thus the circumstances under which the use of *mayafi* and *lullubi* as well as *gyale* among Hausa women became widespread are different from those of the *hijab*. While the earlier change of dress was dictated by availability and resources of the individual woman, the use of *hijab* is devised by macro organizations through the educated elite, as religious obligation.

Why Wear the Hijab?

In March 2011, I held an in-depth telephone interview with a forty-two-year-old nurse named Halima, who lives in Abuja, and I later followed it up with a discussion with her in August 2011. In February 2008 I also interviewed five other younger women in Kano, all of whom wore the *hijab*.[9] Halima is the most passionate about the *hijab* among my respondents and insists her decision to wear it is purely religious, even as she gives other reasons for her choice of dressing. My conclusions about Hausa Muslim women's reasons for wearing the *hijab* in Kano are mainly based on the formal interviews with these women. But I have also had persistent discussions and arguments with Hausa and other Muslim women about the issue over the years. I would like to provide portions of my interview with Halima as a way of establishing how the wearing of *hijab* proliferated, and why her responses are relevant to my hypothesis.

My conversation with Halima, the nurse:

> I: Why do you wear the hijab?
>
> Halima: Because it is Allah's words—it is in the Qur'ān. I cannot remember the particular verse now.
>
> I: Do you, or did you read the Qur'ān?
>
> Halima: Yes, I do. I also listen to religious sermons on radio and cassette recordings.
>
> I: Can you speak or read Arabic?

HAUWA MAHDI

FIGURE 7.1. Women returning from farm, wearing *gyale*-style veils (photograph by H. Mahdi).

Halima: Not fluently.

I: Did you start wearing the hijab after you had started learning Arabic?

Halima: No. I started wearing it before learning Arabic. I first heard about the obligation to wear hijab at a sermon given by a student when I was at nursing school.

An important factor in this excerpt is the sequence of events leading up to her choice to wear the *hijab*. In a society where the majority of the population is illiterate, the required practices of any religious group are transmitted through word of mouth rather than Qur'ānic or other Islamic texts. As with other norms of Islam in Nigeria, Halima's initial conversion to becoming a *hijab* wearer was not through her personal reading of the *Qur'ān*, but rather through religious sermons. Although her first contact with the idea was a sermon she attended in person, many more women are probably converted to the idea of wearing it through radio, cassette recordings, or conversations with family members or friends. These media of religious proliferation have expanded since the 1970s, particularly in state-sponsored sermons over radio waves across the country. But in addition to the obligation for religious conformity, urban *hijab* wearers have clear strategic and existential explanations for wearing this type of veil. Halima, as did my other respondents, had at least two other reasons for wearing it. According to Halima, "the woman's body is a source of evil; she needs to cover it up in order not to provoke male attention. *Hijab* is 'garkuwa' [protection-cum-shield] to deflect male attention." She argues further that if a woman is veiled, men with mischievous intentions will avoid her.

While it is impossible to use Halima alone to generalize for all Muslim women, she provides many of the arguments that others present. This argument will be pursued further in this chapter in relation to the discourses the elite carry out regarding the public sphere.

Dressing Women's Bodies and Addressing Moral Decline

Along the line of Ekaette's arguments for introducing the Nudity Bill, Halima, without a direct question from me, accused Nigerians, including those who call themselves Muslims, of being morally bankrupt. "Ba'a son biyayyan maganan Allah [they do not want to obey the word of God]." "Was Nigerian society more religious?" I interjected, which both she and I understood to mean, before the spread of modernization. "Yes. But I mean, a long time ago. There are more extramarital affairs, more pregnancies out

of wedlock. . . ."[10] It is emotionally possible to see the arguments the moralists are making about the link between women's dress and sexual morality, whether the point is made by legislators who do not make a direct connection, or whether the speakers are *hijab* wearers who consider themselves more morally upright than those who do not wear the veil. Historically and intellectually, it is very difficult to make the connection between how women have dressed and the unsubstantiated claims of sexually moral societies of an undefined past. As the *hijab* is a recent innovation in Nigeria, it is curious that Muslims are assumed to have been more sexually upright in a past when women barely covered their bodies. It further complicates the question of morality based on dress when we know that although it was not unknown in the past for Muslim women to wear blouses or other types of tops, the majority of Hausa and Fulani women seldom wore those items of clothing until well into the twentieth century.

Rural Muslim Women's Work and Dress

The answers of the rural women I interviewed on the same question were completely different from Halima's. Both women I interviewed wear the *hijab,* but only when they leave their village to go to town or when they pray. Neither do they explain their choice of wearing the *hijab* outside the house as religious obligation. Maimuna is a working woman of many roles. She has, since being married in the mid-1970s (by my estimation), worked making and selling groundnut oil as well as prepared food and snacks. She also farms, this being her most important current employment. Maimuna was very lucid and incisive about the nature of her dress styles when she does any of those activities. Among other things she was detailed about the kind of dress she must wear doing all these trades, all of them carried out either outside her house or outside the village. While she was explaining the delicate differences in dressing, she mentioned *gyale* (a loose rectangular cloth veil) as impractical garb for any of the activities she does and also mentioned the impracticality of wearing an *abaya*.[11] My direct question to her was, "you appear dressed just like I am, with *atampa* wrapper and blouse. Do you change into other clothes when you do the other activities you have just listed?" When I had come to her house for the interview she had been pounding corn under a tree outside her house. One could wear neither *gyale* nor *abaya* to pound corn or bend over to farm, she insisted. It is therefore interesting to know when and why she wears *abaya,* which might not be the correct Arabic name of what she and most *hijab* wearers in Nigeria wear. She wears *hijab* to do the five daily prayers or when going out

on non-work-related errands, she says, especially if going to town. She adds, "*Abaya* or *hijabi* is new in our village. It is probably only about five years old or less." I asked, why did she start to wear *abaya*? "Because we saw people wearing it. It is like fashion, isn't it? We saw them [pointing at a woman I had come along with] wearing it when we visited the cities and towns. So we said we will do it too, so as not to be left behind."[12] I asked Nana Fatsuma, who lives in another homestead in the same village, if she knew *abaya*. Her testimony coincides with other interviews with rural women, who stated that a woman cannot wear *abaya, hijab,* or even *gyale* to do the kind of work they do. She lists the uses of *abaya* as others have done, but insists, "farm work does not go with *abaya*." "For us villagers *abaya* is hard to get [economically], and I personally have never bought one, but was given one as a gift. Eventually, my adult daughter took it. They brought it for me from Kano. I haven't had one for three years now."[13] It is simply not practical to wear veils of any kind to do the farm activities most rural women do, whether it is pounding corn with pestle and mortar, or bending over dirt with a short hoe or even the modern *ashasha*.[14] All veils hinder the movement of the arms and are therefore impractical for these kinds of work. Maimuna also says that if you are threshing corn as they do, you have to have a completely separate kind of clothing, which you remove immediately after the work because it is itchy. "For all these works I do, I can only wear a *zane* [wrapper], *taguwa* [blouse/top], and *kallabi*," says Maimuna. In addition, as Maimuna says of *abaya*, "tana da ji6i" [It is warm/sweaty]. All veils are either a hindrance or sometimes a danger in the kinds of work they do, or they are too warm, so these rural women never use any veils when they are working.

Further, on the day of this interview about ten other women were in the vicinity of Maimuna's house and passed by as they fetched water from the village well, and none of them wore any type of veil. When I approached them at the well, the one woman who did not wear a blouse felt embarrassed only when I asked to photograph them. In addition, in July 2010 and July 2011 I visited and interviewed five women working on the farm and encountered at least ten others with whom I did not speak, and only one young bride working on her husband's farm appeared to "work" with a *hijab*. Interestingly, there appears to be a generational change taking place in this village, because Maimuna's daughters-in-law, while not wearing *hijab* when I was there, also do not work as Maimuna does. In fact while her sons are away she fetches water, firewood, and other necessities for the in-laws because their husbands have put them in *tsari* (partial purdah).

I can hardly add any more to what the women farmers have themselves said about veils and their kind of employment. Neither do their

HAUWA MAHDI

husbands, who were present when I interviewed their wives, appear concerned about their wives' limited use of *hijab*. It is clearly an urban habit that has begun to filter into their lives and is in some ways beginning to affect their family relationships and responsibilities, as with Maimuna's in-laws.

Hijab Discourse in Nigeria

At the macro level, the growing importance of religious civil society organizations such as Izala, the Islamic Movement of Nigeria (IMN), and lately Ahlis Sunna Lidda'awati wal-Jihad, also known as Boko Haram, is a significant factor in the ideological pressure on women to wear the *hijab* (Mahdi 2007, 2009).[15] Christian churches have equally joined the clamor for so-called decent dressing (Vandu 2007). The above-mentioned organizations and other Islamist movements have in the last few decades each advocated for the *hijab* as part of women's dressing. The public discourse in the media is vibrant and often cites failures of women to uphold their duty as the cause of social disorder, ultimately implying different standards of what is expected of women and of men. This discourse has in turn emboldened men's aggression toward women, especially when cases of rape or other offences against women become subjects of discussion. In such cases the offenders have sometimes defended or explained their actions in terms of the failure of the female victim. Such assaults on women explained in terms of their inadequate dress are also carried out by law enforcement agencies.[16] Eferovo Igho's tirade about women on one of his blog contributions, hinged on Biblical excerpts, sums up the general attitude of the religious right irrespective of their particular denomination. "Nothing corrupts society more than women advertising their ordinarily private parts; nothing causes and multiplies profligacy in government quarters, armed robbery and other vices more than obscene women and girls in our streets, offices and homes, and this is not merely being sententious" (Igho 2011). Igho concludes by urging government to tackle the immorality "with a magisterial tool such as a well-conceived legislation." The zealots using religious bigotry have convinced people such as Ekeatte and other state actors to blame the failures of the Nigerian state on women's skimpy dressing. Among these actors are the Kano State government officials, who have continued to expand the compulsory use of *hijab*. Overall, the *hijab* issue has contributed to the rising temperature of the Nigerian polity. Even without the likes of Igho asking for it, the institutionalization of dressing that empowers the religious right has been long under way.[17]

Academic analysis of *hijab* in Nigeria is less extensive, but nonetheless exists (Abdulraheem n.d.; Bayero 1998; Mahdi 2009; Mir-Hosseini and Hamzić 2010; Oba 2009). Many who discuss the subject in Nigeria are critical of institutions that disallow or discourage women from wearing the *hijab*, accusing them of slavishness to Western values. An underlying foundation is the critique of Western values that is replete with contradictions, all of which I will not be able to address in this short chapter. But one important premise on which these arguments are based is the belief that *hijab* is unquestionably Islamic and Nigerian.

Thus, some analysts of the veil begin with the premise that women wearing *hijab* is religious "compliance" (Abdulraheem n.d.; Oba 2009). "Any pious Muslim woman would therefore feel strongly, the imperative to adopt the *hijab*. This is because it is a great sin not to do so. It is therefore not surprising that many enlightened and highly educated Muslim women are now turning to the *hijab*" (Oba 2009:53). Yet Oba does not reveal the fact that, as Abu-Lughod (2002:785) points out, some women may be unable to afford such types of veils and clothes. It is clear that while both Abdulraheem and Oba could have a justifiable case within the legal and educational professions, where the *hijab* can be argued to challenge the colonial traditions of those professions, the issue of the cloth must be seen beyond those areas. It is the certainty with which the Qur'ānic verse on veiling is assumed to be immutable (Abdulraheem n.d.:7–8), without the least consideration for historicity or indeed other verses of the Book, that could pose a quandary. It is not surprising that she concludes that "The Nigerian Law School prohibits Muslim female students to use even at least a cape *hijab* while attending the Dinner. Hence they are made compulsorily to leave their hair open, in contravention of their religious background" (Abdulraheem n.d.:10). Abdulraheem (n.d.:8) argues further that

> 48. Hence, hijab could be referred to as the manifestation of correct Islamic modesty. Islam lays down a complete code of conduct for human beings and stresses the point that the best place for women is the home. . . . A Muslim woman is allowed to wear whatever pleases her in the presence of her husband, family or other female friends. . . . If there is any reason why a woman must go out of her home, Islam enjoins and directed her to cover their physical adornments, to be modest and hide their physical charm. . . . In modern times and practically in the West, the hijab has become synonymous with the head covering worn by Muslim women.
>
> There are now five clearly [*sic*] stages or categories of *hijab* used by Muslim women. There is the headscarf which covers

the head and leaves no portion of hair exposed. There is also the "cape *hijab*" which covers the hair and extends to the shoulders and bosom. There is the "medium" *hijab* which is a cape *hijab* that extends to the near the knees. Fourthly, there is the "full" *hijab*, which extends to near the ankles. Lastly, there is the "full *hijab*" plus veil (*niqāb*) covering the face. The first four types are fairly common among students and professionals. The fifth type is a comparatively recent development in Nigerian institutions of learning but is slowing gaining adherents.

If any of these five *hijab*s she has listed means fitting the cloth tightly around the face, or indeed fitting tightly just the head, it is doubtful that one can trace its history beyond the colonial period, i.e., the ultimate expression of Western dominance. As my informants above have clearly indicated, the veil could not be said to have been in common use in Nigeria before then. Indeed, even today, when the use of *hijab* has definitely grown, one has to make the clear distinction between the classes of women and the needs of their different professions. And as Abdulraheem rightly admits, the fifth style of *hijab* has the shortest history in Nigeria. What I assert is that the colonial period of Western dominance in Nigeria witnessed the expansion of veiling, though not of the fitted type.

One ought not take issue with the need of the legal profession to abandon the black robes and wigs in Nigeria for any number of reasons. However, it is problematic if, as Abdulraheem assumes, the transition necessarily has to mean adopting the *hijab* for women as an alternative, simply because the discussion of *hijab* and the very Islamic tradition of *ijtihad* are being made redundant by Islamists. Indeed, a great disservice could be done to Islam if the power politics of Nigeria, including religious and ethnic demographic manifestations, are put before discourse and review as part of the Islamic tradition. Interestingly, Abdulraheem uses "culture" to indicate an unchanging behavior, even as she seeks to change the culture of the legal profession. She states that in Nigeria "an outfit is said to be complete or proper when it respects or meets three values, viz social, cultural and spiritual values" (n.d.:11), a formulation in which she gets trapped, as I see it. The social and cultural dimensions imply negotiation with others and by oneself—the very factors that make culture dynamic, enduring and transient at the same time. If Abduraheem does not recognize the agency of individuals, and the right to be different is negated because it is Western, how is the insistence on wearing *hijab* any different? The real problem in Abdulraheem's argument is the failure to recognize the problematic engrained in balancing the human rights of groups, as well

as balancing the rights of groups and the individual. There is no question that no one should have the right to decide what proper dress is for Muslim women. "Muslim women see the western position as an expression of cultural imperialism and as an insult to their right of choice and a denial of their freedom to comply with the tenets of their religion" (Abdulraheem n.d.: 11), she argues, unmindful of her generalizations with respect to the meanings of *hijab* as well as "Muslim women."

Several points must be recognized in the debate of the legal and other professions. The established traditions of a profession require uniforms of some sort—certain garments and accoutrements. In the case of the legal profession, the robe and wig as the dress of this profession have outlived their usefulness, and some thus seek inclusiveness for all female lawyers by negotiating for a change that is not religion-bound. Or one can take the "religious" option, which would face the same challenge as the wig, since *hijab* is no more Nigerian than the former. There are third and fourth options to pursue: to creatively invent a professional gown that is "exclusively" Nigerian, perhaps inspired by the kind of dressing earlier Nigerians invented and lived by for years preceding both the wig and *hijab*. Or dispense with the whole idea of any uniformity altogether, which again will include the *hijab*.

Reasons for Differentiation

Beyond the macro-level concerns, logistical and personal factors also come into play in the decisions made toward wearing the *hijab*. As we see from the rural women's responses, the financial cost of either buying 6–8 meters of cloth and sewing it into a *hijab*, or buying the imported fancier ones, for an item of dress that has little practical function amid the everyday chores of rural women's lives, could be wasteful for those who have limited resources. Urban women are more likely to defend their wearing of the *hijab* in religious terms than are rural women, and as I have argued elsewhere (Mahdi 2009), the grave insecurity of the Nigerian public space explains the concrete need for protection. Distance to and from the place of work does not appear to be a decisive factor in wearing the veil to work. The rural women I have quoted here, and many I have not, cover longer distances (4–5 kilometers) to the farm than a nurse or teacher in an urban setting would travel to work. However, in the reality and perceptions of urban Nigerians, an urban woman is more likely to be exposed to males within the distance she covers.

Many women have "chosen" to wear the *hijab* and vehemently defend its sacrosanctity and their choice in the name of Allah. The Islamist manner of scripting the *hijab* to women's faith in Nigeria is, as Lehmann (1998) has observed elsewhere, based on selective and sometimes false claims and adoption of practices that are bereft of authentic historicity even as they claim historical pedigree. As an observer of the changing dressing styles, my perception of the *hijab* and its place in Nigeria is varied and contingent on who wears it, and indeed where, when, and how it is worn and adorned. However, what is consistent in my mind is the prominent weight of the politics of rights in the choices women, and indeed men, make about this cloth. I hypothesize that the *hijab* serves as a symbolic interface of including or excluding women's voices in exercising and negotiating power in public politics.

As Mallam Shuaibu Pate noted, "In those days there was not much of this religious talk as today. A man worked his farm together with his wife. It is now different, you will not find many women on men's farms. If you see them farming, it is their own farm (*gayauna*). Nowadays they also work as hired hands in other people's farms. Even if you are the husband you have to pay them to work on your plot" (Interview, 2010).

Until very recently, the *hijab* as part of discourses of power and/or religious faith in Nigeria has largely been non-existent. I will quote extensively from an interview with Malam Musa, a near-octogenarian whose life has run the gamut of female dressing for nearly a century.

> Nowadays there are more women, and at the same time they are more *mukami* [hold privileged positions]. This is because women in the past were *sakarai* [unreliable or lacking common sense]. In addition, modern people speak more of the fear of God, but in their hearts people of the past were more God-fearing.

I asked my informant to explain what he meant by that. He continued:

> For example, in our village/town in the past, you would hardly find three adults among our neighbors such as Ate, Mati, Attau, Kurma, Rabo, Shawai, Audu, etc., all of them respected elders, fasting during Ramadan (Interview, 2011).

Malam Musa's philosophical thoughts suggest to me the importance of being perceptive to what obtains in reality. Fasting for Ramadan is one of the five pillars of Islam, one which, he argued, few people observed in the past. However, he thought the general conduct of the same people was

more decent than that of people today, and he went on to give examples of cheating and so on. I concluded a previous article on *hijab* thus: "wearing the hijab is a demand that can only be required of urban women, because of the nature and location of their work" (Mahdi 2009:11). My case rests on the one hand with the different attitudes and arguments presented by urban elites, both academic and state actors, and the use of instruments of state to alter women's dress code. On the other hand, it considers the practical circumstances of rural people, both men and women, whose livelihoods dictate their relationship to dressing.

NOTES

I thank the following people who agreed to be interviewed for my research:

Interviews 2010
Shuaibu Pate, Birnin Kuka
Kudi Maryam, Birnin Kuka
Mallam Abdulhamidu, Birnin Kuka
Mallam Musa, Birnin Kuka

Interviews 28–29 July 2011
Mallam Musa, Nakaye and Birnin Kuka
Maimuna, Nakaye
Nana Fatsuma, Nakaye
Halima

1. The types of veils that pre-date the 1970s have been discussed at length. "*Kallabi* is a scarf of approximately one square meter or less, folded into a triangle and firmly tied from the forehead and knotted at the back of the neck to cover only the head, sometimes only partially. An alternative to *kallabi* is *saro,* which has the same width as *kallabi* but is twice longer, less often used, covers only the head, and often only partially. *Gyale* is rarely less than two meters long, with varying widths but seldom exceeds a meter. It is used in many ways: either it is folded lengthwise and thrown back over the shoulders making a triangle on the chest; folded to a quarter of its full length and thrown on one shoulder; or it is spread out to its full length and width to cover from the head down or from the shoulder down, as far as the material can go. When it is adorned in the last style it becomes *mayafi,* meaning a throw around" (Mahdi 2009:2).

2. The *niqāb* covers the face, leaving the area around the eyes clear; *burqa* covers the entire face and body, with a mesh screen for the eyes; *al-amira* is a two-piece ensemble with a close-fitting cap; *shayla* is a rectangular cloth thrown over the head, usually exposing the front of the neck; the *khimar* is a long, cape-like veil that hangs down to the waist, covering the head and shoulders completely, leaving the face open; and the Iranian *chador* loosely covers the whole body.

3. I will give limited information about my respondents to minimize any potential repercussions for them and their families, although I do provide their

first names, and the general area where they reside. All three men who offered the details on textile production, women's dresses, and fashion are from Katsina State, close to the Kano State and Niger Republic borders. They are Mallam Abdulhamidu, a centenarian who passed away in early 2011; Mallam Musa, and Mallam Shuaibu, either octogenarians or nonagenarians. I interviewed Mallam Musa several times from July 2010 to August 2011. The others were interviewed in July 2010 only.

4. *Hannu uku* means three arm-lengths, from the elbow to the tip of the middle finger, and was used as measure of textiles in Hausaland, according to Mallam Musa.

5. *Walki* is a plain, tanned sheep hide used as a wrap-around for men. *Bante* is a man's panty brief made from tanned sheep hide.

6. A *tiya* or *tia,* in my estimation, is a measure for grains the contents of which would weigh around one kilo.

7. *Karabi* is closest to an apron that hangs around the neck on to one side of the body, and is made from tanned leather.

8. It is difficult to translate *mayafi* and *lullubi* directly into English. Both mean "to cover," but the latter implies a more encompassing covering, meaning "to cuddle," while *mayafi* implies a looser covering.

9. In December 2008, I interviewed five young women between the ages of seventeen and thirty who were on vocational training run by a non-governmental organization in Kano City. One of them was married with children; the others were not. All of them wore the *hijab* when they left the school. They are Mariya Garba, Zulaiha Musa, Laila Abubakar Guri, Aisha Abdullahi, and Habiba Aliyu. My interviews with them were not directly on *hijab,* but rather on personal life situations, including issues of education, family relations, and boyfriends and husbands.

10. Telephone interview with Halima, March 2011.

11. *Abaya* is the name of a specific type of *hijab* or loose cloak-like veil with sleeves, and it is often of black cloth. However, I used the word in my interviews with the women because that is what they call their *hijab.*

12. Interview with Maimuna, 29 July 2011.

13. Interview with Nana Fatsuma, 29 July 2011.

14. The *ashasha* is a more recent implement for tilling sandy soils of the Sahel savannah that is used in many parts of this geographical region, including both Niger and Nigeria. The implement has a wide V-shaped iron head attached to a thin wood shaft of about a meter and a half long, although the length can be shorter or longer depending on the height of the user. The implement is used in an upright position but requires a free movement of the arms, as the farmer pushes the implement in front of her as she tills.

15. I have discussed the influence these religious organizations exert on women to wear the *hijab* in Mahdi (2009).

16. "Nigerian skimpy dressers arrested," BBC News, 7 July 2007. http://news .bbc.co.uk/2/hi/africa/6919581.stm.

17. In 2009, a nurse was dismissed for wearing a *hijab* whose length supposedly exceeded the allowed length at the Ahmadu Bello Teaching Hospital Kaduna. What should have been an administrative concern led to a massive mobilization of religious CSOs and the intervention of the Kaduna State Council of Ulamas.

WORKS CITED

Abdulraheem, Nimatallah Modupe. n.d. The hijab, barristers' dress code and religious freedom in the legal profession in Nigeria. Working paper, University of Ilorin. http://www.unilorin.edu.ng/publications/abdulraheemnm/THE_HIJAB_BARRISTERS_DRESS_CODE_AND_RELIGIOUS_FREEDOM_IN_THE_LEGAL_PROFESSION_IN_NIGERIA.pdf (accessed 7 October 2011).

Abu-Lughod, Lila. 2002. Do Muslim women really need saving? Anthropological reflections on cultural relativism and its other. *American Anthropologist* 104 (3): 783–790.

Adaramola, Zakariyya. 2008. Muslim group wants indecent dressing bill. *Daily Trust,* 18 July. www.dailytrust.com (accessed 18 July 2008).

Alliances for Africa (AFA). 2008. Unconstitutional and indecent: A legal opinion on the indecent dressing bill. http://www.imow.org/dynamic/user_files/file_name_183.pdf.

Bayero, Mariam. 1998. The prescribed mode of female dressing by Allah's Shari'ah: A case for Muslim lawyers. *Al-Maslaha—A Journal of Law and Religion* 1: 92–109.

Bello, Ahmadu, Sardauna of Soto. 1986. *My Life.* Zaria: Gaskiya Corporation.

Boyd, Jean. 2000. *The Caliph's Sister: Nana Asma'u 1793-1865, Teacher, Poet and Islamic Leader.* London: Frank Cass.

Danbatta, M. Magaji. 1958. What impresses these women. *Nigerian Citizen,* 23 July.

Dudley, Billy J. 1968. *Parties and Politics in Northern Nigeria.* London: Frank Cass.

Ekaette, Eme Ufot, et. al. 2008. *Bill for an Act to Prohibit and Punish Public Nudity, Sexual Intimidation and Other Related Offences in Nigeria.* SB [Senate Bill] 13.

Gabriel, Chioma, and Uduma Kalu. 2008. Nudity bill Nigeria's worst moment at the UN. *Vanguard,* 19 July 2008. http://allafrica.com/stories/200807210369.html.

Global Fund for Women. 2011. Top ten wins for women's movements. *Global Fund for Women: Top Stories.* http://www.globalfundforwomen.org/impact/success-stories/top-10-wins-for-womens-movements-2011.

Hammami, Rema. 1990. Women, the hijab and the intifada. *Middle East Report* 164/165:24–28, 71, 78.

Igho, Eferovo. 2011. Time for dress code for Nigerian women. *Nigerian Village Square,* 8 March 2011. http://www.nigeriavillagesquare.com/articles/guest-articles/time-for-dress-code-for-nigerian-women.html.

Kraft, C. H., and A. H. M. Kirk-Greene. 1977. *Hausa.* Sevenoaks, Kent: Hodder and Stoughton.

Last, Murray. 2000. Children and the experience of violence: Contrasting cultures of punishment in northern Nigeria. *Africa* 70 (3): 359–393.

Lehmann, David. 1998. Fundamentalism and globalism. *Third World Quarterly* 19 (4): 607–634.

Mahdi, Hauwa. 2006. Gender and citizenship: Hausa women's political identity from the Caliphate to the Protectorate. Ph.D. diss., University of Gothenburg.

———. 2007. Sharia in Nigeria: a reflection on the debates. *Gombe: Journal of Gombe State University* 1 (1): 95–121. Also in *Arbete, Kultur, Politik: en vänbok till Lennart K. Persson*, ed. M. Cavallin Aijmer, et al., 273–294. Göteborg: Göteborg University.

———. 2009. The hijab in Nigeria, the woman's body, and the feminist private/public discourse. Working Paper No. 09–003. Evanston, Ill.: The Roberta Buffet Center for International Comparative Studies, Northwestern University.

Maiwada, Salihu, and Elisha Renne. 2007. New technologies of machine-embroidered robe production and changing work and gender roles in Zaria, Nigeria. *Textile History* 38 (1): 25–58.

Mernissi, Fatima. 1991. *The Veil and the Male Elite.* Cambridge, Mass.: Perseus Books.

Mir-Hosseini, Ziba. 2007. The politics and hermeneutics of hijab in Iran: From confinement to choice. *Muslim World Journal of Human Rights* 4 (1). http://www.degruyter.com/view/j/mwjhr.2007.4.1/mwjhr.2007.4.1.1114/mwjhr.2007.4.1.1114.xml?format=INT.

Mir-Hosseini, Ziba, and Vanja Hamzić. 2010. *Control and Sexuality: The Revival of Zina Laws in Muslim Contexts.* London: Women Living under Muslim Laws. http://www.wluml.org/node/6869 (accessed 1 September 2011).

Oba, Abdulmumini A. 2009. The hijab in educational institutions and human rights: Perspectives from Nigeria and beyond. *Identity, Culture and Politics: An Afro-Asian Dialogue* 10 (1): 51–74.

Obende, Senator Domingo, et al. 2011. *An Act to Prohibit Marriage between Persons of Same Gender, Solemnization of Same and for Other Matters Related Therewith.* SB [Senate Bill] 05, No. C896 2011.

Ogunbiyi, I. A. 1969. The position of Muslim women as stated by 'Uthman b. Fudi. *Odu*, n.s., 2: 43–60.

Vandu, Chippla. 2007. Between Christian and secular Talibans. *The New Black Magazine*, 19 November. http://www.thenewblackmagazine.com/view.aspx?index=1087 (accessed 12 September 2011).

Wadud, Amina. 1999. *Qur'an and Woman: Rereading the Sacred Text from a Woman's Perspective.* New York: Oxford University Press.

———. 2006. *Inside the Gender Jihad: Women's Reform in Islam.* Oxford: One World.

"We Grew Up Free but Here We Have to Cover Our Faces": Veiling among Oromo Refugees in Eastleigh, Kenya

PERI M. KLEMM

THE ADOPTION OF the veil among Oromo refugees living in Eastleigh, Kenya, one the largest urban refugee communities in Africa, is a recent phenomenon. Women feel increasing pressure to cover their heads and bodies in accordance with the practices of their Somali neighbors and fellow refugees. More and more, as instability and violence escalate, Oromo women are choosing to adopt full hair, head, and body covering as a kind of urban camouflage with which to conceal their ethnicity. As one female resident acknowledged, "We grew up free but here we have to cover our faces" (B. B. H., personal communication, September 2011).[1] Yet, just five years ago, Oromo women in Eastleigh proudly wore their cultural dress in public. For refugees with little in the way of material heritage, women's dress, hairstyles, and jewelry have served not only as a vital marker of Oromo identity in their home country of Ethiopia but also as a fundamental assertion of Oromo nationalism in the diaspora.

In the West, the emblematic removal of the veil by Muslim women is a testament to a woman's sense of empowerment and liberation. For Oromo women, I will argue, the opposite is true, as only through veiling do women feel free and secure. And while the phenomenon of veiling by Muslim women as a public display of modesty has become a metaphor in Western popular media for female subordination and gender asymmetry, especially post–September 11, the Oromo example is one in which women veil to protect themselves from harassment, rape, and imprisonment.[2] That they feel so threatened is hardly a recommendation for veiling. Yet whether it is viewed as empowering or repressive by the women themselves, they speak of this choice as a strategy. While women, as reflected in their deco-

rated bodies, have always been viewed as those who create, reproduce, and transmit traditional Oromo consciousness (*Oromumaa*), the wearing of *abaya* (a long, full dress), *hijab* (hair, neck, and torso cover), and *niqab* (facial veil) is a recent and temporary tactic by refugee women to outwardly guard their ethnic affiliation (Figure 8.1).[3] This chapter explores the ambivalent relationship refugee women have today to the wearing of this dress.

The Veiling Phenomenon

When I arrived in Eastleigh, Kenya, the refugee-dominated suburb of Nairobi, in spring 2010 to continue my research on Oromo women's dress, I was disappointed. The situation I knew from 2004, where refugee women took great pride in recreating and displaying the traditional costumes of their homeland in Oromia, Ethiopia, had changed. Instead, these same women were now publically covered: a loose, long-sleeved, floor-length dress (*abaya*) and a small scarf to hold the hair in place (*mandila*) covered by a longer scarf or a sewn garment that fits securely over the head and reaches down to the knee, enveloping the head, neck, and torso (*hijab*). More and more, women are also veiling their faces (*niqab*).[4] This entire ensemble is referred to as "that which covers the body," *jilabiya* (in Arabic, *jilbab*), in Eastleigh.[5] Today, as hundreds of drought-affected refugees stream into the Kenyan refugee camps and shanty towns near Nairobi on a weekly basis and a heightened sense of desperation and fear infuses the place, few Oromo women would dare don traditional dress.[6]

Sleeping in the multipurpose living/sleeping/dining/prayer room commonly found in most refugee households, I was pleased to find, however, that my hostess had kept the familiar trappings of an Oromo Muslim interior dwelling, including a carpeted room with pillows along the wall covered in intricate embroidery of flowers and leaves. These small and durable cases, along with her prayer mat, a clay coffee pot, and a *Qur'ān*, are often the only non-necessities an Oromo woman will carry with her when she flees her country. In time, she will strive to recreate the sitting rooms of Muslim Oromo families back home, complete with these hand-embroidered pillows, walls decorated with Oromo-made baskets, and imported items of prestige. These foreign items might include Arabic rugs, wooden trays stacked with porcelain demitasses for coffee placed on plastic grass, and a doily-adorned television set ready to play an assortment of videos of Oromo weddings, singers, and comedians when the power comes on. In addition, items only found outside Ethiopia, such as clocks in the shape of Oromia and national flags, can also be found on the wall.

FIGURE 8.1. The woman on the right wears *abaya* with *hijab* while the woman on the left wears *durriyya* and *gogora* with a *foota,* although the *gogora* is hidden beneath her skirt in this image (photograph by P. Klemm).

These interior spaces, free from the eyes of strangers, have not changed. How is it that dress, then, has so completely transformed? In my discussions surrounding nationalism and dress within the Oromo community in Eastleigh and surrounding suburbs in 2004, women's bodies and their personal arts were viewed by men and women as instrumental in the production and preservation of Oromo identity and culture. As the designers and assimilators of Oromo cultural symbols, female bodies have become the most tangible, albeit subtle, means to display Oromumaa in Oromia and the diaspora (Klemm 2009:55). In Eastleigh, where many Oromo have settled and are visibly present, aspects of traditional Oromo culture were routinely celebrated with pride. Christians, Muslims, and traditional practitioners (*Waqeffannaa*) recounted that Oromumaa is cause for celebration, especially in Eastleigh, where one is no longer under the watchful eye of the Ethiopian government and has ample time on his/her hands. On public occasions, including political marches, church and mosque festivals, and cultural holidays, Oromo traditional dress along with modern t-shirts, scarves, and flags in red, yellow, and green emblazoned with the

PERI M. KLEMM

sycamore tree, a pan-Oromo symbol of democracy and peace, were noticeably present.

In early 2000, for example, the Saphalo Education Foundation staged a cultural day in the outskirts of the city to serve the Oromo refugee community. All Oromo living as refugees in the city or in Dadaab and Kakuma refugee camps were invited to participate. In the countryside under a ficus tree, several hundred Oromo men, women, and children, originally from all areas of Ethiopia, came together to hold a prayer ceremony (*wadaajaa*), drink coffee (*buna qalaa*), and celebrate their heritage with singing and dancing. The events were recorded on video by the Saphalo staff and duplicated so the community, which is transient by nature, could enjoy the performances more than once.

That day, all female participants who could afford it purchased and wore a white cotton dress with a green and red border. Lineage-based body arts, so central to rural communities within Oromia, were discarded for an emergent pan-Oromo look. No longer tied to regional styles, women were zealously buying and sewing cloth, embroidering designs, and beading headbands and necklaces with Oromo colors and words. This new dress, created in the wake of great hope for a new life free from suppression by the Ethiopian regime, was a means through which women felt unified and supported in their ethnic affiliation. The dress was loosely based on the dominant dress style of rural eastern Oromia, the white *saddetta*. A length of white sheeting wrapped toga-like around the body and secured with a cloth belt and a final tie at the right shoulder, the *saddetta* is the dress of choice for all ritual and lifecycle events and is still worn daily by postmenopausal women in rural communities (Figure 8.2).[7] Saddetta, meaning eight, is cut from eight yards of cloth, originally handwoven and later created with merikani cloth from the United States. The Eastleigh dress retained this white sheeting but with added trim, and some women had it tailored into a tunic and skirt. This ultimately covered more of their arms and back and was considered more modest and thus more appropriate to their new, urban environment.

In 2010, women told me that this kind of dress and other more traditional styles are only worn at weddings where they are still the appropriate dress for female participants. Women conceal their white *saddetta* under a dark *abaya* and display their cultural dress only when they are safely in the wedding hall or in the countryside, where they can dance, sing, and engage in ritual unobserved by city officials and neighbors (Figure 8.3). The festival of 2000, which was intended to create harmonious relations between the Oromo participants and their environment, has not been practiced

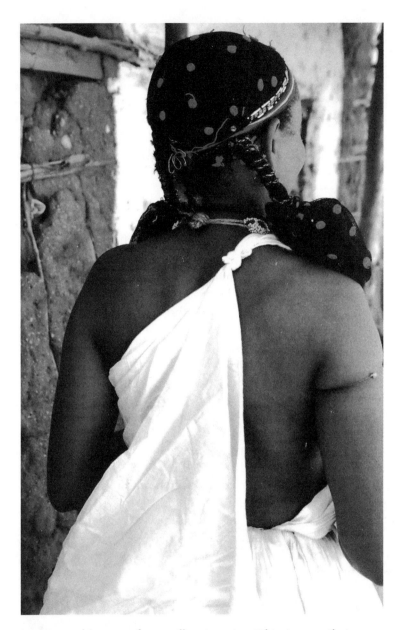

FIGURE 8.2. This woman from a village in eastern Ethiopia wears the traditional women's dress of the region: *saddetta,* a dress of white sheeting wrapped around the body and secured with a belt and a tie at the right shoulder. Her hairstyle, called *hamasha,* consists of a part down the middle with the hair allowed to ball at the bottom after being twisted. It is covered with *gufta,* a black, embroidered net (photograph by P. Klemm).

again. Further, Saphalo, a community-based organization founded in 2000 to serve the needs of Oromo refugees living in the Eastleigh neighborhood, is now close to lifeless. The free classes in English, Afaan Oromo, and computers taught by volunteer Oromo and Kenyan teachers, the music program, and the dance and theater groups are offered only sporadically. The Saphalo Foundation motto, "let us learn while we are on the run" is no longer embraced as in 2004 (when donor backing and class sizes mushroomed), and more and more adults relinquish education to remain indoors at home. A twenty-three-year-old Oromo mother stated, "We are unable to dress culturally. We can't express our culture like before. If we celebrate, they are more hostile" (Oromo Support Group 2010:35).[8]

Today, women restrict their movement. When they must go out, they tie their hair back with a headscarf called *shashii* or *mandila,* put on a full dress that disguises their form, and cover their head and torso with *hijab.* These items, readily available in the numerous dress shops in Eastleigh's malls and sold by Somali and Arab vendors, come from Saudi Arabia, Pakistan, the United Arab Emirates, Afghanistan, India, and China. But women can also purchase the cotton, silk, or polyester fabric, ranging in color from black to blue-black to dark brown, and have it sewn by male tailors who wait outside the cloth shops (Figure 8.4). Imported ensembles can fetch up to 10,000 KES (approximately US$100), while locally made dress can cost a mere 1,500 KES (approximately US$15). Underneath the public *abaya,* Oromo women usually wear the national dress of the Ogaden—a long dress with short sleeves of thin, imported rayon, called *durriyya,* worn with a brightly-colored cotton or polyester underskirt with eyelet design, called *gogora.*[9] The *durriyya* extends to the ground, and in order to keep it from dragging, women will tuck the sides into the elastic waistband of the *gogora,* revealing the lacework trim of the *gogora* as they move. As it is lightweight, is easily cleaned, and doubles as a nightgown and house dress, this dress set is the private wear of choice for Somali and Oromo women. For those Oromo women who have lived with or near Somali communities in eastern Ethiopia, this dress may be quite familiar. For others, it is another type of adaptation.

Being Oromo in Eastleigh, Kenya

Eastleigh, known by locals as Little Mogadishu, refers to the sprawling outskirts of Nairobi where Somali refugees have created one of the most competitive commercial centers in East Africa amid garbage piles, open sewers, and heightened criminal activity. It is so well known that

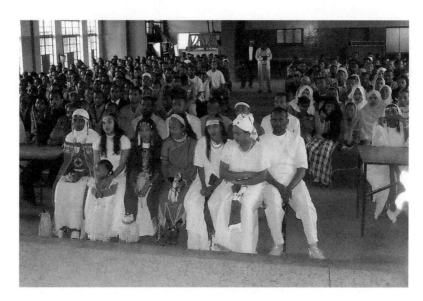

FIGURE 8.3. Refugee women in Eastleigh wear cultural dress on the occasion of a graduation for adult students of the Saphalo Education Foundation. They clapped and ululated when students received their certificates (photograph by P. Klemm).

Somali- and Oromo-populated high-rises in Minneapolis are called "Little Eastleigh" by their tenants. When I visited Eastleigh in 2004, the Kenyan police would not come after dark, a time when the streets were unsafe and tenants in the upper stories who had to relieve themselves threw baggies of human waste onto the street below rather than face the danger of unlocking the door to access the common, ground-floor pit-latrine. Six years later, the police presence had increased—but to the dismay of many refugees, who describe their activities as suspicious: stopping crime one day, demanding brides and confiscating precious documents on another (B. Y., I. M., personal communications, April 2010). Most refugees in Eastleigh reported having been detained by the Kenyan police at least once. They could leave only when relatives or friends brought bail—ranging from 5000 KES to a mobile phone (Oromo Support Group 2010:41). Further, local Kenyan gangs come through Eastleigh and prey on those who appear vulnerable, following single women to residences and shops where there are goods to steal. Almost all women I spoke with in 2010 had had cell phones, earrings, purses, and watches taken or their homes looted.

Further, the escalation of Islamic fundamentalism and with it, the rumors that Eastleigh has become the latest recruiting center for militant

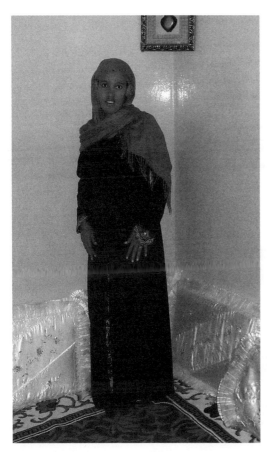

FIGURE 8.4. An Oromo woman in her sitting room in Eastleigh. She wears an *abaya* dress with embroidered and beaded sleeves made in Saudi Arabia and purchased in a Somali boutique. Her head and hair are covered with a *foota* (photograph by P. Klemm).

groups such as Al-Shabaab and the growing infrastructure attributed to Somali pirate investments, means that Eastleigh has become synonymous with power, wealth, extremism, and lawlessness. This makes for a unique situation that Kenyan administrators are currently striving to control. In the meantime, Oromo refugees face persecution from the local police, undercover Ethiopian officers, Kenyan gangs, neighboring refugees, radical Islamic groups, and the Somali who control the city. A young woman recalls that in 2010 she heard that Al-Shabaab was coming to her camp at night to "kill all the Gaal" (a term that has gained popularity recently among the Somali to refer to "pagan" Oromo). "Nobody slept the whole night," she explains (Oromo Support Group 2010:29). A thirty-four-year-old former detainee describes her situation: "I can't count the number beaten and raped here. I spent six years and four months in prison in Ethiopia and I feel more frightened here" (Oromo Support Group 2010:39).

The streets of Eastleigh are filled with hundreds of young men who are unemployed or underemployed and have very little hope for resettlement. The nearest refugee camps, Dadaab and Kakuma, are several times over capacity in 2011 due to the drought in Somalia and Ethiopia. Dadaab is now the largest refugee camp in the world, with almost half a million people. Many Oromo living in the camps and the cities are designated as urban refugees by the United Nations High Commissioner for Refugees (UNHCR), but unless they are able to secure a mandate letter of residence, which may take several years, they are living illegally and are more vulnerable to arrest and refoulement. By and large, refugees in Eastleigh are growing increasingly disillusioned, unable to return to their countries and put off each year by overworked UNHCR staff. Since the time of my first fieldwork in 2002, I have seen several young Oromo families I knew from Ethiopia wait ten years or more for a mandate letter. Many now have children who will never know the homeland of their parents and who have, at best, an uncertain future. Education for refugee children is free, so many attend national schools or mosque-sponsored madrassas. In both institutions, Muslim girls are expected to wear *abaya* and *hijab* as soon as they enter school (Figure 8.5).

Today the number of Oromo refugees and asylum seekers in the Nairobi area is estimated at over twenty thousand (Trueman 2011:21). This number is likely much higher, given the fact that many displaced Oromo are never granted or never apply for official status as refugees or asylum seekers. Oromo refugees first began to come to Eastleigh and the surrounding camps in large number in the mid-1990s. Many had been accused of supporting the Oromo Liberation Front (OLF), a political organization established in 1973 to foster self-determination, equal political representation, and freedom for all Oromo people within the Ethiopian state. The Oromo, who make up approximately 40 percent of the Ethiopian population, about thirty million people, are the largest ethnic group in the Horn of Africa. Their language, Afaan Oromo, is the most widely spoken African language after Arabic and Hausa (Brooke 1956:69). They are by no means homogenous, living as agriculturists, pastoralists, traders, Christians, Muslims, and traditional practitioners in their homelands in Ethiopia and parts of present-day Kenya and Somalia. They share, however, cultural practices, a common language, a historic governing institution based on age grades (*gada*), an aesthetic system, and a collective experience of Abyssinian colonization. The potential for this population to mobilize under the leadership of the OLF is a perceived threat to the stability of Ethiopia's current government, the Ethiopian People's Revolutionary Democratic Front

PERI M. KLEMM

FIGURE 8.5. All Muslim girls wear *hijab* to school. Their arms, legs, and hair must be covered (photograph by P. Klemm).

(EPRDF). The OLF was outlawed in 1992 and was recently classified as a terrorist organization by the EPRDF. The anti-terrorist campaign has been used to legitimize state-sponsored, ethnic targeting of those perceived as OLF supporters or critics of the state, including nationwide arrests, imprisonments, tortures, and extrajudicial killings (Dugo 2011:3). Dugo argues that the ongoing fight between the ruling EPRDF and the OLF for control over Oromia has led, in part, to the refugee crisis in Kenya today. Ethiopia and Kenya share mutual antagonism toward the OLF, which they view as a threat to their political, social, and economic stability. Under the umbrella of the 2008 anti-terrorism law, the Ethiopian government is now actively retrieving and refouling Oromo refugees in Kenya despite their mandated status with the UNHCR and/or their rights as asylum seekers as dictated in the 1951 UN Convention on Refugees. Kenyan authorities, informants claim, have collaborated with their Ethiopian counterparts by incarcerating and then deporting Oromo refugees.

Within Ethiopia, some Oromo and Somali groups have lived in close proximity since at least the fifteenth century. They have married, fought, competed over rights to grazing lands, and adopted allegiance to either the Ethiopian or Somali nation, depending on their political situation. Many Oromo clans and sub-clans have also shared oaths or joined affiliation with various Somali groups. One group in particular, the Hawiyya in Baabbile, who take their name from one of the largest and most powerful Somali pastoralist clans, appear to be a fusion of a faction of Hawiyya Somali and Babile Oromo who settled together in the area over a century ago. They speak both languages, and during my fieldwork in 1999 in Ethiopia, identified themselves as both Somali and Oromo in origin (M. F., personal communication, March 2000). Today, in Eastleigh, these historical ties are severed and even marriage between the two groups is frowned upon. One Oromo woman noted, "The Somalis say we are pagans. Even at the water tap. After us, they insist on washing the tap, saying pagans have used it. They say we are animals . . . Oromo Muslims and Christians live together OK, but they don't consider us as human beings" (Oromo Support Group 2010:34–35). The rising antagonism between Oromo and Somali on the one hand, and the adoption of Somali dress and veiling practices by Oromo women on the other, signal mounting pressure to subvert and disguise Oromo identity.

Why Veil?

Women's motivations for adopting head, hair, neck, and facial cover are neither simple nor easily categorized. One woman describes borrow-

ing a friend's *niqab* in order to attend a wedding. Her husband could not accompany her to the event and she knew he would not want her to go alone. Wearing *niqab* with her face concealed, no one recognized her in the crowd. She liked the sense of anonymity and power it provided. Another woman wore *niqab* as she felt it best communicated her identity as a practicing Muslim to non-Muslims. Still other women I spoke with felt *abaya* and *hijab* made an appropriate and fashionable alternative to the revealing dress of Christian Kenyan women, who, they felt, appeared overly exposed in public, parroting the worst of Western wear (I. M., B. B. H., D. A., personal communications, April 2010).

Dress has become a central, visual strategy within the Muslim refugee community in Eastleigh, where tensions between moderate Muslims and extremists have escalated since 2004.[10] Women's veiling is a recent condition that communicates the social, political, and economic climate of Eastleigh today. It is therefore a newsworthy topic of discussion among friends, family, and neighbors, who often note how a woman dresses in public. Muslim Oromo women and men readily provided the following seven reasons for the increased use of *hijab* and *niqab* by women during my fieldwork. Reason 1: To go to nightclubs and other non-Muslim spaces undetected, removing the *hijab* and *abaya* once inside to reveal a miniskirt or jeans. This explanation was most popular among unmarried women under twenty-five years of age. These young women have very little opportunity to meet publically, hear new popular music, dance, and enjoy the company of members of the opposite sex in other contexts. Reason 2: To appear in public like rich Somali women. One husband stated, "Somali refugees eat meat every day, drink tea with milk in it every day and their women dress smartly. Oromo women see the way they dress, the ornaments they wear, and ask their husbands, 'why not them?' Husbands feel they can't compete and lose pride" (Trueman 2011:37). In this sense, Somali dress reflects women's economic goals. Women did not necessarily view *hijab* and *abaya* as a symbol of piety or its owner as any more religious than other women in their community. Instead, *abaya* and *hijab* represented the luxurious, transnational fashions from countries like Saudi Arabia and Oman and gave the wearer a worldly, modern air. Reason 3: To appear to be the recipient of support from family and friends in Western countries and thus be subject to less harassment than those who don't have a connection to outside assistance. Women perceived as Somali, for example, felt they would be less targeted by thieves, as their dress indicates that they have access to wealth and a larger community of support. In other words, Somali men might be more likely to step in and assist a

woman who is publically assaulted on the street or when gathering water or wood away from the camps. Reason 4: To garner support from the more militant mosques which provide alms for the poor and free or inexpensive education for children. Reason 5: To appear to embrace a nascent religious fanaticism, especially at times of crisis. This was viewed as a good and a bad thing by different individuals, but all agreed that moderate Muslims such as Shaykh Mohammed Rashad and Shaykh Bakri Saphalo, who advocated for a religious foundation in Oromo heritage, are today publically denounced by radical Muslim sects in a campaign against moderate Islam. Women want to disassociate from the more moderate movements. Yet critics of the more radical clerics say these men are working in favor of the Ethiopian government, which is trying to create rifts between Oromo populations in the diaspora. Reason 6: To dress fashionably and to be modern in accordance with their Islamic belief. When I surveyed Somali and Oromo acquaintances on Facebook in August 2011 who either had lived in Eastleigh or had relatives there, most responded that it is the Islamic way of life to dress modern in *abaya* and *hijab*. And reason 7: To provide protection from Ethiopian agents. Government officials are thought to disguise themselves as civilians and kill or kidnap refugees who are viewed as anti-EPRDF and as OLF supporters. Some Oromo feel that infiltrators are in Eastleigh in order to play one group of Oromo against another, to gather information for the government, and to refoule OLF sympathizers and their family members. A forty-two-year-old Oromo woman explains:

> We Oromo women living in Eastleigh wear *hijab* or *niqab* to protect ourselves from attacks by Ethiopian agents living amongst us. There is no religious reason, as we are Muslims for generations and there was always harmony between our culture and moderate religion. Religion is being used as a tool to agitate others to abandon their traditions and embrace a stricter adherence to Islam. If somebody openly wears traditional clothes, it is simple to label her a supporter of OLF, which in turn has serious consequences, including forceful deportation to Ethiopia. (B. B. H., personal communication, September 2011)

Her friend continued:

> Islam is the religion of our fathers' grandfathers, but the underlying reason to wear it here is to protect our identity and hide from Ethiopian agents or spies secretly operating here in Eastleigh. If you wear Oromo traditional clothes, you can be easily traced and accused of supporting or sympathizing with OLF, the arch-enemy

of the Ethiopian government. We have been forced to hide our traditional clothes in our houses, though it is source of our pride and dignity to wear something that is original and belongs to us. Unfortunately we are under pressure from so-called religious scholars who are openly discouraging Oromo women from wearing our own cloth. It is the interest of almost all Oromo women to wear clothes of her taste of interest. It is the denial of right to choose that has reduced us to slavery. (K. D. H., personal communication, September 2011)

The fact that Oromo informants did not mention Islam as the reason for their choice to veil suggests that this fundamental garment equated with Islamic conviction in the non-Muslim world needs further consideration within the African context. The veil is a powerful symbol of disguise that allows Oromo women to blend in, become Somali, appear wealthy, and escape persecution. In this sense, veiling is a potent means of survival at this moment.

Veiling and Concealment in Traditional Oromo Thought

In rural communities in eastern Ethiopia, where Oromo clans have professed Islam since at least the fifteenth century, only a few dozen women were wearing *hijab* in the last decade (Plate 8).

While the wearing of *hijab* is new to many refugees, the need for concealment is embedded in the Oromo aesthetic system. Oromo women, especially those who are young and beautiful, are involved in a complex negotiation between attracting the gaze of young men through bodily enhancements and repealing harmful spirits, strangers, and those with the evil eye (*buda*). This is achieved by covering and containing certain parts of the body and using multiple materials, colors, and textures to be attractive and, at the same time, to direct the focus of the gaze. The Oromo aesthetic of dress arrangement is dependent on two competing concepts within Oromo society. On the one hand, sacred objects and acts should be kept hidden. In this sense, the most spiritually or socially powerful body art practices should not be perceptibly pronounced. On the other hand, women should be recognized first and foremost for their ethnic distinction, a process that is only made possible by drawing attention to the ensemble of things with which they decorate their bodies. These two ideals between concealing that which is most value-laden and making available the visual symbols of Oromo identity are brought into dialogue on the body through an aesthetic of accumulation. This accumulation of adornments is mapped

together onto the body, creating a layering of form, color, and texture for the eye to perceive. This is achieved at a woman's head, for example, by layering fiber, cloth, and beaded bands over and under a hairnet and head-scarf that may be further ornamented with flowers and herb sprigs, while more potent medicines and stones remain tucked up under the hair. This layering effect both disguises the clarity of individual objects and brings them into a relational patterning with other similar and different items. As objects shift in position or as they are replaced with items of more modern appeal, such as temporary pink nail polish dabbed onto the face over permanently tattooed marks, they continue to be arranged through this aesthetic of accumulation. In eastern Ethiopia among the Afran Qallo Oromo, for example, women wear *saddetta* wrapped and belted around the body with a scarf loosely draped over the head. Visible beneath the scarf is the distinct hairstyle of married women—two balls of hair bouncing at the shoulder, called *hamasha.* The hair itself must be tightly contained in a black, mesh hairnet called *gufta* (see Figure 8.2). While not all Oromo women wear *gufta* and *hamasha* after marriage, keeping the hair contained is intentional throughout Oromia.[11]

Within Oromia, the visual language of hair and its various modifications and supplements communicates a woman's position in society, including her marital and reproductive status, her clan affiliation, and her social and economic position. Hair publically indicates the physical and social changes of a woman's life: short and full in the prime of life, and thinning, flattening, and lengthening as she ages. Hair parallels the life-cycle of her breasts, which grow into fullness at adolescence and ripeness at pregnancy, then flatten and lengthen in post-childbearing years. Female toddlers have their heads shaved save for a ring of hair at the hairline and a small round tuft at the crown. These concentric circles of hair are meant to reference both a thatched house surrounded by a thorn fence and her mother's breast, signifying her tight bond to her mother and her own future path toward homemaking and motherhood (R. M. O., personal communication, March 2000). When she marries, this same woman will part her hair down the center, pull it back, and secure it into two large balls. Over this she will wear a thin fiber headband to keep the *hamasha* style in place and the black hair net, *gufta,* on top. This might be further covered with a long scarf, *foota,* if it is cold out or she is visiting the mosque. In addition, throughout life, hair is adorned with herbs, amulets, shells, leather, and fiber to beautify and protect women. Seed bead and silver headbands can accentuate and call attention to a girl's intricately braided hairstyle,

PERI M. KLEMM

while pungent herbs and shiny amulets can shield the head of attractive girls who might fall prey to the evil eye of jealous neighbors and strangers.

Unlike modern Islamic dress, a woman's *foota,* a long scarf that is worn over the head and torso, has been worn for centuries in Muslim communities in Oromia, Ethiopia. Richard Burton, the British explorer who visited the walled city of Harar in present-day eastern Ethiopia in the 1850s, remarked that "women of the upper classes, when leaving the house, throw a blue sheet over the head, which, however, is rarely veiled" (Burton 1987:17). The *foota* can be removed and readjusted in public and the *gufta* itself may be visible without consequence. *Foota,* as an outer headcloth that can be used to shield the wearer from the gaze, is not dissimilar to the *hijab* as used by women in Eastleigh today. Both operate in Oromo belief first and foremost as an external referent of Islamic faith—an outer shell of one's religious conviction. It is neither a permanent fixture nor a necessity to the conception of oneself as Muslim. The *foota* and *hijab* activate notions of faith and community by connecting Oromo women to their Muslim neighbors; they conceal that which is most meaningful (contained hair) and they protect from harmful forces. In the case of the *hijab,* women are protecting the identity that they used to work so hard to cultivate: Oromumaa.

The *gufta* that ties down the hair, obscured beneath the foota or *hijab,* is, on another level, a very different kind of adornment in Oromo traditional thought. As the *gufta* is worn publicly and privately, alone and with others, asleep and awake, it becomes a kind of second skin for a married woman. The black coloring and mesh pattern of the *gufta* even resemble strands of plaited hair. Unlike the *hijab,* which is meant to invoke a moral code of concealing the hair before man and Allah, the webbing of the *gufta* allows head hair to be visible. The wearing of *gufta* is therefore not an act of hiding but rather an act of containing as it relates to ideal Oromo womanhood. A married woman is expected to be "contained" in character. This is most clearly articulated through the virtues of patience, restraint, humility, and chastity. Once a woman puts on a *gufta* after marriage, her head hair is no longer cut or braided. Instead, it is allowed to grow long naturally as a woman matures. But it is not allowed to "stand erect" like men's hair or fly about while dancing like in adolescence. It becomes a visual indicator of the convention of the wife and mother within marriage and engagement, and therefore, an important expression of ethnic affiliation.

In the case of Oromo refugees, whose situations have become dire in the last years, the need to hide from a threatening and hostile environment supersedes the previous focus on communicating an Oromo identity. A

woman now covers her Oromoness in favor of an outward armor against forces she cannot control. Asked what she would wear if she were resettled, something all refugees dream of and wait for, an Oromo woman in Eastleigh responded, "If I had a chance to live in a country where there is full rights, I will not be obliged to wrap myself with black clothes. If my right to choose is respected, I will wear the clothes of my preference" (B. B. H., personal communication, September 2011).

Daly (1999:147) writes that "Head coverings . . . portrayed in the print and visual media . . . have tended to depersonalize, essentialize and even objectify Muslim women as no more than a head covering." For Oromo women living in refugee camps, the veil is intended to do just that: it depersonalizes them. *Abaya, hijab,* and *niqab* shield women from their cultural identity, an identity that just six years ago they delighted in promoting and displaying. In this sense, the veil becomes a kind of mask and women manipulate the mask properties of disguise and concealment to create something different than themselves.

How long veiling will be necessary and desirable is unclear (see Arthur 1997). What remains clear is that this recent "switching" that Oromo women engage in between the dress of the public spheres of Eastleigh (*abaya, hijab, niqab*) that hides their ethnicity and the dress of the interior spaces of private homes (*durriyya* and *gogora* or *saddetta*) that reveals their cultural identity suggests that dress is the most potent tool at their disposal in their current situation.

NOTES

I am grateful to the Mike Curb College of Arts, Music, Media, and Communication and the Art Department at California State University, Northridge, for granting me a sabbatical leave to travel to and conduct research among Oromo communities in Ethiopia and Kenya in Spring 2010. Follow-up interviews were conducted in Eastleigh by my research associate Bakalcha Yaya. He and his family continue to live as refugees at the time of this publication.

1. All names of informants are abbreviated to protect anonymity. All translations from Afaan Oromo to English were provided by Bakalcha Yaya, Eastleigh, Kenya.

2. See Donnell (2003) for a discussion of representations of veiling and women's repression in Western media.

3. The spellings (and sometimes meaning) of Muslim dress terms vary slightly from culture to culture in the Horn of Africa. For example, the Somali use *nikab* to refer to face and head covering while the Oromo say *niqab;* the Somali call a small scarf that covers the hair *shaash;* the Oromo, *shaashii.*

4. Most Oromo men continue to wear trousers, collared shirts over t-shirts, and a jacket. Their Somali counterparts wear white tunics called *mudawara*. If an Oromo man can afford it, he will wear *mudawara* for Friday prayer (*salat*).

5. According to Heather Akou (2011:113), *jilbab* has become "the new (albeit controversial) icon of Somali women's dress in the twenty-first century."

6. Abdi (2007:192) notes that Somali women's dress has also gone through similar transformation, particularly in the Dadaab refugee camp, where almost all women now wear *jilbab*. A decade ago, most women wore *durriyya* and *gogora*.

7. Among the Somali, a similar dress style, *saddexqayd*, was once common in certain regions (Akou 2011:46).

8. The Oromia Support Group is a non-political organization which attempts to raise awareness about human rights abuses in Ethiopia. OSG lobbies governments to withdraw support from the Ethiopian government until it abides by its constitution, which guarantees human rights and self-determination for all peoples of Ethiopia. The report cited is based on a fact-finding mission conducted by Dr. Trevor Trueman, OSG Chair, in September 2010 in Kenya on behalf of the Oromo Relief Association.

9. There is slight variation in these dress terms depending on the ethnicity, clan, and regional background of the wearer. In eastern Ethiopia and western Somalia, the pronunciation is nearest to the spelling in the text above. Among Somalis in Minneapolis, the term *dirac* is also used for the dress, and *gorgorad* for the underskirt (Akou 2004:57).

10. In the same vein but with very different means, Somali women in the diaspora in Minneapolis have, since September 11, 2001, stopped wearing the conservative *nikab* for fear of persecution in the U.S. (Akou 2004:59).

11. The importance of dress as a mechanism of concealment is in no way unique to the Oromo. Daly (1997:152) writes that among Afghans, for example, to wear a *chaadar* "is to practice paarda, the concealment in varying degrees of the female body."

WORKS CITED

Abdi, Cawo Mohamed. 2007. Convergence of civil war and the religious right: Reimagining Somali women. *Signs: Journal of Women in Culture and Society* 33 (1): 183–207.

Akou, Heather. 2004. Nationalism without a nation: Understanding the dress of Somali women in Minnesota. In *Fashioning Africa: Power and the Politics of Dress*, ed. J. Allman, 50–63. Bloomington: Indiana University Press.

———. 2011. *The Politics of Dress in Somali Culture*. Bloomington: Indiana University Press.

Arthur, Linda. 1997. Cultural authentication refined: The case of the Hawaiian holoku. *Clothing and Textile Research Journal* 15 (3): 129–139.

Brooke, Clarke Harding. 1956. Settlements of the Eastern Galla, Hararghe Province Ethiopia. Ph.D. diss., University of Nebraska.

Burton, Richard. 1987 [1856]. *First Footsteps in East Africa, or, an Exploration of Harar.* Ed. Isabel Burton. New York: Dover.

Daly, M. Catherine. 1999. The *Paarda* expression of *hejab* among Afghan women in a non-Muslim community. In *Religion, Dress and the Body,* ed. Linda Arthur, 147–161. New York: Berg.

Donnell, Alison. 2003. Visibility, violence and voice? Attitudes to veiling post–11 September. In *Veil: Veiling, Representation and Contemporary Art,* ed. D. Bailey and G. Tawadros, 120–135. Cambridge: MIT Press.

Dugo, Habtamu. 2011. No safe haven: The duplicity of East African states in the transnational Ethiopian war on Oromo refugees. Paper presented at the Oromo Studies Association Annual Conference, University of Minnesota.

Klemm, Peri M. 2009. Oromo fashion: Three contemporary body art practices among Afran Qallo women. *African Art* 42 (1): 54–63.

Oromo Support Group. 2010. *Human Rights Abuses in Ethiopia: Reports from Refugees in Kenya, September 2010.* Westminster: OSG.

Trueman, Trevor. 2011. Ethiopia exports more than coffee: Oromo refugees, fear and destitution in Kenya. Paper presented at the Oromo Studies Association Annual Conference, University of Minnesota.

Vulnerability Unveiled:
Lubna's Pants and Humanitarian Visibility
on the Verge of Sudan's Secession

AMAL HASSAN FADLALLA

> *Journalist Lubna Ahmed Al-Hussein traveled to France to sign a book based on her story on the 23rd of November, 2009. Internet sales of her book . . . reached half a million copies, each selling for 18 Euros, 6% of which will go to Lubna. Lubna told reporters that the book will be translated into various languages.*
>
> —Reuters (Paris), 2009

IN JULY 2009, the transnational media circulated news about yet another grave human rights violation perpetrated by Sudan's Islamist regime, the latest in a series of violent crimes against humanity.[1] Lubna Al-Hussein, dubbed "the pants journalist" for wearing pants in public and hence countermanding the prevailing dress code of modest body covering, was sentenced to flogging after an arrest by the public order police in Sudan. This case became one of the most widely reported narratives about the subordination of Muslim women in the world.[2] Lubna was arrested, along with twelve other women, in a public restaurant in Khartoum and charged with disturbing public order by dressing indecently. Lubna contested the immodesty charge by addressing the media and arguing that at the time of her arrest she was wearing baggy pants, a long blouse with long sleeves, and a headscarf.

During her first trial, Lubna, a UNAMID employee, asked that her UN immunity be revoked in order to allow her to contest the charge as a Sudanese national.[3] In her second trial and in response to transnational attention, the judge altered the flogging sentence and sentenced her to

one month in prison or the equivalent of a US$200 fine. Although Lubna chose to go to prison, the head of the journalists' union paid the fine on her behalf and she was released.

Lubna's case mobilized human rights advocates, politicians, and diplomats to contest the legitimacy of Sudan's Islamist regime and to shame the government (see also Fadlalla 2008, 2009; Keenan 2004 for earlier examples of this human rights strategy of shaming). The sensationalized media coverage of the case, with its focus on the heroic struggles of human rights activists and the condemnation of their oppressors, however, downplayed complex issues such as the debate over equal citizenship rights and the culture of dissent present in this turbulent country. Missing from the media narrative of suffering Muslim women is an oppositional feminist politics concerned with equal citizenship rights and invested in protesting both local and global hegemonies and oppressions. I argue that Lubna's pants served as a symbolic site for competing transsovereign visions about Muslim women's dress, about the meanings of veiling and unveiling, and about morality and freedom. One vision represents a transnational hegemony anchored in neoliberal moral ethos and in discursive practices of universal humanitarianism and human rights (see, e.g., Clarke 2009; Fadlalla 2008; Malkki 1994), and the other represents a translocal order that thrives on moral religiosity and discourses of containment and exclusionary citizenship rights.[4] Within the sovereign transnational vision, Lubna is made visible through the neoliberal ethos of secular democracy, freedom, and humanitarianism, pitted against a competing (oppressive) moral other.[5] But the exclusionary moral terms present in both transnational and translocal visions of women's struggles leave little room for women's maneuvering strategies of empowerment and political dissent that veiling or unveiling may represent. On the one hand, as global citizens, subaltern Muslim Sudanese women can only make their voices heard through a cause célèbre fitting preconceived orientalist narratives of Islam's misogyny (Mohanty 2004; Said 1978, 1981). On the other, as national citizens, they can only gain recognition by lending consent to a hegemonic civilizing Islamic project.

Feminists and anthropologists have paid increasing attention to mass media as a site where gendered discourses and imageries of identities, nationhood, otherness, and imperial racism are reproduced.[6] The fast-growing influence of neoliberal capitalism and the expanding realms of high-tech communication have facilitated the travel of images and stories and have challenged the construction of locality and nationhood in various ways. For instance, the retreat of the neoliberal state from previous social

AMAL HASSAN FADLALLA

responsibilities and the expanding governmental roles of communication networks and non-governmental organizations (NGOs) (e.g., Ferguson and Gupta 2002; Harvey 2005) have led to the spread of a human rights culture that has informed activist discourses and practices globally.[7] In the context of a "new humanitarian order" (Mamdani 2008), the media serve as an important conduit through which stories and testimonies of suffering and victimization are made visible for public consumption (see Levine 2009). I argue here that such testimonies and stories of suffering construct new identities, role models, and causes célèbres whose struggle is alienated from and consumed through hegemonic colonial and post-colonial gender, race, and class relations. To prove my point, I want to propose what I term "routing visibility" as a feminist counter-panoptical strategy for tracing how Muslim women's struggles are harnessed by competing political orders and made visible to legitimate certain kinds of power and authoritative knowledge (Foucault 1980; see also Peters 1997). Muslim women's dress, and the veil in particular, figure as one such focal point for these competing struggles. My analysis of Lubna's case brings the concept of humanitarian visibility into feminists' and anthropologists' growing debate in gender studies. It further shows how competing sovereignties seek political legitimacy through moral assumptions about a vulnerable, veiled and unveiled, feminized body. By routing (course-plotting) Lubna's visibility via cyberpublic and other ethnographic settings during my travel between Sudan and the United States, I attempt to offer an embedded narrative that redirects attention to Sudanese feminists' intertwined histories and to subaltern Muslim women's struggles, particularly as they are exposed through dress. It is also an attempt to redeem the anthropologist's voice from the competitive grip of high-tech media and communication networks that characterize this neoliberal global moment.

The Civilizing Islamic Project: A Brief History

The civilizing Islamic project, *almashraua alhadari,* within which this chapter situates Lubna's case, goes back to the last years of Gaafar Mohamed Nimeiry's dictatorship in Sudan (1969–1985). Backed by the Islamists, President Nimeiry introduced Shari'a law in 1985 as a last-ditch effort to mobilize public support in a sapped economic climate characterized by government corruption, spreading famines, and escalating public unrest.[8] Shari'a law legitimated the silencing of dissent and the reordering of social relations and public conduct, including the regulation of women's bodies, movements, and dress. A massive popular revolution in April

1985, however, put an end to the regime (Collins 2005). But the short-lived democracy that followed failed to abrogate the contested Shariʻa laws and their politically constructed sentimental tie to Islam.

A coup d'état orchestrated by the Islamists in 1989 toppled the democratic regime and reinstated Shariʻa as national law. Furthermore, the introduction of the public order laws in 1991 legitimated government regulations and the surveillance of bodies and minds. Again women took the center stage in nationalist rhetoric and discourses of morality and bodily containment (see also Hale 1997). In particular, women in schools, colleges, and public offices were ordered to veil. This new regulatory order was instituted through a popular policing unit called the public order police (*shurtat alinizam ala'am*) that has the right to detain and punish women who do not abide by the rules in such public spaces. At the University of Khartoum, where I attended undergraduate school, for instance, women guards were appointed to surveil female students whose dress did not fit the modesty code and prevent them from entering the university building. This move generated heated debated among secular and non-secular groups in Sudan, who saw this new policing order as an attack on the multiple practices of Islam in Sudan and their legacy of diverse Sudanese forms of dress. At universities and in public media alike, opposing groups used the Sudanese female bodywrap (*taube*), a marker for northern Sudanese women's national identity, as an example of *hishma* (modesty) to counter the government's monolithic representation of Islamic dress. This time also witnessed a range of resistance strategies by young women, who wore colorful dresses and skirts with colorful scarves to counter the drab Islamic dress (usually long grey or black gowns [*jalabiya*], worn with black gloves, and head covers that show the face only) presented by Muslim sisters and the Sunna resurgence movement that gained increasing support during the Islamist early days. A popular strategy among urban girls in Khartoum was to veil in public and to unveil when they entered private spaces (e.g., parties, clubs, or homes). The scarf, however, which many young women referred to as "just in case" (in English), should be handy in case of any foreseeable threat by the public order police. Thus the production of a hegemonic religious order under Shariʻa law in the 1990s presented the veiled, modest Muslim woman as an icon of national integrity, sovereign identity, and exclusionary citizenship, with other unveiled Sudanese women as its antithesis. Such state-based exclusionary strategies fueled the schism and violent civil war between Muslim Northern and Christian Southern Sudan and led to massive internal and external migration and mobilization of opposition politics abroad. Dispersed Sudanese from Cairo

to the United States utilized multiple cyberspheres to comment on and mobilize against Sudanese domestic politics.

On a transnational level, however, the resurgence of the American right in the aftermath of the September 11, 2001, attacks reanimated a politics of fear, and Sudan became associated with the so-called axis of evil, which was said to threaten global security and values of democracy and human rights (Fadlalla 2008; see also di Leonardo 2008). The representation of Sudan as a place of terror increased dramatically after the escalation of the Darfur conflict in 2003 and the Bush administration's mediatory role in the implementation of the Comprehensive Peace Agreement (CPA) between the North and the South in 2005. These interrelated events have shaped transnational activism for Sudan and influenced Western governments' foreign policies toward the regime. Increasing Western pressures and sanctions, translocal dissent, and splits among the Islamists have led to the relaxation of the Shari a laws but have not abrogated their arbitrary application.[9] Upper-class women are often untouched by these laws, but the arrest and flogging of powerless women for perceived violations of modest dress continues to legitimate the workings of the public national moral code.

Meeting Lubna

It was my second week in Khartoum when two female friends invited me to one of the city's magnificent new Lebanese restaurants. I could not believe I was in the city I had left ten years ago, remnants of which still exist beyond the walls of such marvelous spaces. The restaurant is among many in the capital city that cater to an emerging transnational elite and business class. Sprayed water mist in the air replaced the dry heat of the summer with a cool freshness and mixed with the smell of Lebanese food, Ethiopian coffee, and *shisha.*[10] I looked at the faces around us: mostly Chinese, Arab, and Western expatriates, and a few Sudanese. Such a transnational scene attested to the government's strategy of engaging Asia and the Arab world in order to mitigate the effects of Western sanctions and to the mushrooming of Western humanitarian NGOs in Sudan thanks to its contemporary crises. My hosts pointed to a separate space on the right where women can also smoke *shisha.*

This zone of comfortable consumerism is common in many of the new cafés and restaurants I frequented during my visit. Now one can also enjoy wireless internet services and escape the long hours of power cuts in working-class neighborhoods. Many times I commented to family and

friends about the changing public scene of Khartoum, changes that to the naked eye might make the city seem less restrictive than it was during the first years of the Islamists' imposition of the Shari'a law in the 1990s (dubbed the "public order laws"). It was rare then to see couples intimately sitting side by side in public parks during the day or girls wearing tight pants (with long blouses and headscarves) in the streets of the capital city. Yet for many Sudanese friends whom I asked about this new situation, the changing public scene represents a contradictory façade of a country in turmoil because of the fragile peace agreement and the internal and external pressures imposed on the government. Some of my interviewees in both the United States and Sudan called this public rupture the "Nifasha syndrome," referring to the negotiated "margin of liberties" (*hamish alhuriat*) in the CPA agreement, which allowed for freedom of the press and assembly.[11]

It was not until I read about Lubna's case in transnational Sudanese electronic media—such as *Sudanile, SudaneseOnline,* and *Sudan Tribune*—during my second week in Sudan, that I was able to refine my questions about Khartoum's public contradictions. At dinner one night I spoke with some of my family and friends about Lubna's arrest; their common response was, "girls wear pants all the time. She must have done something really immoral." "What is immoral?" I probed one of my male relatives. He replied, "You know, some girls drink and smoke *shisha* in these public spaces." Such perceptions are not uncommon. Women and girls are easily stigmatized if they are arrested by public order police and punished with flogging for indecent public acts, especially immodest dress. For this reason many would keep silent rather than contest the laws. The debate surrounding such ideas of respectability contributed to my desire to meet with Lubna.

I later met Lubna at the restaurant where she and twelve other women had been arrested. During our conversation, Lubna expressed how she felt about her arrest: "I did not care about myself. I was worried about the young girls who were arrested. Some of them were sixteen years old. I had to comfort them all the way, but the whole scene was scandalous" (Figure 9.1).

Lubna was right to be less worried about her arrest. She is a visible journalist and well known among Sudanese elites and activists for her critical column, Kalam Rujal (Men's Talk), in the leftist journal *Alshafa* (Journalism), established by her late husband Abdel Rahman Mukhatar, who is known as the father of Sudanese journalism. In fact, many people I spoke with tied Lubna's boldness to her marriage with a man who was forty years older than her. Some frowned upon the union of a young woman who came from a less-well-to-do family from central Sudan with a wealthy, well-known man. But Lubna maintains it was a marriage for love and by choice.

FIGURE 9.1. Lubna at Umkulthum Restaurant in Riad, Khartoum, July 2009 (photograph by A. Fadlalla).

She quit her job as a critical writer with *Alshafa* because of the restrictions imposed on journalists and joined the office of the spokesperson for UNAMID. According to Lubna, both her journalism and UNAMID experiences expanded her translocal connections and immersed her in human rights discourses and practices. In fact, as we were sitting at the restaurant, a human rights assistant to the UN Special Human Rights Investigator for Sudan joined the table and took notes on Lubna's case and the latest news.

Within a week after her arrest, Lubna's story covered the pages of top transnational news journals and other media outlets and stirred heated debates about human rights violations and violence against Muslim women (Figure 9.2). Transnational media and activists instantly linked Lubna's case to the ICC indictment of President Al-Bashir and the rape of Darfurian women in an effort to compare a just humanitarian order with a failing Islamic one. This activism and the humanitarian response to Lubna's case ignited Sudanese pro-government media discourses about morality and women's containment as a strategy to contain dissent and defend a vulnerable nation-state. For example, pro-government media depicted the ICC as a tool of Western imperialism mobilized by unpatriotic members of the Sudanese opposition at home and abroad. It responded to the French endorsement of Lubna's case (Fadlalla 2011) as an attack on Sudanese national sovereignty and the definition of morality endorsed by the Islamists' interpretation of Shari'a.

Lost in Humanitarian Visibility

During Lubna's two court appearances, many Sudanese feminist activists demonstrated outside the court to challenge the state's monolithic interpretation of Islam, exposing themselves to police violence and detention. Such violence spurred alliances and solidarities among feminists and various opposition groups in and outside Sudan (Fadlalla 2011). Many feminists I spoke with celebrated the transnational solidarities with Lubna, but they were skeptical about how such solidarities, armed by human rights and humanitarian sentiments, elided the history of Sudanese women's struggle against Sudan's Islamist regime. Under the current Sudanese regime, feminists from different opposition parties have continued their activities in exile and collaborated with human rights organizations, such as the Sudan Human Rights Organization and other NGOs working on Sudanese issues, to contest the application of the public order laws (Yusif 1997). Many activist feminists interviewed said that Lubna's case may serve as a turning point to revive a once-strong women's movement in Sudan, referring to the decolonization period during the 1950s and 1960s when women won major rights related to suffrage, education, employment, and unionization. In an interview with exiled Sudanese Elham Abdel al Raziq, she maintains, "Sudanese women's struggle against oppressive colonial and post-colonial rule goes back to 1946. I will take Lubna's case as a symbol of resistance, a stone that stirred a still pool of history of women's and

AMAL HASSAN FADLALLA

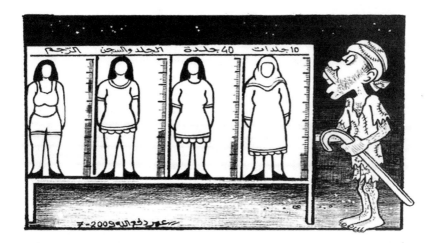

FIGURE 9.2. Political cartoon by the exiled Sudanese artist Omer Dafalla Ahmed, who now lives in the Netherlands. It reads, from right to left: "10 lashes, 40 lashes, lashing and prison, stoning" (courtesy of Omer Dafalla Ahmed, July 2009).

men's struggle to abolish restrictive laws against minorities in the Sudan; Article 152 is just one."

After her first trial, Lubna told me that she had received a call from the French minister for women's affairs, who talked to her at length about her situation and the situation of women in Sudan. The French support for Lubna's cause and concern about her fate was translated into an invitation for her to reside in France (see Sudan Tribune 2009a). This response, however, cannot be divorced from Western liberal ideas and ensuing human rights practices (see Brauman 2004; Mutua 2008). Such ideas are also not immune to Western hegemonic practices and to misconceptions associated with the realities of the people they claim to liberate. In a campaign speech, President Sarkozy presented France as a liberated woman ready to rescue her sisters who have been forced to wear the *burqa* by their misogynist Muslim leaders. These women, in Kouchner's terms, seem to be located in Africa and the Arab world, an assumption that masks the historical struggle of migrant Muslim women in France (see Bowen 2007; Scott 2007). The simplistic assumption behind such messages, as Lila Abu-Lughod (2002) warns, is that Muslim women would remove the veil if oppressive Muslim rulers were overthrown. Although some Muslim women may willingly remove their veils (as Lubna did when she went to

Paris), a large number of Sudanese Muslim women may choose to abide by existing social norms and practices. Codes of honor and modesty have defined the boundaries of private and public in different parts of Sudan for decades and have shaped the ways in which both men and women are socialized. Such disciplinary codes are not static and are constantly negotiated and contested with reference to relations of power and constructions of gender and collective identities (Fadlalla 2007).

Lubna, however, was not unaware of the murky colonial and postcolonial routes she took in her search for human rights and justice. Because of the ban on her travel, Lubna snuck out of the country wearing a *burqa* on her way to France to sign her co-edited book, in which she details the experience of her attempted flogging (see the opening epigraph). In France Lubna removed her scarf and appeared in the media wearing a formal suit during her meeting with Kouchner and other French officials. Her strategic gesture of wearing the *burqa* to break her travel ban and to leave the country is itself a powerful sign of the transformative meanings of Islamic dress. At that unique moment of border crossing, the *burqa* can actually be read as a sign of liberation rather than oppression. Yet when pressed by media about her experiences with Islam and women's rights, Lubna, unlike Hirsi Ali (see de Leeuw and van Wichelen 2005), has remained adamant about her position. At a public ceremony I attended in Khartoum, she maintained her perspective, saying, "Show me where in the *Qur'ān* or *hadīth* it says anything about flogging women for wearing trousers." In her interpretation of these religious texts, at the ceremony, she contested the policing vision of Islam that mandates the "hiring of morality police from taxpayers' money to chase after women." She continued, "The Islam I know respects women and asks men to discipline themselves in order not to violate women's bodies." After her conversation with the French minister for women's affairs, Lubna told me that she had thanked the minister for her support but emphasized that she is using her case to fight for vulnerable women who are subject to the arbitrary application of public order laws. Since the implementation of the Shari'a laws in Sudan, she maintained, powerless women are being harassed, lashed, and jailed without national and international attention, and some of these women are non-Muslims. However, Lubna later accepted the French invitation and is now residing in France for fear of political prosecution.

It is undeniable that Lubna's case struck a gendered chord with translocal human rights advocates and their media allies. It mobilized Sudanese activists and their allies to meld human rights discourses, humanitarian sentiments, and feminist politics to claim a grand narrative of identity and

citizenship that challenges the state's monolithic vision of political Islam. The media serves as the conduit through which Lubna's case was rendered visible. But beyond celebrating such transnational alliances, one ought to ask why the visibility of the 1991 public order law and the struggle against it was rendered possible at that particular moment? Would the lashing of poor women have been visible for the transsovereign humanitarian community and its allied media if Lubna had not been in the right place at the right time? And how does such transnational visibility render invisible other socioeconomic injustices and the plight of women in different parts of Sudan (see Fadlalla 2007)? I argue that such humanitarian visibility requires an initiation on the part of a human rights defender, one who masters the tools of narrating his or her own experiences of oppression to endorse a humanitarian cause (see also Das 2000; Kleinman and Kleinman 1997; Schaffer and Smith 2004). Above all, however, such narration and communication have to be directed toward a savage nation-state that is in dire need of political transformation through liberal democracy (Mutua 2008). In a parallel way, what women wear—pants, veils, burqas—fits into this narrative. Just as this savage state needs political transformation, so Muslim women need to be liberated by Western dress. Women's own perceptions about dress and its temporality as they move through different social and political spaces are ignored.

Sudanese activists whose ideas are shaped by humanitarian practices are not unaware of the usefulness of such practices as mediums of resistance in the face of oppression. Lubna's strategies of veiling and unveiling, her insistence on going to trial for "indecent exposure," are examples of this public resistance. But the limitation of such practices, I argue, is the construction of totemic figures and causes célèbres whose identities and struggles are cut off from their own historical courses and validated through newly constructed routes of visibility that select social and political actors through humanitarian ethos, class status, and an economy of translating suffering as indicated in the epigraph of this chapter.

Back/Lash: When the State Strips Women Down

At Lubna's second court appearance in September 2009, the judge found her guilty on counts of disturbing public feelings by wearing indecent clothing, including unveiling. His sentence was based on Article 152 of 1991. This article, he stated, resembles laws from other countries, such as Nigeria, Somalia, Qatar, and Iraq. Seeking legitimacy through regional and religious alliances, the judge continued, "All monolithic religions preached

women's modesty [*hishma*] and sexual purity ['*aifa*]."[12] Accounts of the trial, circulated on *SudaneseOnline* the same day, described the conflicting statements of the witnesses—who were themselves male members of the police—over the color and form of Lubna's clothing (*SudaneseOnline* 2009). As police officers, sworn to tell the truth, they had the right to gaze at Lubna's bodily attire and to graphically describe it to the public. This policing panoptic (Foucault 1980) offers the general public an opportunity to peek closely to see the underwear, the belly button, and the bra. According to the judge's statement that circulated in Sudanese media, "The defendant was wearing pants and a blouse. The pants were tight showing her thighs and underwear. The form and the color of the underwear were transparent. The color of the underwear was beige. The sheer blouse was short sleeved and showed the shape and the form of the bra. The blouse was slit at the front and showed the upper part of her chest. The blouse was slit on the sides and showed the bellybutton and the underwear [and] the defendant's head was uncovered" (see *Sudan Tribune* 2009b). The graphic description of Lubna's dress evokes feminist anthropologists' classic arguments that women's bodies serve as sites of conflicting political debates about morality, containment, social regulation, and public order.[13] Following the court decision, a lull in mainstream media coverage was countered by numerous expressions of disappointment in Sudanese electronic media; those in the opposition had hoped for a firm action that would lead to the annulment of Article 152 of the public order law. Lubna wrote a cynical counterargument about her sentence on *Sudanile* (Al-Hussein 2009), commenting on how her class position and her translocal alliances spared her the flogging and imprisonment. In fact, two weeks after Lubna's second trial, two female engineers arrested with her were sentenced to twenty lashes. Lubna attended their trial and stated to Agence France Press, "during my trial there were media and diplomats; today there is no one" (*Sudanile* 2009).

In fact, however, Lubna's pants and her uncovered head were not the subject of the trial. She explained to me the arbitrary nature of her arrest by saying that she was at the restaurant in the first place "to inquire about renting a hall for a social event." Apparently, the crackdown at the restaurant occurred because a colonel who lives in the neighborhood called the police, complaining that a party there was getting louder and it was past the official curfew. What was on trial, it seems, was the publicity of Lubna's arrest, her alliances with opposition members, and the case she made for powerless women, whose subjection to discipline provided national legitimacy to the work of the legal moral code.

Wearing pants, for both men and women, continues to be debated within the context of a diverse Sudanese culture that privileges costumes as symbols of national identity. Although wearing pants for men does not bear the same moral connotations, wearing pants in a "modest feminine fashion" (i.e., with a lengthy, long-sleeve blouse and a headscarf) is regarded as more acceptable for women. For both men and women, however, pants and suits evoke an association with Western masculinity. For Lubna's pants to take center stage at the height of Western interventionist and protectionist discourses about Sudan is more than emasculating for a regime accused of violating human rights by oppressing and raping its own women. Lubna, through her translocal alliances, is relegated to the category of unpatriotic citizens, as if she seductively yielded to the West and allowed it to penetrate an already vulnerable nation. As Lubna and her translocal alliances expose and shame the regime, the state asserts its legitimacy by stripping her down and contesting her morality and national allegiance. This state of vulnerability is mirrored in the escalating fear of sexual order gone awry and in official discourses about the decay of morality and the dangers of external interventions.

To say that a country on the brink of secession is thrown into turmoil because of moral panic over a headscarf and a bra strap is not rhetorical. I felt this state of vulnerability daily during my informal conversations with family, neighbors, and friends, and when I watched the news and read the newspapers. Wherever I visited, conversations often turned to panicky subjects: little girls sexually abused by older men, good girls picked up in cars at night, husbands and fiancés burning their partners' faces with phosphoric acid, and children killing their rich parents for money. The number of illegitimate children abandoned in the streets of Khartoum and in orphanages was increasing, one friend maintained, and "some of them look half Syrian and half Chinese." Another friend commented, "The UN and NGO vehicles are more than the number of taxicabs in the streets of the capital city." Watching Sudan's national television via satellite dish in Michigan has confirmed this sense of vulnerability. National songs and the rhetoric of a country under threat are the dominant themes. A few days after Lubna's second trial, the Council of Ministers discussed the National Security Bill, which gives the national intelligence and security services sweeping powers of arrest, search, and seizure, despite the disagreement of its Southern partner and other opposition groups. In a speech, the President of Sudan emphasized, "We are targeted and we have to defend ourselves."[14] And in a rerun from a previous speech the president vowed

to protect the nation, saying that Sudan was the first nation south of the Sahara to gain its independence, and it won't be the last one south of the Sahara to be colonized.

Lubna's pants and her veiling and unveiling practices, therefore, serve as symbolic sites where both sovereign and transsovereign discourses and practices about morality, freedom, and rights compete.[15] While the former mobilize religious sentiments and alliances on a pan-Africanist, pan-Islamist model of transnationality, the latter mobilize global solidarities, armed with moral discourses and practices of humanitarianism and human rights. According to the state's moral logic, Lubna—like so many Sudanese women who are contesting these laws—has to assimilate to such a national order despite her alternative vision.

As a journalist who was not deeply immersed in political and feminist activism in Sudan, Lubna mobilized her visibility to forge alliances and to illuminate an important issue that both the media and human rights proponents missed: how her class position renders powerless women invisible. Lubna's transnational visibility highlights a dual predicament of the humanitarian politics within which subaltern visibilities are enabled and produced. As a subaltern Muslim woman, her transnational visibility is made possible through orientalist biases (see Mohanty 2004; Said 1978) that obsessively focus on signs such as the veil, which mask class hierarchies and humanitarian politics. But Lubna's emphasis on class does not appeal to humanitarian practices because, as Makau Mutua (2008) maintains, the duty of human rights practices is to police the space between the state and its citizens. This duty is not to investigate class injuries produced by neoliberal global economic disparities that put certain groups at risk and uplift others. Sudanese activists and feminists on the ground, who are struggling for social and economic justice, continue to battle oppressive laws in order to establish a new national order (see also Alarcón, Kaplan, and Moallem 1999; Anderson 1991). Routing visibilities will require the engagement of multiple players, such as anthropologists, feminists, and journalists, to situate such fragmented voices and visions in the interplay of both power and knowledge productions in ways that attend to the intersections of history, gender, and class injuries. Only then will it be possible to shed light on the implications of feminists' histories and struggles.

NOTES

This chapter has been revised from the article that appeared in the journal *Signs* (volume 37, number 1; © 2011 by The University of Chicago. All rights reserved). The author thanks the University of Chicago Press for publication permission.

1. After a January 2011 referendum in southern Sudan, Sudan officially became two states, The Republic of Sudan and Southern Sudan, on 9 July 2011 (BBC News 2011).

2. France 24, "Lubna Ahmad Al-Hussein, Sudanese Journalist and Activist," video, 26 November 2009, http://www.france24.com/en/20091125-interview -lubna-ahmad-al-hussein-sudanese-journalist-and-activist; MSNBC, "Sudan Fines Trouser-Wearing Woman," video, 7 September 2009, http://www.msnbc.msn.com /id/21134540/vp/32725030#32725030.

3. UNAMID is the hybrid United Nations and African Union mission authorized by the Security Council in July 2007 to be stationed in Darfur both to implement the Darfur peace agreement (signed in 2006 with some rebel factions) and to protect civilians in the area.

4. I use the term "translocality" to indicate that the local is no longer an autonomous entity; it is, rather, shaped by global processes through the fluid circulation of people, capital, and ideas (cf. Appadurai 2001; Ferguson and Gupta 2002; Harvey 2005; Ong 2003).

5. Although humanitarianism and human rights are historically guided by different principles, the past decade witnessed the emergence of a new humanitarianism that advocates for development issues and rights-based interventions in conflict zones (see, e.g., Fadlalla 2008; Leebaw 2007).

6. See, e.g., Askew (2002); Bernal (2005); de Leeuw and van Wichelen (2005); and Shohat and Stam (2002).

7. See, e.g., Abu-Lughod (2010); An-Na'im and Deng (1990); and Fadlalla (2009).

8. See Deng and Minear (1992); De Waal (1997); Fadlalla (2007); and Fluehr-Lobban (1987).

9. In 2000, conflict among the Islamists caused by international allegations of terrorism and other internal factors led to a decline in the power of Hassan Al-Turabi, the main ideologue of the regime, and to his imprisonment in 2005. A new Islamic coalition was formed under the National Congress Party.

10. *Shisha* is a flavored tobacco water pipe associated with Middle Eastern countries.

11. According to the Comprehensive Peace Agreement, Southern rebels joined the government as junior partners to facilitate the implementation of the agreement and to push for democratic reform and unity. Transnational pressures and negotiations between the two partners continued for over five years, during which time the CPA had produced what my interviewees labeled as the "margin of liberties" that allowed for freedom of press and assembly, among others. This agreement is sometimes referred to as the "Nifasha syndrome," since Nifasha is the Kenyan city where the CPA agreement was signed.

12. This is not to deny that Islamist feminists are active in public policy; the president's top legal advisor, who contributed to tailoring the Shari'a laws, is a woman.

13. See, e.g., Bledsoe (2002); Douglas (2003); Ong (1990); and Stoler (1991).

14. Sudan National TV, news broadcast at 7 AM, October 2009.

15. I use the term "transsovereignty" here to show how ideas about morality, freedom, and rights transgress national borders and may be used strategically by different activist and political actors to contest national sovereignty and the hegemonic construction of gendered identity, class, and belonging.

WORKS CITED

Abu-Lughod, Lila. 2002. Do Muslim women really need saving? Anthropological reflections on cultural relativism and its others. *American Anthropologist* 104 (3): 783–790.

———. 2010. The active social life of "Muslim Women's Rights": A plea for ethnography, not polemic, with cases from Egypt and Palestine. *Journal of Middle Eastern Women's Studies* 6 (1): 1–45.

Alarcón, Norma, Caren Kaplan, and Minoo Moallem. 1999. Introduction: Between woman and nation. In *Between Woman and Nation: Nationalisms, Transnational Feminisms, and the State,* ed. Caren Kaplan, Norma Alarcón, and Minoo Moallem, 1–16. Durham, N.C.: Duke University Press.

Al-Hussein, Lubna. 2009. Iza tabarajat altaifa jaladauha wa alsharifa qaramauha thuma dafa'aw alqarama [They flog the weak and fine the "honorable" and then pay the fine]. *Sudanile,* 14 September. http://www.sudanile.com/index .php?option=com_content&view=article&id=5666:2009-09-14-06-58-17& catid=34:2008-05-19-17-14-27&Itemid=55.

Anderson, Benedict. 1991. *Imagined Communities: Reflections on the Origins and Spread of Nationalism.* Rev. ed. London: Verso.

An-Na'im, Abdullahi Ahmed, and Francis M. Deng, eds. 1990. *Human Rights in Africa: Cross-Cultural Perspectives.* Washington, D.C.: Brookings Institution.

Appadurai, Arjun, ed. 2001. *Globalization.* Durham, N.C.: Duke University Press.

Askew, Kelly. 2002. Introduction to *Anthropology of Media: A Reader,* ed. Kelly Askew and Richard R. Wilk, 1–13. Malden, Mass.: Blackwell.

BBC News. 2011. South Sudan's flag raised at independence ceremony. 9 July. http://www.bbc.co.uk/news/world-africa-14092375.

Bernal, Victoria. 2005. Eritrea on-line: Diaspora, cyberspace, and the public sphere. *American Ethnologist* 32 (4): 660–675.

Bledsoe, Caroline H. 2002. *Contingent Lives: Fertility, Time, and Aging in West Africa.* Chicago: University of Chicago Press.

Bowen, John R. 2007. *Why the French Don't Like Headscarves: Islam, the State, and Public Space.* Princeton: Princeton University Press.

Brauman, Rony. 2004. From philanthropy to humanitarianism: Remarks and an interview. *The South Atlantic Quarterly* 103 (2/3): 397–417.

Clarke, Kamari Maxine. 2009. *Fictions of Justice: The International Criminal Court and the Challenges of Legal Pluralism in Sub-Saharan Africa.* Cambridge: Cambridge University Press.

Collins, Robert O. 2005. *Civil Wars and Revolution in the Sudan: Essays on the Sudan, Southern Sudan, and Darfur, 1962-2004.* Hollywood, Calif.: Tsehai.

Das, Veena. 2000. The act of witnessing: Violence, poisonous knowledge, and subjectivity. In *Violence and Subjectivity,* ed. V. Das, A. Kleinman, M. Ramphele, and P. Reynolds, 205–225. Berkeley: University of California Press.

de Leeuw, Marc, and Sonja van Wichelen. 2005. "Please, go wake up!" *Submission,* Hirsi Ali, and the "War on Terror" in the Netherlands. *Feminist Media Studies* 5 (3): 325–340.

Deng, Francis M., and Larry Minear. 1992. *The Challenges of Famine Relief: Emergency Operations in the Sudan.* Washington, D.C.: Brookings Institution.

De Waal, Alex. 1997. *Famine Crimes: Politics and the Disaster Relief Industry in Africa.* Bloomington: Indiana University Press.

di Leonardo, Micaela. 2008. Introduction: New global and American landscapes of inequality. In *New Landscapes of Inequality: Neoliberalism and the Erosion of Democracy in America,* ed. Jane L. Collins, Micaela di Leonardo, and Brett Williams, 3–20. Santa Fe, N.M.: School for Advanced Research.

Douglas, Mary. 2003. *Purity and Danger: An Analysis of Concepts of Pollution and Taboo.* New York: Routledge.

Fadlalla, Amal Hassan. 2007. *Embodying Honor: Fertility, Foreignness, and Regeneration in Eastern Sudan.* Madison: University of Wisconsin Press.

———. 2008. The neoliberalization of compassion: Darfur and the mediation of American faith, fear, and terror. In *New Landscapes of Inequality: Neoliberalism and the Erosion of Democracy in America,* ed. Jane L. Collins, Micaela di Leonardo, and Brett Williams, 209–228. Santa Fe, N.M.: School for Advanced Research.

———. 2009. Contested borders of (in)humanity: Sudanese refugees and the mediation of suffering and subaltern visibilities. *Urban Anthropology* 38 (1): 79–120.

———. 2011. State of vulnerability and humanitarian visibility on the verge of Sudan's secession: Lubna's pants and the transnational politics of rights and dissent. *Signs* 37 (1): 159–184.

Ferguson, James, and Akhil Gupta. 2002. Spatializing states: Toward an ethnography of neoliberal governmentality. *American Ethnologist* 29 (4): 981–1002.

Fluehr-Lobban, Carolyn. 1987. *Islamic Law and Society in the Sudan.* London: Routledge.

Foucault, Michel. 1980. *Power/Knowledge: Selected Interviews and Other Writings 1972-1977.* Ed. Colin Gordon. Trans. Colin Gordon, Leo Marshall, John Mepham, and Kate Soper. New York: Pantheon.

Hale, Sondra. 1997. *Gender Politics in Sudan: Islamism, Socialism, and the State.* Boulder, Colo.: Westview.

Harvey, David. 2005. *A Brief History of Neoliberalism.* Oxford: Oxford University Press.

Keenan, Thomas. 2004. Mobilizing shame. *South Atlantic Quarterly* 103 (2/3): 435–449.

Kleinman, Arthur, and Joan Kleinman. 1997. The appeal of experience; the dismay of images: Cultural appropriations of suffering in our times. In *Social Suffering,* ed. Arthur Kleinman, Veena Das, and Margaret Lock, 1–24. Berkeley: University of California Press.

Leebaw, Bronwyn. 2007. The politics of impartial activism: Humanitarianism and human rights. *Perspectives on Politics* 5 (2): 223–239.

Levine, Iain. 2009. The limits of shaming: Evaluating the effectiveness of the human rights advocate's favorite tool. Paper presented at the Conference on the Practices of Human Rights, New School, New York, 25–26 September.

Malkki, Liisa. 1994. Citizens of humanity: Internationalism and the imagined community of nations. *Diaspora* 3 (1): 41–68.

Mamdani, Mahmood. 2008. The new humanitarian order. *Nation,* 10 September. http://www.thenation.com/article/new-humanitarian-order.

Mohanty, Chandra Talpade. 2004. *Feminism without Borders: Decolonizing Theory, Practicing Solidarity.* Durham, N.C.: Duke University Press.

Mutua, Makau. 2008. Human rights in Africa: The limited promise of liberalism. *African Studies Review* 51 (1): 17–39.

Ong, Aihwa. 1990. State versus Islam: Malay families, women's bodies, and the body politic in Malaysia. *American Ethnologist* 17 (2): 258–276.

——. 2003. Cyberpublics and diaspora politics among transnational Chinese. *Interventions* 5 (1): 82–100.

Peters, John Durham. 1997. Seeing bifocally: Media, place, culture. In *Culture, Power, Place: Explorations in Critical Anthropology,* ed. Akhil Gupta and James Ferguson, 73–92. Durham, N.C.: Duke University Press.

Said, Edward W. 1978. *Orientalism.* New York: Random House.

——. 1981. *Covering Islam: How the Media and the Experts Determine How We See the Rest of the World.* New York: Pantheon.

Schaffer, Kay, and Sidonie Smith. 2004. *Human Rights and Narrated Lives: The Ethics of Recognition.* New York: Palgrave Macmillan.

Scott, Joan Wallach. 2007. *The Politics of the Veil.* Princeton: Princeton University Press.

Shohat, Ella, and Robert Stam. 2002. The imperial imaginary. In *The Anthropology of Media: A Reader,* ed. Kelly Askew and Richard R. Wilk, 117–147. Malden, Mass.: Blackwell.

Stoler, Ann Laura. 1991. Carnal knowledge and imperial power: Gender, race, and morality in colonial Asia. In *Gender at the Crossroads of Knowledge: Feminist Anthropology in the Postmodern Era,* ed. Micaela di Leonardo, 51–101. Berkeley: University of California Press.

Sudan Tribune. 2009a. French president vows support for Sudan trouser journalist. 6 August. http://www.sudantribune.com/French-President-vows-support -for,32051.

———. 2009b. Sudan court 'Graphic' ruling on female journalist. 14 September. http://www.sudantribune.com/TEXT-Sudan-court-graphic-ruling-on,32446.

SudaneseOnline. 2009. Min dakhil almahkama [Inside the court]. 7 September. http://www.sudaneseonline.com/cgi-bin/sdb/2bb.cgi?seq=msg&board=486 &msg=1255411821.

Sudanile. 2009. Alhukm 'ala imratayin awqifta ma'a Lubna Alhussein bi 20 jalda fi alsudan [Two women arrested with Lubna Al-Hussein sentenced with 20 lashes in Sudan]. 22 October. http://www.sudanile.com/index.php ?option=com_content&view=article&id=6668:———-20—-&catid=42:2008 -05-19-17-16-29&Itemid=60.

Yusif, Sulima. 1997. Nashrat munazmat hiquq alinsan alsudania [Sudan Human Rights Organization bulletin]. Alqahira aljam'aia alsudania lihuquq alinsan. Cairo Sudan Human Rights Organization.

CONTRIBUTORS

AMAL HASSAN FADLALLA is Associate Professor of Anthropology, Women's Studies, and Afroamerican and African Studies at the University of Michigan. Her areas of specialization include global perspectives on gender, health, and reproduction, and on gender, diaspora, and transnationalism. Her recent work also focuses on issues related to human rights, humanitarianism, and development in Africa and the diaspora. Her publications include her book, *Embodying Honor: Fertility, Foreignness, and Regeneration in Eastern Sudan,* and a co-edited book, *Gendered Insecurities: Health and Development in Africa 2012,* as well as articles in *Signs, Urban Anthropology,* and *Identities.* Her most recent research focuses on Sudanese in the diaspora.

LAURA FAIR is Associate Professor in the Department of History at Michigan State University. Her research interests focus on the cultural, religious, and social history of Zanzibar, with an emphasis on issues concerning women and gender. Her book, *Pastimes and Politics: Culture, Community, and Identity in Post-Abolition Urban Zanzibar, 1890–1945,* was published in 2001.

PERI M. KLEMM is Associate Professor of Art History at California State University, Northridge. Her dissertation, published materials, and curated exhibitions focus on identity, dress, and the body in the Horn of Africa. She has published in *African Arts* and her book on the historical and contemporary body art practices of Oromo women in Ethiopia and Kenya is forthcoming.

HAUWA MAHDI is a researcher on gender and women at the Centre of Global Gender Studies in Gothenburg and coordinator of GADNET, a Swedish gender researchers' network. From 1980 to 1990 she worked at Ahmadu Bello University, Zaria, and she has been teaching African history at the Centre for African Studies in Gothenburg since 2000. Her recent publications include edited volume chapters, "Sharia in Nigeria: A Reflection on the Debates," and "Gender and Citizenship: Hausa Women's Political Identity from the Caliphate to the Protectorate."

ADELINE MASQUELIER is Professor of Anthropology at Tulane University. Based on her research in Niger she has published on spirit possession,

Islam and Muslim identity, witchcraft, twinship, dress, and medicine. She is author of *Prayer Has Spoiled Everything: Possession, Power, and Identity in an Islamic Town of Niger,* and editor of *Dirt, Undress, and Difference: Critical Perspectives on the Body's Surface* (Indiana University Press, 2005). Her book *Women and Islamic Revival in a West African Town* (Indiana University Press, 2009) won the 2010 Melville J. Herskovits Award. She is editor of the *Journal of Religion in Africa.*

LESLIE W. RABINE is Professor Emerita of Women's Studies and French at the University of California, Davis. Her books include *Reading the Romantic Heroine: Text, History, Ideology; Feminism, Socialism, and French Romanticism* (Indiana University Press, 1993); *Rebel Daughters: Women and the French Revolution;* and *The Global Circulation of African Fashion.* She has also published several articles on African fashion and photography.

SUSAN J. RASMUSSEN is Professor of Anthropology at the University of Houston. Her interests include religion, symbolism, aging and the life course, gender, medico-ritual specialists, and verbal art performance. She has conducted anthropological field research for approximately twenty-five years in Tuareg (Kel Tamajaq) communities of Niger and Mali, and, more briefly, among other Berber (Amazigh)–speaking expatriates and immigrants in France. Her four authored published books are *Spirit Possession and Personhood among the Kel Ewey Tuareg; The Poetics and Politics of Tuareg Aging; Healing in Community;* and *Those Who Touch: Tuareg Medicine Women in Anthropological Perspective.*

ELISHA P. RENNE is Professor in the Department of Anthropology and the Department for Afroamerican and African Studies at the University of Michigan. Her research focuses on reproductive health; the anthropology of development; gender relations; and religion and textiles, specifically in Nigeria. Recent publications include *The Politics of Polio in Northern Nigeria* (Indiana University Press, 2010); *Population and Progress in a Yoruba Town; Regulating Menstruation* (co-edited with E. van de Walle); and *Cloth That Does Not Die.*

JOSÉ C. M. VAN SANTEN is Senior Lecturer and Researcher at the Institute of Cultural and Social Studies, University of Leiden, and until recently also a member of the Amsterdam School for Social Science Research (ASSR) in the NWO Research Programme "Islam in Africa." She has worked for twenty-six years in West Africa, especially in Cameroon, focusing on gen-

der relations within Islamic societies and processes of conversion. Her book, *"They Leave Their Jars Behind": The Conversion of Mafa Women to Islam,* is being revised in an updated French version. She has also researched on environment and development issues in North and West Africa and edited the volume *Development in Place: Perspectives and Challenges.* This article was written during her stay at the Netherlands Institute for Advanced Study in the Humanities and Social Sciences (NIAS-KNAW).

INDEX

Page number in italics refer to figures.
Color plate numbers are indicated with the abbreviation *Pl.*

aesthetic(s), 5, 74, 106, 123, 133; of accumulation, 199–200; beauty, 55; corporeal, 107; of creativity, 106; dress, 64; Hindi, 129; moral, 131; system, 194; as "weapon" of protest, 107

Algeria, 34, 38, 52

Al-Hussein, Lubna Ahmed, 205–207, 209–218, *211*; arrest, 205, 209, 210, 213, 216; description of Lubna's clothing, 205, 216; flogging sentence, 205; French support for, 212, 213; Lubna's case and Sudan's women's movement revival, 212–213; strategy of veiling and unveiling, 206, 215, 216; trials, 205, 213, 215, 216, 217; view of Islam, 214–215

alms, 120, 198

Al-Qaeda, 16, 18

amulets, 40, 200–201

anonymity, 29, 117, 127, 197

Ansar-Ud-Deen Society of Nigeria (Jam'iyyat Ansar ad-Din Naijiriya), 58–59, 67, 68, 73, 75, 76, 77n5

anti-veiling law (2004), France, 85, 86, 102; Scasi Commission report, 102

Arab, 19, 24, 41, 46, 47, 48; expatriates, 209; headgear, 152; influence, 91; scholar-traveler, 66; vendors, 191; way of hiding body, 151; world, 209, 213

Arabic, 61, 187; classes, 134; concept of 'aura, 44; language, 106, 166, 172, 174, 194

aristocratic background, 45, 50, 52; Fulbe, 142; Omani, 20; Tuareg, 55

austerity, 9, 87

Awaliyya (a Sufi order), 120, 121, 133; Malam Awal, 120, 133, 134n5

backwardness, 111, 112, 138

beauty contests, 99; *taghamanant* (women's beauty contests in Tamajaq), 49. *See also* men

black face-covering veil: dress and terrorism, 151; veil, 137, 149, *150*, 151, 154, 156n10. See also *niqāb*

Boko Haram (Ahlis Sunna Lidda'awati wal-Jihad), 114

boundaries, 37, 52; behavior, 127; moral, 111; public/private, 214

Brazil, 66, 76, 132; Aguda returnees in Lagos, 66, 76

Cameroon, 8, 139, 142, 146, 156n6, 157n12; Mokolo, 143, *144*, 145; North/northern, 139, 140, 142, 143, 156n3. *See also* colonialism; gender(s); hajj; *hijab, hijabi, hijabai* (pl.); *niqāb*; slave(s); veiling; women

Christianity, 8, 69, 76, 99, 139, 168; Christian Association of Nigeria (CAN), 69; churches, 68, 177; Pentecostal Christianity, 69; Southern Sudan, 208

civil society organizations (CSOs), 165, 170, 177

class, 15, 30, 215, 220n15; business, 145, 166, 209; in East African coastal societies, 18, 24; hierarchies, 218; leveling, 122, 125; lower-class, 171; political, 169; relations, 207; in Senegal, 90; in Tuareg society, 36, 45, 50; upper-class women, 209; working, 170, 209; in Zanzibar, 20, 15, 28, 29

colonialism, 87, 139; Belgian, 8; British colonial officials, 59, 75; in

Cameroon, 139, 143, 156n2, 156n4; French, 36, 96; German, 139; in Nigeria, 72, 168, 172, 179; in Senegal, 36, 96; in Sudan, 212

color, 16, 23, 91, 113, 123, 133, 137, 142, 191, 200, 216

comfort, 106, 116

cosmopolitanism, 19, 24, 111, 130

courtship, 34, 35, 36–40, 41, 53, 55n5

coverings, meaning of, 1, 26, 54, 61, 76, 113, 114, 116, 125, 132, 137, 183n3

crisis of identity: among Oromo women, 202; among Tuareg, 55n2

danger: of evil eye, 49, 199, 201; of harmful spirits, 40, 45, 199; of strangers, 199, 201

decency, 34, 69; indecency, 3

democracy, 50, 96, 189, 206, 208, 209, 215

development, 36, 76, 87

diaspora, 6, 76; Oromo, 6, 186, 188, 198; Somali, 203n10

discourses, 138; activist, 207; of containment, 206, 208, 212; defining public space, 167, 174; of exclusionary citizenship rights, 206; feminist, 111; fundamentalist, 141; gendered, 206; human rights, 211, 214; moral (or moralizing), 125, 208, 212, 218; Muslim reformist, 111; of the Muslim veil, 138, 143; official, 217; of power, 169, 181; religious, 113, 181; transsovereign, 218; Western interventionist and protectionist, 217

disguise, 4, 29, 86, 100, 112, 126, 191, 196, 198, 199, 200, 202

distinction(s), 4, 6, 113, 142, 145, 153, 166, 199; ethnic, 70, 199; moral, 116; religious, 69; social, 117, 137

dress, 8, 17, 18, 111, 122, 165, 197, 215; austere, 91; changes in, 168, 181; code(s) or prescription(s) or norm(s), 6, 26, 49, 75, 110, 166, 169–172, 182, 205, 208; as concealment, 203n11; control of, 169; dressing-up, 30, 125, 151; everyday, 68; as expression of commitment to Islam, 74; as expression of moral decency, 69; fashionable, 3, 198; forbidden forms, 21; immodest, 210; inadequate, 177; Islamic, 1, 3, 4, 5, 8, 61, 66, 69, 70, 72, 75, 77n11, 118, 125, 128, 143, 154, 166, 201, 208, 214; link with sexual morality, 175; modest, 30, 35, 45, 60, 75, 77n7, 90, 126, 128, 209; national, 168, 188; new styles of, 154; physical or visual, 35; as "political language," 112; practice(s), 5, 8, 73; prices of, 191; private, 202; professional, 180; proper, 180; public, 64, 202; regulation of, 207; religious, 106; revealing, 197; serious, 86; style(s), 165, 166, 175; system(s), 86, 87, 90, 93; terms, 203n9; as tool of cultural identity, 202; traditional-modern/religious-secular dress dichotomies, 5; transnational, 87; undress, 110

dress, types: *abaya*, 2, 6, 70, 73, 75–76, 83n11, 187, *188*, 189, 191, *193*, 194, 197, 198, 202, *Pl. 1*, *Pl. 8*; *bante*, 170, 183n5; *barakoa*, 20, *21*; blouse, 168, 170, 175, 176, 205, 216, 217; bra, 216, 217; *buibui*, 15, 16, 17, 25–30, *26*, *27*; *burqa*, 7, 58, 68, 78, 182n2, 213, 214; camisoles, 36, 39; *chador* (Iranian), 182; *durriyya* (Oromo long dress), *188*, 191, 202, 203n6; *ẹlẹẹha* (women wearing Yoruba-type of *burqa*), 58, 59, 67, 68, 70, 77n4, *Pl. 3*; *gogora* (underskirt with eyelet design), *188*, 191, 202, 203n6; *grand boubou*, 87, 91, 106; *jaba* (tunic worn over short-hemmed pants), 110; jeans, 16, 36, 39, 90, 91, 92, 93, 125, 197; *jelabiya* (gown) (also *jalbaab, jalibaab, jalabiya, jilabiya*), 2, 67, 68, 70, *71*, 72, 75, 187, 208; *jilbab* (overcoat), 17, 67, 187, 203n5, 203n6, 216; *kanga*, 4, 15, 22–23, *22*, 24, 25, 26, 29, 30; *pagne*(s) (wrapper[s]), 87, 91, 97, *Pl. 4*; *saddetta* (white dress from rural eastern Oromia), 189, *190*, 200, 202; socks, 64, 68, 74; *taube* (northern Sudan national dress), 208; t-shirts, 39, 90, 91, 93, *94*, 130, 188, 203n4; tunic(s), 91, 98, 110, 120, 122, 189, 203; *zane* (wrapper, Hausa), 60, 61, *62*, 63, 113; *zane-da-riga* (wrapper and blouse, Hausa), 168

education: girls,' 48; Islamic, 15, 76; Islamiyya Matan Aure (classes for married women), 61, 63, 64; Muslim practices in Lagos, 66; in northern Nigeria, 60; Western, 5, 8, 9, 66, 68, 70, 76. *See also* school(s)

Egypt, 1, 7, 44, 77n10, 91, 125; Cairo, 208

embarrassment, 43, 44, 47

emirate(s): Hausa 75; Ilorin, 66, 78n12, 78n15

empire(s): Bornu, 60, 76; Mali, 7, 60, 76; Songhay, 60, 76

Ethiopia, 6, 186, 187, 189, 190, 191, 193, 194, 196, 198, 199, 200, 201, 203nn8–9; agents of, 198; anti-terrorism law (2008), 196; officers of, 193; Oromia, 187, 189

ethnicity, 76, 96, 138; East African coastal society, 18; ethnic identity, 60, 168. *See also* Fulbe; Hausa; Oromo; Tuareg; Yoruba

etiquette, 34, 40, 55n2

faith, 6, 97, 111, 121, 140, 143, 181, 201

Fanon, Frantz, 114, 116, 157n19

fashionable, 3, 5–6, 16, 17, 30; in Kenya, 197; in Niger, 113, 121, 123, 125, 128–129, 130, 131; in northern Nigeria, 68, 72–73, 74; in Senegal, 85, 86, 87, 98–99, 104

fashion(s), 3, 16, 73, 87, 88, 93, 99; anti-fashion, 5, 100; codes, 97; consciousness, 21, 123, 125, 129, 130, 131; designer, 104; East African, 23; and faith, 6, 121; "fashion of the time," 73; global, 93; Hindi, 129, 130, 131; "in fashion," 16, 86, 87, 91; industry, 93; Islamic, 3, 4, 73, 91, 125; links with morality and modernity, 121, 122, 127; Meccan, 131; Middle Eastern, 128; Muslim, 91, 111; and religion, 99; and religious modesty, 90, 99; Senegal, 85–88, 90, 91, 93, 95, 97, 98–101, 103, 104, 106; shows, 72; skin lightening, 17–18; systems, 87, 90; transnational, 131; Western, 90. *See also* dress; fashionable; film; *hijab, hijabi, hijabai* (pl.); veiling; veil(s)

femininity, 116, 142

feminist(s), 16, 206, 207; anthropologists' arguments, 216; counter-panoptical strategy, 207; Euro-American ideology, 49; fears, 17; Islamist, 219n12; perspective, 141; in Sudan, 212

film: Bollywood (Indian), 93, 129, 130; Kannywood (Kano film industry), 73

food, 30, 36, 77n9, 127, 147, *148*, 149, 153, 175, 209

foreign, 85, 126, 129; items, 187; logo, 128; policies, 209; practices, 67, 153; television star, 130

France, 1, 7, 8, 85, 86, 87, 94, 101, 102, 138, 142, 157n12, 213, 214; Paris, 93, 214

Friday prayer, 104, 105, 106, 107, 203n4; sermons, 152

Fulbe (sing. Pullo) (also Fulani, Peul), 138, 140, 142, 146, 149, 175; and Islam, 156n3; nomadic culture, 139, 142, 156n3; pre-Islamic nomadic tradition, 146

gender(s), 2, 5, 20, 45, 207; Cameroon, 141, 142; cultural value, 34; differences, 145; dynamics of public space in Nigeria, 64; Egypt, 44; equality, 145, 168; identities, 4, 214, 218, 220n15; mores, 75; northern Nigeria, 75; Oromo society, 186; relations, 5; social subordination, 31; studies, 207; Tuareg society, 47, 48, 49, 50, 51, 53, 54, 55n2

gifts, 3, 8, 96, 126, 147, *148*

glamour, 5, 129; Sénégalaise, 88

globalization, 132, 137, 138

hadīth, 44, 61, 63, 77, 110, 146, 214

hair, 3, 41, 130; *doka* (Hausa hairstyle), 171; extensions, 128; *hamasha* (Oromo hairstyle), *190;* in Niger, 118, 128, 129, 178, 179; in Oromo society, 186, 187, 191, 193, 195, 196, 200–201; in Senegal, 88, 103; in Tuareg society, 55n2

hajj (pilgrimage), 3, 6, 60, 73, 77n4, 120, 157nn22–23; *kayan* Mekka, 60; *mahram* (woman's male supervisor),

145, 146, 157n22; participation of
Cameroon women, 137, 138, 139,
140, 141, 143–155, *Pl. 6*

Hausa: culture, 63; Hausaland, 58, 183n4;
language, 167, 168, 194; Muslims in
northern Nigeria, 59, 70, 71; non-
Muslim, 168; popular culture, 129;
textiles, 169; traders, 72. *See also*
Muslim(s); seclusion; trade; veiling;
veil(s); women

head-covering, types of: fez, 91; *gele*
(Yoruba headtie), 58, 59, 60, *62,* 67,
68, 70, *71,* 77n5; *gufta* (a black mesh
hairnet), *190,* 200–201; *gwarggwaro*
(Hausa headtie), *62; hadiko* (a Fulfulbe
headcovering), 142; *hirami* (head-
cloth), 120, *121,* 133, 134n5; *kofia(s)*
(sewn cap), 20, *22,* 31; Nike caps,
128, 129

headscarf (headscarves), *38,* 87, 88,
89, 98, 130, 188, 208, *Pl. 2, Pl. 4;* in
Cameroon, 142, 155; *ɗan kwali,*
166, 167, 171, *Pl. 7; diko,* 113; in
Dogondoutchi, 113, 130; *foulard(s)*
(scarf/scarves), 88, 90, 96, 102, 104;
in Hausa society, 20, 60, 64; *kallabi,*
60, 61, *62,* 166, 167, 171, 176, 182n1;
mandila (or *shashii*), 187, 191; in
Nigeria, 166, 167, 171, 178; in Oromo
society, 191, 200; in Senegal, 87–88,
89, 97, 101, 104; in Sudan, 217; in
Swahili society, 20

hiding, 201; bodily charms and harmful
intentions, 127; the body, 114, 151;
identity, 17; impiety, 126

high-tech communications, 206, 207;
cell phones, 50, 192; internet, 3, 93,
140, 145, 205, 209

hijab, hijabi, hijabai (pl.), 1, 2, 6, 111; in
Cameroon, 6, 140, *144,* 153, 155; "cape
hijab," 69, 179; in Dogondoutchi
(Niger), 8, 112, 113–114, 116, 118–
129, *119,* 130, 131–133, *132,* 134n4,
134nn6–8, *Pl. 5;* "fashion" *hijab,* 58,
72, 73; five categories of, 178; "full
hijab," 179; *ibadou* (*hijab,* Senegal),
85, 88, 91, *92,* 98, 100; "long *hijab,*"
69; "medium" *hijab,* 179: in northern
Nigeria, 5, 6, 58, 59, 60–61, 63, 64–68,

69, 70–71, *71,* 72, 73, 74, 75, 76, 78n14,
166, 167, 169, 170, 172, 174, 175–180,
181–182, 183n9, 183n11, 183n15,
183n17; in Oromo society, 187, *188,*
191, 194, *195,* 197, 198, 199, 201, 202;
"triangle *hijab,*" 69; white *hijab,* 77n5.
See also dress; fashionable; fashion(s);
hajj; veiling; veil(s)

hip-hop, 90, 93, *94,* 95, 97, 101; reformist
Islam and hip-hop styles, 91, 95

honor (*imojagh*), 34, 35, 38, 43, 44, 46,
47, 48, 53, 88; codes of, 214; killings,
46, 52

household(s), 20, 46, 75, 111, 113, 118,
120, 122, 147, 151, 199

house(s), 4, 39, 44, 48, 64, 67, 141, 146,
150, 151, 175, 176, 200, 201

human rights, 166, 179, 206, 209, 212,
213, 214, 217, 218, 219n5; abuses,
203n8, 205, 212; activists, 206, 214,
215, 218; culture, 207; strategy of
shaming, 206. *See also* discourses

humanitarianism, 206, 218, 219n5;
humanitarian visibility, 207,
212–215

humility, 47, 201

identity: formation and power negotia-
tion, 166, 168; identification, pro-
cesses of, 141; imaginary identities,
86, 100, 106; politics, 112, 168–169

imam(s), 90, 139, 146, 149, 151, 152, 153,
154, 155

immorality, 61, 75, 170, 177

India, 19, 132, 191

Iran, 85, 91, 157n19

Islam, 1, 2, 7, 8, 9, 26, 28, 44, 45, 58, 63,
68, 99, 113, 138, 140, 145, 153, 156n1;
five pillars of Islam, 137, 181; in
France, anti-secular, 86; global, 6, 8,
93; interpretations of, 5, 6, 16, 140;
Middle Eastern, 90, 93; in Niger, 118,
128; in North Cameroon, 140; in
northern Nigeria, 168, 174, 179; in
Oromo society, 198–199; orthodox,
86, 88, 90, 98; pure, 133n1; radical,
15, 16; reformist, 90, 91; in Senegal,
85, 93, 95, 96, 97; in southwestern
Nigeria, 76; in Sudan, 208, 212. *See*

also Islamic brotherhoods; Izala;
Muridiyya; Qadiriyya; Sufi, Islam;
Tijaniyya; veiling; veil(s)
Islamic: fundamentalism, 15, 18, 192;
militancy, 118; reform, 16; revivalist/
reform movements, 8, 61, 140, 166
Islamic brotherhoods, 97; Sufi, 28, 85,
96, 97
Islamic Movement of Nigeria (IMN) (Yan
Shia), 166, 177
Islamic scholars, 4, 28, 37, 76, 153, 155,
199; Arab, 48, 66; Indian, 76; Iranian,
16; Izala, 63, 76; Tuareg, 40, 42, 45,
50, 52; and scholarship, 28, 153; *ustas,*
158n28
Izala (Jamā'at Izālat al-Bid'a wa Iqāmat
al-Sunna [Society for the Removal
of Innovation and the Restoration of
Tradition]), 8, 59, 61, 67, 70, 73, 76,
110, 111, 113, 127–128, 166, 167, 177;
beliefs, 133n1; critique of Qadiriyya
and Tijaniyya, 63; gender-segregated
society, 127; Gumi, Sheikh Abdullahi,
61; leaders, 69; reformists, 126;
reforms, 63, 64; values, 131. *See also*
Awaliyya; *hijab, hijabi, hijabai* (pl.);
Niger, Dogondoutchi; women

jihad: and colonialism in Cameroon,
139–140; dan Fodio, 'Uthman, 60,
66, 75, 77n1, 139, 140, 143; and
Sokoto Caliphate, 60. *See also* Sokoto
Caliphate

Kenya, 6, 16, 186, 187, 191, 194,
196, 203n8; Eastleigh ("Little
Mogadishu"), 186, 187, 188, 189, 191–
194, 196, 197, 198, 201, 202; Nairobi,
16, 187, 191

laïcité, 7, 8, 102, 137; secularism, 3, 7, 8
leather, used in dress, 21, 98, 170, 183n7,
200
Libya, 34, 37, 47, 54n1
livestock, 36, 41, 52, 53. *See also* wealth

Mali, 36; Bambara, 36; descendants of
slaves, 38; former slaves, 8; Kidal,
35, 36–37, 41, 43, 47, 48, 49, 51, 52,

53, 55n4; northern, 35, 36, 37, 47, 52;
official language, French, 43; post-
coup d'etat, 55; social upheavals, 39;
Songhai, 36; Tuareg residents, 34, 38
marabout(s), 39, 40, 45, 46, 50, 96,
153n31
marriage, 41, 42, 45, 48, 50, 51–52, 64, 87,
94, 122, 125, 133n2, 147, 165, 196, 200,
201, 210; bridewealth, 46, 48, 52, 53;
divorce, 48, 53, 122, 213; polygynous
marriage, 53
Mecca, 3, 6, 73, 120, 129, 137, 140, 143,
144, 146–148, 149, 150, 152–153, 154,
155
men: beauty contests, 49; dress, 55n6;
Tuareg turban-veils (*tagelmust*), 37,
39, 41, *42,* 55n2
Middle East, 1, 2, 7, 76, 96, 131, 138, 153,
167, 170
missionaries, 59, 139; Christian mission-
ary activity, 66
modernity, 3, 8, 50, 73, 121, 123, 137;
Western, 59
modesty, 90, 99, 110, 111, 113, 114, 117,
126, 128, 131, 132, 133, 178, 186,
214, 216; codes of, 208; definitions,
118–122; *hishma* (modesty, Sudan),
208, 216; immodesty, 117
moral: assumptions, 207; community,
117; comportment, 64; critique, 43;
dichotomy, 46; interiority, 116; panic,
127, 217; religiosity, 206; time, 73
morality, 51, 110, 111, 112, 121, 122, 127,
206, 217, 218, 220n15; debates about,
216; definition of, 212; female, 128;
Islamic, 113; legislation, 165, 166,
169; police, 165, 214; sexual, 175. *See
also* discourses
mosque(s), 7, 15, 68, 71, 90, 127, 188, 200;
AEMUD, 91; Friday, 118; Maroua, 154;
militant, 198; movement, 132; Tijani
mosque in Dakar, 97
Muridiyya, 95, 96, 97
Muslim: attire, 133; calendar, 122; com-
munity (also communities), 2, 6, 8,
44, 66, 70, 121, 157n23, 201; comport-
ment, 63; identity, 68, 88, 110, 111,
112, 132; leaders, 120, 121, 213; poli-
ticians' alliance with Islamist CSOs in

Nigeria, 169; practice(s), 67, 76; rules of pious deportment, 130–131; sartorial trends, 111; secondary school students, 69; society (also societies), 6, 112, 128, 138

Muslim(s), 2, 3, 5, 66, 90, 92, 99, 100, 102, 137, 138, 144, 145, 146, 155; conflict with Christians, 76; East African, 29; educated elites, 76; French-schooled, 130; good, 137, 140, 143, 153; world, 140. *See also* Cameroon; Ethiopia; France; Mali; Niger; Nigeria; Oromo; Senegal; Somalia; Sudan; Zanzibar

naked, 116; nakedness, 31

neoliberal: capitalism, 206; ethos of secular democracy, 206; global economic disparities, 218; global moment, 207; moral ethos, 206; neo-liberalism, 18; state, 206

Niger, 4, 5, 34, 36, 37, 38, 110, 130, 183n3, 183n14; Agadez, 43; Dogondoutchi, 110, 112, 121, 128, 133, 134n5, 135, 145; French as official language, 43; Niamey, 53. *See also* gender(s), relations; Tuareg; veiling; veil(s)

Nigeria, 57, 59, 75, 76, 77, 179, 183n14; government officials, 75; Ibadan, 59, 60, 69, 70, 71, 72, 77n6, 77n8; institutions of learning, 179; Jos, 59, 76; Kaduna, 59, 61, 69, 70, 72, 73, 76, 183n17; Kano, 73, 74, 141, 167, 169, 172, 176, 183n9; Katsina State, 167, 171, 183n3; Lagos, 66, 67; Lagos establishment of Ansar-ud-Deen, 59, 76; laws, 215; NASFAT (Nasrul-Lahi-il Fathi), 68, 69, 70, 73; national constitutions, 168; northern, 5, 8, 59, 61, 66, 70, 72, 73, 75, 76, 134n5, 139, 144; politics, 168, 179; southwestern, 5, 9, 59, 66, 68, 69, 71, 72, 73, 75, 76, 78n15; Zaria, 8, 58, 59, 60, 61, 63, 64, 65, 71, 72, 77n9. *See also* Ansar-ud-Deen Society of Nigeria; Brazil; education; Izala; Sierra Leone; trade; veiling; veil(s)

niqāb, 2, 7, 15, 182n2; in Cameroon, 137, 142, 152, 155, 156n10; in Dogondoutchi (Niger), 131, *132;* in Nigeria, 78n13, 179; in Oromo society, 187, 197, 198, 202, 202n3; in Zanzibar, 16–18, 26, 29, 31, *Pl. 1. See also* veiling; veil(s)

nomadic. *See* Fulbe; Tuareg

non-governmental organizations (NGOs), 207; in Nigeria, 168, 183n9; Saudi, 138

non-veiling in Senegal communities, 95; in Tuareg communities, 35

Nudity Bill (2007), in Nigeria, 165, 169, 174; Ekaette, Senator Ufot Eme, 165, 166, 169, 174

Oman, 19, 197

oppression(s), 47, 112, 138, 206, 214, 215

Oromo, 194, 196, 198; aesthetic of dress, 199, asylum seekers, 194, 196; Babile Oromo and Hawiyya Somali, 196; diaspora, 198; flags, 187, 188; heritage, 198; identity disguise, 196; national identity, 186, 188; Oromo Liberation Front (OLF), 194, 196, 198; Oromuumaa (Oromo consciousness), 187, 188, 201; refoulement (illegal repatriation of refugees), 194; weddings, 187. *See also* dress; household(s); *hijab, hijabi, hijabai* (pl.); Muslim(s); refugee(s), camps; veiling; veil(s); women

pagan: family background, 151; as pejorative, 127, 193, 196

Pakistan, 140, 191

pants: in Niger, 110, 120, 122, 130; in Omani society, 20; in Sudan, 210, 215, 217; western, 39; and western masculinity, 217. *See also* Al-Hussein, Lubna Ahmed

perfume, 104, 106

piety, 5, 28, 29, 35, 74, 111, 112, 113, 118, 120, 121, 122, 123, 125–128, 130, 131, 132, 133n3, 134n4, 197

pilgrimage. *See* hajj

pilgrims, 3, 137, 138, 140, 143, 145, 146–147, 149; male (*alhadzai*), 144, 152, 153; female (*alhadzja*), 137, 145, 147, *148, 150,* 153, 155

police, 37, 149, 192, 193, 205, 208, 210, 216. *See also* morality, police

politics, 75, 137, 155, 167, 181; humanitarian, 218; identity, 112, 168–169, 172; power, 179; religious identity, 114; in Sudan, 208, 209. *See also* women's bodies

prayer: beads, 71; ceremony (*wadaajaa*), 189; mat, 187; rugs, 65, 70, 71; scarf, 88; shawls, 118

prayer(s), 76, 104, 126, 150, 155, 175

prestige, 34, 45, 187

Prophet Muhammad, 5, 17, 58, 66, 118, 146, 157n22. *See also* time of the Prophet

propriety, 24, 120, 125, 126; Islamic, 66, 130, 132; Muslim, 5; sartorial, 128

prostitutes, 128, 147

purity, 111, 125, 126, 127, 131

Qadiriyya (a Sufi order), 28, 61, 64, 76

Qur'ān, 28, 60, 61, 63, 68, 75, 77, 77n2, 93, 95, 101, 118, 139, 140, 143, 157n16, 172, 174, 187, 214

Qur'ānic: education, 140; legal interpretations and policies, 52; religious injunctions, 45; schools, 134n6. *See also* education

racism, 90, 106, 206

Ramadan, 17, 29, 98, 99, 104, 122, 126, 181

rap, 39, 91; "gangsta rap," 51; music, 50; performers, 130; You Tube rap videos, 93

refugee(s): camps, 202; children, 194; Oromo in Kenya, 4, 191, 192, 193, 194, 196, 197, 198, 199, 201–202; Somali, 191, 197; Tuareg, 4, 47

religious obligation, 93, 95, 172, 175

reserve, 34, 41, 54; *takarakit,* 4, 40, 41, 43–54

respect, 8, 18, 19, 23, 24, 26, 31, 64, 125, 132, 142, 153

respectability, 24, 26, 28, 29, 63, 64, 87, 113, 118, 122, 123, 127, 128, 210; codes of, 88

Salafiyya, 73, 74, 75

sañse, 88, 90, 91, 98

sartorial: dialogic, 97; "global village," 93; irony, 91; practices, Euro-American, 129

Saudi Arabia, 60, 85, 91, 137, 152, 154, 191, 193, 197; government of, 146

school(s), 49, 63, 66, 69, 77n9, 208; *allo,* 77n2; British, 76; Ibadhi and Shafiʻi, 28; French public, 157n12; Islamic, 138, 140, 142, 143, 155, 156n6; missionary, 156n4; national, 194; public, 69, 78n13, 87, 142, 143; Qur'ānic, 134n6; secondary, 69, 77n8, 156n6; secular, 47; uniforms, 59, 63, 68, 69, 70, 143, *144. See also* education

seclusion (purdah), 24, 67, 74, 141, 168; and Ansar-ud-Deen, 67; *ẹha* (Yoruba), 24; and Izala, 61, 67, 114, 133n2; in Kidal (Mali), 52, 53; kulle (Hausa), 24; mobile, 67; in Niger, 116, 117, 118; in Nigeria, 59, 61, 67, 70, 75, 76, 141; partial (*tsari*), 176; portable, 127; in Tuareg society, 47

security/insecurity, 64, 66, 74, 75, 90, 180, 209

Senegal, 87, 89, 90, 100, 101; Dakar, 91, 93, 97, 98, 100; Islam, 93, 94, 96; Islamic groups, 97; Jamāʻatou Ibadou Rahman, 88, 94; Saint-Louis, 87, 98, 99, 100

Senegalese fashion systems: Senghor, Léopold Sédar, 96; tenue africaine, 90, 91; tenue européenne, 90; tenue traditionnelle, 90, 93, 97, 98, *Pl. 4;* Wolof, 95, 96

sexual: allure, 99; behavior codes, 166; desire, 44; harassment, 2, 100; innuendo, 37; offences, 165; prohibitions, 47; purity ('*aifa*), 216; relations, 41, 165; restrictions, 53; vulnerability, 47

sexuality, 2, 44, 47, 117, 127, 130

shame, 4, 117, 217; concept of, 5, 34, 35, 39; *kumya,* 117, 132

Shariʻa law, 7; Cameroon, 139; northern Nigeria, 8, 66, 75, 133n1, 169; Senegal, 97; Sudan, 207–208, 209, 210, 212, 214, 219n12

Sierra Leone, 66, 76; Saro returnees in Lagos, 66, 76

slavery: abolition in Zanzibar, 4, 19, 20, 22, 23, 28; in Africa, 7; anti-slavery justification, 8; in northeastern Nigeria and western Cameroon, 8; slave labor in East Africa, 19; slave-owners in Zanzibar, 28; transatlantic trade, 87; in Zanzibar, 24–25. *See also* Brazil; Sierra Leone; slave(s), Arab and Africa

slave(s), Arab and Africa, 19; eman-cipated, Zanzibar, 31, 31n3; in Cameroon, 8; in Nigeria, 168; in Zanzibar, 19, 20–23, 24, 28, 31, 31n3

slaves, former (also descendants): in Fulbe society, 142; in Mali, 8; in Tuareg society, 38, 45, 55n1; in Zanzibar, 4, 8, 20–22, 24, 28

social: distance, 41, 55n2; skin, 114, 116

Sokoto Caliphate, 7, 60, 66, 75, 76, 77, 78nn15–16, 139, 143, 170. *See also* jihad

Somali, 199; dress, 196, 203n4, 203n7; in Eastleigh (Kenya), 186, 191, 193; in Ethiopia, 191, 196; men, 197; in Minneapolis, 203n9; pastoralist clans, 196; pirate investments, 193

Somalia, 194, 203n9, 215

spirits, 40, 45, 46, 55n2, 199

status, 4, 18; inferior status as unbe-lievers, 156n4; in Niger, 117, 118; in Senegal, 87, 95, 99; in Sudan, 215; in Tuareg society, 45, 47, 55n2; in Zanzibar, 20, 21, 24, 28

stole/shawl: *foota* (long scarf), *188, 193,* 200, 201, *Pl. 8; iborun* (Yoruba), 58, 59, 67–68, 70–71, *71, 72,* 77n5; *kudel* (stole), 142, 150, 151, 152, 154; *lafaay* (shawl-veil), 142, 145, 150, 152; *lullu'bi, lullubi,* 113, 171, 172, 183n8; *mayafi* (Hausa), 60, *62,* 113–114, *115,* 117, 118, 121, 167, 171–172, 182n1, 183n8

sub-Saharan Africa, 1, 2, 5, 7, 8, 9, 87, 137

Sudan: Al-Hussein, Lubna Ahmed, 205–207, 209–218, *211;* critique of public order law on dress, 208, *213;* feminist

politics in Sudan, 206, 212, 214, 218; Khartoum, 205, 208, 209, 210, 211, 214, 217; public order law, 208, 210, 212, 214, 215, 216. *See also* Al-Hussein, Lubna Ahmed

Sufi: brotherhoods, 28, 85, 94, 96, 97; Islam, 96, 98; orders, 86, 96, 104; practices, 90, 133n1; religious ritu-als, 28. *See also* Muridiyya; Tijaniyya; women

Swahili, 20, 21, 22, 24; coastal societ-ies, 7; free, 21, 23; men's clothing, 20; towns, 19. *See also* dress; trade; women

takarakit. See reserve

television, 3, 93, 130, 187, 217; Latin American, 130; soap operas, 113, 130; telenovelas, Brazilian, 130, 132, 134n9

textiles: *atampa* (manufactured printed textiles), 171, 175; *bazin* (cotton dam-ask weave fabric), 122; cotton cloth, 20, 25, 170, 171; handwoven strip-cloth, 88; *merikani* cloth, 20, *21, 22,* 189; nylon, 150

Tijaniyya (a Sufi order), 61, 63, 64, 94, 96, 97, 98; Niassène movement (Senegal), 98

time of the Prophet, 59, 74

trade, 87; British, 23; caravan, 36; expansion, long-distance, 71, 72; neoliberal, 18; networks, 7; textile, 87, 171; transatlantic slave, 87; trans-Saharan, 60

transgressions, 44, 53

travel, 18, 41, 42, 138, 144, 207, 214; agencies, 146; travelers, 144, 147

Tuareg (Kel Tamajaq), 4, 34, 35, 43–44, 45, 46, 47, 49, 50, 51, 52, 54; age-mates, 49; aristocracy, 38, 48; armed rebellions, 36; Berber (Amazigh) lan-guage, 34; communities, 41, 43; cul-ture, 37; ethnographers, 43; festivals, 36, 37; leaders, 52; man (men), 39, 40, 42, 46, 47, 48; origins, 54n1; national-ists, 55nn4–5; rebels, 47; refugees, 4, 47, sociability, 43; traditional leaders,

37; youths, *ichumaren,* 49, 55n3. *See also* veiling; veil(s); women

Turkey, 1, 3, 91, 125

uniformity, 113, 123, 180

United Nations: and African Union Commission (UNAMID), 205, 211, 219n3; Convention on Refugees (1951), 196; High Commissioner for Refugees (UNHCR), 194

United States, 20, 189, 207, 209, 210; Bush administration, 209; September 11, 2001, 186, 203n10, 209

values: of democracy, 209; French, 102; Fulbe, 153; Izala, 131; Muslim, 114; in Nigeria, 179; Tuareg, 34, 44, 50, 51; Western, 178

veiling, 1–2, 3: in Africa, 2, 3, 7; in Cameroon, 8, 137–138, 140–141, 142, 147, 149, 152, 153, 154–155; and concerns with indecency and nudity, 3; counter-veiling practices, 6, 7, 8, 9; critique of western-educated women, 3; debates about, 85–86, 111, 112, 127, 128, 133, 138, 140, 143, 165, 180, 208; and disguise/duplicity, 4; in Dogondoutchi (Niger), 111, 112, 114, 118, 127, 128, 132–133; in Egypt, 1, 91, 112, 125, 131, 132; in Europe, 1, 3; as expression of Islamic identity, 6; and fashion, 3, 5, 6; in France, 8; and independence movements, 2, 8; and modernity, 3, 59, 137; in Nigeria, 5, 58–60, 67–68, 70, 71, 72, 74, 75–76, 77, 77n1, 77n4, 78n13, 166, 178, 179; in Oromo society, 6, 186, 187, 196, 199, 202; and political ideology, 58, 78n13, 86, 141, 206; practices, 6–7, 9; representations in Western media, 202n2; requirements, 7; restrictions, 7, 85; in Senegal, 85, 86, 93, 94–95, 97–98, 99, 101, 102–103, 104, 105, 106; and status, 24; styles, 3, 4, 5, 6, 8; in Sudan, veiling and unveiling, 206, 215, 218; in Tuareg society, 4, 5, 35, 45, 54; in Turkey, 1, 3; Zanzibar, 4, 15, 18, 24, 25

veiling, uses and meanings, 5, 6, 9, 206; "just in case" strategy, 208; as metaphor, 106, 141, 186; nationalist uses of, 2, 3, 208; in Nigeria, 74, 75, 133n3, 170, 179, 180; in Oromo society, 186, 199, 202; in Senegal, 85–88, 90–95, 97–107; in Sudan, 208, 218; "veiled" sentiments, 34, 35; veiled spirit(s), 127, 128; in Yoruba society, 59, 67; in Zanzibar, 15, 16, 17, 18, 24, 25, 28, 30, 31; in Zaria, 61, 62. *See also* dress; head-covering; veil(s)

veil(s), 1, 2, 4, 5, 15; adoption by slave women in pre-colonial Zanzibar, 24; debates on and interpretations of, 7, 54, 111–113, 114, 118, 131–132, 138, 140–141, 143, 155; Egyptian, 131; face, 2; as focal point for competing struggles, 207; French debate on, 85–86; interpretation as sign of subordination in West, 15, 31; in Iran, 126; Izala (Dogondoutchi, Niger) beliefs about, 110–118, 120, 121, 127, 167; as personal choice in Senegal, 93–98, 99, 103; in public, 4; as religious obligation (in Nigeria), 172, 175: as religious obligation (in Senegal), 93, 95; removal of, 104, 186, 213; as strategy to restrict movement, 111; style transformations, 31, 74; as symbol of militancy, protest and resistance, 111, 118; as "technique of the body," 116; in Tuareg society, 35, 37, 39, 41, 42, 46, 55n2

veils, ornamentation of: beading, 88, 189; embroidery, 16, 46, 87, 88, 98, 119, 123, 187; fringe(s), 118, 123; rhinestones, 16, 123, *Pl. 5;* sequined, 16, 68, 88, 98, 99, 118

veils, types of: *gyale* (imported veil, Hausa), 58, 59, 60, 61, 63–65, *65,* 72, 73, 167, 171, 172, *173,* 175, 176, 182n1; *haïk* (veil, Algeria), 117; *khimar, khimur* (type of fitted veil), 68, 72, 167, 182n2; *ukaya* (sheer veil worn with *buibui*), 25; *le voile* (veil), 88. *See also* head-covering; headscarf; *hijab, hijabi, hijabai* (pl.); niqāb; stole/shawl

violence, 40, 186, 212; between Muslims
and Christians, 69, 78n14; political, 4,
42, 46, 48; against women, 168, 212
vulnerability, 34, 47, 75, 117, 217

Wahhabism, 158n29; Wahhabite influ-
ences, 153
wealth, 24, 25, 29; in Cameroon, 144;
livestock as, 39; middle-class, 29;
in Somali society, 193, 197, 199; in
Tuareg society, 52; in Zanzibar, 19
West, the, 2, 7, 15, 16, 25, 76, 85, 129, 132,
138, 178, 186, 217
Western: dress, 9, 68, 215; hegemonic
practices, 213; humanitarian NGOs,
in Sudan, 209; imperialism, 112,
157n19, 212; inspiration, 125; lib-
eral ideas, 213; media, 186, 202n2;
powers, 85; press, 15, 16; sanctions,
209; stereotypes, 95
white, 123; cloth, 20, 98, 145; clothes
(also clothing, garments), 104, 120,
145, 152; handwoven cloth, 171; out-
fits, 98
"white" people: Arabs, 155; itinerant
preachers, 140, 153; sheeting, 189,
190; veil, 91, 104, 105, 143
women (also women's): Algerian, 114,
116, 117; Cameroon, 6, 137, 138, 139,
140–143, 155; Cameroon women and
the hajj, 143–149, 152, 154; economic
autonomy, 18, 24; education, 59,
60–61, 63, 66–67, 73, 74, 75, 77n1,
78n12; and the hajj, 73, 157n22; Izala,
113–133; migrant Muslims in France,
213; Muslim Sudanese, 206, 208, 218;
in Nigeria, 58–69, 70, 71, 73, 77, 129,
168, 170, 171; Oromo, 186, 187, 191,
193, 196, 197; pilgrims, 137, 145, 147,
154; in public life, 141; rights (and
Islam), 112, 165, 214; Senegalese,
85–86, 87–91, 93–104, 106–107;
slave(s) in Zanzibar, 19, 20, 21, 22, 24;
subordination, 3, 15, 18, 31, 131, 186,
205; Swahili, 21, 22; Tuareg, 4, 35,
36, 38, 39, 41, 45, 47, 48, 55n2, 55n5;
Zanzibar(i), 4, 15, 16, 17, 23, 25, 27,
29, 31
women's bodies, as sites of political
debates, 111, 216

Yoruba, 59, 66, 67; multi-religious soci-
ety, 59, 76; Muslims, 59, 68, 70, 71, 72;
reformist groups, 67, 70, 73, 76

Zanzibar, 4, 15, 16, 18, 19–20, 23, 28, 30,
31, 31n3; "the Paris of East Africa,"
23; Said, Seyyid (sultan of Oman),
19; traders, 19. See also dress; slav-
ery; slave(s); slaves, former; veiling;
veil(s); women